# Andrew Wyeth
## *Memory & Magic*

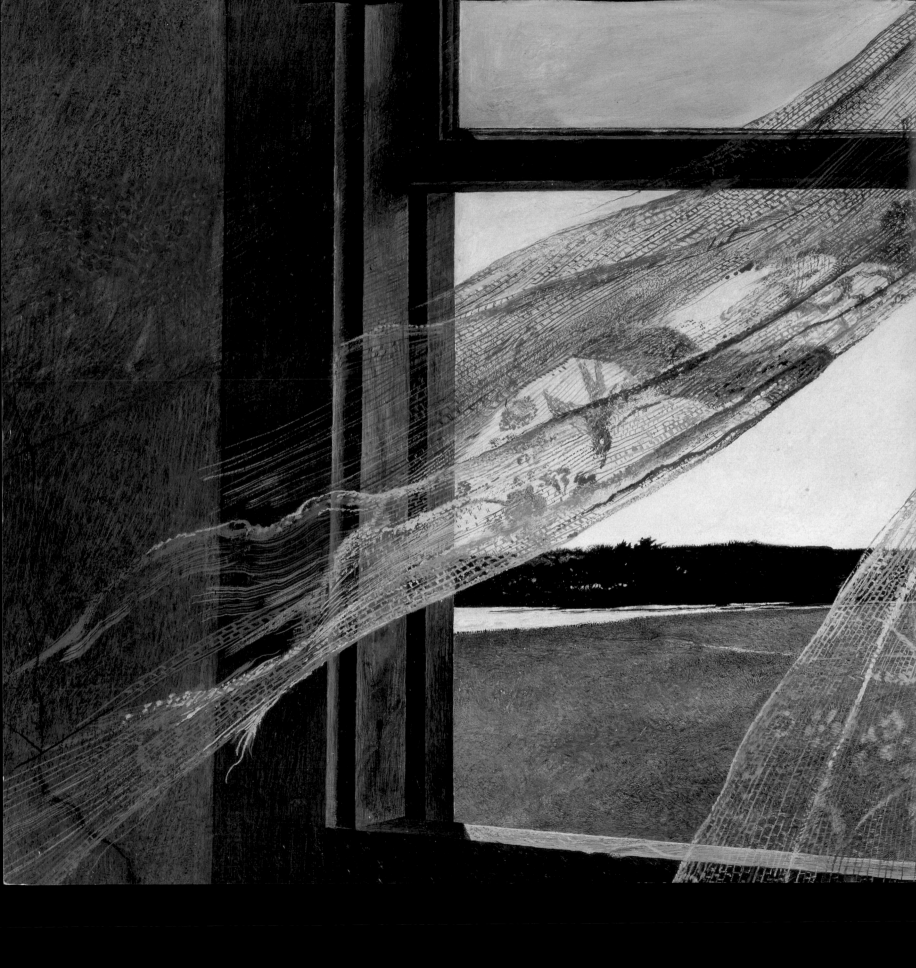

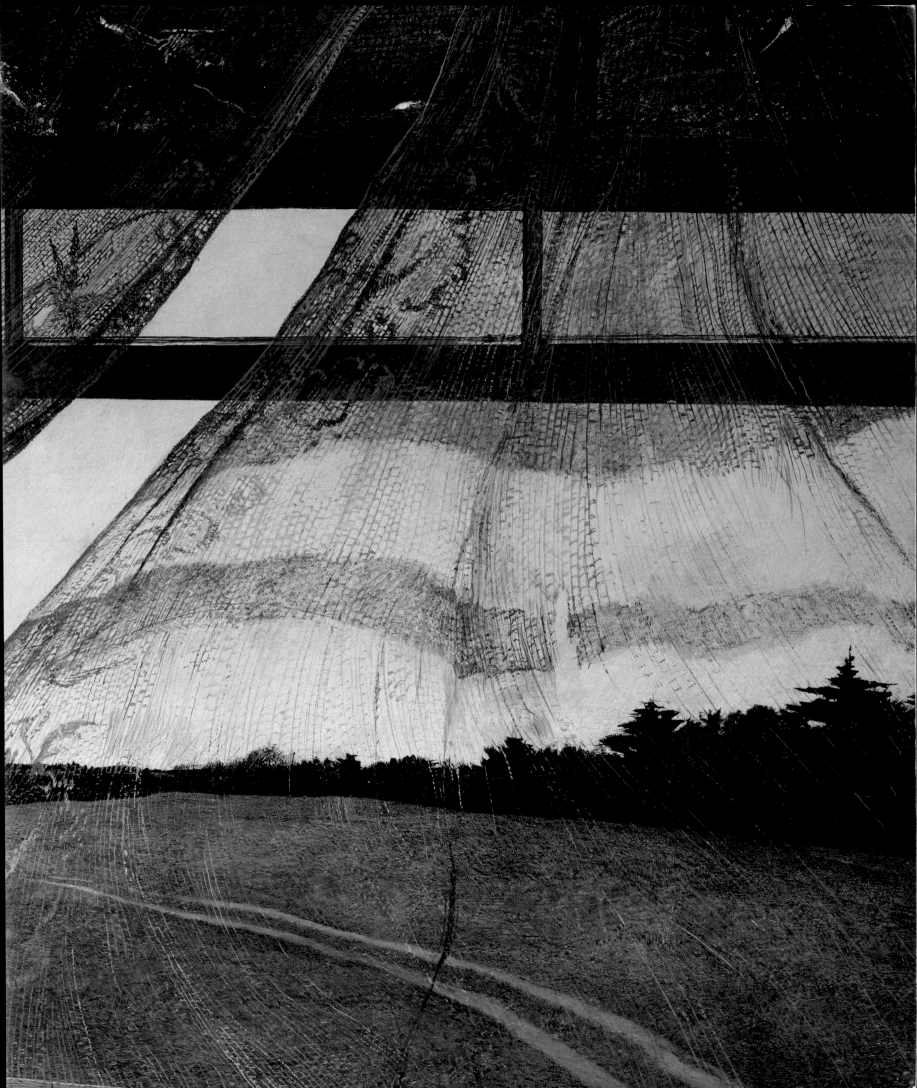

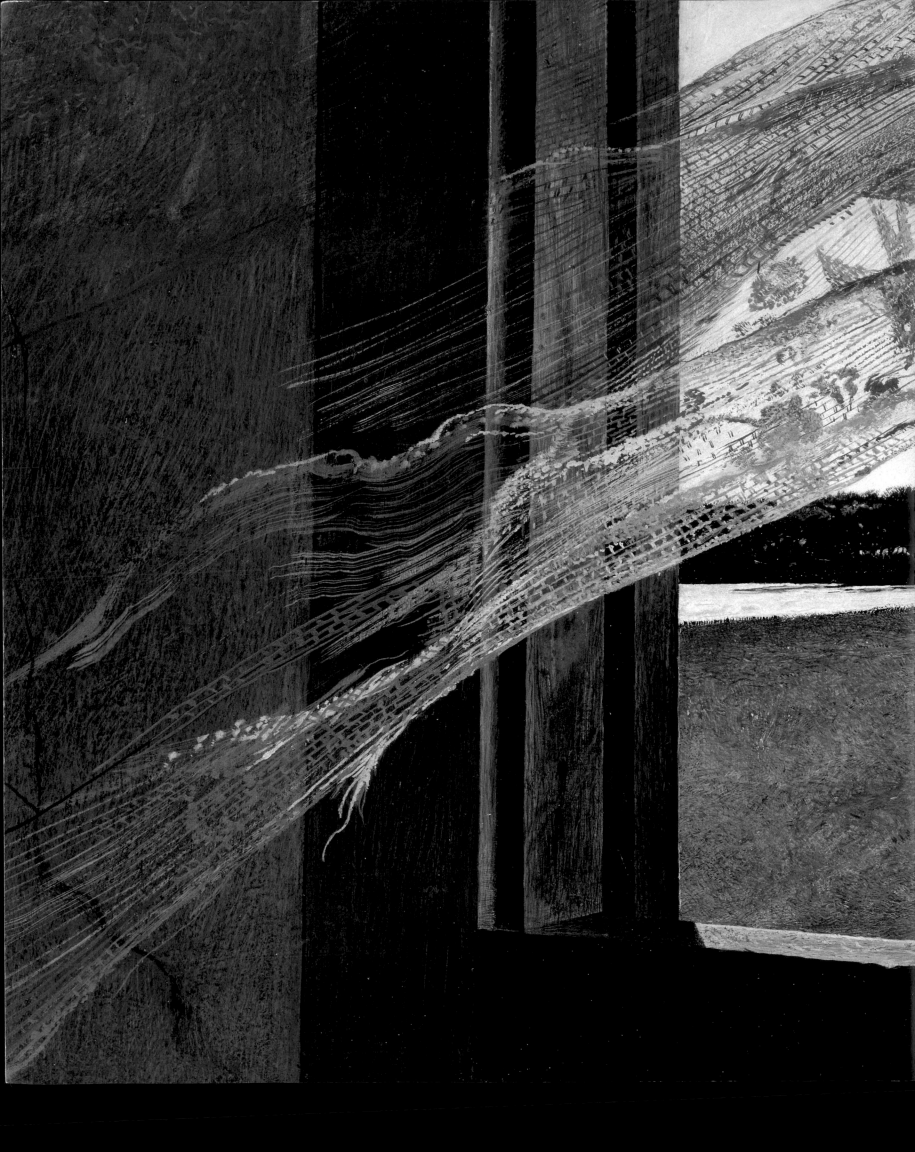

Anne Classen Knutson

*Introduction by*

John Wilmerding

*Essays by*

Christopher Crosman

Kathleen A. Foster

Michael R. Taylor

# Andrew Wyeth
## *Memory & Magic*

HIGH MUSEUM OF ART, ATLANTA

PHILADELPHIA MUSEUM OF ART

*in association with*

**RIZZOLI** NEW YORK

Published on the occasion of the exhibition

# Andrew Wyeth: Memory & Magic

Organized by the High Museum of Art, Atlanta, and the Philadelphia Museum of Art

High Museum of Art
November 12, 2005–February 26, 2006

Philadelphia Museum of Art
March 29–July 16, 2006

*Andrew Wyeth: Memory & Magic* is made possible by Ford Motor Company.

In Atlanta, the exhibition is generously supported by the Lincoln Mercury Division of Ford Motor Company.

Additional support is provided in Atlanta by the Fraser-Parker Foundation and the National Endowment for the Arts.

In Philadelphia, the exhibition is generously supported by the Lincoln Mercury Division of Ford Motor Company; GlaxoSmithKline; and PECO, An Exelon Company.

Additional support is provided in Philadelphia by an endowment from The Annenberg Foundation for major exhibitions at the Philadelphia Museum of Art. Promotional support is provided by NBC 10 WCAU.

This publication is supported by a generous grant from the Davenport Family Foundation.

Library of Congress Cataloging-in-Publication Data
Knutson, Anne Classen.
  Andrew Wyeth : memory & magic / Anne Classen Knutson ;
introduction by John Wilmerding ; essays by Christopher Crosman,
Kathleen A. Foster, Michael R. Taylor.
    p. cm.
  Catalog of an exhibition at the High Museum of Art, Nov. 2005–Feb. 2006
and at the Philadelphia Museum of Art, March–July 2006.
  Includes index.
  ISBN 0-8478-2771-2 (hardcover : alk. paper)
  ISBN 1-932543-05-8 (softcover : alk. paper)
  1. Wyeth, Andrew, 1917——Themes, motives—Exhibitions.  I. Title: Memory & magic.  II. Crosman, Christopher.  III. Foster, Kathleen A.  IV. Taylor, Michael R.  V. High Museum of Art.  VI. Philadelphia Museum of Art.  VII. Title.
ND237.W93A4 2005
759.13—dc22                              2005012837

Published by the High Museum of Art, Atlanta, and the Philadelphia Museum of Art

in association with

Rizzoli International Publications, Inc.
300 Park Avenue South
New York, NY 10010
www.rizzoliusa.com

Kelly Morris, Manager of Publications
Lori Cavagnaro, Chief Project Editor
Linda Merrill, Special Editor

Cover: Andrew Wyeth, *Trodden Weed* (detail, plate 24)
Back cover: Andrew Wyeth, *Pentecost* (detail, plate 74)
Pages 2, 3, 4: Andrew Wyeth, *Wind from the Sea* (detail, plate 20)
Pages 12, 13: Andrew Wyeth, *Her Room* (detail, plate 40)
Pages 122, 123: Andrew Wyeth, *Winter, 1946* (detail, plate 18)

Designed by Susan E. Kelly with assistance by Zach Hooker
Proofread by Alice Marsh
Indexed by Jennifer Harris
Color separations by iocolor, Seattle
Produced by Marquand Books, Inc., Seattle
    www.marquand.com
Printed and bound by CS Graphics Pte., Ltd., Singapore

# Sponsor's Statement

*Andrew Wyeth: Memory & Magic* explores the world of Andrew
Wyeth through a far-reaching survey of his paintings and drawings.
At Ford Motor Company, we are committed to enriching communities
across the country through exhibitions and programs that expand
America's artistic legacy. We are proud to support this rich example
of our cultural heritage and to bring the works of a man known as
"America's painter" to a wide national audience.

The works of Andrew Wyeth examine the beauty of everyday life,
crafted with simplicity of line and form. In these evocative images
of small-town America, viewers can see the hardworking spirit of our
country and our neighbors. Wyeth's quintessentially American vision
has created enduring icons for our time. We were proud to learn that
he counts some of our works as American classics—from his beloved
Lincoln Continental Mark II to his inclusion of a 1940 Ford truck in
his 1943 painting *Public Sale*.

Ford is pleased to partner with the High Museum of Art and the
Philadelphia Museum of Art in celebration of this American icon.

William Clay Ford, Jr.
Chairman and Chief Executive Officer
Ford Motor Company

*Andrew Wyeth: Memory & Magic* is organized by the
High Museum of Art, Atlanta, and the Philadelphia Museum of Art.

The exhibition is made possible by Ford Motor Company.

In Atlanta and in Philadelphia, the exhibition is generously supported by
the Lincoln Mercury Division of Ford Motor Company.

In Atlanta, additional support is provided by
the Fraser-Parker Foundation and the National Endowment for the Arts.

In Philadelphia, the exhibition is generously supported by
GlaxoSmithKline and PECO, An Exelon Company.

Additional support in Philadelphia is provided by an endowment from
The Annenberg Foundation for major exhibitions at the Philadelphia Museum of Art.
Promotional support is provided by NBC 10 WCAU.

This publication is supported by a generous grant from the Davenport Family Foundation.

# Contents

# Directors' Foreword

THE IDEA FOR THIS EXHIBITION was born in 2000 when Terry Stent, the current Chairman of the Board of the High Museum of Art, acquired Andrew Wyeth's *The Quaker*. The two eighteenth-century coats hanging on the wall in that tempera painting suggest a pair of figures engaged in conversation. From this spark, an exhibition was conceived that examines Wyeth's passion for the animated object. This focus offers a fresh interpretation of the art of one of America's most iconic painters. Andrew Wyeth's depiction of everyday things—domestic, natural, and architectural—constitutes a significant body of work that has received relatively little attention, yet offers a new perspective on his overall artistic achievement.

The Philadelphia Museum of Art, which has rejoiced in the possession of *Groundhog Day* for over four decades, was recently given two other remarkable paintings that contribute much to this fresh view of Wyeth's art. The two museums happily joined forces in this project to invite viewers and readers to take a closer look at Wyeth's work over an astonishing seven decades. The exhibition and catalogue reveal many new insights about the influences and ideas with which the artist contended and the methods he used to express them.

Wyeth's art grew out of his boyhood experiences both in the Brandywine Valley near Philadelphia and on the coast of Maine. His intensely personal vision has been etched in the American national consciousness for at least half a century. While many of his landscapes and interior views may seem familiar to those who live in southeastern Pennsylvania, Wyeth's work is ultimately elusive and enigmatic in its meaning. We hope this exhibition will provide a fuller understanding of his contribution to American art.

We are deeply indebted to Andrew and Betsy Wyeth, without whom this exhibition would never have taken shape. The artist and his wife generously lent many important works in the exhibition and freely shared information and insights with the curatorial team. The Wyeths' kind and highly efficient collections staff, led by Mary Adam Landa, were critical to the preparation of the exhibition.

We are truly grateful to the lenders, public and private, who have parted with important works of art, sharing them with viewers in Atlanta and Philadelphia. Our sponsors are owed a debt of gratitude of equal proportion. The High Museum of Art and Philadelphia Museum of Art salute the Ford Motor Company with special appreciation as the national sponsor for *Andrew Wyeth: Memory & Magic*. It is only with such enlightened support that we are able to bring extraordinary, distinctive exhibitions to our diverse communities. Additional exhibition support has been provided by the Lincoln Mercury Division of Ford Motor Company. We also appreciate the generous support for the catalogue provided by the Davenport Family Foundation, to which a number of distinguished publications have owed much over the years. The Fraser-Parker Foundation's early and enthusiastic support enabled the High Museum of Art to proceed with this project. We also had invaluable help from the National Endowment for the Arts. In Philadelphia, we are delighted to have two additional corporate sponsors: GlaxoSmithKline and PECO, An Exelon Company, both of whom have contributed so much to the arts and culture in Philadelphia. We would also like to thank The Annenberg Foundation, whose gift of endowment funds allows the Philadelphia Museum of Art to take on major projects such as this one, as well as our partners at NBC 10 WCAU, who extend the reach of major exhibitions in Philadelphia to a broad public.

The exhibition was conceived and organized by Anne Classen Knutson, whose thoughtful research and devotion to this project it is our pleasure to acknowledge. At the Philadelphia Museum of Art, Kathleen A. Foster, The Robert L. McNeil, Jr., Curator of American Art, and Michael R. Taylor, The Muriel and Philip Berman Curator of Modern Art, were ideal collaborators, refining and shaping the exhibition and its catalogue. John Wilmerding, the Christopher B. Sarofim '86 Professor of American Art at Princeton University, contributed an introduction to the catalogue and served as an invaluable advisor to the curators. Christopher Crosman, Director of the Farnsworth Art Museum, offers an overdue discussion of the role of the artist's wife, Betsy James Wyeth. Elsewhere in this volume, Anne Classen Knutson acknowledges the remarkable number of people without whose help this exhibition could never have come into being. Her gratitude to them is here most heartily seconded.

Michael E. Shapiro
*Nancy and Holcombe T. Green, Jr. Director*
High Museum of Art, Atlanta

Anne d'Harnoncourt
*The George D. Widener Director and Chief Executive Officer*
Philadelphia Museum of Art

# Acknowledgments

THIS EXHIBITION would not have been possible without the enthusiastic support of Andrew and Betsy Wyeth, who graciously shared many works from their private collection with us. I am immensely grateful to the indefatigable Wyeth curatorial staff—Mary Landa, Karen Baumgartner, Amy Morey, and Lauren Raye Lewis—who were crucial in locating and identifying works of art, securing loans, and expediting rights and reproduction. They never failed to respond promptly and cheerfully to my thousands of questions, and they are just plain fun to work with.

It was a great pleasure to collaborate with colleagues at the Philadelphia Museum of Art, Kathleen A. Foster, The Robert L. McNeil, Jr., Curator of American Art, and Michael R. Taylor, the Muriel and Philip Berman Curator of Modern Art, whose ideas, insights, and essays strengthened the exhibition and catalogue. John Wilmerding, the Christopher B. Sarofim '86 Professor of American Art at Princeton University, not only contributed an important introductory essay to the catalogue but also participated in the development of the checklist. Christopher Crosman, Director of the Farnsworth Art Museum, wrote an essay on Betsy James Wyeth that offers new research and fresh insights into Betsy's role in Andrew's art. We are indebted to Wanda M. Corn, who offered important feedback as we developed the intellectual framework of the show. Her groundbreaking study on Andrew Wyeth in the early 1970s laid the foundation for later studies, including this one. Joyce Hill Stoner combined her expert knowledge of Wyeth's paintings and her passionate commitment to his work to solve numerous conservation issues and to persuade lenders to lend essential paintings. Frank Fowler's help was vital in getting the project started and in securing loans. Shuji Takahashi, Curator at the Aichi Prefectural Museum of Art, Nagoya, Japan, procured key loans from Japan.

I would also like to acknowledge the many staff members at the High Museum of Art and the Philadelphia Museum of Art who have given indispensable assistance. Michael E. Shapiro, Director of the High Museum of Art, first proposed that the High develop an Andrew Wyeth exhibition, and perceived the possibilities of my approach at its earliest conceptual stage. Sylvia Yount, the Margaret and Terry Stent Curator of American Art, was a wonderful colleague, offering advice and guidance. David. A. Brenneman, Chief Curator and Frances B. Bunzl Family Curator of European Art, was always available to answer questions and offer encouragement. Jim Waters, Exhibition Designer, Angela Jaeger, Manager of Graphic Design, and Julia Forbes, Head of Museum Interpretation, brought their considerable talents to the design and interpretation of the exhibition. Saskia Benjamin and Nicole Smith, Exhibition Coordinators, deftly oversaw the details, keeping us on track. Curatorial Assistants in American Art Laurie Carter and Akela Reason offered valuable support. Manager of Exhibitions Jody Cohen and Maureen Morrisette, coordinated the project with great efficiency. This handsome catalogue, packaged by Marquand Books of Seattle, owes its design to Susan E. Kelly and Zach Hooker and its thoughtful editing to Kelly Morris, Lori Cavagnaro, and Linda Merrill.

At the Philadelphia Museum of Art, Conna Clark, Manager of Rights and Reproductions; Holly Frisbee, Permissions Officer; Carol Ha, Administrative Assistant, American Art; Jessica Jacquay, Administrative Assistant, Modern and Contemporary Art; Bethany Morris, Assistant Coordinator of Special Exhibitions; Suzanne Penn, Conservator of Paintings; Danielle Rice, Associate Director for Programs; Jack Schlechter, Installations Designer; Irene Taurins, Senior Registrar; Cynthia Haveson Veloric, Exhibition Assistant; Suzanne Wells, Coordinator of Special Exhibitions; and many other staff members lent invaluable support, for which we are grateful.

This project depended upon the generosity of the many private and public lenders who made this assembly of Andrew Wyeth's works possible. We extend special thanks to the following, who facilitated our loan requests and provided information on works in their collections: Cynthia Burlingham, Armand Hammer Museum; Judy Boerner-Rule; Jean A. Gilmore, Registrar, and Tara Cliff, Assistant Registrar, Brandywine River Museum; Cathy Conley; Rose A. Mack, Curtis Galleries; Graham Beale, Director, and Joseph Cunningham, Curator of Contemporary Art, Detroit Institute of Arts; Jane W. I. Droppa and John N. Irwin III; Thomas W. Styron, Director, and Martha Severens, Curator, Greenville County Museum of Art; Ellen Simak, Curator of Collections, Hunter Museum of American Art; Ronald L. Crusan, Director, and Nancy Stula, Curator and Deputy Director, Lyman Allyn Art Museum; Marcia A. McLean; Trinkett J. Clark, Curator of American Art, Mead Art Museum, Amherst; Ann Richards Nitze; Larry Wheeler, Director, and John Coffey, Deputy Director for Collections and Programs, North Carolina Museum of Art; and Don Bacigalupi, Director, and Lawrence W. Nichols, Curator of European and American Painting and Sculpture Before 1900, Toledo Museum of Art.

Anne Classen Knutson

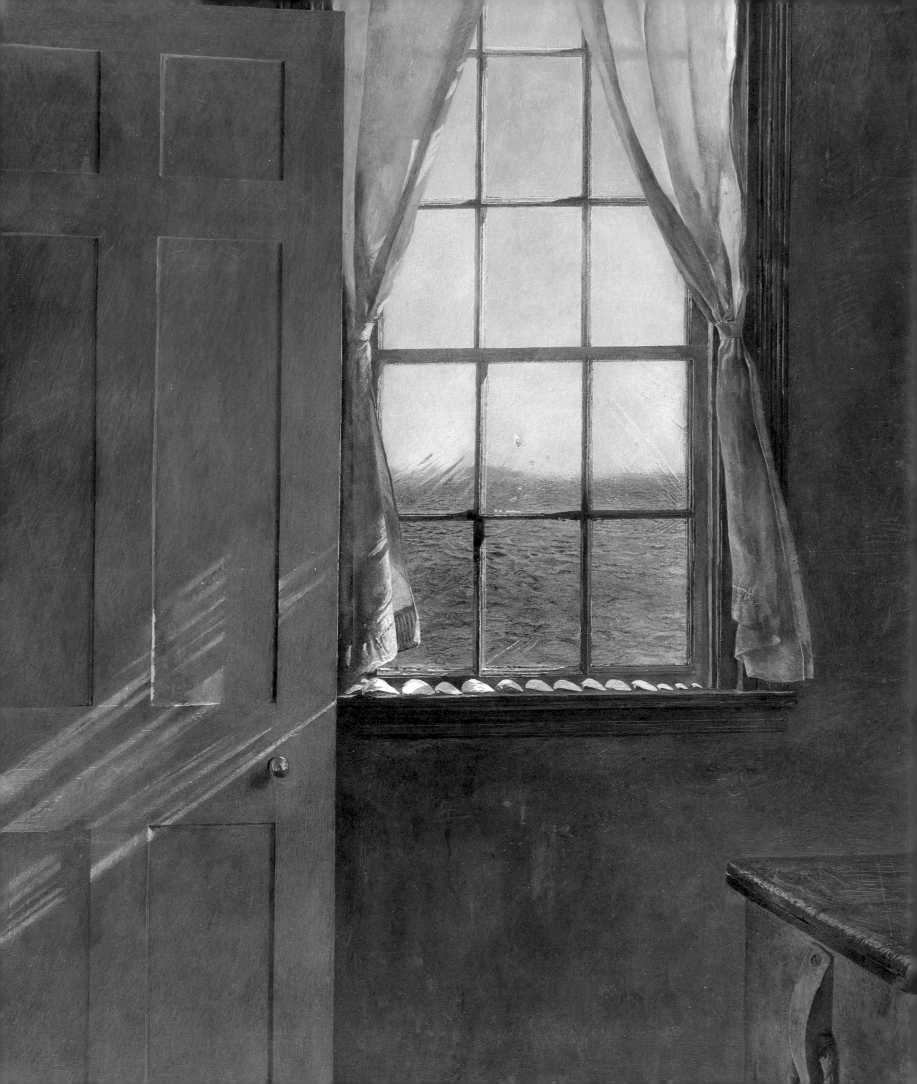

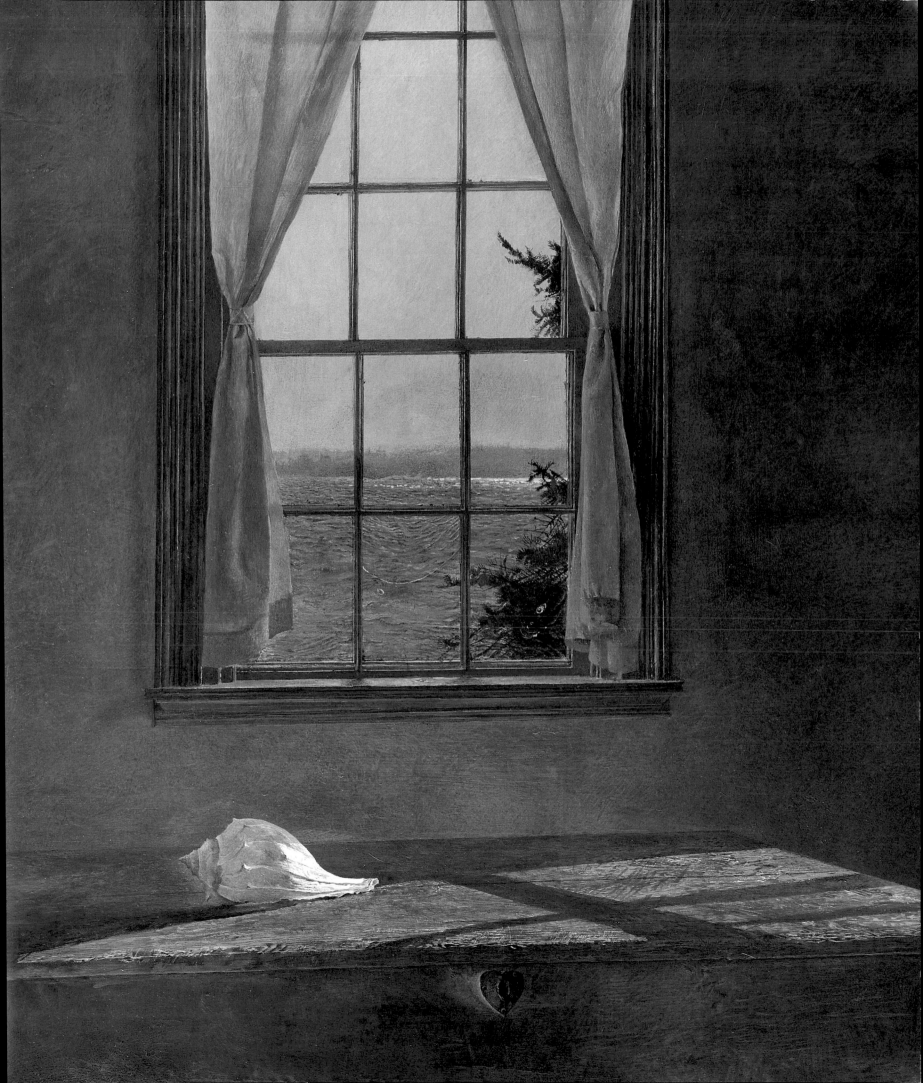

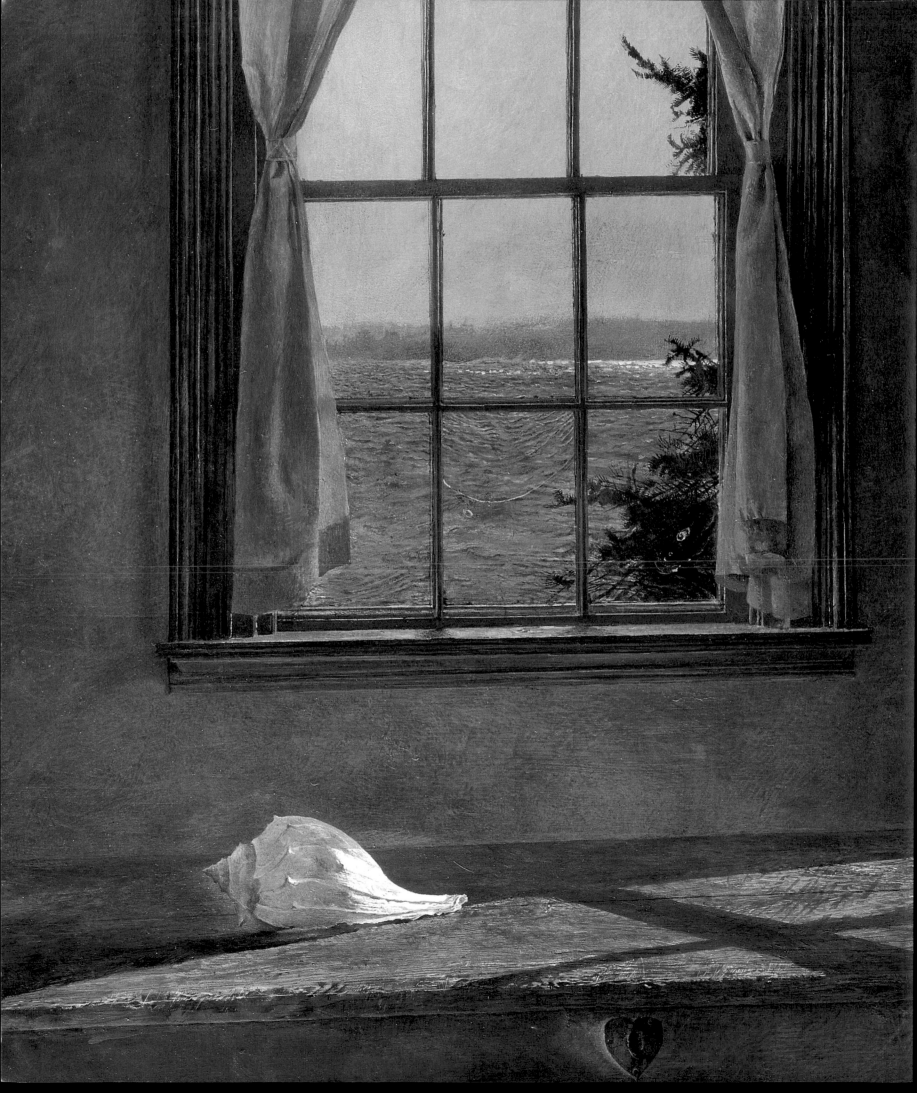

# Introduction

## John Wilmerding

An 1887 still life by the American painter John F. Peto is entitled *Ordinary Objects in the Artist's Creative Mind*. So far as we know, Andrew Wyeth has not been particularly influenced by Peto's mysterious and colorful trompe l'oeil images, but the title has a suggestive resonance in his art, and both artists invest commonplace objects with personal feeling and autobiographical associations. Throughout his long career, Wyeth has painted ordinary things as surrogates for the human presence, both of others and himself. One dialogue that emerges from the critical writing about his work is whether posterity will ultimately honor his portraits and figure paintings or his landscapes and architectural imagery. In fact—as this exhibition demonstrates—it is his impulses toward still life that dominate and unify his artistic endeavor. Wyeth's landscapes often seem as distilled and abstracted as still lifes, focusing on fragments of nature or objects within the view, or composed with a still-life sensibility. Correspondingly, many of his images of the human figure objectify the body or isolate the sitter. Especially in portraits in nearly square formats, the face and torso possess a stark stillness of form and mood.

By his early maturity Wyeth had developed a personal style of meticulous realism in both his temperas and watercolors that was firmly shaped by the American tradition. Yet what we often overlook in his paintings are two elements that seem contrary to this realism but are powerfully modern in their character—Wyeth's sense of the psychological and the abstract. His style has retained an internal consistency almost from the beginning, paralleling in its longevity two of his famous contemporaries, Edward Hopper and Georgia O'Keeffe. Now approaching ninety, Wyeth has been painting for more than three-quarters of a century, and his art is as much admired and beloved as it is maligned and misunderstood. It is the inner life of things and the formality of his designs that we seek to appreciate here.

The art that is so familiar today took shape from a confluence of sources and influences—personal, circumstantial, and artistic. Born in 1917, Andrew Wyeth was tutored at home, taught to look carefully

Fig. 1. N. C. Wyeth (American, 1882–1945), *I Said Good-Bye to Mother and the Cove*, 1911, from *Treasure Island*, oil on canvas, 47¼ × 36⅛ inches, Collection of the Brandywine River Museum, Chadds Ford, Pennsylvania, acquisition made possible through the generosity of Patricia Wiman Hewitt, 1994.

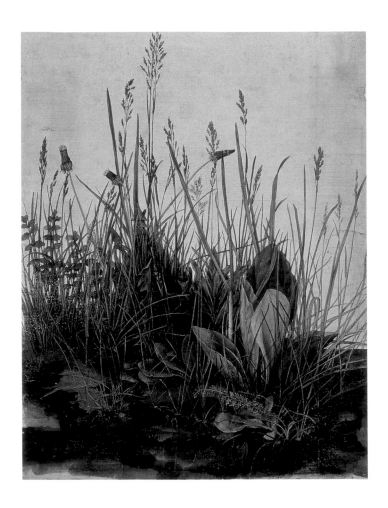

Fig. 2. Albrecht Dürer (German, 1471–1528), *The Great Piece of Turf*, 1503, watercolor and drybrush with zinc white on paper mounted on cardboard, 16 × 12⅜ inches, Courtesy of the Albertina, Vienna.

Fig. 3. Winslow Homer (American, 1836–1910), *Sloop, Nassau*, 1899, watercolor and graphite on off-white wove paper, 14⅞ × 21⅜ inches, The Metropolitan Museum of Art, New York, Amelia B. Lazarus Fund, 1910, 10.228.3.

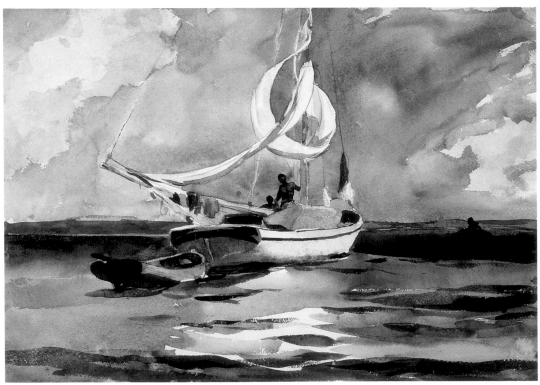

at his surroundings by his father N. C. Wyeth, and regularly exposed to music and poetry. Though he learned to write and enjoyed reading, illustrations captured his imagination, and he best expressed himself through drawing. His father had studied with the foremost illustrator of the late nineteenth century, Howard Pyle, and the tradition of American illustration was a powerful formative influence on young Andrew's artistic course. The narratives of book illustration in the work of his father (fig. 1) and his father's teacher became compressed with poetic economy and visual metaphor in Andrew's painting. N. C. Wyeth recounted to his son many of Pyle's stories, instilling in Andrew a dual, almost conflicting, love of fantasy and observation. Wyeth was already drawing by the age of six under the critical eye and guidance of his father, with whom he undertook formal art training from 1932 to 1934.

Albrecht Dürer's meticulous rendering of the natural world was a major early inspiration. We can see frequent echoes of the German artist's famous watercolor *The Great Piece of Turf* (fig. 2) in the foregrounds of Wyeth's landscapes throughout his career. Wyeth has also studied art books and visited museum collections and special exhibitions, absorbing imagery and scrutinizing techniques. He has found his strongest kinship among American masters. Above all, Winslow Homer and Thomas Eakins, respectively, have provided the inspiration for landscape and figure subjects. In the late 1920s, N. C. bought a place in Port Clyde, Maine, and not long after Andrew began to spend summers there painting. His early watercolors (see pl. 3) show the direct influence of Homer's work (fig. 3) both in Maine and the Caribbean; in 1936 Wyeth made his first visit to Homer's house and studio at Prout's Neck. Wyeth's Maine world expanded and deepened a few years later when he married Betsy James, whose family had a farm in Cushing. Through his in-laws he was introduced to the Olsons, whose faces, possessions, and surroundings would become the intimate subjects of the artist's brush over the next three decades.

By contrast, Eakins's art and career were more closely associated with the Wyeth family's winter residence at Chadds Ford, in the Brandywine Valley of Pennsylvania west of Philadelphia. Except for a few years of art training in Paris, Eakins spent much of his life in Philadelphia, where he had a powerful and controversial impact as a longtime teacher at the Pennsylvania Academy of the Fine Arts. Eakins had a dark and brooding side, as does Wyeth, and the earlier artist's portraits and figure paintings (fig. 4) are among the strongest and most compelling in the history of American art. Their starkness and probing truthfulness echo through Wyeth's imagery of the human figure.

As Wyeth's art began to mature, stylistic parallels with some of his contemporaries emerged—for example, the moody and haunted regional landscapes of Charles Burchfield or the simplified aerial farm scenes of Grant Wood. Several of Wyeth's early Maine watercolors, such as *Shoreline* (fig. 5), compare in their nervous rhythmic repetitions

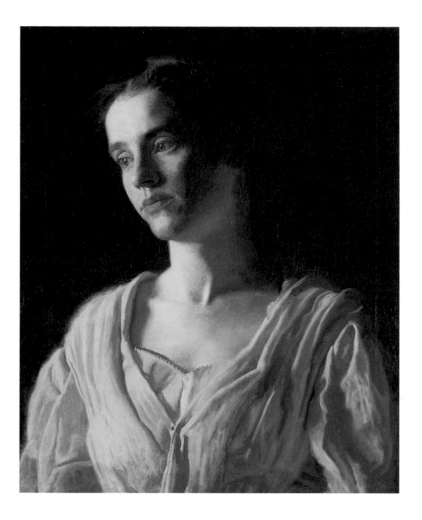

Fig. 4. Thomas Eakins (American, 1844–1916), *Maud Cook (Mrs. Robert C. Reid),* 1895, oil on canvas, 24½ × 20¹⁄₁₆ inches, Yale University Art Gallery, New Haven, Connecticut, bequest of Stephen Carlton Clark, B.A., 1903.

Fig. 5. Andrew Wyeth, *Shoreline*, 1938, watercolor on paper, 18 × 22 inches, Greenville County Museum of Art, South Carolina, purchase with funds bequeathed by Bernard Bertland.

Fig. 6. John Marin (American, 1870–1953), *Wave on Rock,* 1937, oil on canvas, 22¾ × 30 inches, Whitney Museum of American Art, New York, purchase with funds from Charles Simon and the Painting and Sculpture Committee, 81.18.

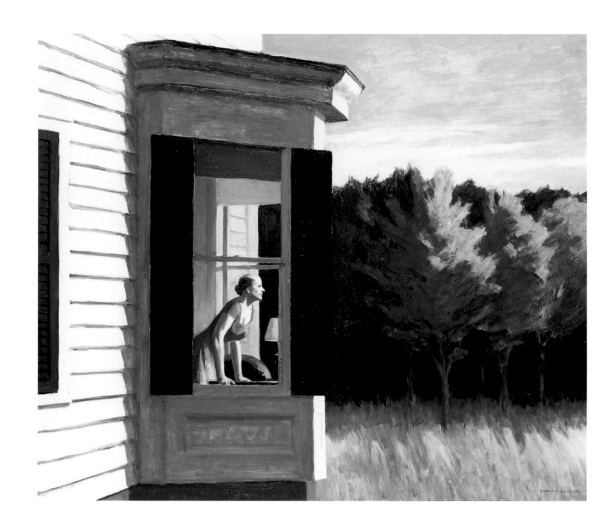

Fig. 7. Edward Hopper (American, 1882–1967), *Cape Cod Morning*, 1950, oil on canvas, 34⅛ × 40¼ inches, Smithsonian American Art Museum, Washington, D.C., gift of the Sara Roby Foundation, 1986.6.92.

with John Marin's nearly abstract seascapes (fig. 6) from the same period. Perhaps the closest visual connections may be drawn with the art of the other great realist of the twentieth century, Edward Hopper, whom Andrew met in 1942 and has since affirmed as one of his contemporaries that he most admires. In Hopper's art there is a similar consciousness of the psychological and sexual beneath the surface of things; a concentration on architectural fragments and an association of structures with personalities; a brooding emptiness in the landscape and strong abstract design underlying the realist view; and a vision attuned to modern loneliness and alienation (fig. 7).

With family and artistic tradition, environment is the other crucial factor that nurtured and shaped Wyeth's art. Andrew and Betsy Wyeth divide their year between Pennsylvania and Maine, and the different coloration of each conditions his palette: Chadds Ford is often seen in monochromatic tans, browns, and whites; Maine in brighter greens and blues. Like Homer during his later years at Prout's Neck, Wyeth has found an expansive cosmos to explore at his feet, as it were, a universe of feeling within the circumscribed horizons of the familiar.

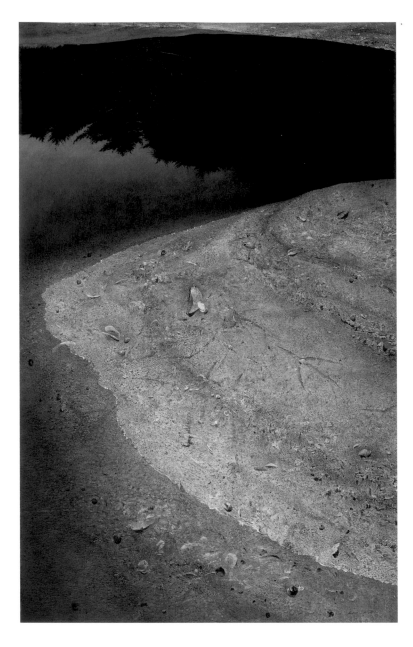

Fig. 8. Andrew Wyeth, *River Cove,* 1958, tempera on Masonite, 48 × 30⅛ inches, private collection. See plate 34.

Wyeth paints what he sees as if under a microscope, which brings us back to his paintings as permutations of still life, broadly considered. First of all, he has painted the traditional *nature morte,* arrangements of commonplace objects on a tabletop. These basically academic exercises later evolved to clusters of mussels and seashells isolated on the ground, or dead birds hung on a wall or lying in a field, as in *Winter Fields* (pl. 8). He also painted straightforward botanical studies, such as *Apples on a Bough* (pl. 7), *Blackberry Branch* (pl. 9), and *Winter Corn* (pl. 22). These close-up vignettes of flower and leaf clusters had later incarnations in *Quaker Ladies* (pl. 30), and *Long Limb* (pl. 81). This category could be expanded further to include depictions of both large portions of tree limbs and roots as well as isolated blades of grass within broader landscapes. *Trodden Weed* (pl. 24) takes its title from a flattened strand of grass subtly dominating the field's foreground, while abstract tendrils of grasses in the foreground screen the view in *Winter Fields.* These still-life elements in Wyeth's landscapes have counterparts in his portrait compositions in curving strands of hair, often caught in the light or seen against a darkened ground.

Cropped views of tree trunks, roots, or limbs, as in *Spring Beauty* (pl. 13) and *The Hunter* (pl. 14), treat portions of the forest as oversized still lifes. This practice recurs in the abstracted curve of a sandbank in *River Cove* (fig. 8, pl. 34). In addition, Wyeth sometimes compresses space with a downward point of view that captures fragmented reflections of the sky, as in *River Cove* and a decade later in *Thin Ice* (fig. 9). The abstraction in these landscapes has a striking parallel in the art of the Abstract Expressionists, particularly the near-contemporary work of Mark Rothko and Franz Kline. (It is worth noting that around this time Wyeth spoke with Rothko about the spiritual content of their art.) Elsewhere, Wyeth simplifies, exaggerates, or purifies forms, as in the powerful shadow of an evergreen that dominates the foreground of *Raven's Grove* (pl. 72), or the bold geometries in *Moon Madness* (fig. 10), which may also be a subliminal recollection of Homer's *Kissing the Moon* (fig. 11). The edge of the roofline in Wyeth's painting is a reminder of how often he composes around the corners of buildings and angles of rooflines, as in *Weatherside* (pl. 43) and *End of Olsons* (fig. 12).

When we turn from Wyeth's landscapes to his interiors, we find constant repetitions of mantels, lintels, paneled walls, and above all of doorways and windows. As they were for Burchfield, windows are for Wyeth the eyes of a house and an expression of its personality. Windows, of course, both separate and bring together outside and inside. As constructed shapes, they contrast with the animate and organic presence of natural and human forms. Perhaps most familiar are the windows of *Wind from the Sea* (pl. 20) and *Groundhog Day* (pl. 35), with their later variations in *Her Room* (pl. 40), *Spring Fed* (pl. 48), *Off at Sea* (pl. 55), *Night Sleeper* (pl. 66), and more recently *Love in the Afternoon* (fig. 13, pl. 76), and *Renfield* (pl. 82). On occasion, windows have opened out

Fig. 9. Andrew Wyeth, *Thin Ice,* 1969, tempera on panel, 42⅜ × 48 inches, private collection.

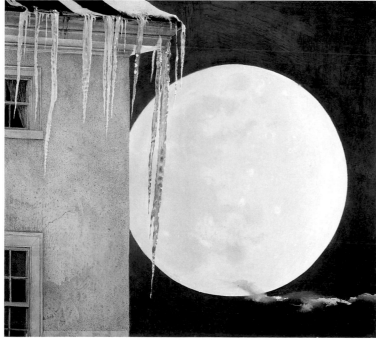

Fig. 10. Andrew Wyeth, *Moon Madness,* 1982, tempera on panel, 18 × 20 inches, private collection.

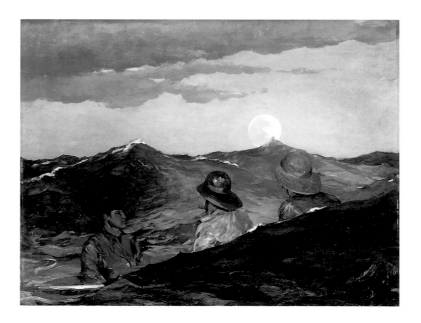

Fig. 11. Winslow Homer (American 1836–1910), *Kissing the Moon,* 1904, oil on canvas, 30¼ × 40⅜ inches, Addison Gallery of American Art, Phillips Academy, Andover, Massachusetts, bequest of Candace C. Stimson.

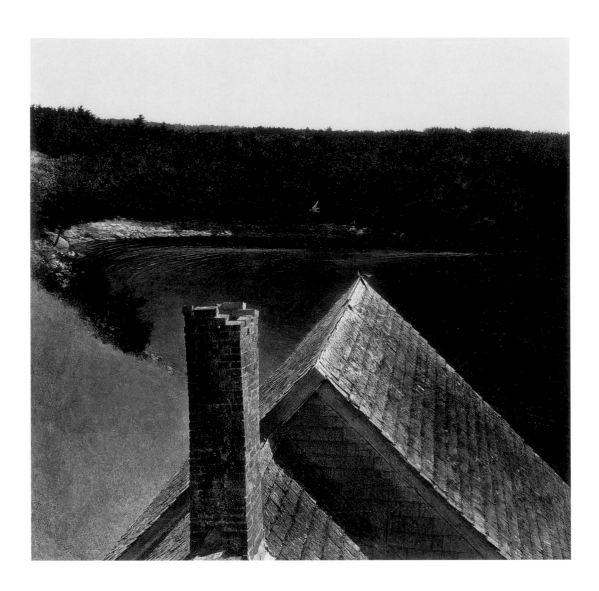

Fig. 12. Andrew Wyeth, *End of Olsons*, 1969, tempera on panel, 18¾ × 19⅛ inches, private collection.

onto a blankness that allows for the release of the imagination or admits the unconscious realm of dreams, most notably in *Overflow* (fig. 66) and *Day Dream* (pl. 68). Doorways have played a less insistent role in the form and content of Wyeth's imagery, though one of his most evocative appears in *Christina Olson* (pl. 19), where a seated figure looks out from a sunlit doorstep.

In their rectangular formats, whether vertical or horizontal, windows take on another function in Wyeth's art, as a visual play on the panel itself. His views are often contained within one section of a composition, making us aware of frames within frames. Usually these openings are parallel to the picture surface, but occasionally there is a tension between the two planes; sometimes one or more of the framing edges of a window is contiguous with the actual frame of the painting. This formal playfulness calls attention to the act of looking, to the juxtaposition of landscapes within and without, and to the synapse between reality and artifice.

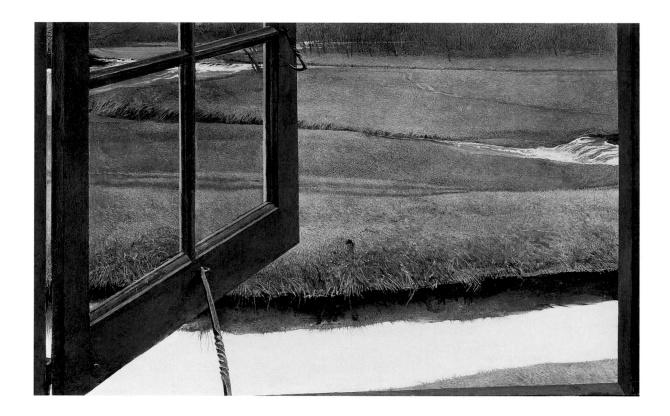

Fig. 13. Andrew Wyeth, *Love in the Afternoon*, 1992, tempera on panel, 17⅝ × 28⅝ inches, Ambassador and Mrs. William S. Farish. See plate 76.

Wyeth's processes of painting the figure are not very different from his approach to landscape and interiors. Some portraits are painted as if they are human still lifes. Indeed, the iconic *Christina's World* (fig. 44) may be viewed as a monumental figurative still life. Wyeth has also portrayed parts of the body, items of clothing, or familiar objects as surrogates for people. As in his landscapes, compositional artifice and selective concentration are used as expressive devices. Often, things carry explicit biographical (or autobiographical) associations. Among the most eloquent instances of objects serving as forms of portraiture is *Chambered Nautilus* (pl. 31), in which the shell at the foot of the bed, which gives the picture its title, echoes the claustrophobic enclosures of the room and the bed hangings, while also standing in for the fragility and private inwardness of the artist's mother-in-law, who is the subject of the picture. *Groundhog Day* (pl. 35) depicts a spare table setting of cup and saucer, plate, and knife that embodies the unseen presence of Wyeth's neighbors, Karl and Anna Kuerner.

When he reached his seventieth year, Wyeth painted a symbolic self-portrait in *Snow Hill* (fig. 14), which includes seven characters, friends or neighbors who had modeled for him over the course of his career, joined together in a ring, dancing around a maypole at the top of the snow-covered Kuerner's Hill in mid-winter. It is a tour de force of creamy whites and off-whites for the entire landscape and sky, border-ing on abstraction, and also referring to the title of the final chapter of Herman Melville's symbolic masterpiece *Moby Dick*. Coming to life

through his art, these artificial figures embody Wyeth's creative imagi-nation and artistic autobiography.

Besides portraying objects as the ghosts of people he knows, Wyeth has concentrated on parts of the body, and even more, on clothing, to represent himself and others. The cropped view of his boot-clad legs in *Trodden Weed* (pl. 24) was intended as a self-portrait during his recovery following lung surgery, when he saw an apparition of death coming for him. Four decades later, the artist became obsessed with his arthritic hands, which were threatening his ability to paint. Molds had earlier been taken of his hands, and the bronze casts usually rest on a windowsill in the Brandywine house. In *Breakup* (pl. 78), Wyeth magi-cally transposes the casts to an ice floe on the nearby river seen from that window, creating a haunting disembodied self-portrait. *Squall* (fig. 65) depicts two slickers hanging from pegs, flanked on one side by a window looking out on turbulent weather at sea, and on the other by a door opening onto a bleak sky and dark hillside. Set in the house on the Wyeths' Maine island, these coats represent the artist and his wife— some say at a time of tension in their marriage after the controversial surprise of the Helga pictures, which were unveiled after a long period of secret work. Not surprisingly, throughout his painting life Wyeth

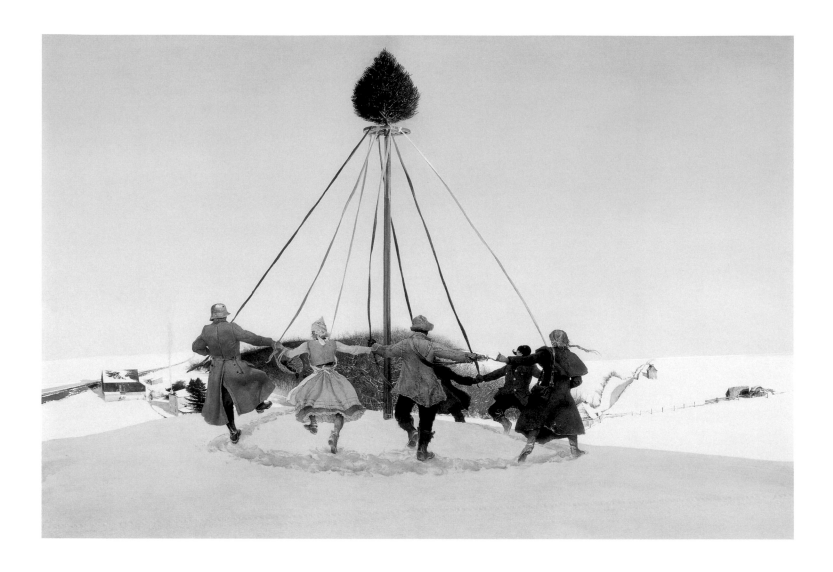

Fig. 14. Andrew Wyeth, *Snow Hill,* 1989, tempera on panel, 48 × 72 inches, Collection of Andrew and Betsy Wyeth.

has painted portraits of his wife Betsy, but he has also represented her metaphorically in objects associated with her: a doll, a raspberry pie, · a fur hat, a berry-picking pail.

Another category of portrait still lifes, perhaps better called "stilled lives," is the sequence of sleeping or deathly figures imagined or observed by the artist from the beginning of his career. These include an apparitional memory image in *Christmas Morning* (pl. 15); Helga Testorf sleeping in *Black Velvet* (fig. 15), *Overflow* (fig. 66), and *Day Dream* (pl. 68); Karl Kuerner in the snow in *Spring* (pl. 65); Tom Clark in *Garret Room* (pl. 39); Walt Anderson in a boat in *Adrift* (pl. 71); and two neighbors under bedcovers appearing to be (in the appropriate phrase) dead asleep in *Marriage* (pl. 77). Some of these are explicit portraits of individuals, while others are conjurings of the artist's imagination. They show us equally the dreams of the sitters and of the painter.

A final group of portraits has another distinctive kind of artifice, which stresses the figure as an animate still life. These works depict the

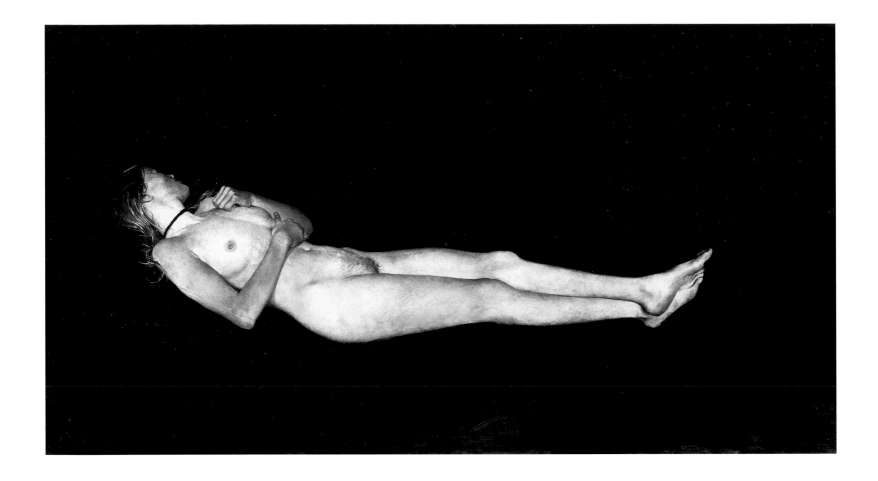

Fig. 15. Andrew Wyeth, *Black Velvet*, 1972, drybrush on paper, 21¼ × 39½ inches, private collection.

sitter framed in a square or near-square format. Unlike the vertical rectangle that simulates a window onto nature, or the horizontal rectangle that matches a stage proscenium, the pure geometry of the square seems more arbitrary and distilled. Like other basic geometric shapes, the square is more perfect than nature's irregularities, and in a painting it calls attention to form as much as content. We have seen this earlier in American painting in the late seascapes of Homer, which emphasize abstraction over representation in their high horizon lines, compression of spatial recession, and attention to the brushwork on the canvas. The framing square also became an abstract formal principle in the 1960s work of Frank Stella and Ellsworth Kelly. Interestingly, Wyeth repeatedly used the near-square format during the late 1960s and early 1970s in some of his strongest and most formally conscious portraits, including *Maga's Daughter* (pl. 46), *Anna Christina* (pl. 47), and *Nogeeshik* (pl. 54). These works vary from profile to three-quarter to frontal poses, but most frequently they are torso figures set against stark blank backgrounds without accessories or visual embellishments.

*Braids* (pl. 64) is perhaps the finest of the Helga images, and part of its strength lies in the isolation of the head within this static format. Wyeth has said that the painting was originally slightly longer, to include the ends of the braids that splayed out across Helga's chest. Feeling that this effect was too pretty and distracting, he cropped the image at the lower edge. This trimming, we may suspect, also tightened the design, giving the composition heightened formal power and psychological intensity, not unlike the late portrait masterpieces of Wyeth's great Philadelphia predecessor, Thomas Eakins. Such formal and psychological expressiveness is a hallmark of Wyeth's best painting, and informs the particular realism for which he has come to be known. Along with Hopper's distilled and suggestive vision, Wyeth's art is likely to stand as an indelible contribution to the realist tradition of the twentieth century.

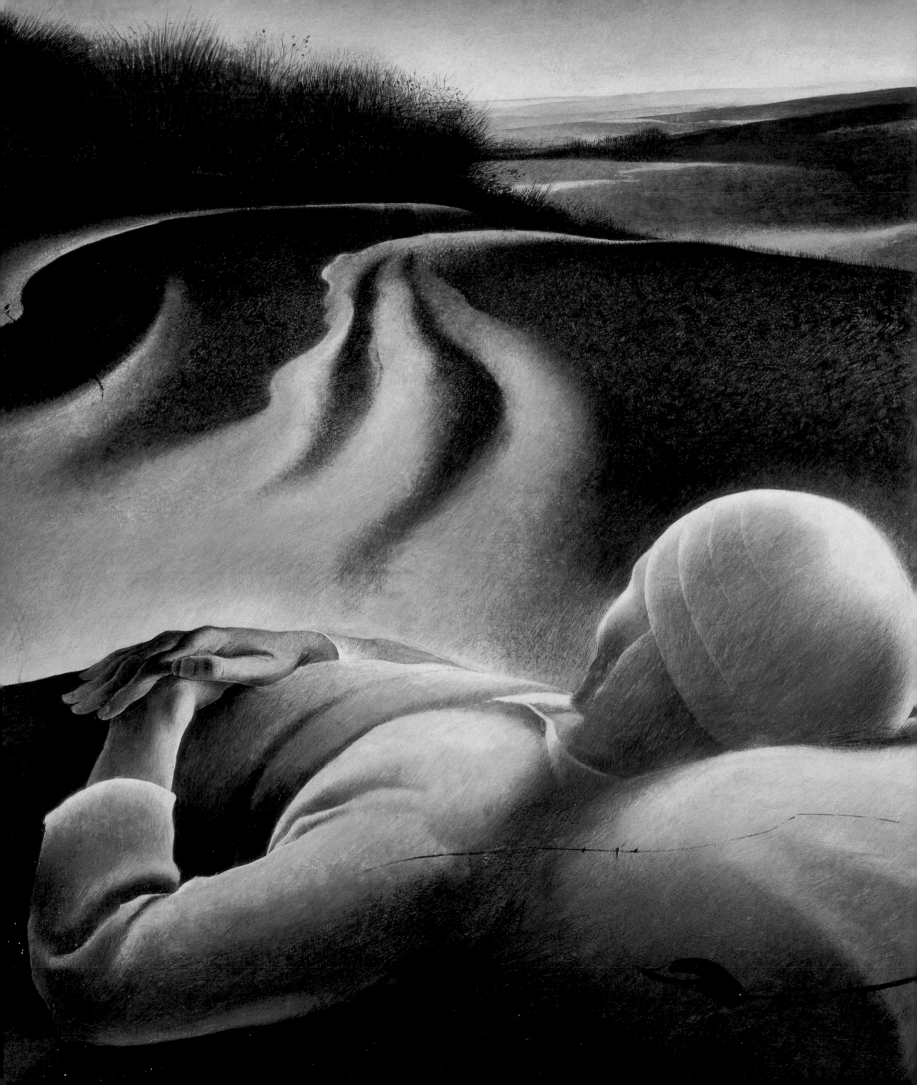

# Between Realism and Surrealism: The Early Work of Andrew Wyeth

Michael R. Taylor

THE EARLY WORK OF ANDREW WYETH has for too long been considered in isolation from the codes of representation that characterized American realist painting in the 1930s and early 1940s.[1] Wyeth began exhibiting his work in the mid-1930s, during one of the most turbulent and polarized periods in the history of American art, when debates about art and politics, and abstraction and figuration, were bitterly contested. Despite efforts by art historians and museum curators to place the artist within the mainstream of American modernist painting, Wyeth has remained stubbornly resistant to such claims, preferring instead to present himself as a reclusive outsider, immune to the artistic practices and debates of his time. Since the late 1940s, Wyeth has constructed a romantic image of himself as a contented loner, a modern-day Henry David Thoreau on Walden Pond, who seeks inspiration only from the landscape and people of Chadds Ford and the surrounding Pennsylvania countryside and the area of northern coastal Maine around Cushing. Many of the artist's admirers, as well as his critics, have never questioned this improbable scenario, which I believe has hampered our understanding of the artist's contribution to American art of the twentieth century.

Wyeth's potential as an artist of merit was recognized as early as 1935, when he was included in a group exhibition at the Art Alliance in Philadelphia entitled *The Wyeth Family.* The advance publicity for the exhibition concentrated on the work of his father, N. C. Wyeth, the distinguished painter, muralist, and illustrator, and Andrew's oldest sister, Henriette, who was hailed as "one of the most brilliant of the younger generation of American artists."[2] However, it was the eighteen-year-old Andrew who stole the show with sixteen works of extraordinary maturity. Wyeth was represented by several important oil paintings, such as *1776* and *Jimmy,* a portrait of a Chadds Ford Quaker, but it was his freely brushed watercolors, like *Ruins— Washington's Headquarters* and *McVey's Barn* (fig. 16), that caught the attention of visitors to the show. On the strength of these works on paper, the prominent Philadelphia artists Earl Horter and Yarnall

Abbott offered Wyeth a return engagement at the Art Alliance the following year.

When Abbott took over as president of the Art Alliance in April 1936, he enlisted the help of Horter—who owned a world-class collection of avant-garde painting and sculpture, including works by Pablo Picasso, Georges Braque, Henri Matisse, Marcel Duchamp, and Constantin Brancusi—to revitalize the organization through an exhibition program that would be sympathetic to modern art (fig. 17).[3] That Horter and Abbott should single out Wyeth as a "youngster [with] a brilliant future" suggests that of all the Wyeth clan it was Andrew whose work was most closely aligned with the modern sensibility that Horter sought in contemporary American painting, which he also collected.[4] Wyeth's early exposure to Horter's collection of Cubist paintings would lead to a lifelong admiration for Braque's work. Indeed, Wyeth could well have had Horter's collection in mind when he told George Plimpton and Donald Stewart, "I like Braque's work very much. I think he has beautiful color—wonderful greens—a fresh feeling about him."[5] This remark reflects Wyeth's early appreciation of modern European art, which undoubtedly had an impact on his own work, despite his later claims to the contrary.[6]

Wyeth was also familiar with the collection of modern paintings from Eastern Europe formed in the 1920s by the prominent art critic Christian Brinton, who lived just a few miles north of Chadds Ford. Brinton's acclaimed collection, which he donated to the Philadelphia Museum of Art in 1941, included paintings, sculpture, and works on paper by modern artists from the former Soviet Union, including Alexander Archipenko, David Burliuk, Marc Chagall, Mikhail Larionov, Nicholas Roerich, Nikolai Stepanovich, and Nicholas Vasilieff. Wyeth first saw this collection in the winter of 1936, when he visited Brinton's house and, after lunch, went tobogganing with the collector. He later recalled being overwhelmed by the early works by Chagall in the collection, which he still considers to be "the best things he ever did," but he was equally impressed by Brinton's vital energy and sparkling

Fig. 16. Andrew Wyeth, *McVey's Barn*, 1933, watercolor on paper, 15 × 22 inches, private collection.

personality.[7] That Brinton made a deep impression on the young artist is clear from a fine pencil drawing of the art critic that he made around the time of this visit (fig. 18).[8] Wyeth was thus exposed to modern painters and collectors during his earliest years as an artist, when his own mature style began to be formed.

When the *Exhibition of Thirty Watercolors by Andrew Wyeth* opened in Philadelphia in November 1936 it caused a sensation, and the critical acclaim more than justified Horter and Abbott's decision to offer the artist his first one-man show. The thirty works on paper that N. C. Wyeth selected for his son's exhibition—all completed since the close of *The Wyeth Family* exhibition the year before—demonstrated his increasing sophistication as a watercolorist. The artist later dismissed this body of work as belonging to his "blue sky" period of brash watercolors, but his daring, bold color and rapid, spontaneous handling reveals his profound appreciation for the fluid watercolor style of such American forebears as Winslow Homer and John Singer Sargent.[9]

The Art Alliance exhibition also provided the artist's first critical reviews. Writing in the *Wilmington Morning News,* Mina Carol praised Wyeth's "flare for originality and dash. His painting may be but a raging sea in blue-green and white, but it has a sure and nonchalant treatment that is definitely his own. In the drabness of a field of shocked

corn he puts a reality that sets it far and apart from a trite autumn scene."[10] This extended article, until now overlooked in the Wyeth literature, offers insights into the artist's working methods of the time: "The eagerness and thoroughness with which the young Wyeth carried on his research when working on an illustration or a period picture has led him to haunt newspaper morgues for days. He will pour over old files of the times in which he is interested and is a regular visitor of historical museums, galleries, and libraries in both Pennsylvania and Delaware."[11]

Wyeth's Art Alliance exhibition coincided with the centennial of Winslow Homer's birth in 1836, which was celebrated in New York with a comprehensive exhibition of 170 paintings, prints, and drawings at the Whitney Museum of American Art; a selection of forty watercolors from the last two decades of the artist's life at the Knoedler Gallery; and a smaller display of early works at the Macbeth Gallery, where Wyeth would exhibit his own work the following year.[12] Elsewhere, the Pennsylvania Museum of Art (now Philadelphia Museum of Art) paid special tribute to Homer in an exhibition of thirty oil paintings, twenty-nine watercolors, eleven drawings, and a selection of etchings and woodcuts.[13] Finally, the walls of Homer's old studio in a small cottage on the rocks at Prout's Neck, Maine, were filled with paintings,

watercolors, family mementos, and studio detritus, such as the artist's easel, the casting rods and net he used to land fish, a wheel salvaged from an old wreck, and a ship's sextant that appears in the dramatic painting *Eight Bells* of 1886.[14] Wyeth made the pilgrimage to Prout's Neck to see the *Century Loan Exhibition* with his sister Carolyn, and through this visit came to know Charles Lowell Homer, the artist's nephew, who showed him Homer's writings on the cottage wall. Wyeth's intense study of Homer's paintings, especially his late watercolors, thus coincided with a resurgence of interest in the artist's work in the United States and abroad that lasted well beyond the Homer centennial celebrations.

These exhibitions, which Wyeth would either have seen or read about in journals and newspapers, cemented Homer's reputation as an American Old Master, a hardy Yankee whose humility before nature and reverence for the silent presentation of the seen fact spoke to contemporary concerns about realism in American painting. As evidenced by his subsequent watercolors, Wyeth was clearly enthralled by Homer's life and work, especially as presented in the exhibitions, books, and articles celebrating the artist's centenary, which relied on the legend of the artist's semi-civilized hermit existence on the coast of Maine.[15] Homer emerges from these accounts as a heroic figure who worked instinctively to obtain an authentic vision and distinctly American style. "Winslow Homer was the first of our painters to speak authoritatively in the native accent," wrote Henry McBride in the *New York Sun*. "Like Walt Whitman, he looked on this country and saw that it was good."[16]

The critical success of Wyeth's first solo exhibition encouraged the New York dealer Robert Macbeth to show twenty-three Wyeth watercolors at his gallery in October 1937.[17] In the 1930s, Macbeth was one

Fig. 18. Andrew Wyeth, *Portrait of Christian Brinton, Study for Map of Historical Chester County,* 1936, pencil on paper, 4¾ × 3¾ inches, Collection of the Christian C. Sanderson Museum, Chadds Ford, Pennsylvania.

of the foremost authorities on Homer and would have recognized Wyeth's debt to the earlier artist's work in the sparkling color and bravura brushwork of these Maine watercolors (pl. 3). Art critics also noticed Wyeth's reliance on Homer and Sargent in his freely executed washes, although they were divided as to whether this was a danger or an asset to his future development.[18] The critical reaction to Wyeth's first New York exhibition is perhaps best summed up by Howard Devree's review in the *New York Times*, which praised the exuberant watercolors as

> evidence of a very real talent, though the shadow of Homer falls athwart many of them. On the negative side it must also be noted that many of the large papers might have been more effective in a smaller version. On the positive side be it reported that young Wyeth's color sense is excellent; that he gets light and atmosphere into his pictures, and that almost all the work has a real emotional impact. Skies, as in *Early Morning,* are well done. Action, vitality, the depth and play of deep sea water are there. It is exciting stuff.[19]

Despite certain reservations from Devree and McBride, the exhibition was a phenomenal success, both critically and financially, since all of

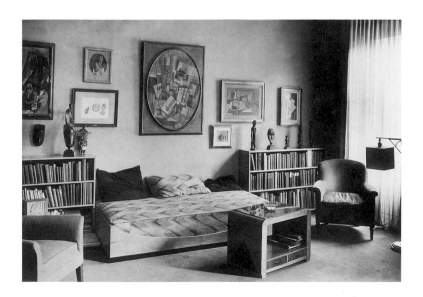

Fig. 17. Earl Horter's living room at 2219 Delancey Street, Philadelphia, ca. 1930, Philadelphia Museum of Art: Earl Horter Archives.

the watercolors on display had been sold by the end of the second day. But Wyeth was dissatisfied. "I was skimming along on a very superficial level," he later recalled, "I had a terrible urge to get deeper, closer to nature."[20]

Two years later, in October 1939, Wyeth exhibited a second group of Maine watercolors at the Macbeth Gallery that revealed a new depth and maturity.[21] The artist had clearly listened to the critics who believed that the exuberance of his earlier efforts had come too easily. Writing in *Artnews*, James W. Lane observed that the artist's dashing style "has deepened, however, in the interval, in his power to call up the freshness of salty breezes, to give in one swift stroke the watery reflections of a boat near the shore, and to present the whole look of the sea in every kind of weather with more actuality than most of the marine painters three times his age."[22] The most successful works in the exhibition continued to rely on instinct, rather than formal design, but watercolors such as *The Captain's House* and *Turkey Cove Ledge* (fig. 19) revealed a deeper, richer color than seen in his earlier "blue sky" efforts.[23]

By the time of Wyeth's third solo exhibition at the Macbeth Gallery in October 1941, the broad, sweeping brush strokes and bold color of

Fig. 19. Andrew Wyeth, *Turkey Cove Ledge*, 1939, watercolor and under-drawing on paper, 17⅞ × 29⅞ inches, The Metropolitan Museum of Art, New York, gift of Miss Amanda K. Berls, 1967, 67.56.

his Homer-inspired Maine watercolors had been largely replaced with painstakingly observed, close-up studies of crustaceans and bivalves in their natural settings (pl. 5).[24] These exquisite works hint at the enormous change Wyeth's painting was undergoing as he attempted to master the medium of egg tempera, which required extraordinary precision and control, in striking contrast to the fluid virtuosity of his watercolors. The artist's early reputation had been built upon his consummate skill as a watercolorist, but his tempera paintings of the early 1940s mark his transition from promising tyro to mature artist.

Wyeth's earliest oil paintings reveal a profound debt to the work of N. C. Wyeth, under whom he had received a severely disciplined studio apprenticeship, as well as artists his father admired, such as Daniel Garber, William Lathrop, and other American impressionists

of the New Hope School. These oil paintings lacked the assurance of Wyeth's best watercolors, however, and were rarely exhibited. It was not until 1936 that Wyeth, under the tutelage of his brother-in-law Peter Hurd, began to experiment with egg tempera, an exacting medium that demands time and patience as well as skill. Beginning with a humble portrait of his Boston bull terrier Lupe, painted on a small gessoed panel as a present for his mother, Wyeth took several years to master the painstaking technique of working in tempera.[25] This education included visits to the Philadelphia Museum of Art, where Wyeth and Hurd closely examined the early tempera paintings in the John G. Johnson Collection, which included important works by Fra Angelico, Sandro Botticelli, Luca Signorelli, and other Italian Renaissance artists.[26] Wyeth also fondly remembered discovering the work of Hieronymus Bosch and Pieter Bruegel the Elder on these research trips, which undoubtedly influenced his subsequent development as a painter.[27]

In March 1938 the two artists visited the museum to witness a demonstration of tempera painting by Daniel V. Thompson, Jr., an authority on the materials and techniques of medieval painting.[28] Wyeth recalled standing transfixed for an hour and a half as Thompson expertly copied a portrait from the museum's collection. Thompson began by modeling the features of the head very carefully in ink, using extensive cross-hatching on the white surface of a gesso panel, before passing over it a thin layer of *terre verte* pigment as preparation for the flesh tones. The painting was completed in egg tempera and distilled water, again using an elaborate network of cross-hatching.[29] This method closely follows the technical instruction of Cennino Cennini, the fifteenth-century Florentine painter who wrote the *Il Libro dell'Arte* or *The Craftsman's Handbook,* which Thompson had translated into English in 1933.[30] This remarkable and unforgettable painting demonstration changed the course of Wyeth's career, as can be seen in his own *Self-Portrait* (fig. 20), an impressive work that was directly inspired by Thompson's instructions, in which he experimented with early Florentine techniques of tempera painting, obtaining a smooth, translucent surface that allowed for a remarkable command of detail.[31]

By the early 1940s, at the same time that *Artnews* was hailing Wyeth as "Watercolor's White Knight," the artist began to achieve the exquisite clarity that he was after in his tempera paintings, which seemed imbued with the power of mysterious suggestion that went beyond literal representation.[32] One of the artist's most successful early efforts in this vein was *Soaring* (pl. 11), a large painting that he began in 1942 but did not complete until 1950, due to his father's harsh judgment of the work. When N. C. Wyeth saw the painting in a semi-finished state, he was put off by the highly imaginative concept of looking down on three turkey vultures and seeing the world from their point of view. "Andy, that doesn't work," he said. "That's not a painting."[33] Deflated, Wyeth abandoned work on the panel and threw it in the cellar, where his sons later

used it as a base for their electric train sets, nailing the tracks into the back of the board.[34] It was only when Lincoln Kirstein encouraged him to resurrect the work for his 1950 exhibition at the Macbeth Gallery that Wyeth repaired and finished the painting.[35] *Soaring* allowed Wyeth to imagine himself as a broad-winged bird of prey gliding high above the rolling hills of Pennsylvania. This vantage point offers the viewer a bird's-eye vista of a tiny farm dwarfed by the great outspread wings of the circling turkey vultures, which provide a visual rhyme with the lines of the landscape below. One can feel Wyeth's excitement in painting this subject, which invokes a palpable sensation of rising and hovering, as if carried on the wings of these graceful birds as they endlessly scan the ground below for their next meal. As a boy, Wyeth loved "to lie on my back in the fields in March and April, when you get those turkey vultures here, and find myself looking up and wondering how it would look looking down."[36] In *Soaring,* he imagined this vertiginous viewpoint and in doing so introduced a panoramic aerial perspective that

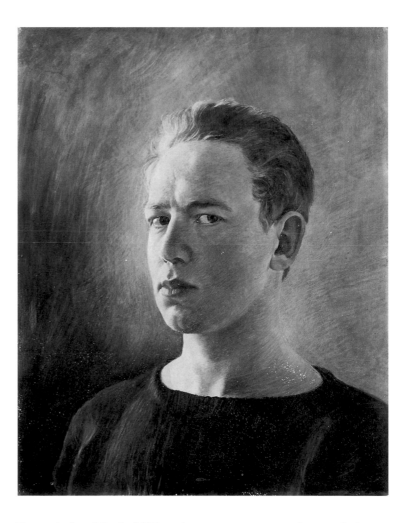

Fig. 20. Andrew Wyeth, *Self-Portrait,* 1938, tempera on panel, 20 × 16 inches, private collection.

recalls the stylized landscape paintings of Grant Wood, such as *Spring Turning* (fig. 21).

The birds of prey in *Soaring* have a veristic authenticity based on the artist's prolonged study of a turkey vulture that Karl Kuerner had helped him catch. As Kuerner later recounted, Wyeth needed to trap the bird to observe and sketch it from close quarters: "Buzzards always interested him, and one day he comes and says he has to have one so he can paint it. So Andy 'n me got the placenta from a newborn calf, put it in the pasture field back there, and set a ring of traps with it. And, by golly, we caught one. So there was Andy out there with that buzzard for days, painting. He wanted to paint it from above, and he had to *see* it. He has to get to know what he paints."[37] The artist produced many studies of the turkey vulture, such as the drawing reproduced on the cover of the September 1942 issue of *American Artist* magazine, which showed the bird's enormous wingspan as it swooped down on some unknown prey. This desire for an almost scientific objectivity, which dates back to his earliest history paintings and commercial assignments, led the artist to keep the bird alive for as long as possible by feeding him pounds of ripe beef scraps, which he eagerly devoured.[38] Wyeth's painting emphasizes the wings of the red-headed vultures as they lift, wheel, and glide above the landscape. Vultures are of course notable scavengers, and it may not be too much of a stretch to read a metaphorical meaning into *Soaring,* which was made during the darkest years of the Second World War, when civilian populations were menaced by dive-bombing warplanes. Suddenly, the tiny homestead below seems threatened by the fearsome birds that are naturally drawn to the weak and the vulnerable.

This interpretation of *Soaring* provides several new frames of reference for understanding Wyeth's work as well as reinforcing existing arguments that have until now been viewed with suspicion and doubt. In an important reevaluation of the artist's work, Jay Jacobs argued in 1967 that traces of American regionalist painting could be found in much of Wyeth's output, as in the 1955 drybrush portrait *Alexander Chandler,* which he convincingly compared to Thomas Hart Benton's 1941 oil and egg tempera painting *Aaron,* which had been acquired by the Pennsylvania Academy of the Fine Arts in 1943.[39] That Wyeth's *Soaring* can also be related to the landscape paintings of Grant Wood underlines the fact that the artist's work bears the imprint of his exposure to contemporary art in the mid to late 1930s, when he first began exhibiting his work in Philadelphia, New York, Boston, and Chicago. As Wanda Corn has argued, Wyeth's work needs to be seen within the context of the prevailing artistic trends of its time, namely the Depression-era paintings of artists such as Thomas Hart Benton, Charles Burchfield, Morris Graves, Edward Hopper, Reginald Marsh, Ben Shahn, and Grant Wood, along with photographers such as Walker Evans, Dorothea Lange, and Edward Weston, all of whom shared Wyeth's belief that American art should reflect the character of the American people.[40] The impact of these artists can be felt in

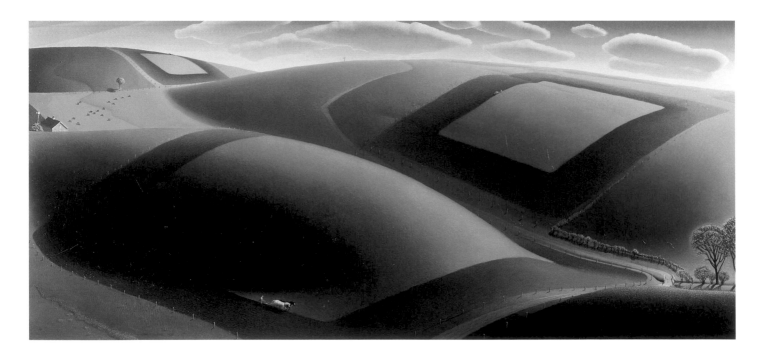

Fig. 21. Grant Wood (American, 1862–1942), *Spring Turning,* 1936, oil on Masonite, 18½ × 40½ inches, Reynolda House, Museum of American Art, Winston-Salem, North Carolina. Estate of Grant Wood/Licensed by VAGA, New York, NY.

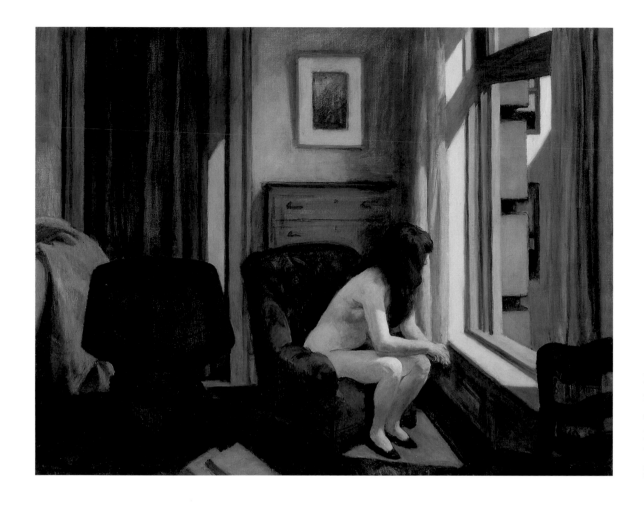

Fig. 22. Edward Hopper (American, 1882–1967), *Eleven a.m.*, 1926, oil on canvas, 28⅛ × 36⅛ inches, Hirshhorn Museum and Sculpture Garden, Washington, D.C., gift of the Joseph H. Hirshhorn Foundation, 1966, 66-2504.

the paintings and watercolors Wyeth made during his formative years, when he was struggling to attain the technical mastery and singular vision he needed to free himself from the overbearing influence of his father.

In a 1965 interview, Wyeth confessed that he admired "Edward Hopper more than any painter living today—not only for his work but because he's the only man I know who actually feels that America can stand on its own."[41] This is a rare admission that his work can be related to that of his contemporaries in addition to his accepted canon of influences, which includes Albrecht Dürer, Rembrandt, Winslow Homer, N. C. Wyeth, and Howard Pyle. Wyeth's paintings share the sense of quiet loneliness and spiritual malaise that characterizes Hopper's carefully crafted scenes of isolated individuals in sharply lit interiors, such as *Eleven a.m.* (fig. 22), where the woman looking out the window appears to be ensnared by the rigid geometry of her surroundings. Wyeth has reflected on the "strange dignity of Hopper's people," and the way Hopper had "stripped everything away till there was nothing, till you are filling nothingness with emotion. He ended up painting a corner of a vacant room and a patch of sun. The whole world in a shaft of light."[42] Indeed, it was Hopper's skillful handling

of the steady light of the sun on flat surfaces, along with his distinct sense of place, that appealed to Wyeth. He fondly recalled that in his last conversation with Hopper, who died in 1967, the older artist told him, "Andy, I've decided that the only thing that interests me is how the sun hits a white wall."[43]

Wyeth met Hopper in New York in 1942, and the two artists saw each other intermittently during the next quarter of a century. One of Wyeth's favorite memories of the older artist was an evening with Hopper and several other notable painters at the New York apartment of Robert Beverly Hale, the associate curator of American art at the Metropolitan Museum of Art. During cocktails on the terrace, the conversation turned to abstract art, with Jackson Pollock and Stuart Davis in hot disagreement over the definition of abstraction. "Finally," Wyeth recalled, "Hopper had tapped Davis on the shoulder and pointed from the penthouse window to the incredible light of the setting sun on the buildings. 'Can you ignore that?' Hopper had asked. It stopped them, at least for a moment."[44] The story of this gathering, which probably took place in June 1950, counters the common view of Wyeth as an insular artist unaware of the trends of contemporary American painting after the Second World War.[45] In fact, Wyeth has

often expressed his admiration for the energy and vitality of Abstract Expressionist painting, especially the monumental canvases of Franz Kline and Jackson Pollock.[46]

Hopper's disquieting scenes of New York and Cape Cod and Burchfield's poetic evocations of his adopted home of Buffalo, New York, resonate strongly with Wyeth's depictions of the landscape and people of Chadds Ford and Cushing.[47] Another artist to consider in this context is Charles Sheeler, whose highly finished renditions of red barns and white clapboard houses in Bucks County, Pennsylvania, used impeccable craftsmanship to mask an underlying abstraction predicated on cubist aesthetics.[48] Sheeler was the subject of a grand retrospective at the Museum of Modern Art in 1939 that secured his reputation as an artist of "precision, sharpness, the angles of architecture, the clean metallic beauty of engineering, the rhythm of severity, and the glare of gleam."[49] Although Wyeth never saw this exhibition, the impact of this fellow Pennsylvanian's work is keenly felt in his paintings of the 1940s and 1950s, especially *Cooling Shed* (pl. 26), which can be related to the ascetic geometry of Sheeler's paintings of pre-Revolutionary houses, such as the dramatic spiral staircase in *Staircase, Doylestown* (fig. 23). Sheeler's statement in the 1939 exhibition catalogue

that his abstract work left him with "the growing belief that pictures realistically conceived might have an underlying abstract structure" has close affinities with Wyeth's efforts to reinvigorate the American tradition of realist painting in the following decade by incorporating the lessons of abstraction.[50]

Like Thomas Eakins before him, Wyeth's investigative naturalism led him to scrutinize his subjects with the scientific detachment of a surgeon or an engineer. In the 1942 tempera painting *Winter Fields* (pl. 8), for example, Wyeth manipulated the viewpoint to give the impression that he had made the painting while lying down at eye-level with a dead crow, a worm's-eye view comparable in its displacement of the expected angle of vision to the bird's-eye vista of *Soaring*. Wyeth had stumbled across the dead crow during a walk in the fields behind N. C. Wyeth's studio and immediately recognized its pictorial and metaphorical possibilities.[51] The painting combines a carefully observed, detailed drawing of the dead bird, which Wyeth carried back to his studio for protracted scrutiny, with another drybrush drawing of the landscape made from life. The result is an extraordinary composite image of the dead crow, partially hidden by vegetation, lying frozen on ground that is tilted to form a high horizon line. The contours of the countryside echo the curved shape of the bird's wings and tail, thus unifying the composition, while the muted palette, consisting mainly of earthy browns and tans, sharpens the eye to the cold isolation and raw beauty of the fields in winter. This bleak environment, which Wyeth once compared to "the color of a young fawn," provides a stark backdrop for the blue-black feathers of the dead crow, whose silky plumage suggests the transitory nature of life in the rural countryside.[52]

The oblique viewpoint and unflinching verisimilitude of *Winter Fields* has close parallels with European contemporary art, such as the astringent realism of George Grosz, Otto Dix, and other Neue Sachlichkeit painters working in Weimar Germany, or the investigation of the human figure in the work that Francis Bacon and Lucian Freud produced in London shortly after the Second World War. A 1954 statement by Freud resonates with Wyeth's efforts to study the five-foot wingspan of a turkey vulture or the shiny plumage of a decomposing crow: "The subject must be kept under close observation: if this is done, day and night, the subject—he, she or it—will eventually reveal the all without which selection itself is not possible."[53] For both artists this pictorial strategy of constrained interrogation, with its overtones of voyeurism and surveillance, provides the point of departure for more serious meditation on the metaphorical implications of the subjects that will

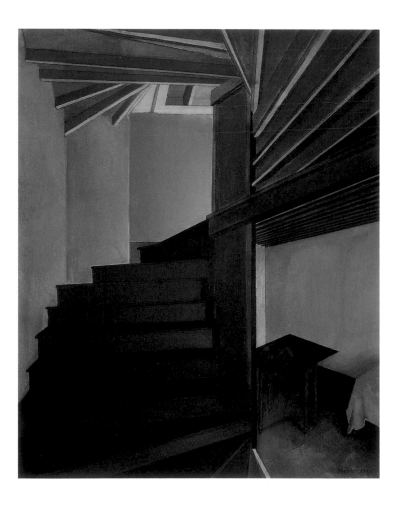

Fig. 23. Charles Sheeler (American, 1883–1965), *Staircase, Doylestown*, 1925, oil on canvas, 25⅛ × 21⅛ inches, Hirshhorn Museum and Sculpture Garden, Washington, D.C., gift of the Joseph H. Hirshhorn Foundation, 1972, 72-265.

Fig. 24. Andrew Wyeth, *Dil Huey Farm*, 1941, tempera on panel, 22 × 48 inches, private collection.

be addressed in the finished work. In another painting, *The Hunter* (pl. 14), which was used as the cover for the October 16, 1943, issue of the *Saturday Evening Post,* Wyeth imagined himself as a squirrel perched in the upper branches of his favorite buttonwood tree, looking down on the hunter below. This act of surveillance has a sinister side, with Wyeth taking aim like an unseen sniper, whose overwhelming gaze has turned the tables on the hunter, who now becomes the artist's quarry in his own pursuit of realism through assimilated experience.

It was probably the abrasive, anti-sentimentalizing objectivity of Wyeth's work that caught the eye of Alfred H. Barr, Jr., the legendary director of The Museum of Modern Art. Barr had greatly admired Wyeth's large tempera painting *Dil Huey Farm* (fig. 24), which he saw at *The Seventeenth Biennial Exhibition of Contemporary American Oil Paintings* at the Corcoran Gallery of Art in Washington, D.C., in 1941.[54] Barr subsequently wrote to Wyeth to say that he was "much impressed" by the painting and to inquire about its price, since he hoped to purchase the work for his museum.[55] The carefully planned *Dil Huey Farm* is almost Mondrian-like in the severe geometry of its composition, which is dominated by the splayed limbs of "the lower half of a huge buttonwood tree, its limbs, branches, and twigs spread against the sky like veins and capillaries, bare except for one poignant spray of leaves," to use Richard Meryman's memorable description.[56] Behind the tree flows the Brandywine River, neatly bisecting the

painting, while in the far distance stands Dil Huey's stone farmhouse and wooden barns.

In 1943, Barr included *Dil Huey Farm* and seven other works by Wyeth in the landmark exhibition *American Realists and Magic Realists,* which he organized with Dorothy Miller and Lincoln Kirstein at The Museum of Modern Art. The exhibition was devoted to artists who used "sharp focus and precise representation, whether the subject has been observed in the outer world—realism, or contrived by the imagination—magic realism."[57] The five temperas and three ink drawings by Wyeth shown in the exhibition combined close attention to detail with improbable elements drawn from his imagination, thus suggesting that his work fell into the magic realist camp. In the previous year Barr had applied the term magic realism, which he borrowed from Franz Roh's important 1925 study *Post-Expressionism, Magic Realism: Problems of Recent European Painting,* to "the work of painters who by means of an exact realistic technique try to make plausible and convincing their improbable, dreamlike and fantastic visions."[58] This designation of the artist as a magic realist was supported by art critics like Emily Genauer, who noted in her review of the exhibition that Wyeth's "lines have been manipulated into swinging rhythms" in his paintings, which for all their apparent realism, were "as contrived and as arbitrary as if the artist had painted a nude as a series of circles or made a house a purple cube."[59] However, not all of Wyeth's works

matched this description and to this day his work stubbornly defies easy categorization.

In 1943, operating in the space between realism and surrealism, Wyeth's highly individual paintings stood out from the other works in the show, which were more closely aligned with either Salvador Dalí's psychologically charged images of his dreams and personal obsessions or the trompe l'oeil illusionism of such American forerunners as William Michael Harnett and John F. Peto. The artist's willful independence, which powerfully comes across in his own statement in the catalogue, caused problems for the curators of the exhibition.[60] In Kirstein's introduction, he unconvincingly compares Wyeth's paintings such as *Dil Huey Farm* and *Winter Fields* with "the feathery coolness" of John Frederick Kensett's romantic landscapes and coastal scenes.[61]

This effort to place Wyeth and other artists within a lineage of eighteenth- and nineteenth-century American realist painting— stretching from Charles Willson Peale to Eakins, Harnett, and Homer— is symptomatic of the exhibition's deeply nationalist agenda. The organizers chose to ignore the fact that many of the paintings on display were directly inspired by contemporary European art, especially Surrealism, reflecting the crisis of confidence that American artists underwent during the Second World War, when their livelihoods were threatened by the massive influx of artists from Europe. Although their work had been enthusiastically received in the United States during the 1930s, the recent arrival of European Surrealists such as Salvador Dalí, Max Ernst, Yves Tanguy, and Roberto Matta Echaurren was widely viewed with suspicion, envy, and distrust, in keeping with the fervent patriotism in the United States during the war years.[62] Wyeth's attempt at this time to model himself after the Winslow Homer of romantic legend thus reflects the insularity of the wartime American art world, and has probably hindered our appreciation of the artist's ties to European modernism.[63]

Having his work shown alongside such notable artists as Ivan Le Lorraine Albright, Peter Blume, Paul Cadmus, Jared French, Louis Guglielmi, and Ben Shahn transformed Wyeth from a precocious up-and-coming artist to a painter of national importance. The exhibition, however, was negatively reviewed by art critics such as Maude Kemper Riley, who considered it "the dullest exposé of lesser things and decadence of thought, downright pedestrianism and inartistry, muscle-bound paintings by little circles of artists facing inward, it was possible to corral."[64] Wyeth's tempera paintings, which many critics were seeing for the first time, escaped this invective and were even singled out by Doris Brian in her review in *Artnews:* "Young Andrew Wyeth is the exception within the group, for no one can fail to be deeply impressed by his landscapes and bird studies. Precision is there, perhaps even more sharply than in the hands of some other practitioners, but poetry

of content and of unconventional color comes first and the camera tricks are secondary."[65]

Wyeth went to see the exhibition with his father while working on *Public Sale* (pl. 12), a pivotal work that conveys his strong feelings for the rich farm country of southeastern Pennsylvania, with its ancient fieldstone buildings and fiercely individual inhabitants. This tempera painting depicts the forced sale of a farm and its contents near French Creek, in the Conestoga Valley of Lancaster County, after the death of the farmer's wife.[66] Wyeth and his wife Betsy were taken to the country auction by their friend Herbert Guest, an antiques dealer in Chadds Ford, who led them through the house whose contents were being sold. N. C. Wyeth, writing to his daughter Henriette on April 4, 1943, reported that Andrew had returned from the farm sale "very dramatically stirred by the sad and sober mood of the event."[67] The loneliness and sadness of this man, whom the artist remembered as a tall, lanky Pennsylvanian by the name of Pew, who was forced to sell his worldly possessions under tragic circumstances, had clearly made a deep impression on Wyeth, who expressed the bleak mood of that day in *Public Sale*.[68]

This panel painting, with its raw emotional intensity and innovative formal design, represents a turning point in Wyeth's career. The viewer's attention is drawn into the center of the picture by the ruts of a winding country road, now turned to mud, and the fresh tire tracks left by Bert Guest's pickup truck. Although the gathering crowd in the middle distance suggests that something is happening there to grab their attention, the artist denies the viewer any sense of what is going on. The scene is thus imbued with a portentous and rather ominous atmosphere that, without the aid of the title, might suggest that a criminal act was taking place, such as a grisly murder or a mob lynching. Wyeth's decision to focus attention on the barren landscape rather than the anguish of the bereaved farmer permeates this poignant scene with an air of haunting melancholy. As such, the work rises above the social realism and clichés of many of Wyeth's contemporaries and exemplifies his consummate ability to create memorable images from the humdrum existence that surrounded him.[69]

The tire tracks that have churned up the earth in the foreground are redolent of the artist's gut-wrenching feelings at witnessing the sad dispersal of this French Creek farm, a fate that could just as easily have befallen one of his neighbors in Chadds Ford.[70] This notion is reinforced by the use of plunging perspective lines to lead the viewer into the heart of the painting, a pictorial device that Wyeth had earlier developed in *Road Cut*, of 1940, which depicted the curving road by which one enters Chadds Ford and the Brandywine valley. Indeed this basic configuration has served Wyeth throughout his career and can even be found in his recent painting *The Carry* (pl. 86), where the mud-tracks and hills are reinvented as swirling currents of water that lead into a waterfall at the picture's core.

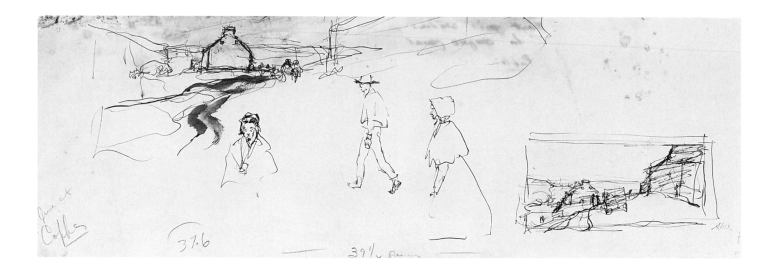

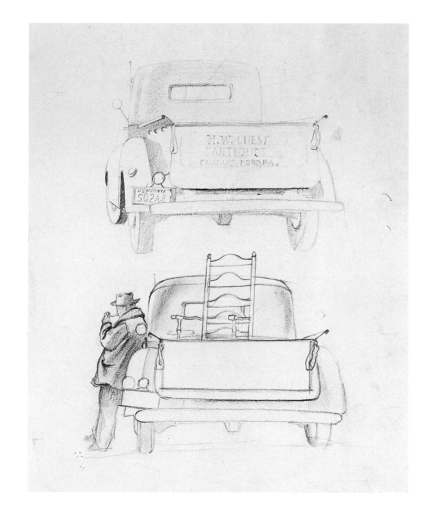

*Public Sale* was not painted entirely from memory, as has been previously suggested, but was based upon rough sketches made on the spot.[71] These preparatory studies begin with rapidly drawn ink sketches of Amish men and women walking to and from the scene (fig. 25). Other drawings are more detailed, such as the stacked images of a Ford truck that Wyeth made in pencil on a single sheet of paper (fig. 26). The lower image of this double drawing depicts Bert Guest smoking a pipe, while leaning against his Ford Old Reliable pickup, which contains an eighteenth-century ladder-back chair he has purchased at the auction. Above this image is another drawing of the truck, rendered in detail, including the license plate and company name in capital letters.

Although the antiques dealer and his truck appear in the finished painting, the chair and the commercial sign were deliberately left out to give universal significance to a local event. As Wyeth later explained, "it's not what you put in but what you leave out that counts."[72] The careful editing of factual detail in *Public Sale* is a good example of what Ernest Hemingway would call the principle of the iceberg. In his 1932 book on bullfighting, *Death in the Afternoon,* Hemingway argued that "if a writer of prose knows enough about what he is writing about he may omit things that he knows and the reader, if the writer is writing truly enough, will have a feeling of those things as strongly as though the writer had stated them. The dignity of movement of an iceberg is due to only one-eighth of it being above water."[73]

Wyeth, like Edward Hopper, created an atmosphere of pervasive solitude, or sometimes even tension and violence, by omitting specific details and events. His pictures are not direct transcriptions of what he sees, which is why many admirers are disappointed when they actually visit "Wyeth country" and find telephone poles, modern houses, and cars, rather than the unspoiled countryside they expect. This process of gradual elimination and concealment is a key aspect of Wyeth's working practice that has been largely overlooked. I would argue that

Fig. 25. Andrew Wyeth, *Public Sale Study,* 1943, ink on paper, 7¼ × 21 inches, Collection of Andrew and Betsy Wyeth.

Fig. 26. Andrew Wyeth, *Public Sale Study* (detail), 1943, pencil on paper, 13¾ × 16½ inches, Collection of Andrew and Betsy Wyeth.

Fig. 27. Clarence Holbrook Carter (American, 1904–2000), *Lady of Shalott*, 1927, oil on canvas, 37¼ × 53½ inches, private collection.

one cannot fully understand Wyeth's work without understanding how he refines and transforms his initial ideas—often sketched out in pre-liminary watercolors or drawings with ink, drybrush, or pencil—into the completed painting. The finished work often carries the memory trace of the studies, which explains why the viewer can sometimes sense that there is more to a Wyeth image than meets the eye—an unsettling sense of expectancy, apprehension, or even violence that is felt rather than seen. Indeed, as Wyeth explained in an interview published in *Time* in 1963, his skill in eliminating unnecessary details while retaining the overall mood or theme of a painting was so strong by then that he felt "that he could even have removed Christina from *Christina's World* and still have conveyed the same sense of loneliness."[74]

Mark Rothko once remarked that "Wyeth is about the pursuit of strangeness," and the artist's inclusion in the *American Realists and Magic Realists* exhibition proved that he was not alone in this quest.[75] Indeed, Wyeth's exposure to a diverse range of Surrealist-inspired paintings by other American artists must have underlined his commit-ment to the realm of the imagination, while encouraging him towards greater experimentation and ambition in his subsequent work. The eerie, dreamlike *Christmas Morning* (pl. 15), painted the following year, reveals the lessons Wyeth learned from the New York exhibition. Although the artist would later claim that he made the work from

memory, it is clearly based on Clarence Holbrook Carter's celebrated painting *Lady of Shalott* (fig. 27). Carter had eight paintings included in the *American Realists and Magic Realists* exhibition, many of which were based on his experiences as a child growing up in the Ohio River Valley, such as *Jane Reed and Dora Hunt* of 1941, which Wyeth thought was the strongest work in the show.[76]

Carter's meticulously detailed pictures, inspired by nineteenth-century Symbolist and Pre-Raphaelite paintings, clearly made a deep impression on Wyeth, but none more so than this early work that Carter completed after reading Alfred, Lord Tennyson's famous poem as a student. *Lady of Shalott* depicts a shrouded young woman, whose face is the ashen green-gray of death, floating on a watery tomb strewn with crimson morning glories while stars shine in the purple-tinted dawn. Carter intended the flowers, which open in the morning and close at night, to symbolize the brevity of human existence and the transition from life to death. Carter later connected the tragic theme of Tennyson's poem with his childhood memory of the death of his younger sister one Christmas Eve. As he later recalled, "the Christmas tree was taken down and all the happy expectations vanished with the sorrow of a warm, happy little sister now cold and lifeless."[77]

Wyeth's *Christmas Morning* represents a radical departure from his earlier landscape scenes. The variant title, *Death of Mrs. Sanderson at*

*Christmas,* identifies the ethereal figure with the bandaged head as Hannah Sanderson, the mother of Christian Sanderson, a much-loved schoolteacher and local historian, who was an acknowledged authority on the Battle of the Brandywine. Andrew had painted a life-sized *Portrait of Christian C. Sanderson* in 1937, which had been included in the annual exhibition at the Wilmington Society of the Fine Arts that fall, where it won an honorable mention. When it was removed from the family home on October 25, 1937, Hannah wrote in her diary, "Thomas came for the picture. Will miss it so much. I cried after it had gone. Hope Andy is successful in Wilmington show."[78] On Christmas Eve, Wyeth presented it to the schoolmaster and his mother as a Christmas gift, along with a book and a basket of fruit.[79] Hannah died six years later, on Christmas morning, 1943, and Wyeth was one of the three people Chris immediately notified after she passed away. The last entry in her diary, dated December 22, 1943, concerned Andrew's new baby son, Nicholas, who was about to celebrate his first Christmas.[80]

Seeing Mrs. Sanderson lying in state in the family dwelling, swaddled as one sees her in the painting and covered with the Betsy Ross flag that served as her winding sheet, Wyeth felt compelled to sketch his late friend. This drawing would lead to *Christmas Morning,* a painting that represents Wyeth's first response to human death.[81] The finished work fused the memory of Hannah's dead body with Wyeth's own vivid imagination, which had been recently stimulated by the visionary paintings of Clarence Holbrook Carter. Given his apparent familiarity with the underlying theme of *Lady of Shalott,* it seems likely that Wyeth had seen this work and perhaps even spoken with the artist, possibly during Carter's tenure at the Carnegie Institute of Technology in Pittsburgh between 1938 and 1944 or during the run of the Museum of Modern Art exhibition. It is also worth noting that Carter moved to Bucks County, Pennsylvania, in 1944, the year Wyeth completed *Christmas Morning.*[82]

The interconnected themes of life and death, and time and eternity, which had always obsessed Wyeth, are heightened by his placement of the silver-hued figure on a snow bank that doubles as a strange bed or tomb, since it is not clear where the body of the prone woman ends and the winter fields begin. This deliberate ambiguity allows Wyeth to surpass Carter in his portrayal of the calm silence and pervading mystery of death, as the figure fades away like an emanation or a memory under the light of a solitary star. At one point Wyeth included the figure of Chris Sanderson coming up the road but later painted him out, so that the mother's gaze no longer focuses on her son but surveys the rolling countryside and trees in the distance, where an elaborate Victorian mansion called Windtryst once stood.[83] The striations of snow flowing from her body lead into the background, converging on the spot where Chris once stood, much like the orthogonal lines of the winding tracks in *Public Sale.* As in that earlier painting, the decision to simplify the

composition by removing the figure of Chris is in keeping with Wyeth's method of getting to the essence of a scene or situation, although the artist could not have anticipated that his friend's figure would return in the form of a ghostly pentimento as the thin overpaint began to dry. That Hannah's body seems to evaporate into streams of light or snow may be related to a dream that Wyeth had on Christmas Eve 1943, in which he saw the corpse of Mrs. Sanderson floating in a flooded cellar, although the striations could also have been suggested by the stripes of the flag that covered her dead body like a shroud, as recorded in her son's photograph.[84]

In 1978 Wyeth revived the imagery of *Christmas Morning* in the large tempera painting *Spring* (pl. 65). It depicts the recumbent figure of his close friend and surrogate father, Karl Kuerner, embedded in a melting mound of ice and snow at the foot of the hill that bears his name. The artist conveys his intense feelings for the now-frail German farmer in this imaginary portrait, made after he saw the old man in bed during the final year of his life, when cancer had begun to ravage

Fig. 28. James Ensor (Belgian, 1860–1949), *Skeletons Warming Themselves,* 1889, oil on canvas, 29½ × 23⅝ inches, Kimbell Art Museum, Fort Worth, Texas.

his body. In the painting, Kuerner is not just placed on the hillside but is fused with it through a cocoon-like blanket of snow. The themes of death and regeneration encoded in *Christmas Morning* are again explored in this work, with the implication that Karl's mummified body will disappear when the snowdrift melts in the spring, thus returning his frozen corpse to the ground that had sustained him during his lifetime.

Wyeth would later consider paintings such as *Christmas Morning* and other works apparently inspired by Surrealism and magic realism as aberrations in his development. Although the vast majority of his subsequent work is based upon direct observation of the natural world, albeit filtered through his childhood memories and life experiences, there are occasional relapses into the world of dreams and the imagination. *Dr. Syn* (pl. 70), a self-portrait of the artist as a seated skeleton wearing a blue and gold naval jacket from the War of 1812 that once belonged to Howard Pyle, is one such example. This work has been related to the artist's memory of his formal academic training with his father, who gave Wyeth a human skeleton and had him draw it from all angles for six months, before removing it and requiring him to continue to draw it from memory.[85] However, Wyeth didn't use the old studio skeleton (which he still has) as the model for *Dr. Syn*, but instead used an x-ray of his own body. That disconcerting fact turns the painting into a traditional memento mori, as Wyeth, with cannon at his side, sits staring out to sea facing his own mortality. The image of the skeleton in pirate garb, no doubt informed by the work of Howard Pyle and N. C. Wyeth, can also be related to the Belgian artists James Ensor and Paul Delvaux, whose macabre and fantastic paintings often feature dressed-up human skeletons. Ensor's *Skeletons Warming Themselves* (fig. 28), a morbid commentary on the human condition, shares Wyeth's deeply personal vision and taste for the bizarre. Wyeth's title refers to Russell Thorndike's classic novel, *Doctor Syn*, published in 1915, which recounted the swashbuckling exploits of the fictional Vicar of Dymchurch, the Reverend Doctor Christopher Syn, who was formerly known as the notorious pirate Captain Clegg, but now leads a double life as the Scarecrow, the fearsome head of a gang called the Night Riders.[86] Wyeth, a lifelong nonconformist, may even have intended a double meaning in the title of his self-portrait, which perhaps refers to his own penchant for mischief, wickedness, and clandestine activities as well as his love of disguises and make-believe.

After the double tragedy of the deaths of his father and his brother's three-year-old son, who were killed when N. C. Wyeth's car was hit by a train on October 19, 1945, Wyeth's work underwent a slow but dramatic transformation. His tentative early efforts to find his own visual language were replaced by a new seriousness and austerity. In paintings such as *Winter, 1946* (pl. 18), which marks the beginning of this new phase of the artist's career, he sharpened his perceptions and explored his deepest emotions. The experience of this personal catastrophe has been purified in the painting, so that the boy hurtling down Kuerner's Hill succinctly conveys Wyeth's sense of disconnectedness and bewilderment at the loss of his father, without resorting to sentimental or maudlin images of death and remembrance.

As in all of the artist's best works, the disconcerting formal elements of *Winter, 1946* are inextricable from the mysterious potency and psychological penetration of Wyeth's images. By concentrating on the outward appearance of a deliberately circumscribed environment, Wyeth construes a world that discharges its meaning through the most fleeting and elusive moments. The figure of a young neighbor, Allan Lynch, chased by his shadow down a sunlit hill, becomes through metaphorical association a poignant image of the artist alone and adrift in a world without his father, the family patriarch, whose presence is nonetheless felt in the bulging landscape that has become the living embodiment of N. C. Wyeth's massive, heaving chest.[87]

## Notes

1. For a notable exception to this rule, see Wanda M. Corn, *The Art of Andrew Wyeth* (Greenwich, Conn.: Published for the Fine Arts Museums of San Francisco by the New York Graphic Society, 1973), pp. 93–162. My understanding of Wyeth's work of the 1930s and early 1940s, especially as it relates to that of his contemporaries, is greatly indebted to this groundbreaking study, which was later updated and expanded upon in Wanda M. Corn, "Andrew Wyeth: The Man, His Art, and His Audience" (Ph.D. diss., New York University, 1974).

2. "Exhibitions of the Month: The Wyeth Family," *Art Alliance Bulletin*, March 1935, p. 2. *The Wyeth Family* exhibition was on view at the Art Alliance from March 25–April 19, 1935. This important, yet previously overlooked, exhibition was the first joint showing of all the artists in the Wyeth family, whose number at that time consisted of N. C. Wyeth, his daughters Henriette (Mrs. Peter Hurd) and Carolyn, and his son Andrew.

3. For more on Horter and his collection of modern art, see Innis Howe Shoemaker, *Mad for Modernism: Earl Horter and His Collection* (Philadelphia: Philadelphia Museum of Art, 1999).

4. "Wyeth—A New Star," *Art Alliance Bulletin*, November 1936, n.p.

5. George Plimpton and Donald Stewart, "Andrew Wyeth," *Horizon* 4 (September 1961): 100.

6. See, for example, Wyeth's tirade against all things "Renoiresque or Frenchy" in Richard Meryman, "Andrew Wyeth," *Life* 58 (May 14, 1965): 110.

7. Andrew Wyeth, interview with the author, January 14, 2005.

8. Wyeth later recalled that Brinton was a frequent visitor to the Wyeth household in the 1930s, during which time he would encourage N. C. Wyeth to abandon illustration and experiment with modern art and abstraction: "Brinton used to bring European painters down to see him. My father told me that one Russian painter said to him, 'Mr. Wyeth, there is too much painting in your work to be good illustration, and too much illustration to be good painting.'" This negative criticism shook his father, who was going through a difficult transitional period at this time, but left its mark on Wyeth's subsequent development as an artist. Wyeth sat in on many of the long conversations that his father had with Brinton and the exiled Russian artists he supported, which strengthened his resolve to fuse N. C. Wyeth's teachings with the dictates of modern art. E. P. Richardson, "Andrew Wyeth," *Atlantic Monthly* 213 (June 1964): 68.

9. Andrew Wyeth, *Andrew Wyeth: Autobiography*, ed. Thomas Hoving (Boston: Little, Brown; Kansas City, Mo.: Nelson-Atkins Museum of Art, 1995), p. 18.

10. Mina Carol, "Youngest Wyeth to Make His Bow in One-Man Show," *Wilmington Morning News,* November 10, 1936, p. 6.

11. Ibid.

12. "Winslow Homer, America's Old Master, Assumes Universal Stature," *Art Digest* 11 (January 1, 1937): 8. The exhibition at the Whitney Museum, which was on view from December 15, 1936 to January 15, 1937, was by far the largest presentation of Homer's work during his centennial. The catalogue included an extended essay by Lloyd Goodrich that presented the artist as a pure naturalist, who painted only what he himself had seen and observed. Goodrich went on to praise Homer's severe simplification of unnecessary details in his paintings, in terms that resonate with Wyeth's own working process: "Where other naturalists cluttered their work with a thousand and one petty details, Homer saw his subject in its largest and simplest terms, eliminating everything unessential, concentrating on vital elements of action and drama." See Goodrich, "Winslow Homer, 1836–1910," in *Winslow Homer Centenary Exhibition* (New York: Whitney Museum of American Art, 1936), pp. 12–13.

13. The exhibition *Winslow Homer, 1836–1910* was on view at the Pennsylvania Museum of Art, Philadelphia, May 2–June 8, 1936.

14. "Homer, Artist and Man, Revealed at Show in His Old Studio," *Art Digest* 10 (August 1, 1936): 5–6.

15. As Sarah Burns has pointed out, Homer's life in Prout's Neck was enmeshed in family economic and social activity, with the artist's own interest in real estate investments eventually yielding enough income to meet his expenses and more. The romantic vision of Homer as a tough, undomesticated man of nature who embodied stern, selfless heroism was thus a media construct, fuelled by the artist and his circle, in which the sophisticated businessman artist masqueraded as the quintessential manly American painter, living in solitude and surrounded by the elemental forces of nature. See Sarah Burns, *Inventing the Modern Artist: Art and Culture in Gilded Age America* (New Haven: Yale University Press, 1996), pp. 187–217.

16. Henry McBride, "Winslow Homer's Watercolors," *New York Sun,* January 25, 1936; reprinted in Daniel Catton Rich, ed., *The Flow of Art: Essays and Criticisms of Henry McBride* (New York: Atheneum Publishers, 1975), p. 331.

17. *First Exhibition of Water Colors by Andrew Wyeth,* Macbeth Gallery, New York, October 19–November 1, 1937. In the catalogue introduction, Robert Macbeth states "Andrew Wyeth first showed us his watercolors and pen drawings a year ago." However, Wyeth later recalled that it was his father who had shown his Maine watercolors to Macbeth in the hope that he would mount a show of his son's work in his New York gallery. See Thomas Hoving, *Two Worlds of Andrew Wyeth: Kuerners and Olsons* (New York: Metropolitan Museum of Art, 1976), p. 13.

18. James K. Brown, an art critic for *Art in America,* thought that the "spectacular freedom" of Wyeth's watercolors takes "one back to the work of Winslow Homer and [they] do not suffer an eclipse from the comparison." James K. Brown, "The Watercolors of Andrew Wyeth," *Art in America* 26 (January 1938): 41. Henry McBride, on the other hand, saw an easy proficiency in these works that marked them as suspect. McBride's comments, first expressed in his regular art column for the *New York Sun,* were reprinted in [Henry McBride], "Andrew Wyeth, in Debut, Wins Critics' Acclaim," *Art Digest* 12 (November 1, 1937): 15. McBride remarked that Wyeth had "the breadth of view that is associated with the name of Homer, and he has a brave way of applying wash to the paper and he is unafraid of color, and with these accomplishments he finds it easy to present you with clean, crisp watercolors that immediately catch the eye. Homer, the great, however, lacked this facility, and did not find it easy to make watercolors."

19. Howard Devree, "Four Good First Shows," *New York Times,* October 24, 1937, Section 11, p. 11.

20. Pennsylvania Academy of the Fine Arts, *Andrew Wyeth: temperas, watercolors, dry brush, drawings, 1938 into 1966* (New York: Abercrombie & Fitch, 1966), p. 16.

21. *Second Exhibition of Watercolors by Andrew Wyeth,* Macbeth Gallery, New York, October 10–30, 1939.

22. James W. Lane, "Briskness and Discipline in A. Wyeth's Work," *Artnews* 38 (October 14, 1939): 12–13.

23. Of one picture, *Wreck on Doughnut Point,* the artist told a reporter that the local people in Maine "objected so much to the inclusion of three figures in the foreground whose backs interrupted a clear view of the floundered schooner that, as an appeasement to the townspeople, he had to paint another version in which the ship could be seen in all its misfortune." "Andrew Wyeth Repeats Success in New Show," *Art Digest* 14 (October 15, 1939): 22.

24. *Third Exhibition of Water Colors by Andrew Wyeth,* Macbeth Gallery, New York, October 7–27, 1941.

25. Tempera paints are made by mixing powdered dry pigments with egg yolk thinned with water. For more on Wyeth's early experimentation with the egg-tempera medium, see Joyce Hill Stoner, *A Closer Look: Howard Pyle, N. C. Wyeth, Andrew Wyeth, and Jamie Wyeth* (Wilmington, Delaware: Delaware Art Museum, 1998), pp. 22–27. Wyeth also gave a detailed description of his tempera painting process in a series of interviews with Elaine de Kooning that took place while he was working on his painting *A Crow Flew By,* of 1949–1950. See de Kooning, "Andrew Wyeth Paints a Picture," *Artnews* 49 (March 1950): 38–41, 54–56.

26. Wyeth recalled his visits to the Johnson Collection at the Philadelphia Museum of Art in an interview with Richard J. Boyle and Hilton Brown on April 13, 1993. See Boyle, "Synopsis: The America Tempera Revival," in Richard J. Boyle, Hilton Brown, and Richard Newman, *Milk and Eggs: The American Revival of Tempera Painting, 1930–1950* (Chadds Ford, Pa.: Brandywine River Museum; Seattle: University of Washington Press, 2002), p. 84.

27. Wyeth was especially struck by *The Unfaithful Shepherd* (ca. 1575–1600), a painting that is now attributed to Marten van Cleve, but which in the 1930s was considered to be an original work by Pieter Bruegel the Elder. This image of a young shepherd running away from his flock may have served as a reference point for Wyeth's *Winter, 1946,* which depicts a similar scene of a boy running down a hill. Andrew Wyeth, interview with author, January 14, 2005.

28. Thompson's book, *The Practice of Tempera Painting* (New Haven: Yale University Press, 1936) remains a useful introduction to the subject.

29. Andrew Wyeth, interview with author, January 14, 2005.

30. In *The Practice of Tempera Painting,* Thompson had argued that "there is something to be learned from this method of Cennino's, in painting flesh, something that a modern painter may absorb and turn to good account," p. 113.

31. Wyeth's *Self-Portrait* is dated March 29, 1938, on the back, thus confirming its link to Thompson's painting lesson at the Philadelphia Museum of Art.

32. Doris Brian, "Watercolor's White Knight: Andrew Wyeth," *Artnews* 40 (October 15, 1941): 27. Brian's comment that "it's not hard to see why *Wunderkind* watercolorist Wyeth walks away with so many prizes," in her review of Wyeth's third exhibition at the Macbeth Gallery, reveals how easy it would have been for the artist to continue to record his summer experiences in Maine through the medium of watercolor, for which he had an innate talent, rather than risk his reputation on his new tempera paintings.

33. Richard Meryman, *Andrew Wyeth: A Secret Life* (New York: HarperCollins, 1996), p. 160.

34. Andrew Wyeth, "N. C. Wyeth," in James H. Duff, ed., *An American Vision: Three Generations of Wyeth Art; N. C. Wyeth, Andrew Wyeth, James Wyeth* (Boston: Little, Brown, 1987), p. 86. Wyeth recalled how his children had used the panel as a base for their model railroad setup in a taped conversation with James H. Duff in May 1986.

35. The *Andrew Wyeth* exhibition at the Macbeth Gallery, New York, was on view from November 21 to December 9, 1950. *Soaring* was listed as number six in the accompanying catalogue. This exhibition, curated by Lincoln Kirstein, was organized to celebrate the Diamond Jubilee of the Philadelphia Museum of Art, 1875–1950, and included six temperas and fourteen watercolors by Wyeth.

36. Quoted in Plimpton and Stewart, "Andrew Wyeth," pp. 99–100.

37. Gene Logsdon, *Wyeth People: A Portrait of Andrew Wyeth as He Is Seen by His Friends and Neighbors* (Garden City, N.Y.: Doubleday, 1971), p. 32.

38. Lloyd Goodrich, "Andrew Wyeth," *Art in America* 43 (October 1955): 19.

39. Jay Jacobs, "Andrew Wyeth—An Unsentimental Reappraisal," *Art in America* 55 (January–February 1967): 30.

40. Corn, *Art of Andrew Wyeth*, pp. 93–162.

41. Meryman, "Andrew Wyeth," p. 116.

42. Meryman, *Secret Life*, p. 394. Wyeth may have been thinking of Hopper's magnificent late painting *Sun in an Empty Room* of 1963 when he made these remarks.

43. George Howe Colt, "Wyeth: Face to Face," *Life* 20 (March 1997): 82.

44. Selden Rodman, "Andrew Wyeth," in Rodman, *Conversations with Artists* (1957; repr., New York: Capricorn Books, 1961), p. 220.

45. This party was probably the one that Robert Beverly Hale organized to celebrate the opening on June 16, 1950 of the *20th-Century Painters* exhibition at the Metropolitan Museum of Art. This special exhibition consisted of oil paintings, watercolors, and drawings that Hale had selected from the museum's permanent collections of American art, including Wyeth's *A Crow Flew By* of 1949–1950, which had been acquired earlier that year through the Arthur H. Hearn Fund.

46. Corn, *Art of Andrew Wyeth*, p. 96.

47. The artist's admiration for Burchfield's depictions of the bleakness and loneliness of Buffalo's streets and buildings, as seen in paintings such as *Winter Twilight* and *Rainy Night*, both made in 1930, is reflected in Wyeth's *My Mother's Birthplace* of 1943, an evocative tempera painting of the house where Carolyn Bockius was born at 1310 Van Buren Street in Wilmington, Delaware. At some point in the mid-1940s Wyeth visited Burchfield's studio in Buffalo, taking with him a 1944 watercolor entitled *Blakely Road* that he thought the older artist would admire, due to its carefully observed effects of sifting snow. According to Wyeth, it "didn't mean a thing to him." Details of Wyeth's visit to Burchfield are included in an unpublished letter dated February 26, 1946, from Burchfield to his daughter Martha. Charles Burchfield to Martha Burchfield, February 26, 1946, Collection of Mortimer Spiller, Buffalo, New York.

48. That Wyeth may have been influenced by the meticulous precision of Charles Sheeler's architectural paintings of the 1920s was first suggested by Henry McBride. See McBride, "Wyeth: Serious Best-Seller," *Artnews* 52 (November 1953): 67.

49. James W. Lane, "Of Sheeler's Immaculatism," *Artnews* 38 (October 7, 1939): 10.

50. Charles Sheeler, "A Brief Note on the Exhibition," in *Charles Sheeler: Paintings, Drawings, Photographs* (New York: Museum of Modern Art, 1939), p. 10.

51. Pennsylvania Academy of the Fine Arts, *Andrew Wyeth*, p. 53.

52. Aline B. Louchheim, "Wyeth—Conservative Avant-Gardist," *New York Times Magazine*, October 25, 1953, p. 28.

53. David Alan Mellor, *Interpreting Lucian Freud* (London: Tate Publishing, 2002), p. 9. In this important study, Mellor argued that Freud's hallucinatory optical precision and concentration on sharp focus had formal affiliations with American artists such as Andrew Wyeth, Jared French, Paul Cadmus, and Louis Guglielmi, whose work was championed in the 1940s by Lincoln Kirstein, the co-founder and director of the New York City Ballet Company. Kirstein was a close friend of both Wyeth and Freud during this period. Freud probably saw Wyeth's work for the first time in 1950, in the *Symbolic Realism in American Painting, 1940–1950* exhibition that Kirstein organized for the recently inaugurated Institute of Contemporary Arts in London. This show, which was on view from July 18 to August 18, 1950, included three tempera paintings by Wyeth; see Mellor, *Interpreting Lucian Freud*, pp. 51–52.

54. Wyeth's painting is listed as catalogue number 295 in *The Seventeenth Biennial Exhibition of Contemporary American Oil Paintings* (Washington, D.C.: The Corcoran Gallery of Art, 1941), p. 61. *Dil Huey Farm* was included in the central gallery of the exhibition, which was on view from March 23 to May 4, 1941.

55. Meryman, *Secret Life*, p. 162. Unfortunately, wartime austerity prevented Barr from acquiring the work, and he was forced to explain to Wyeth that there were "no funds for purchases at the present time."

56. Ibid.

57. Dorothy C. Miller and Alfred H. Barr, Jr., eds., *American Realists and Magic Realists* (New York: Museum of Modern Art, 1943), p. 5.

58. Alfred H. Barr, Jr., ed., *Painting and Sculpture in the Museum of Modern Art* (New York: Museum of Modern Art, 1942), p. 42. See also Franz Roh, *Nach-Expressionismus, Magischer Realismus: Probleme der neuesten europäischen Malerei* (Leipzig: Klinkhardt and Biermann, 1925).

59. Emily Genauer, "New Museum Show Devoted to Realism," *New York World-Telegram*, February 13, 1943, p. 16.

60. In stark contrast to other artists, such as Louis Guglielmi and Ben Shahn, who listed the contemporary artists they admired and who had influenced their work, Wyeth stressed the importance of his father's teachings and the beauty of the Brandywine River valley farms and grazing lands, which had prepared him for his excursions into subjective moods and emotional expression. Wyeth's statement, although indebted to the "significant form" credo of the English art critic Clive Bell, also expressed his desire to escape his medium and "to leave no residue of technical mannerisms to stand between my expression and the observer. To seek freedom through significant form and design rather than through the diversion of so-called free and accidental brush handling. In short, to dissolve into clear air all impediments that might interrupt the flow of pure enjoyment." See Andrew Wyeth, "Statement," in Miller and Barr, *American Realists*, p. 58.

61. Lincoln Kirstein, "Introduction," in Miller and Barr, *American Realists*, p. 8.

62. For more on the positive reception of Surrealism in the United States during the 1930s, see Dickran Tashjian, *A Boatload of Madmen: Surrealism and the American Avant-Garde, 1920–1950* (New York: Thames and Hudson, 1995). The arrival in New York of the displaced European avant-garde during the Second World War is chronicled in Martica Sawin, *Surrealism in Exile and the Beginning of the New York School* (Cambridge, Mass.: MIT Press, 1995).

63. Although never touched upon in the literature on the artist, the impact of Surrealism can often be detected in Wyeth's work of the 1940s and 1950s, which has a particularly close affinity to Salvador Dalí's detailed illusionism and virtuoso technical skill as seen in paintings such as *Imperial Violets* of 1938, which was widely reproduced in American art magazines of the late 1930s. Dalí's flamboyant self-promotion won him international recognition in the 1930s, when his work was exhibited on a regular basis at the Julien Levy Gallery in New York, where Wyeth first encountered his provocative Surrealist paintings. To this day Wyeth can vividly recall seeing the Spanish artist's hallucinatory *Paranoiac-Astral Image* (1934), which depicts four figures and a beached rowboat on a vast expanse of sand. This work, now in the collection of the Wadsworth Atheneum Museum of Art, Hartford, Connecticut, bears a striking resemblance to Wyeth's subsequent scenes of the Maine coastline and inhabitants. Andrew Wyeth, interview with the author, January 14, 2005.

64. Maude Kemper Riley, "Americans 1943: Realism and Magic Realism," *Art Digest* 17 (February 15, 1943): 6.

65. Doris Brian, "Is the Sharp Focus Clear?," *Artnews* 42 (March 1, 1943): 20.

66. "Andrew Wyeth: An American Realist Paints What He Sees," *Life* 24 (May 17, 1948): 105.

67. N. C. Wyeth, letter to Henriette Wyeth, April 4, 1943, in N. C. Wyeth, *The Wyeths: The Letters of N. C. Wyeth, 1901–1945*, ed. Betsy James Wyeth (Boston: Gambit, 1971), p. 822.

68. Pennsylvania Academy of the Fine Arts, *Andrew Wyeth*, p. 14.

69. The New York art critics unanimously agreed with this assessment of *Public Sale* when it was first shown in the *Temperas and Watercolors by Andrew Wyeth* exhibition at the Macbeth Gallery, November 1–20, 1943. On the basis of this painting, and others such as *The Hunter* (pl. 14) and *Blackberry Picker* (pl. 10), *Artnews* voted Wyeth's exhibition as one of "the year's outstanding one-man shows by living artists." See "What They Say About *Artnews*' "Ten Best of 1943,'" *Artnews* 42 (January 15, 1944): 16–17. The magazine's selection of the "Ten Best of 1943" was commemorated in a group exhibition at the Durand-Ruel galleries in New York, which included two works by each artist. Wyeth was represented by *The Hunter* and *Public Sale* (pl. 12), which were hung alongside paintings and sculpture by artists of the caliber of Burchfield, Eugene Berman, Marc Chagall, and Ossip Zadkine, see Josephine Gibbs, "Best for 1943 Selected by *Artnews*," *Art Digest* 18 (January 15, 1944): 12.

70. N. C. Wyeth's 1945 painting *Nightfall* portrayed just such a scene, as a local farmer stoically stands watch with his daughter while his wife lies dying in the room with the lighted windows of the farmhouse below. However, N. C. Wyeth's decision to spell out the sad meaning of the painting through the drawn, haggard face of the farmer and the averted gaze of the young girl is in stark contrast to his son's painting, which eschews the melodramatic and artificial. As Wanda Corn has argued, the mood of *Public Sale* "is conveyed less by an attempt to describe the scene than by using expressive pictorial elements that suggest its sadness: the bleakness of the gray sky and barren land, the lifeless, craggy trees, the parched colors of the hills, and the plunging dirt road." See Corn, *Art of Andrew Wyeth*, p. 132.

71. The false claim that *Public Sale* is one of the few works in Wyeth's oeuvre to have been painted entirely from memory has been propagated in numerous articles and publications. See, for example, Frank H. Goodyear, Jr., *Contemporary American Realism since 1960* (Boston: New York Graphic Society in association with the Pennsylvania Academy of Fine Arts, 1981), p. 132.

72. de Kooning, "Andrew Wyeth Paints a Picture," p. 40.

73. Ernest Hemingway, *Death in the Afternoon* (New York: Charles Scribner's Sons, 1932), p. 192. The best-known example of the artist's use of the iceberg principle can be found in *Groundhog Day* (1959, pl. 35), which exemplifies Wyeth's consummate ability to translate simple objects to a higher plane of emotional feeling. The stark simplicity of Karl Kuerner's life is encapsulated in the white cup and saucer, plate, and single knife (the only utensil he used for eating) laid out on the pristine tablecloth for his noonday meal. However, the preliminary studies for the painting included the farmer's fierce German Shepherd, Nellie, lying asleep on a cushion in the corner of the room. In the completed painting the dog disappeared, although its presence can still be felt in the splintered end of the roughly hewn log seen through the window, which resembles the bared fangs of an animal. This sharp, ragged edge, together with the log encircled by heavy chains and the barbed wire fence, all combine to create a menacing atmosphere that is completely at odds with the quiet solitude of the still-life arrangement on the table. The threatening atmosphere of *Groundhog Day* shows how the artist had refined his working process since the early 1940s to create an art based on reduction rather than effusion. For an extensive analysis of the meaning and genesis of *Groundhog Day* see Kathleen A. Foster's essay in this catalogue.

74. "Andy's World," *Time* 82 (December 27, 1963): 51.

75. Brian O'Doherty, "Andrew Wyeth: Outsider on the Right," in O'Doherty, *American Masters: The Voice and the Myth* (New York: Random House, 1973), p. 231.

76. Andrew Wyeth, interview with author, January 14, 2005. Wyeth's high opinion of this "very fine" painting of two women picking up coal from railroad tracks was shared by the Museum of Modern Art, which acquired the painting shortly before the exhibition opened.

77. Monroe A. Denton, Jr., "Some Notes on Clarence Carter," in *Clarence H. Carter* (Allentown, Pa.: Center for the Arts, Muhlenberg College, 1978), n.p. Upon hearing the news of his sister's death, Carter and his father were forced to return home through a driving snowstorm, at one point dangerously running across the tracks at a railroad crossing just seconds before a steam locomotive passed through, all of which made him "aware of the vastness of the universe and that something more powerful than any one of us was always bearing down upon each life existing at a given time upon this planet." See Lawrence Campbell, *A Retrospective Exhibition of Paintings and Constructions by Clarence Holbrook Carter* (Trenton, N.J.: New Jersey State Museum, 1974), p. 6.

78. Thomas R. Thompson, *Chris: A Biography of Christian C. Sanderson* (Philadelphia: Dorrance, 1973), p. 303.

79. Ibid.

80. Ibid., p. 335.

81. A photograph taken by her son that showed Mrs. Sanderson on her deathbed, with her head wrapped and her jaw tied to keep her mouth from flopping open, also served as source material for the painting. This photograph is reproduced in ibid., p. 340.

82. Carter had also received widespread publicity in the previous year, when his realistic genre painting *Let Us Give Thanks* of 1942 won the $200 Popular Prize in the 1943 Carnegie Institute exhibition, *Painting in the United States*. The decision came from visitors to the Pittsburgh exhibition who voted during a two-week period, see, "Carter Voted Carnegie Popular Award," *Art Digest* 18 (December 15, 1943): 9. Although now a largely forgotten figure, Carter was an artist of national importance during the early 1940s, when his work, which was frequently reproduced on the covers of prominent art magazines, was shown at the Ferargil Galleries in New York.

83. It should be noted that Chris Sanderson picked his Christmas holly every year near the ruins of Windtryst. Wyeth was also fascinated by these ruins, situated on a high ridge of land behind the house George Washington had used for his headquarters, because N. C. Wyeth and his new bride, Carolyn Bockius, had rented a few rooms in the top section of the house when they first moved to Chadds Ford in 1907. Windtryst was destroyed by fire on September 11, 1914.

84. Meryman, *Secret Life*, p. 96.

85. Jeffrey Schaire, "The Unknown Andrew Wyeth," *Art and Antiques* 2 (September 1985): 50.

86. Russell Thorndike eventually published seven novels relating to the eighteenth-century adventures of the genial, kindly, well-loved vicar of the small coastal town of Dymchurch-under-the-wall, who at night assumed the masked identity of the Scarecrow and prowled the Kent marshes with his daring band of "gentlemen" thieves and smugglers. The story had been popularized in a 1937 film and, more recently, in the 1962 Walt Disney film, *Dr. Syn, Alias The Scarecrow,* which starred Patrick McGoohan as the villainous vicar-smuggler.

87. Meryman, *Secret Life,* p. 231.

# Andrew Wyeth's Language of Things

## Anne Classen Knutson

Shortly after I began this project, my father died. My older brother was tapped to deliver the eulogy and asked me to help him remember stories about Dad for his speech. Numb, we struggled to retrieve specific memories. It was not until I went through my father's possessions that memories began to flood my mind—the things, the objects, triggered startlingly vivid recollections of my childhood. A heavy pewter dish with silver beading instantly recalled the overcooked lima beans, green velvet drapes in the dining room, and seating assignments at family dinners, with a stern father at the helm. My dad's worn, black medical bag with rounded sides that folded down brought back memories of late-night earaches and the patient, gentle doctor administering shots of penicillin that eventually brought relief.

As anthropologists have noted, when a loved one dies, his or her things assume a heightened significance as they help survivors shape and preserve memories of the deceased. Andrew Wyeth has said repeatedly that his work is mostly about memories, and the objects he portrays often emit the strangely reverential aura that my father's possessions assumed after his death.[1] There is a strong correlation in Wyeth's work between people disappearing or dying and objects becoming alive with meaning and associations. Wyeth paints things to explore loss and the inevitability of death, and many of those objects become posthumous homages to dead family and friends. At its core, Wyeth's art examines the complex intersections between objects, the body, and memory, delving into the common experience of things triggering reminiscences.

Wyeth's depictions of everyday things—domestic, natural, and architectural—constitute a significant body of work that has received curiously little critical attention. Wanda Corn, the first art historian to systematically study Wyeth's work, noted the abundance of things in his paintings and catalogued his use of windows, half-open doors, womblike spaces, and vessels.[2] In general, the objects he paints fall into three categories: still lifes in nature, vessels, and thresholds. What I have come to think of as "still life in nature" compositions—hybrids of still-life

and landscape painting—are close-up views of rocks, flowers, trees, animals, and seashells in a landscape setting.[3] The vessel compositions feature bowls, boats, furniture, clothing, and architectural structures. The threshold pictures provide views through windows and mysteriously half-opened doors. These motifs have appeared in his work since the late 1930s, giving a strong sense of continuity to his art even though his treatment of these subjects has changed over time.

In his art, Wyeth creates a protected world filled with nonthreatening objects on which he can project his own thoughts, much as he deployed lead soldiers in imaginary battlefields when he was a child. Wyeth has retained an ability to perceive emotion and intelligence in inanimate objects, and even to imaginatively inhabit them; conversely, he can discern inanimate (or still life) qualities in people. In the safe, fictional realm of his art, he explores complex and difficult feelings, develops inchoate ideas, formulates and solves questions related to temporality, embodiment, and the metaphysical, and defies the laws of nature by animating insensate things. In this way, he identifies with objects and creates a distinctively private iconography. Once the symbolism of these objects is unlocked, we can better understand Wyeth's entire body of work, including such well-known paintings as *Christina's World* (fig. 44).

By 1948, when *Christina's World* was completed, Wyeth had developed his mature style and turned inward, closing his art to outside influences. Before this moment, he had regularly transformed his style, seeking out the work of other artists and experimenting with a variety of aesthetic approaches. Since the late 1940s, Wyeth has sealed his work from the contemporary art world and plumbed his own life and art for subject matter, creating and continually refining the heightened symbolic and sentient qualities of his best-known paintings. This process yielded intriguing stylistic transformations that a strictly chronological survey of his art might overlook. Examining the development of Wyeth's three major themes highlights these changes and reveals the uncanny sense of animation that suffuses Wyeth's art.

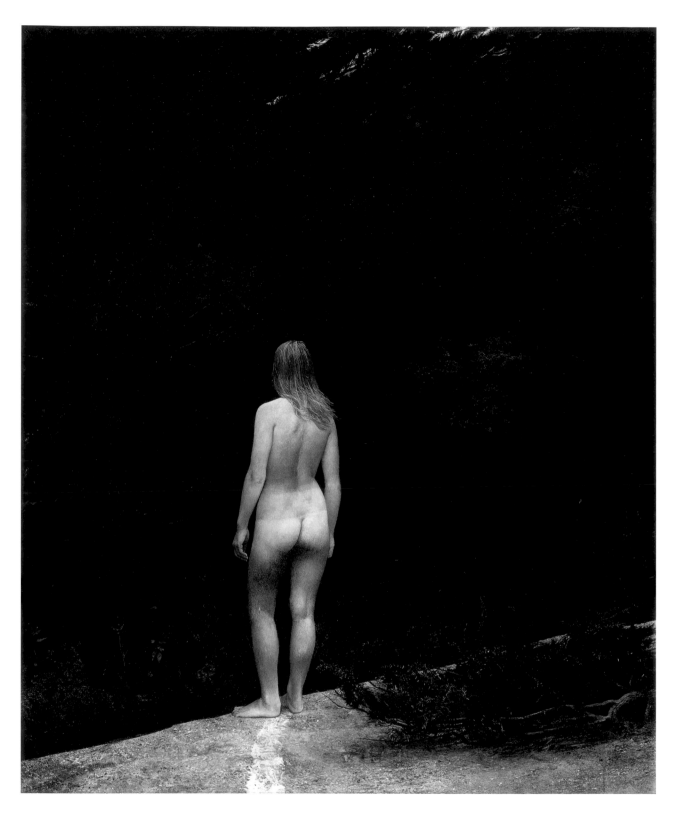

Fig. 29. Andrew Wyeth, *Indian Summer,* 1970, tempera on panel, 42 × 35 inches, Collection of the Brandywine River Museum, Chadds Ford, Pennsylvania, purchase by John T. Dorrance, Jr.; Mr. and Mrs. Felix du Pont; Mr. and Mrs. James P. Mills; Mr. and Mrs. Bayard Sharp; two anonymous donors; and The Pew Memorial Trust, 1975.

More than simple reflections of the lives and personalities of their owners, the things that Wyeth paints function as symbols, giving shape to intangible memories. Many of the natural and domestic objects that Wyeth foregrounds in his paintings have long been used in western rituals of mourning and death. Flowers, trees, and other organic matter are traditional metaphors for death and the fragility of life, and the enduring properties of granite and other rock symbolize the persistence of memory, making them ideal for tombstones and grave markers. Vessels are often used in memorials as metaphors for memory storage, and thresholds suggest transformation, a concept often explored in images of mourning. When Wyeth is not representing the transience of life, he often tries to freeze time in his paintings, just as nineteenth-century postmortem photographs were sometimes placed within the face of a stopped clock.[4]

Wyeth's paintings may seem accessible because we have all mourned the death of a loved one; because we all live with everyday objects that can suddenly, without warning, bring back memories of loss; because we are all transfixed by the inevitability of death; because we all wonder how we can stay it. Wyeth's paintings address these common experiences, and their spare, silent settings encourage us to bring our own bittersweet memories to the experience of viewing his work.

But if Wyeth's paintings have broad appeal, they also are intensely personal. As the artist himself admits, his works manifest his "strong romantic fantasy about things" and evolve "from dreaming of . . . past experience."[5] Idiosyncratic memories and associations collide as his mind moves restlessly between past and present, truth and fiction, nature and the supernatural. Objects stimulate and nourish his associative imagination: in the studio, Wyeth scatters leaves, shells, and things from his childhood to trigger memories and initiate the creative process.[6]

Wyeth's childhood memories are especially rich fodder for his paintings. *Indian Summer* (fig. 29), for example, was inspired by the memory of a Christmas tree ornament—a German angel made of wax—that "twirled in the updraft" of the candles illuminating the boughs of the tree. "Whether or not she was a beauty had nothing to do with my painting her," Wyeth said. "That husky little figure standing looking off, with pale blond hair, is the figure of that little angel against the Christmas tree."[7] Wyeth's painted objects are souvenirs that authenticate and revive his past experiences, making them endure into the present and creating what critic Susan Stewart calls a "continuous and personal narrative of the past."[8] The viewer, however, would not know the childhood memory that inspired *Indian Summer*. While Wyeth's paintings address common themes of memory, nostalgia, and loss, they are also intensely private meditations, filled with hidden symbolism and self-exploration. His paintings are deliberate puzzles that challenge the viewer to decode them. A lover of secrets, Wyeth delights in this game of hide-and-seek.

Wyeth is disappointed when his work is praised for its realism. He is most gratified when a painting seems to suspend time and place, triggering in his viewers' minds some of the memories, fantasies, and sensations that inspired him to paint it.[9] The apparently airless and physically uninhabitable settings he creates in his art suggest that these paintings originate in the mind, not the eye. Shifting scales, odd perspectives, unnatural light, and a uniformly sharp focus also contribute to these otherworldly environments that evoke memories, enact dreams, and fulfill desires.[10] His realism is magic realism, prompted by dreams and the imagination rather than observed reality.[11]

Wyeth's painted objects are almost always associated with particular people, although the relationship may be obscure. He tends to perceive people and things through metaphoric associations, so that when he looks at a ruddy man's face, for example, he sees a pumpkin, as in *Jack-Be-Nimble* (pl. 59). A rock in a field can become his father's gravestone, as in *Far from Needham* (pl. 44). On the day he was inspired to paint *Christina's World,* Wyeth perceived Christina Olson as "crawling like a crab on a New England shore," while she looked to him like "a wounded gull" when he painted *Christina Olson* (pl. 19).[12] Conversely, when Wyeth looks at an object, he often sees a portrait of a person. He once described a rack of caribou antlers that he thought would make a great portrait of Karl Kuerner, his Chadds Ford neighbor and an avid hunter.[13] In many cases, objects become portraits of their dead or otherwise absent owners. The empty boat in *Teels Island* (fig. 59), for example, is meant to be a posthumous portrait of Henry Teel, a friend who lived on an island in Maine.[14] Often, when Wyeth juxtaposes people with objects, the objects appear the more specific and detailed, and even seem more animated than the figures. Sometimes Wyeth completely "paints out" the figure, erasing it in the final version and leaving the objects alone to speak.

Wyeth's weathered and worn but enduring objects have much in common with their owners. Many of Wyeth's models were outsiders, misfits who lived on the outskirts of society and endured physical disabilities, mental illnesses, and poverty. Wyeth identified with them. "I don't fit in," he once remarked. "I pick out models who are misfits and I'm a misfit. There's a stigma."[15] For most of his childhood, Wyeth felt like an outsider. His father had him tutored at home, so that he was often alone, roaming the hills when everyone else his age was at school, and he had a hip condition that prevented him from running normally. "I felt so left out from other kids!" he recalls. "Paint was my only point, my only chance."[16]

Peter Hurd, the artist's brother-in-law and mentor, explains that Wyeth's father, the artist N. C. Wyeth, taught his students "to equate [themselves] with the object, become the very object itself," a lesson he passed on to his son. Andrew Wyeth, Hurd observes, "makes people of things, and the person is also himself, and vice versa. It's a curious,

wonderful thing."[17] For Wyeth, objects and people can be interchangeable; he sometimes identifies with or even embodies the objects or figures he portrays. Just as a family heirloom gives physical reality to ancestry, so Wyeth's subjects give shape to his own desires, fantasies, longings, tragedies, and triumphs. As he told his biographer Richard Meryman, "I am an illustrator of my own life."[18] A rich and varied private language of things tracks his inner journey through the stages of his life. Wyeth uses paintings of things from the past to work through the grief of losing his father and others who have died. With time, his hidden symbolism moves ever closer to the surface.

## Influences

Wyeth's obsessive focus on objects and memory began with his famous father and only art teacher. N.C. Wyeth collected all manner of objects, including antique costumes that he used as props in his paintings and in family holiday rituals.[19] Andrew Wyeth would later incorporate many of these objects into his own paintings. N.C. frequently described the process whereby things triggered memories and activated the senses. He relished reliving his youth through old photographs and family mementos and he always looked forward to his mother's annual Christmas package of foodstuffs and fragrant spruce greens, which prompted vivid memories of his Massachusetts childhood.[20]

Inspired by the transcendentalists, N. C. Wyeth taught his children to be attuned to the rhythms and subtleties of the natural world and to look for metaphors and universal messages in the most mundane natural objects. N.C. made sure that Henry David Thoreau's philosophy was known like scripture in his household, frequently invoking *Walden* as if it were "the family bible."[21] Andrew Wyeth's intense observation of natural things, his tendency to find metaphoric and metaphysical associations in nature, and his inclination to anthropomorphize nature all came from his father and Thoreau.[22]

In 1932, at the age of fourteen, Wyeth entered his father's studio to begin his only formal training. The curriculum included perspective drawing, working from plaster casts and the human model, and painting landscapes and still lifes. Like his own teacher, Howard Pyle, N. C. Wyeth preached complete, empathic identification with the thing or person being painted.[23] He taught "that a man can only paint that which he knows even more than intimately, he has got to know it spiritually. And to do that he has got to live around it, in it and be *part* of it."[24] N.C. taught his son not only to memorize the actual shape of a thing, but in the case of a jug, for example, to know it so well that he could reveal "the shape of its insides as well as the phenomena of its hollowness, its weight, its pressure on the ground, its smell, its displacement of air."[25] Under N.C.'s watchful eye, Wyeth spent hours painting

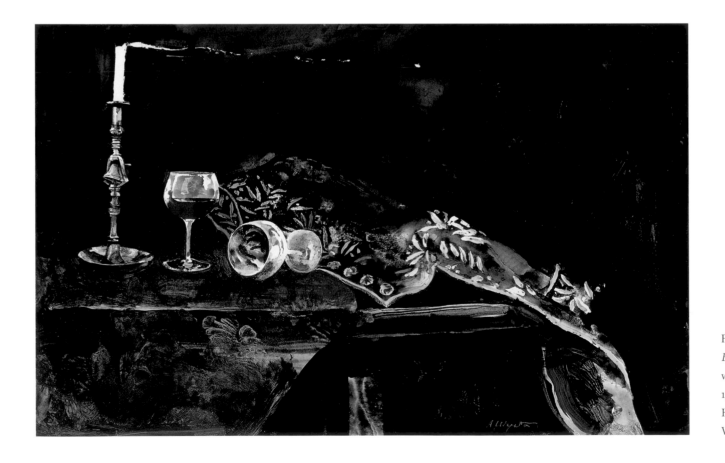

Fig. 30. Andrew Wyeth, *Baron Philippe*, 1981, watercolor on paper, 13¾ × 21¾ inches, Honorable and Mrs. William B. Schwartz, Jr.

objects on a tabletop, yet he insists that he still "can never get close enough to an object, or inside of it enough."[26] From time to time, he returned to the conventional still-life format (fig. 30), but on the whole, his telescoped views of natural and domestic things reveal his early training in still-life painting.

Wyeth both worshipped and feared his larger-than-life father. An imposing man with a volatile temper, N. C. Wyeth insisted on being involved in the lives of his five children. Wyeth embraced yet resisted his father's overwhelming presence.[27] N.C.'s sudden death in 1945 shook Wyeth to the core; the event shaped his inclination to look back in time, ignited his obsession with death, and fostered his association of things with memory. As Richard Meryman has noted, after N.C. died, "painting after painting would become a posthumous portrait of his father."[28] The references to Wyeth's father are oblique, however, and often remain unrecognized by the uninitiated.

In May 1940, Wyeth married a woman who was almost as forceful and formidable as his father (fig. 31). Like N. C. Wyeth, Betsy James Wyeth would become the implicit subject of many of Andrew's paintings. She has devoted her life to nourishing his creativity and building his career, describing her role as that of director, since she would bring Wyeth objects to trigger his imagination and critique his paintings in progress, making suggestions and offering ideas.[29] She supported his aesthetic shift toward greater simplicity and austerity, and encouraged him to rid his works of bright color.[30] She embraced his macabre streak and challenged him to paint in terms of metaphor.[31] She even provided titles for many of his paintings.[32]

Andrew Wyeth was at once attracted and repelled by his wife's intensity, just as he was with his father's:

> She's made me into a painter that I would not have been otherwise. She didn't paint the pictures. She didn't get the ideas. But she made me see more clearly what I wanted. She's a terrific taskmaster. Sharp. A genius in this kind of thing. Jesus, I had a severe training with my father, but I had more severe training with Betsy. . . . Betsy galvanized me at the time I needed it. Later on it became a little hard to take.[33]

The sense of compression and release or containment and freedom that permeates Wyeth's work may reflect his periodic struggles with these dynamic forces in his life.

Many critics and art historians have viewed Wyeth's art as detached from and uninflected by twentieth-century artistic, social, and economic practices. Wyeth and his family foster this interpretation by downplaying or even denying outside influences on his work, save for that of a handful of artists. But Wyeth and his art are products of a particular historical moment, shaped consciously or not by artists who

Fig. 31. Betsy and Andrew Wyeth, 1941. Courtesy of the Wyeth Family Archives.

provided models to emulate. Fashioned between the two World Wars, Wyeth's art shares similarities with the works of many midcentury American painters and photographers.[34] Georgia O'Keeffe, John Marin, Marsden Hartley, Paul Strand, and Charles Demuth also searched the natural forms of their locales for universal metaphors, and frequently transformed objects into metaphoric portraits of their owners. Vessels and thresholds are common in the works of Edward Hopper, Charles Sheeler, Charles Burchfield, Walker Evans, and Dorothea Lange, who, like Wyeth, employed cold, bleached light, animated shadows, and frozen atmospheres to depict poor, dispossessed people and their things, which became emblems of decay, despair, dignity, and endurance.[35] Wyeth, however, imbued objects with intensely personal associations and meanings.

The sense of longing that pervades Wyeth's art derives from an antimodern, anti-urban pictorial mythology that evolved in the United States between the Civil War and World War II. Paintings, prints, photographs, and the popular press offered an idealized view of a rural, pre-industrial New England by focusing on such motifs as lone boats, weathered houses and churches, and close-up views of nature. These images offered an escape from rapid economic, social, and political transformations.[36] Wyeth's art from both Maine and Pennsylvania is informed by this pictorial mythology, yet he used the imagery in an idiosyncratic process of reinvention. In painting these subjects, Wyeth recovered and sometimes magically reshaped his own past for the purposes of his art.

Fig. 32. N. C. Wyeth painting at Eight Bells, Port Clyde, Maine, 1936. Courtesy of the Wyeth Family Archives.

Fig. 33. Andrew Wyeth, *The Fish Hawk*, 1939, watercolor on paper, 21 × 29 inches, private collection.

## The Medium

Early in his career, Wyeth studied Winslow Homer's late watercolors, assimilating their technique and subject matter.[37] Homer was a Wyeth family icon: N.C. Wyeth named his Port Clyde house "Eight Bells" (fig. 32) after Homer's painting, a reproduction of which hung in the living room. Today, Wyeth uses Eight Bells as his studio. As a young man, Andrew Wyeth visited Homer's studio on Prout's Neck and came to know the artist's nephew, Charles Homer.[38] Moreover, Winslow Homer's images of the northern New England coast expressed and celebrated old-time New England values, setting the standard for younger image-makers who would produce pictures in this tradition. According to art historian Bruce Robertson, Homer's work "was presumed to represent the constancy of timeless values, a strong rock amid a sea of change."[39] Like Homer, Wyeth turned his back on the urbanization and industrialization of American cities, looking out to the sea and the adjacent land for universal metaphors of life and death.

Wyeth's early watercolors *The Lobsterman* (pl. 3) and *The Fish Hawk* (fig. 33) exemplify the artist's depictions of Homeresque vessels on the

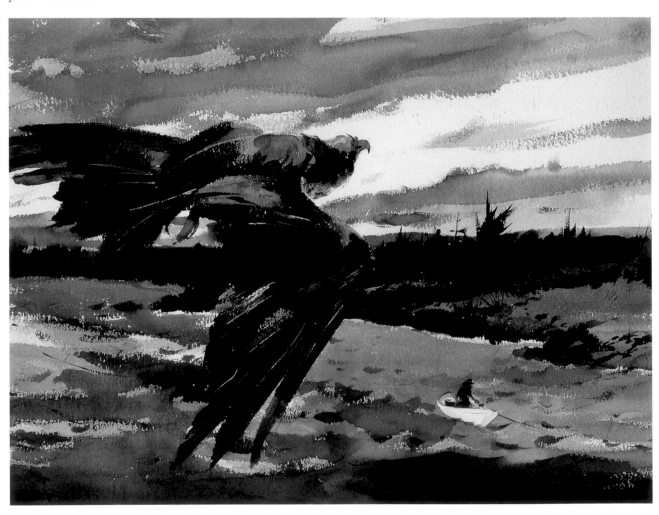

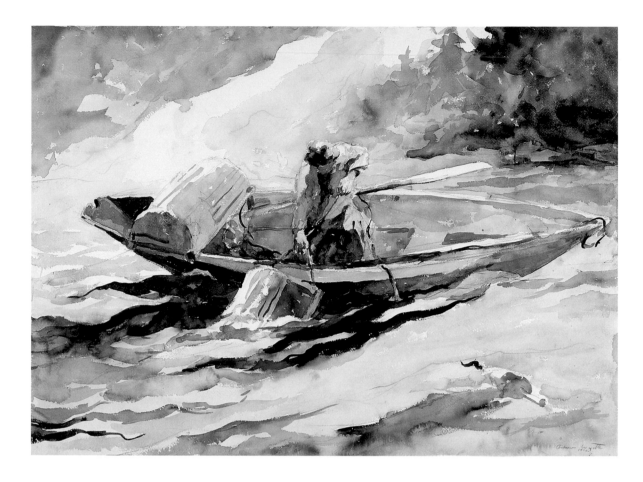

water. The figure of a lone man in a boat was part of the standard repertoire of "old New England" images and a motif that Wyeth was to plumb over the course of his career. His early images of boats closely resemble those of his father, who, also influenced by Homer, was a purveyor of old-time New England imagery. Andrew Wyeth's *Maine Fisherman* (fig. 34), for instance, resembles N. C. Wyeth's *Deep Cove Lobster Man* (fig. 35). In the late 1930s and early 1940s, the works of the two reveal striking similarities, suggesting that they worked in close association.[40]

Wyeth once remarked that "watercolor perfectly expresses the free side of my nature"—the impulsive, wilder side that chafed at the influences of N. C. and later Betsy Wyeth.[41] He first explored the medium in Maine, where he was able to escape the controlling influence of his father. Watercolor allowed Wyeth to capture a fleeting feeling or sudden insight that might later become the subject of a major tempera.[42] In *Blowing Leaves* (fig. 36), for example, watercolor helped him capture the instant that a leaf falls to the ground.[43] And in *Jack-Be-Nimble* (pl. 59), it suggests the moment that a lighted jack-o'-lantern flickers to life.

If Wyeth uses watercolor to set up artistic problems exploring issues of memory, loss, temporality, escape, and desire, he attempts to solve those problems and pin down fleeting memories in the hard, permanent

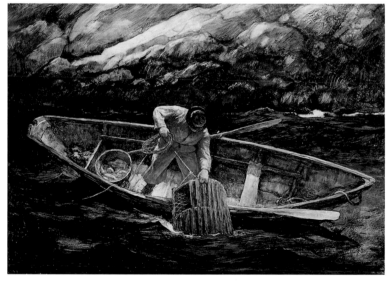

Fig. 34. Andrew Wyeth, *Maine Fisherman*, 1936, watercolor on paper, 22 × 30¼ inches, Collection of Andrew and Betsy Wyeth.

Fig. 35. N. C. Wyeth, *Deep Cove Lobster Man*, ca. 1938, oil on gessoed board, 16¼ × 22¾ inches, courtesy of the Pennsylvania Academy of the Fine Arts, Philadelphia, Joseph E. Temple Fund.

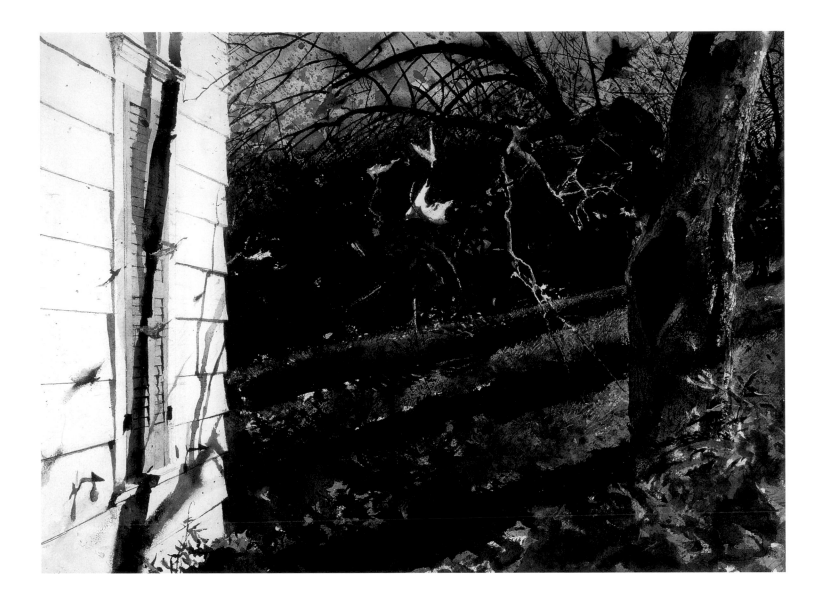

Fig. 36. Andrew Wyeth, *Blowing Leaves*, 1980, watercolor on paper, 20 × 27 inches, private collection.

layers of tempera.[44] Peter Hurd introduced Wyeth to the fourteenth-century technique of egg tempera painting. A surge of interest in Renaissance and Baroque art and a widespread fascination with the past sparked a tempera revival in the United States in the 1930s that lasted through the 1950s.[45] By 1940, Wyeth had come to favor it over oil and regarded tempera painting as an antidote to his messy water-color technique:

> There's something incredibly lasting about the material, like an Egyptian mummy, a marvelous beehive or hornet's nest. The medium itself is a very lasting one, too, because the pure method of the dry pigment and egg yolk is terrifically sticky. . . . It takes tempera about six months or more to dry and then you can actually take a scrubbing brush to it and you won't be able to rub off that final hardness.[46]

Wyeth used the mummy simile in several interviews, and the beehive, in medieval culture, was commonly used as a metaphor for memory.[47] The hard medium of tempera, therefore, allowed Wyeth to fix his memories for eternity, giving enduring life to people, events, and things. Moreover, the dryness of the medium perfectly suited and possibly influenced his decision to move his objects from watery environs to drier, island interiors.

The airless, frozen setting in *Below Dover* (pl. 23) shows how Wyeth's shift to tempera moved him away from exuberant images of Homer-esque boats on the water to more monochromatic views of boats left to decay on land.[48] The labor-intensive medium of tempera, which is

applied methodically, layer by layer, not only suits the meticulous and regimented side of Wyeth's nature but also expresses his love of fine craftsmanship. Wyeth selects subjects with surfaces that suggest similarities to the tempera process. In *Monday Morning* (pl. 29), for example, impastoed flecks of yellow and gold tempera transform an ordinary laundry basket into a marvel of craftsmanship. Wyeth also builds up waves of impasto on the side of the house to suggest the texture of stucco applied in layers over time.

Wyeth uses the medium of watercolor and images of thresholds to explore those things that are fleeting, in transition, and ultimately uncontrollable, but he employs the solid medium of tempera, along with images of vessels, to entomb and contain memories, and to attempt to control the uncontrollable.[49] Tempera can both suggest texture and suppress evidence of the artist's brush strokes. Like mid-century documentary photography, tempera can minimize the viewer's awareness of the artist. The invisibility of the artist is an integral part of Wyeth's creative process and a key to deciphering his paintings, for as the artist disappears, the things he paints come to life.

## Self-Portraits

Four Wyeth self-portraits provide clues to the rich and varied symbolism that pervades his art. *The Revenant* (fig. 37) is a three-quarter-length image of the artist, dressed in faded sailing clothes, in an upstairs room of the Olson house. It is one of Wyeth's few straightforward self-portraits, yet in it he appears to emit an unearthly glow that gives him the ethereal aspect of a revenant, or a ghost. His face is obscured and his body seems to dissolve into air and light. "I wish I could paint without me existing—that just my hands were there," he once said. "When I'm alone in the woods, across the fields, I forget all about myself. I don't exist . . . but if I'm suddenly reminded of myself, that I'm me—then everything falls to pieces."[50] He has often said that he is at his most productive when he feels disembodied and invisible, and many of his paintings allude to that creative state of being. Moreover, Wyeth does not like people watching him paint: it makes him aware of his physical self and causes him to slip out of his creative trance. For this reason, he dislikes portrait painting: "The person has to be there, watching me. I have to talk."[51] Wanda Corn argues that this may be the reason so many of his figures turn away from the viewer or appear absorbed in something—so that the artist would not become self-conscious. Corn proposes that the quality of Wyeth's object-based paintings is high precisely because he can more freely tap into those feelings that well up when the physical fact of a living, breathing person watching him does not impede the process.[52]

*The Revenant* is rare among Wyeth's self-portraits in that it allows the viewer to look directly at the artist's face. *Trodden Weed* (pl. 24) is a more typical example: we see only the artist's boots tromping through the weeds.[53] Wyeth completed the painting shortly after undergoing an operation in which he almost died. During the surgery, his heart stopped; near death, he saw Albrecht Dürer, dressed in black, coming toward him across the hospital floor. When his heart started again, Dürer receded.[54] The hyperrealism of Dürer's art had always appealed to Wyeth, and the drybrush technique and lavish attention given to each blade of grass in *Trodden Weed* pay homage to the Renaissance master.[55] Wyeth explained that the black line and crushed weed beneath the boot symbolize his near-death experience, assigning intensely personal, metaphoric meaning to inanimate objects—metaphors that viewers would not otherwise be able to decipher.[56]

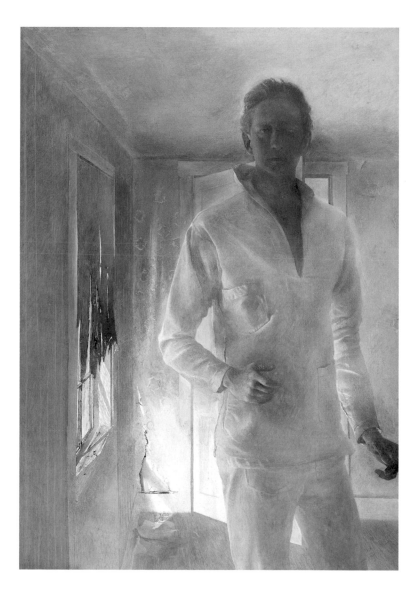

Fig. 37. Andrew Wyeth, *The Revenant*, 1949, tempera on panel, 29 × 20½ inches, New Britain Museum of American Art, Connecticut.

Fig. 38. Andrew Wyeth, *The White Shell*, 1955, watercolor on paper, 14 × 21 inches, Joyce and Henry Schwob.

Fig. 39. Andrew Wyeth, *Virgin Birch*, 1982, watercolor on paper, 21½ × 29½ inches, private collection.

The late self-portrait *Breakup* (pl. 78) is a still life in the landscape of the artist's disembodied hands. Betsy Wyeth had commissioned a hand surgeon to make a cast of her husband's hands in fiberglass, which she had cast in bronze. Those bronze effigies appear alive in the frozen environment of *Breakup,* emerging from an ice floe on the Brandywine River.[57] The fingers press down, leaving imprints in the snow, as if playing a tune on the piano.[58] *Breakup* depicts a theme that pervades Wyeth's oeuvre—inanimate objects that seem alive. Recalling his father's advice to become the things he paints, Wyeth seems to inhabit the bronze objects in *Breakup.* The variously colored and textured layers seen through the cross section of ice represent frozen natural material from the Brandywine Valley's past. As in nineteenth-century memorial photographs, Wyeth freezes time in this tempera. Layers of tempera, like layers of ice, petrify material from a specific time. His hands become fossils, assuring immortality for the most productive parts of his body.

*The Carry* (pl. 86) is a landscape that Wyeth describes as a self-portrait. It is painted in the same range of colors as *Breakup,* signaling an affinity between the two. *The Carry* depicts a pool of turbulent water rushing down a chute and merging with a frothing waterfall that creates a run leading to a calm, dark pool in the background. The landscape is in transformation; the flow of water metaphorically suggests the flow of time and may allude to the transition from life to death. After 1989, Wyeth became more straightforward, even obvious, with his symbolism.[59] In an unusually revealing remark, Wyeth admitted that this waterscape represents his two sides—the calm and the tempestuous (which Wyeth calls his "Helga side").[60] As long as he imagines himself as a thing or a part of a landscape, Wyeth can maintain the fiction that he is an invisible seer. Perhaps he so rarely painted conventional self-portraits because to do so would entail looking into a mirror, thus shattering his cherished concept of himself as a concealed onlooker.

## Natural Things

Wyeth has created a large body of still-life-and-landscape hybrids that focus on flowers, rocks, trees, fruits, and shells in natural settings (figs. 38 and 39). As a young artist, Wyeth had painted descriptive, close-up views of blackberries (pls. 9 and 10), flowers, leaves, and rocks that invite comparison with the work of such American Pre-Raphaelite painters as John William Hill (fig. 40) and Thomas Farrer. Eventually, Wyeth pared down this compositional model into artful arrangements bearing a strong human presence. Deeply informed by the still-life tradition, this series of paintings, which features fragile flowers and dead animals, illustrates Wyeth's preoccupation with images that remind the living of death. Although Wyeth painted memento mori works before his father died, it was after that fateful event that death

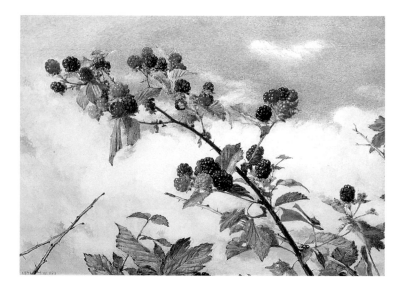

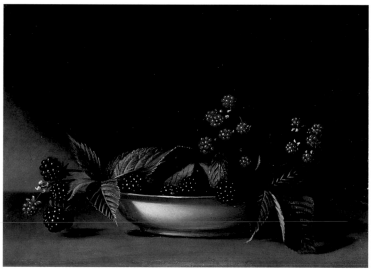

Fig. 40. John William Hill (American, born England, 1812–1879), *Blackberries,* 1876, watercolor on paper, 9⅝ × 13⅜ inches, private collection.

Fig. 41. Raphaelle Peale (American, 1774–1825), *Blackberries,* ca. 1813, oil on panel, 7¼ × 10¼ inches, Fine Arts Museums of San Francisco, gift of Mr. and Mrs. John D. Rockefeller 3rd, 1993.35.23.

and the ephemerality of life became more pronounced subtexts.[61] Some of his depictions of embodied things in nature express Wyeth's interest in the fleeting and the permanent, just as memorial objects and images often suggest decay and preservation.[62]

Wyeth's images are not snapshots of reality but highly composed, carefully arranged personal fictions. In this they are similar to certain early nineteenth-century still lifes by the Philadelphia artist Raphaelle Peale. The art historian Alexander Nemerov has identified a strangely

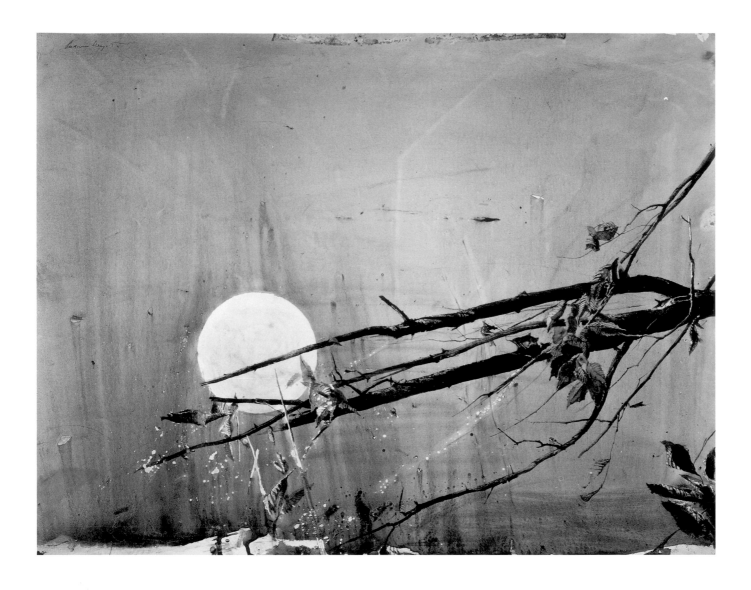

Fig. 42. Andrew Wyeth, *Full Moon*, 1980, watercolor on paper, 21⅝ × 28⅝ inches, private collection.

animated quality in Peale's still lifes that calls Wyeth's work to mind. He argues that the objects in Peale's still-life paintings imply the physical presence of a human being—specifically, the artist himself.[63] Peale's *Blackberries* (fig. 41) might be compared to Wyeth's *Blackberry Picker* (pl. 10). In Wyeth's work, a blackberry bush in the extreme foreground is rendered in exacting detail. Beyond it is a green landscape, with the figure of a man in a white shirt picking berries in the distance. In Peale's painting, a branch loaded with blackberries in a white porcelain bowl sits on a table against an indistinct background. In both works, the blackberries occupy a space that is almost continuous with that of the viewer and the artist (one of Wyeth's brambles even seems to arc into the viewer's space), emphasizing the artist's close identification with the object and suggesting his physical presence. Both artists suggest the heaviness of the ripe berries and the prickly texture of the leaves, engaging our sense of touch and establishing an almost physical connection to the subject. (Wyeth described how he enjoyed eating

each berry after painting it).[64] In both works, the blackberry branches have an oddly frontal alignment, as if posing for the painting and staring back at the artist. In Wyeth's later works, the anthropomorphic quality of such objects grows ever more obvious.

In *Spring Beauty* (pl. 13), Wyeth focuses on one white blossom that pops through the dead leaves at the base of a tree. The perspective is only inches above the flower and the tree's roots protrude into the viewer's space, suggesting intimacy with the artist or viewer. The spring beauty seems to have just sprung up in the center of the panel, displaying the frontality of the blackberry bush in *Blackberry Picker* and giving the same uncanny impression of staring back at the viewer.[65] The fragility of the tiny wildflower is emphasized by its contrast with the thick,

permanent roots and the crusty, dead leaves, whose texture suggests they would crumble in your hand. In *Quaker Ladies* (pl. 30), a constellation of delicate flowers has triumphantly emerged through the layers of dead leaves that carpet the ground. In the upper-left corner, a four-pronged, leafless branch seems to reach into the painting, hovering like a hand ready to poke through the dense weave of flora.[66]

In *Quaker Ladies,* the bare branches recall a part of the body and the brittle leaves evoke the sense of touch; Wyeth's later work becomes even more evocative of both human presence and human mortality. In *Full Moon* (fig. 42), the peripheral branch in *Quaker Ladies* becomes the focal point. The brittle fingers of the limb, in a space contiguous with ours, hover over the scene, appearing to shake the luminescent frost from the twisting leaves, which resemble birds that have just alighted. Wyeth often uses the befuddling quality of moonlight to transform ordinary objects into extraordinary things.[67] In this case, moonlight both highlights the sentient quality of the branch and coldly illuminates its deadness.[68] In *Long Limb* of 1998 (pl. 81), Wyeth focuses on the bare limb, the few dead leaves clinging to it, and the blades of grass in the foreground. Although he has not painted a figure, he imbues the tempera with a strong sense of animation.[69] The dead leaves still clinging to the dormant branch resemble a flock of sparrows about to fly off the limb. The bare branch in a field of dead grass represents both death and life, a common duality in Wyeth's work. The light peeking up behind the hill heightens the ambiguity: Is the sun rising or setting on this scene?

The bird-like animation of the leaves in *Full Moon* and *Long Limb* introduces a ubiquitous motif in Wyeth's oeuvre. Birds allowed him to explore themes of escape and imprisonment, echoes of his larger preoccupation with life and death. In *Soaring* (pl. 11), Wyeth uses buzzards to suggest the floating state he slips into when painting and to express his yearning for freedom. Wyeth frequently juxtaposes birds with windows and doors, symbols of escape and transience. The birds may be flying freely, as in *Soaring,* or dead, contained in some sort of vessel, or tied by a rope.[70] In *Chimney Swift* (fig. 43), a dead bird lies on the sill of a closed window, a symbol of escape entombed within an airless room. Such formal tensions regularly appear in the artist's work and may express personal conflicts, as he sometimes rebelled against the domineering wills of both his father and his wife. Wyeth also explores the divide between freedom and life and containment and death through the motifs of thresholds and vessels. Late in his life, Wyeth admits the world of technology into his painted universe with an entirely different type of bird—an airplane.[71]

The notion of the bird as self-portrait culminates in *Airborne* of 1996 (pl. 80). The Wyeth house on Benner Island, Maine, sits in the background, bathed in fog. The house is in effect a portrait of Betsy Wyeth who, acting as architect and designer, re-created on the island

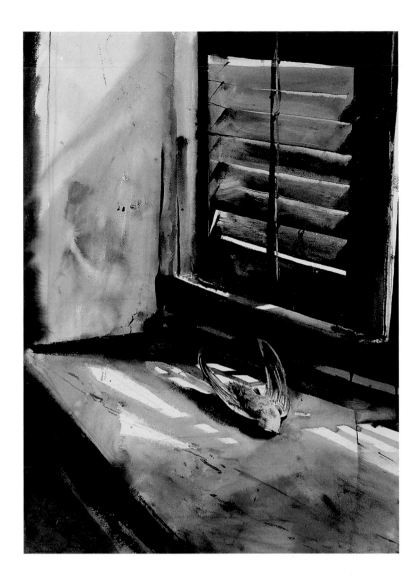

Fig. 43. Andrew Wyeth, *Chimney Swift*, 1947, watercolor on paper, 30 × 21 inches, Collection of Andrew and Betsy Wyeth.

an early eighteenth-century home from Waldoboro, Maine.[72] To Wyeth, the house was an emblem of Betsy's organizing, meticulous, and hovering presence. A dense blanket of grass is hemmed in by water on both sides, suggesting that the few acres of the island felt confining to Wyeth, who liked to nourish his spirit by roaming over large tracts of land. The foreground is thick with feathers floating through the air as if a gull has just exploded, or a gust of wind has plucked them from a bird's carcass. The drifting feathers are at the mercy of the wind, their destination unprescribed—the essential condition for triggering Wyeth's creativity—while the tidy house in the background represents a different sensibility altogether. The explosion of feathers could be Wyeth's rebellious response to the life his wife created in Maine, or an ironic visualization of his frustration with the physical restrictions imposed

by his aging body. Or they could be a metaphor for his own impending death—a topic he often contemplates.

These memento mori themes are treated more extensively in Wyeth's series of figures in the landscape. A key to these works lies in the sudden violence of his father's death. In October 1945, N. C. Wyeth and his three-year-old grandson (the child of Andrew's brother, Nathaniel) were hit and killed by a train at a crossing in Chadds Ford. N.C.'s shocking death changed Andrew Wyeth forever. At the age of twenty-eight, his youthful optimism and sense of immortality were abruptly derailed, and his work began to reflect an increasing interest in mortality. He looked back at his vibrant watercolors and depictions of natural objects as "caricatures of nature." His father's death had brought him to life, Wyeth said, since it caused him to commit to serious themes. "It gave me a reason to paint, an emotional reason. I think it made me."[73] As Richard Meryman observes, "N.C. remains a central, perhaps hourly, presence in his life. The deep and complex emotions, the unfinished business, the love and fear have persisted, never soothed, finding their way year after year into the subtext of his temperas. 'My father is still alive.' Wyeth says. 'I feel my father all around.'"[74]

After N.C.'s fatal accident, Wyeth used his paintings to immortalize his father and to magically fight off the inevitability of his own death. *Winter, 1946* (pl. 18) was the first tempera that Wyeth completed after his father died. "It's of a boy running," Wyeth explains:

almost tumbling down a hill across a strong winter light, with his hand flung wide and a black shadow racing behind him, and bits of snow, and my feeling of being disconnected from everything. It was me, at a loss—that hand drifting in the air was my free soul, groping. Over on the other side of that hill was where my father was killed, and I was sick I'd never painted him. The hill finally became a portrait of him. I spent the whole winter on the painting—it was just the one way I could free this horrible feeling that was in me—and yet there was great excitement. For the first time in my life, I was painting with a real reason to do it.[75]

The image of the boy was inspired by the sight of a neighbor, Allan Lynch, running down a hill near the spot where Wyeth's father was killed. (Lynch was also the one who stood by N.C.'s body that day, keeping the dogs away until help came.)[76] Yet Wyeth's description makes it clear that in this painting, *he* is the boy careening down the hill.[77] The out-of-control aspect of the boy suggests that the death of his father and teacher left Wyeth with a frightening sense of untethered, ungrounded, and overwhelming freedom.

John Wilmerding has argued that "the loneliness and emptiness of this hillside thus came to express the artist-son's deepest feelings of isolation combined with the recognition that this looming mass of landscape was the embodiment of his father's permanent memory."[78] The unusual inclusion of the year, 1946, in the title underscores the significance of that date in Wyeth's development as an artist. Not only does *Winter, 1946* signal a new period of productivity, it also marks the beginning of Wyeth's imagining himself as a figure in his paintings. The unnatural perspective and uniformly sharp focus suggest a dreamscape in which Wyeth plays out his struggles in his mind's eye.[79] Wyeth once compared the boy's "drifting" hand to his own lost soul. As we have seen, he considers his hands his most creative body parts, and made them the subject of the self-portrait *Breakup* (pl. 78); the left hand in that work is almost identical to the boy's in *Winter, 1946*. Can we assume, then, that *Winter, 1946* is a private metaphor for the artist's search for the right creative path?

In order to fully understand *Winter, 1946*, it must be considered beside *Christina's World* (fig. 44), produced two years later. Although generally regarded in the context of Christina Olson's life, the painting is more than an illustration of her physical condition and emotional environment: it addresses the evolution of Wyeth's career and his own private language of metaphor. Wyeth had met his future wife at her home in Cushing, Maine, in 1939; that same day, Betsy took him to meet her neighbors, the siblings Christina and Alvaro Olson, thus beginning an almost thirty-year relationship. The Olsons lived in a dilapidated clapboard farmhouse, and Christina had a disability that left her unable to walk; proudly refusing a wheelchair, she resorted to dragging her body around when her legs became permanently disabled.[80] Wyeth perceived the Olson house, which had never been modernized, as a time capsule from another era. The Olsons themselves were part of a New England lineage that went back to the seventeenth century, when one of their ancestors presided over the Salem witch trials. To Wyeth, then, Christina became "a symbol of New England people in the past—as they really were."[81]

Little in the painting is real. Betsy Wyeth posed for the figure; only the arms and hands were modeled by Christina herself. Wyeth eliminated many of the farm's outbuildings and distorted the space between the house and barn; the slope of the hill is entirely Wyeth's invention.[82] Since this painting originated in the artist's imagination, it can be read as an image of the mind, a personal projection. "I felt the loneliness of that figure—perhaps the same that I felt myself as a kid," Wyeth said. "It was as much my experience as hers."[83] Moreover, certain elements of the painting—the lone figure, brown grassy hill, tire tracks, and high horizon line—link *Christina's World* to *Winter, 1946*, in which the artist merged with the figure. According to Christopher Crosman, *Christina's World* may also be partly about N. C. Wyeth's death.[84] Indeed, the powerful sense of loss in *Christina's World* not only suggests the artist's nostalgia for old New England but also resonates with his incessant longing for his father.

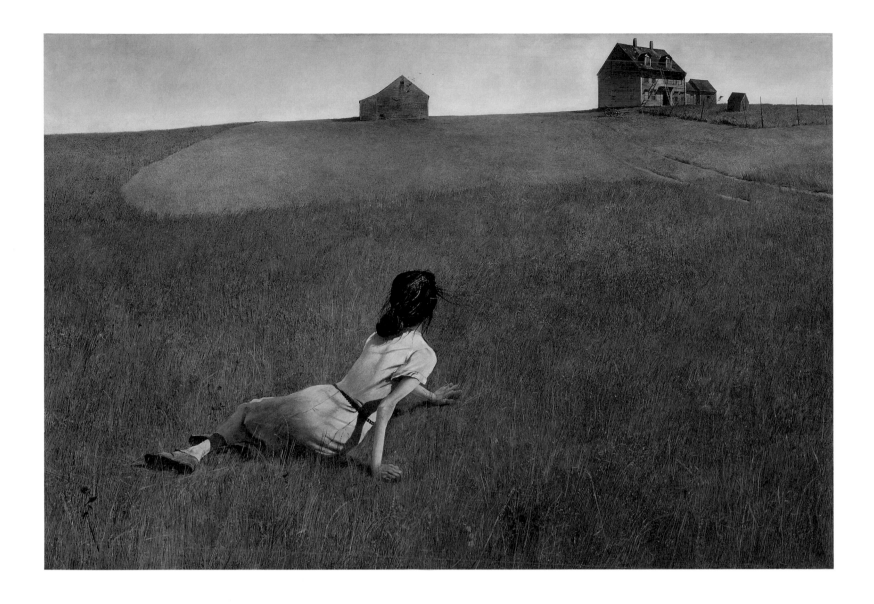

The boy in *Winter, 1946* is aimless, but the figure of Christina sits firmly on the grass, completely focused on the house, her presumed destination. Given that Wyeth frequently merged himself with his models, and given the aesthetic similarities between the two paintings, Christina's figure may be read as a metaphor for the artist himself. If the figure in *Winter, 1946* represents the artist groping for the right artistic path, then Christina's still, focused figure may suggest that the artist has finally charted his course. Indeed, when he finished *Christina's World* in 1948, Wyeth wrote to his mother, "Nobody has seen it, but living with it as I work has made me feel certain that it goes way beyond my other work."[85] That same year, *Christina's World* was purchased by the Museum of Modern Art, igniting Wyeth's career.

Years later, in *Spring* (pl. 65), Wyeth returned to the familiar formula of *Winter, 1946* and *Christina's World*—a figure in a landscape with a bare hillside, a row of tire tracks, and a high horizon line. The model

Fig. 44. Andrew Wyeth, *Christina's World*, 1948, tempera on gessoed panel, 32¼ × 47¾ inches, The Museum of Modern Art, New York, purchase, 16.1949.

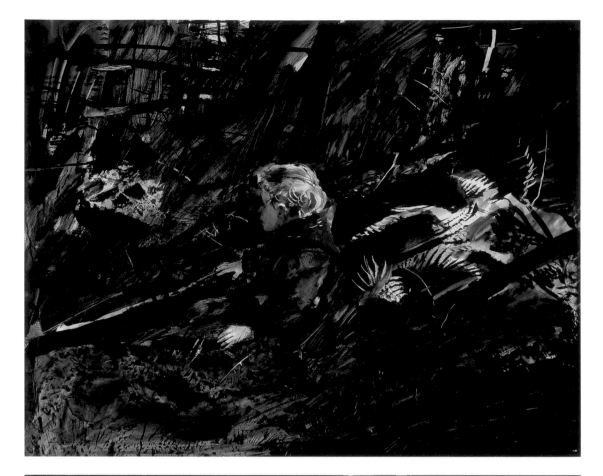

Fig. 45. Andrew Wyeth, *Nicholas in the Woods*, 1948, watercolor on paper, 23¾ × 29½ inches, private collection.

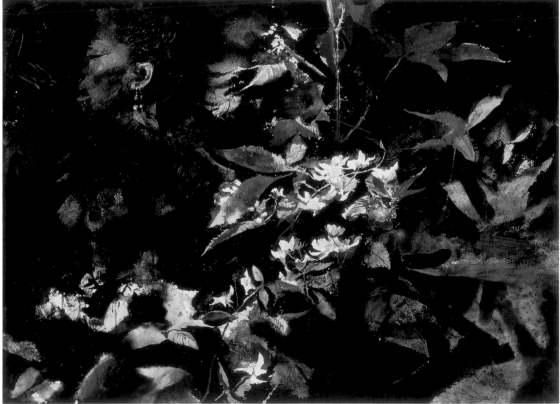

Fig. 46. Andrew Wyeth, *Sarita*, 1978, watercolor on paper, 21 × 29 inches, private collection.

for the naked man submerged in a snowdrift was Wyeth's neighbor
and father figure, Karl Kuerner. The disturbing image was inspired by
Wyeth's visit to see Kuerner who, bedridden and dying, was hallucinat-
ing about his experiences fighting with the Germans in World War I.
Wyeth, who has been fascinated with that war since childhood, was
captivated by those reminiscences and declared the man "timeless."[86]
In *Spring,* Wyeth creates a sense of timelessness by merging Kuerner's
ghostly figure with the regenerative forms of nature—the winter grasses,
rendered in magically realistic detail—and by encasing his image in
the permanent medium of tempera. Wyeth has often said that Kuerner
reminded him of his father, and, indeed, the figure sinks into the very
hill that Wyeth regarded as a portrait of his father in *Winter, 1946.*
Considering the highly autobiographical nature of Wyeth's figures in
a landscape, this picture, whose title suggests rebirth, may obliquely
represent Wyeth's father's decomposing body, while magically assuring
his immortality.

Throughout his career, Wyeth has been obsessed with merging
human figures with the landscape, as in *Nicholas in the Woods* (fig. 45)
and *Sarita* (fig. 46). In these two works from 1948 and 1978, respectively,
the ethereal figures seem to disappear into the ground or the atmo-
sphere, while the surrounding plant material takes on heightened con-
creteness and specificity.[87] Trees are another landscape element that
Wyeth repeatedly foregrounds in his work. While his early depictions
of trees were descriptive, as in *The Hunter* (pl. 14), later renditions
become more symbolic and metaphoric, as in *Snow Hill* (fig. 14).[88] In
many of these works, Wyeth seems to fuse the figure with the tree, just
as he sometimes merged a figure with the ground; in many cultures
trees signify life, regeneration, longevity, and transcendence.[89]

Wyeth's Helga paintings often feature trees and may illuminate the
significance to his oeuvre of this traditional symbol of vitality. Between
the age of fifty-three and sixty-eight, Wyeth underwent a midlife crisis
and produced hundreds of drawings and paintings, many of them
nudes, that he kept hidden from his wife. This secret series of works
portraying Helga Testorf, who was then taking care of Karl Kuerner,
may have expressed Wyeth's need to exert his independence from his
wife.[90] John Wilmerding argues that in these works, "Helga has the
suggestive aura of a personification, if not a goddess, of nature," recall-
ing "the myths of spring and Flora, of Venus and the graces, even Eve
out of Dürer's garden."[91] The aging artist frequently paired trees, a
symbol of rebirth, with the youthful figure of Helga (fig. 47). She was
indeed a figure of regeneration, rejuvenation, and escape for Wyeth,
who, at middle age, faced a growing sense of mortality and lost youth.
It was his "constant, lifelong sense of imminent death" that finally
prompted him to reveal the paintings to his wife and to the world.[92]

After the Helga series, Wyeth created another group of paintings that
made the meaning of his tree symbolism plain. From the mid-1980s

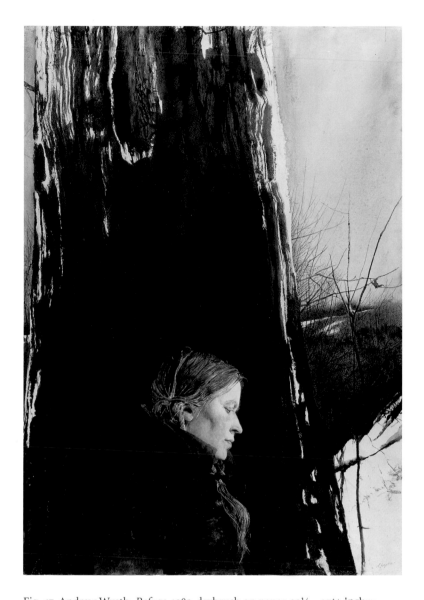

Fig. 47. Andrew Wyeth, *Refuge,* 1985, drybrush on paper, 39¼ × 27½ inches,
private collection.

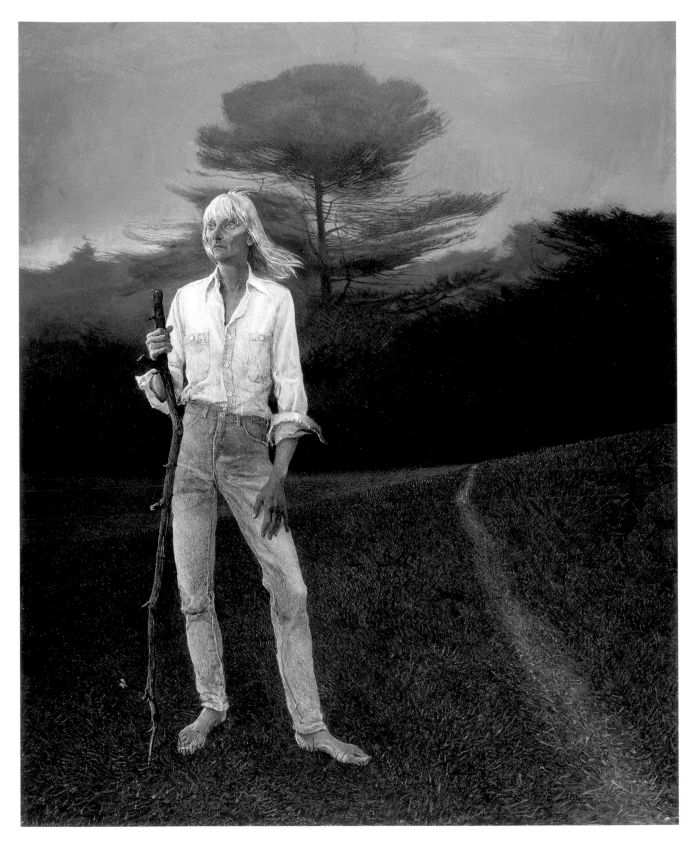

Fig. 48. Andrew Wyeth, *Witches Broom*, 1990, tempera on panel, 26⅝ × 21¾ inches, Collection of Andrew and Betsy Wyeth.

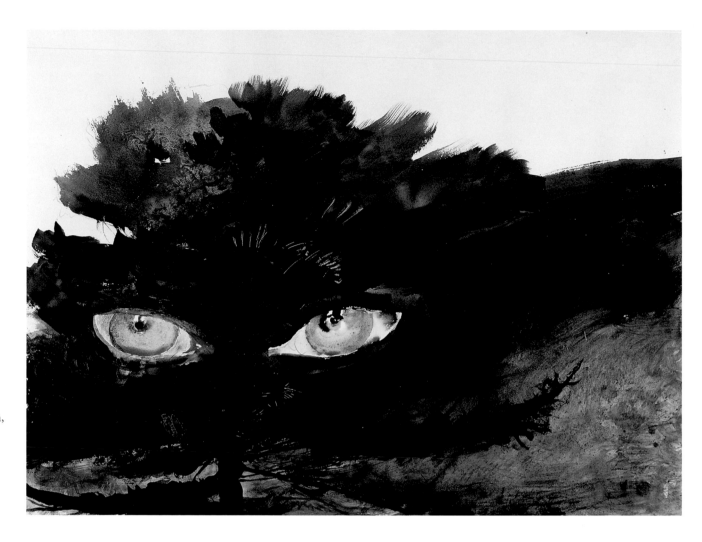

Fig. 49. Andrew Wyeth, *No Trespassing*, 1991, watercolor on paper, 22¼ × 29⅞ inches, Collection of Andrew and Betsy Wyeth.

until 1991, he experimented with merging his model, Ann Call, with Maine pine trees that had suffered a blight, killing off their lower branches and leaving the tops looking, the locals said, like an upside-down witch's broom. Wyeth has long been fascinated by witches and witchcraft, and in *Witches Broom* he transforms Ann Call into a sharply featured witch in contemporary dress (fig. 48). He made drawings of her eyes in the studies for *No Trespassing* (fig. 50). In *No Trespassing* (fig. 49) he magically superimposed those disembodied eyes onto a pine tree, giving it life and personality. In these paintings, Wyeth animates his beloved trees, while giving a favorite model immortality.[93]

The granite rock of New England features prominently in the works of numerous artists who searched the northern coast for traces of old New England, and Wyeth is no exception. As historian Bruce Robertson has pointed out, in the old New England pictorial tradition the rocky coast of Maine represented "the constancy of timeless values."[94] Wyeth himself acknowledged the aptness of the metaphor. "Now I do have this feeling that time passes," he said, describing "a yearning to hold something—which might strike people as sad. . . . I do an awful lot of

Fig. 50. Andrew Wyeth, *No Trespassing Study*, 1991, watercolor and pencil on paper, 14 × 17 inches, Collection of Andrew and Betsy Wyeth.

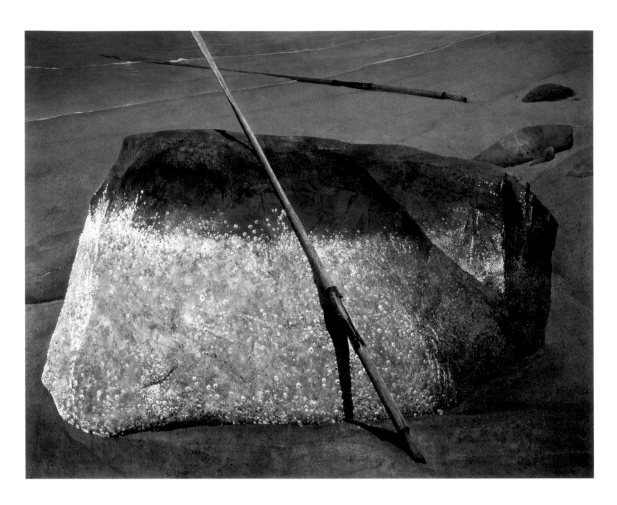

Fig. 51. Andrew Wyeth, *The Duel*, 1976, tempera on panel, 37½ × 48 inches, private collection.

Fig. 52. Andrew Wyeth, *The Duel Study*, 1976, watercolor on paper, 22¾ × 28¾ inches, private collection.

Fig. 53. Andrew Wyeth, *The Duel Study*, 1976, pencil on paper, 14 × 16¾ inches, Collection of Andrew and Betsy Wyeth.

Fig 54. Andrew Wyeth,
*The Duel Study* (detail), 1976,
watercolor and pencil on paper,
24½ × 36½ inches, Collection
of Andrew and Betsy Wyeth.

thinking and dreaming about things in the past and the future—
the timelessness of the rocks and the hills—all the people who have
existed there."[95] Not surprisingly, Wyeth tends to animate his images
of rocks. He began his career by painting images of rocky coasts,
such as *Little Caldwell's Island* (pl. 6), but moved on to quieter, sparer
arrangements focusing on single rocks and their metaphoric possi-
bilities. In *Far from Needham* (pl. 44), Wyeth portrayed a granite rock
he encountered in Maine that, according to Wanda Corn, reminded
him of his father's physical bulk and the swelling hills of Chadds
Ford where he had been killed.[96] Everything in the picture is symbolic
of N. C. Wyeth. Indeed, it was painted while Betsy Wyeth was editing
N. C.'s letters, undoubtedly stirring up old memories. The spruce tree
in the background alludes to N. C.'s love of the fragrance of spruces,
which reminded him of his childhood home in Needham, Massachu-
setts, and the title of the painting is the wistful reflection that N. C.
is buried far from there. The top of the rock appears lit from within,
echoing the portraiture convention of lighting foreheads to suggest
intellect, for Wyeth has a tendency to look at rocks and see people, or
parts of them.[97] Granite, so often used for funerary monuments and
markers, is the ideal material for immortalizing Wyeth's memories of
his father and asserting the timelessness of the old New England values
that his father had embraced.

*The Duel* (fig. 51) and its studies (figs. 52–54) are a culmination of
many of the issues of sentience, memory, and timelessness that Wyeth
had explored in earlier paintings of rocks. The painting depicts a
granite boulder on the beach, an oar carefully propped against its face.
As in his other paintings of rocks, this boulder glows as though lit
from within, illuminating the encrustation of barnacles that attest to
its longevity. Another oar, artfully placed in the background, lies half
in the water. The deliberate placement of the oars implies a recent
human presence, the title suggests a human struggle, and the whole
painting has a strangely animated quality. The more than forty-five
studies Wyeth made for *The Duel* reveal that the composition originally
included the image of Walt Anderson, a crusty old fisherman who had
been a childhood friend of Wyeth's, although the figure was painted
over in the final stage. "Sometimes, when I do a painting with people in
it," Wyeth says, "I have ultimately eliminated them, much to the horror
of those who pose for me, because I find really that it's unimportant
that they're there. If I can get beyond the subject to the object, then it
has a deeper meaning."[98] This process of erasing figures from the com-
position and relying on objects to tell the story is common in Wyeth's
art. As the figures gradually melt away, the objects themselves become
intensely real and almost human. Like the granite boulder, the self-
reliant, persevering Anderson embodies for Wyeth the spirit of old

New England. The weathered facades of both Anderson and the rock preserve marks from an earlier era, quietly recording a struggle between land and sea. Anticipating Anderson's death, Wyeth renders him already invisible, leaving the enduring rock as a memorial.

## Vessels

Often used as posthumous portraits of their owners, vessels function recurrently in Wyeth's work as symbols of mourning. *Tea for Two* (fig. 55), for instance, shows a cloth spread on the grass in the apple orchard that N. C. Wyeth had planted some eighty years earlier. Two empty teacups and a teapot from a set that had belonged to N.C. rest upon the cloth. The cups and saucers tilt precariously on the uneven ground, creating the sense that someone has just stood up and pulled the cloth, making the objects rock. The empty vessels in the apple orchard symbolize N.C.'s absence.[99] Since his father's death in 1945, vessels have served as mementos of the dead in Wyeth's art, preserving memories and symbolically keeping them alive.[100]

Eschewing things of more modern invention, Wyeth paints baskets, boats, houses, clothing, and wagons. In an increasingly mobile, throwaway culture defined by mass-media images, Wyeth's authentic objects from an earlier era have proved to be appealing and reassuring. Many midcentury American artists—Paul Strand, Charles Sheeler, Walker Evans, Edward Hopper—depicted the same types of vessels, using the same formal techniques. Wyeth took plain, well-worn, domestic things and transformed them into portraits of their often poor and dispossessed owners. The message of many of those works is metaphoric: the things, like their owners, withstand the blows of time.[101]

In his early paintings of buildings, Wyeth made his metaphoric meaning explicit by including figures. Gradually the figures disappeared and the metaphors became more elusive. *Charlie Ervine* (pl. 2) is an early, half-length portrait of a man whose chiseled face stares resolutely to the right. The threadbare condition of his cap and clothing is echoed in the dilapidated clapboard of the classic New England saltbox that sits on a rise behind him. Patches of the roof are worn, portions of the walls have been bleached by the sun, and the trim shows signs of peeling paint, yet the house, like Charlie Ervine, stands firmly on the Maine hillside, an emblem of fortitude. The composition recalls Paul Strand's photograph *Mr. Bennett, Vermont* (fig. 56), which uses a similar portrait format and cold, bleached light to depict a stereotypical New Englander. *Mr. Bennett, Vermont* was part of a series of photographs that Strand

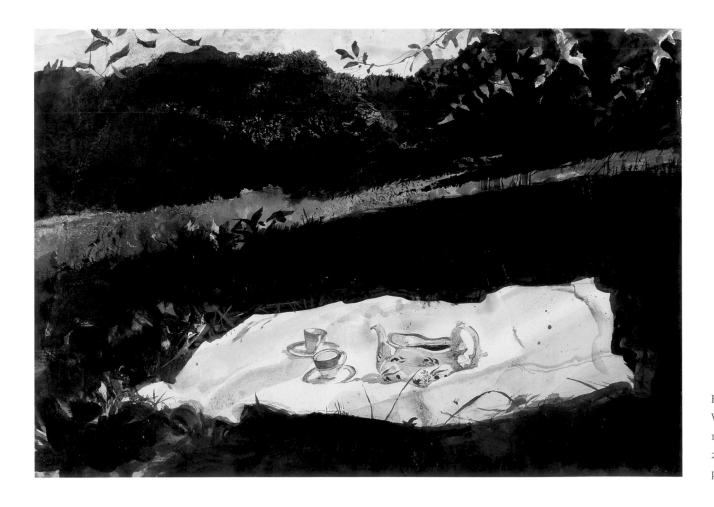

Fig. 55. Andrew Wyeth, *Tea for Two*, 1989, watercolor, 20½ × 29¾ inches, private collection.

took in Vermont and Maine in the mid-1940s and published in his book *Time in New England* of 1950. In his foreword, Strand describes how his photographs attempt to embody historic New England and its core values, which he believed helped shape the nation.[102] Wyeth also used the lone figure in front of a house—a pictorial convention of old New England—to express nineteenth-century values of self-reliance and independence.[103] His work, however, moves beyond the descriptive realism and political intent of Strand's as it becomes inflected with a deeply personal, psychological meaning.

As the artist gradually erased figures from his compositions, architectural structures were left to preserve a commingling of memories of New England and Wyeth's personal past. The subtext of many of his object-based paintings is the celebration of life that has endured adversity and a recognition of the inevitable decay that accompanies such perseverance. Consider the homestead of Christina and Alvaro Olson, the subject of many Wyeth paintings. Referring to *Weatherside* (pl. 43), Wyeth wrote that the Olson house was "like crackling skeletons rotting in the attic—dry bones. . . . The whole history of New England was in that house."[104] Like Edward Hopper's *House by an Inlet* (fig. 57), Wyeth's worn building set against a bleak backdrop underscores the stamina of New Englanders in the face of massive change.[105] Yet Hopper keeps the viewer outside: the opaque windows do not allow a glimpse into the house or offer a hint of its inhabitants. *Weatherside*, in contrast,

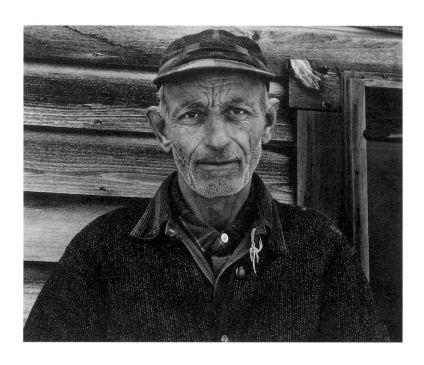

Fig. 56. Paul Strand (American, 1890–1976), *Mr. Bennett, Vermont*, 1944, gelatin silver print, 7¼ × 8¾ inches, Paul Strand Archive.

Fig. 57. Edward Hopper (American, 1882–1967), *House by an Inlet*, 1930, oil on canvas, 28 × 38 inches, Collection of Marie and Hugh Halff.

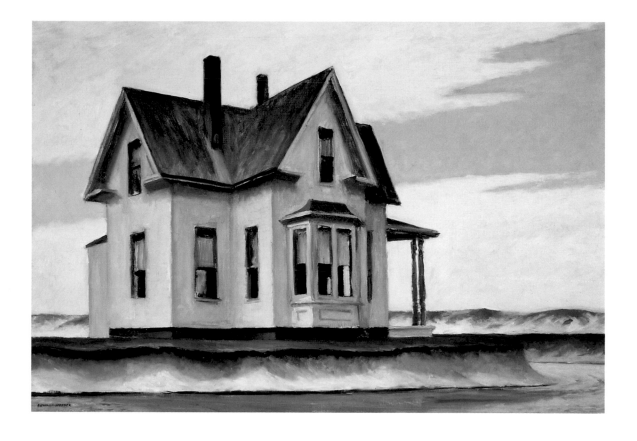

provides glimpses into the rooms, and the slightly canting bucket in the foreground suggests that someone has just set it down.

Wyeth likens houses to human bodies and delights in lending their facades an anthropomorphic quality. Painting the house in *Brown Swiss* (pl. 32), he said, was "like doing a person's face—so complex! It's like a double portrait, because of the reflections of the house in the pond."[106] Believing that buildings have personalities, Wyeth considers *Weatherside* a portrait of Christina and Alvaro Olson.[107] He once described how he had studied the pitch of the roof in the same way he had studied the curve of Christina's nose. The chimney became for him the "ear of the house" that carried Alvaro and Christina's conversation upstairs where he painted on the second floor. "To me, a picture will really contain those remembrances, those voices, those faces, those conversations."[108]

Because Wyeth is acutely aware of time passing, painting becomes a way to imaginatively still that process. Describing the urge to paint *Weatherside,* he wrote: "I had this feeling that it wouldn't be long before this fragile, crackling-dry, bony house disappeared. I'm very conscious of the ephemeral nature of the world. There are cycles. Things pass. They do not hold still. My father's death did that to me."[109] The sense that the house was dying ignited his desire to paint it and halt the passage of time. The house represents a continuum between the past and the present and an opportunity to preserve the relic in tempera, like a fossil.[110] Because the tempera process involves meticulous layering, he often compares it to building: "In my drawings, I literally put the building together as if I were the builder. . . . I actually counted and studied each of those clapboards."[111] In his studies for *Weatherside,* Wyeth included a flock of barn swallows, but he took them out of the final version because, he explained, "the birds made the picture too momentary to suit me."[112]

Wyeth often turns such mundane things as buckets and baskets into portraits of friends and neighbors. *Alvaro and Christina* (pl. 49), for example, depicts the contents of a room adjacent to the Olsons' kitchen, yet as its title implies, Wyeth considers it a double portrait:

> I painted it the summer after Christina and her brother, Alvaro, had both died. I went in there, and suddenly the contents of that room seemed to express those two people—the baskets, the buckets, and the beautiful blue door with all the bizarre scratches on it that the dog had made. The Olsons were all gone but powerfully there nonetheless.[113]

The dented metal bucket and tub and the worn, empty berry-basket immortalize and contain the spirits of his friends, and the scratched and scraped doors are their portraits.[114] Wyeth's doors are usually partly open but these are closed, perhaps to symbolize the finality of death and the end of a productive chapter in the artist's life. The

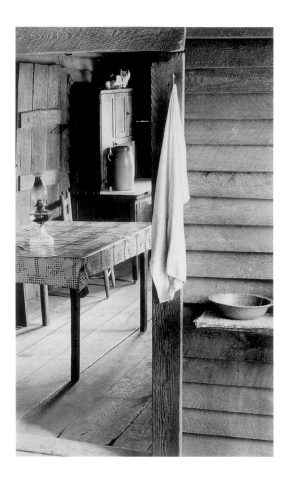

Fig. 58. Walker Evans (American, 1903–1975), *Burroughs Family Cabin, Hale County, Alabama,* 1936, gelatin silver print, 9 × 5½ inches, Photography Collection, Harry Ransom Humanities Research Center, The University of Texas at Austin.

photographer Walker Evans, who like Wyeth gravitated to the poor and dispossessed, also transformed run-down architectural interiors into portraits of their absent owners. In his photograph of the kitchen in the Burroughs cabin (fig. 58), for example, Evans used the same motifs that Wyeth had in *Alvaro and Christina* to reveal the lives of the house's inhabitants—doors, rags, and worn but serviceable vessels set in a perfectly still atmosphere.[115] Both artists elevated the old and the ordinary into icons of a lost past, but Evans's cool, analytic photograph emphasizes the textures and colors that keep the viewer on the surface of the image, while Wyeth's watercolor resonates with a host of highly personal and elusive meanings.

Although Wyeth's architectural images often represent views into the lives of their owners, many emerged directly from his fertile imagination. *Spring Fed* (pl. 48), for example, ostensibly depicts Karl Kuerner's farm and the activities associated with it—"the clang of the bucket, the crunch of hooves, the spilling of water."[116] Sound, of course, is a

powerful trigger of memory. Wyeth told his biographer that *Spring Fed* is about the death of his childhood literary hero, Robin Hood, an event he had often reenacted with his neighborhood friends. For Wyeth, the painting evokes the image of Robin Hood locked in the nunnery and laid out on a slab, bleeding to death. The water trickling from the trough is blood trickling down the stone; the hanging bucket is his helmet.[117] This fantastic subtext testifies to the multitude of musings, dreams, and associations that take place in the artist's mind as a picture materializes. Of the water in *Spring Fed*, Wyeth said: "The way it comes over the ledge of the great trough and runs down the side is timeless. It's like life itself, endlessly moving."[118] If the water represents life, it also suggests Robin Hood's slow death, the blood draining out of him, yet the frozen quality of the painting seems to still that running liquid. Perhaps this is Wyeth's way of visualizing timelessness and magically halting the death of a hero.[119]

Two related paintings, a watercolor and a tempera, demonstrate how Wyeth's choice of medium serves different purposes in his musings on death and immortality. Wyeth painted the watercolor *The German* (pl. 57) of Karl Kuerner in his machine-gunner uniform, when Kuerner was mortally ill. His battered but serviceable helmet contrasts with his pallid face; the translucent skin seems to dissolve into the coarse paper.[120] The German war veteran does not look at the viewer or the artist but seems lost in his memories, perhaps evoked by the military uniform.[121] Only his helmet appears physically substantial.

In *Pine Baron* (pl. 60), a tempera, Wyeth eliminates Kuerner's figure altogether to explore the imaginative possibilities of his helmet. "To me it expresses Karl's background, his experience in the Black Forest during the war."[122] Karl's wife used the sturdy metal helmet to collect pine cones; Wyeth uses it to collect and contain his own childhood memories of poring over his father's World War I artifacts, drawing battle scenes, and enacting skirmishes with his lead soldiers and neighborhood friends.[123] The gleaming helmet takes on a concreteness and specificity that is only suggested in the watercolor portrait. While *The German* captures Kuerner in the process of dying, *Pine Baron* immortalizes Wyeth's memories of the man, permanently fixed in tempera. Today, in Wyeth's studio, the helmet performs its symbolic function by containing some of Kuerner's ashes.

Boats are established metaphors for mortality in American art. Thomas Cole and Winslow Homer, for example, used them to suggest the vulnerability of life. In the pictorial mythology of old New England, the lone figure and lone dory represent endurance and individualism. Wyeth's early depictions of boats are part of those traditions, while his later works lend an idiosyncratic tone to the conventional symbolism. *Teels Island* (fig. 59), a posthumous portrait of its owner, is a classic Wyeth vessel image. "Henry Teel had a punt," Wyeth recalled, "and one day he hauled it up on the bank and went to the mainland and died. I was struck by the ephemeral nature of life when I saw the boat there just quietly going to pieces."[124] In the painting, the beached

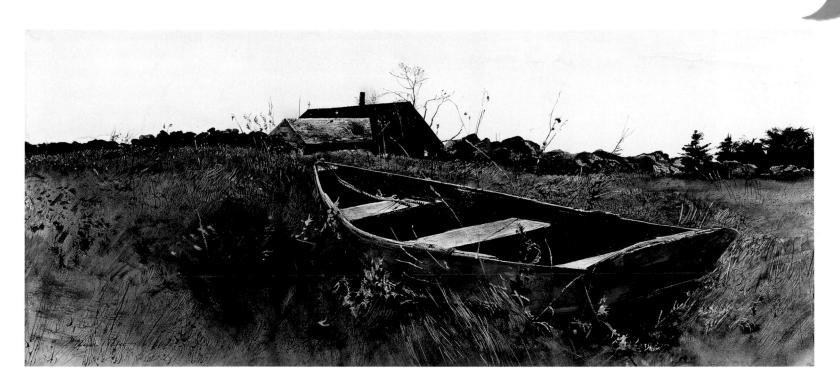

Fig. 59. Andrew Wyeth, *Teels Island*, 1954, drybrush on paper, 10 × 23 inches, private collection.

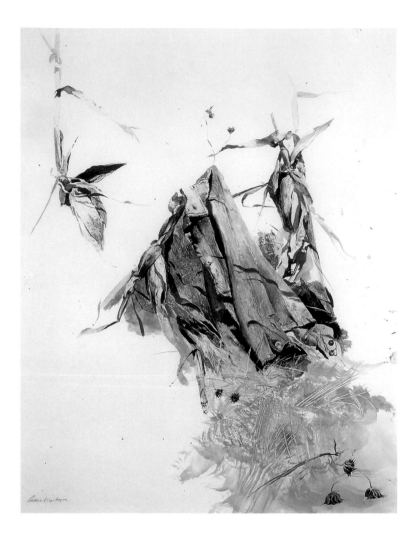

Fig. 60. Andrew Wyeth, *Blue Jacket*, 1954, drybrush on paper, 21½ × 17½ inches, private collection.

punt projects a sense of solidity and permanence that contrasts with the dry, brown beach-grasses surrounding it, which suggest decay. The deteriorating Olson house inspired a similar impulse, prompting Wyeth to rebuild it in tempera, board by board, to create a permanent *Weatherside.*

*Adrift* (pl. 71), painted in 1982, is a tempera that is dramatically different from Wyeth's earlier images of boats. In it, Walt Anderson—whom Wyeth had erased from *The Duel*—lies either dead or asleep in a dory that floats on a calm sea. The figure does nothing to animate the scene; indeed, the prone body deadens the pictorial atmosphere. When Wyeth painted *Adrift,* Anderson was dying, which may account for the work's funereal feeling. As Meryman observed, Anderson looks like a body floating out to sea in a Viking funeral, and his serene expression and gnarled hands gently folded over his abdomen suggest a corpse in an open casket.[125] The dory cradles the body, as if Wyeth

is attempting to preserve Anderson and his memories of him. *Adrift,* then, makes explicit the function of many of the empty vessels in Wyeth's oeuvre.

Walt Anderson had been the subject of several of Wyeth's early watercolors, a symbol of youth, passion, drama, and freedom.[126] But in *Adrift* Anderson lies completely still and assumes the pallor of death. This dichotomy between what Anderson once symbolized to Wyeth and his now-motionless body is expressed in the atmosphere of the ocean setting. The boat floats on stagnant water in a claustrophobic space that better evokes the inside of a coffin than the open sea. In such settings, Wyeth often refers to past paintings: the white line of salt spray in the background recalls the snowdrift that Karl Kuerner melts into in *Spring.* The sleeping or dead figure in a dream-like space, another recurrent motif in Wyeth's art, is almost always associated with his major themes of the vessel, the threshold, and the landscape.[127] Anderson's pallor contrasts with the bright white dory, which seems illuminated by a supernatural light. Pushed to the foreground, the details of the boat's manufacture are apparent—the overlapping layers of wood and the drill holes where it was put together—and Wyeth lavishes attention on the metal oarlocks in the middle ground. He has carefully rebuilt the dory in tempera, making it appear more concrete and permanent than the figure it contains. As the life force drains out of Anderson, it grows in equal proportion in the boat. As so often happens in Wyeth's art, objects appear to become animate in the presence of death.[128]

Wyeth frequently focuses on the details and textures of a person's clothing, which often appears more vivid than the models themselves.[129] In the 1950s, Wyeth began a series of paintings that focused on articles of clothing. Apart from depictions of shoes and boots that are reminiscent of works by Vincent van Gogh and Walker Evans, there is no apparent artistic precedent for Wyeth's depictions of jackets and shirts. Instead, these sartorial vessels provide an inventive solution to an artistic problem peculiar to Wyeth, who dislikes the distraction of models. Clothing mimics the shape of the human body, and having had close contact with a person, retains a sense of embodiment, which Wyeth exaggerates.

Like many of Wyeth's figures, articles of clothing often dissolve into the colors and textures of the landscape.[130] In *Blue Jacket* (fig. 60), a discarded coat becomes part of the cornstalk on which it hangs. While the cornstalk magically assumes the color of the jacket, the jacket takes on the earth tones of the cornstalk. In some works, a jacket draped over the back of a chair suggests a seated person (fig. 61) or coats hung beside windows and doors mimic the posture of standing figures (see pl. 67). He sometimes uses his wife's or neighbors' clothing as props, but he is particularly inspired by antique military uniforms.[131] The artist's preoccupation with vintage clothing began in childhood, when he and his friends would dress up in his father's costumes, becoming

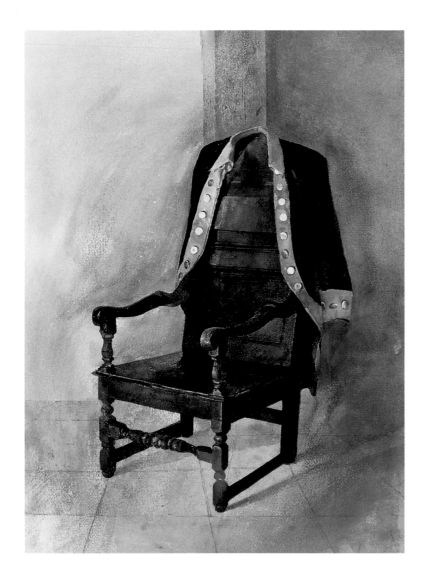

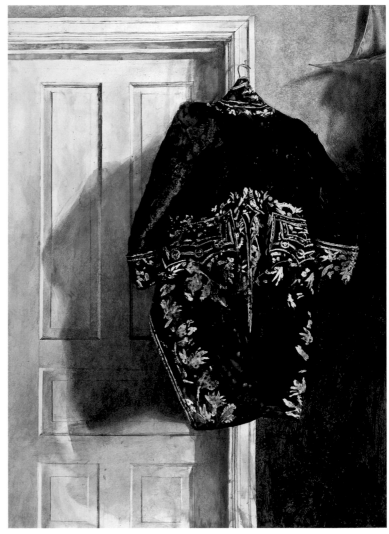

pirates, soldiers, knights, Robin Hood and his Merry Men, or the Three Musketeers. Even today, Wyeth keeps an extensive collection of antique clothing, much of it war-related.[132]

In *The Quaker* (pl. 56), two coats from Howard Pyle's collection hang on a mantelpiece in a darkened room with a single window.[133] The coattails seem to move slightly, suggesting a pair of standing figures engaged in conversation. Although Wyeth rarely portrays more than one person in a composition, clothing allows him to explore the possibility of multiple figures without having to manage models in the studio. Moreover, Wyeth delights in the craftsmanship of antique garments: light seems to flow from the cream-colored coat, illuminating the cloth-covered buttons, red silk stripes, and elaborate stitching. Wyeth gives life to these finely wrought vestments, symbolically reviving the dead as he carefully constructs the coats in paint.

In *French Connection* (fig. 62), an antique-style jacket hangs on a doorjamb, mimicking a standing figure.[134] The jacket, which flares

Fig. 61. Andrew Wyeth, *The General's Chair*, 1969, watercolor on paper, 30½ × 20⅞ inches, private collection.

Fig. 62. Andrew Wyeth, *French Connection*, 1980, watercolor on paper, 27 × 20½ inches, Courtesy of Frank E. Fowler.

at the waist as if stretched by an abundant stomach, reminded Wyeth of the Marquis de Lafayette:

> You know, he had soil from the Brandywine Valley put in his coffin in France. Notice up on the right side the sail of an American sloop of war. The painting is all about my strong feelings for the American Revolutionary War, the aura of which surrounds me here and which I feel from my constant wandering around these hills in the Brandywine Valley.[135]

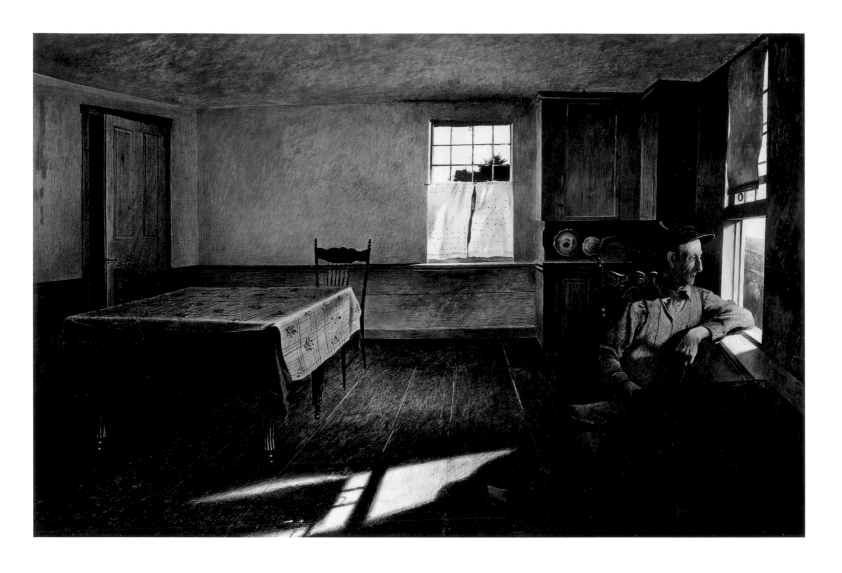

Fig. 63. Andrew Wyeth, *Henry Teel*, 1945, tempera on panel, 22¾ × 34½ inches, Cincinnati Art Museum, Bequest of Paul E. Geier, 1938.62.

Thus the vintage costumes in his paintings may vivify memories of the people, events, and places that the clothes once served. That many were owned by N. C. Wyeth and his teacher Howard Pyle gives Wyeth a further material connection to his own past. The entombing atmosphere of the paintings contains memories of war and of his father, while the thresholds provide an escape and a reminder of how easily memories slip away.

## Thresholds
Early in his career, Wyeth painted traditional views of eighteenth- and nineteenth-century interiors in which windows, doors, chairs, and tables were arranged in rational, orderly space (fig. 63). Gradually, he pared down his compositions to create spaces that held fewer objects of

heightened significance. He began to zoom in on thresholds, compressing space, playing with scale, and creating chambers in which windows and doors become the focus of attention. Another Philadelphia artist, Charles Sheeler, made the thresholds in pre-modern American homes the subject of paintings and photographs. Both artists delighted in the forms of American vernacular architecture and design, but in *The Upstairs* (fig. 64), the simple, abstract shapes of Sheeler's threshold keep the viewer insistently on the surface of the painting, while Wyeth's *Cooling Shed* (pl. 26) draws the viewer in, hinting that there is more to the shed than meets the eye. Wyeth's half-open windows and partially closed doors offer the possibility of change and transformation.

Memory is difficult to envision, but it can become tangible through metaphor. In western culture, rooms and buildings often represent the storage of memory. The ephemeral quality of memory can also be suggested by things that evoke process, instability, and transformation.[136] Wyeth's thresholds offer transitional views with rich metaphoric allusions to the transformations and dualities in his art and life, as well as

to his self-described creative process. Windows in particular recall the structure and shape of a panel and also suggest the process whereby objects from the external world trigger Wyeth's imagination. Such paintings emerge from an art-historical tradition that can be traced to Jan van Eyck, Johannes Vermeer, Caspar David Friedrich, and even Adolph Menzel, who used the liminal space of the window to explore imagination, spirituality and the metaphysical, longing and release.[137] Wyeth's art delves into all these issues but is distinguished by its strong voyeuristic quality and the sense of embodiment that suffuses the vacant interiors.

*Wind from the Sea* (pl. 20) is one of the first examples of Wyeth using a window as the subject of a painting. Wyeth once described the hot summer day when he walked into the stifling attic of the Olsons' house, which had "that special sort of dryness of dead flies that are left in a room that's been closed for years." He opened the window; a breeze blew in, raising the curtain crocheted with birds, and *Wind from the Sea* was conceived.[138] Wyeth's painting appears strangely animated, only partially because of the wind blowing life into the tattered curtain. There seems to be a living, breathing presence in the room. The little birds on the curtains—which may represent the artist's own yearning for freedom—seem to take flight as the wind blows in, and the extremely close perspective suggests the artist's physical proximity. Meryman considers this a portrait of Christina Olson, but it can also be read as a portrait of Wyeth himself.[139]

In *Wind from the Sea*, the vastness of the fields and the possibilities of the water in the distance contrast with the dark, enclosed interior, evoking the excitement Wyeth once felt in Maine. According to Meryman, Maine represented an "intoxicating freedom," both personally and artistically, in Wyeth's early years as a painter.[140] It was a place where he could free himself from his father's dominance, and where the weather, the ocean, and the countryside inflamed his imagination. The view of the Maine countryside seems, then, to express Wyeth's wilder side, the one that soars across the fields, letting his imagination run free. Painted in the year before *Christina's World*, *Wind from the Sea* suggests the artist's new confidence and conviction: he is hitting his stride.

In *Wind from the Sea*, the darkness of the interior contrasting with the bright rectangular view through the window recalls the experience of watching a movie in a darkened theater.[141] Wyeth's threshold images become increasingly voyeuristic, especially those in which the artist seems to be spying on his friends and neighbors. As a child, Wyeth was a notorious Peeping Tom; he once hid in a hamper to watch girls in the bathroom.[142] Telescopes and binoculars—implements of the dedicated voyeur—become the subject of many paintings, such as *Squall* (fig. 65), perhaps because the tunneled, close-up views they provide duplicate the focused perspective of his paintings.[143] Wyeth has always loved dressing up in costume and is delighted when costumes—masks, in

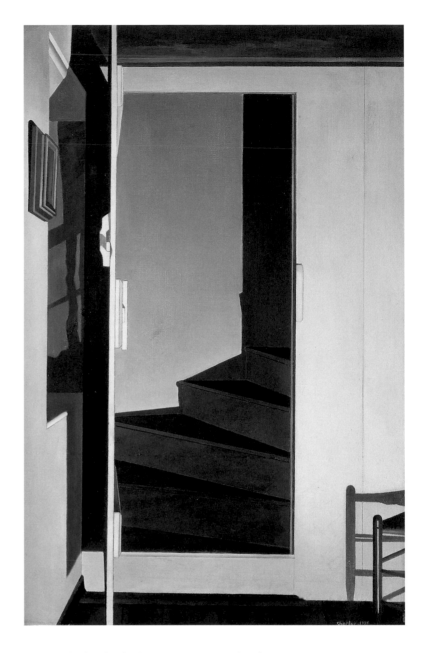

Fig. 64. Charles Sheeler (American, 1883–1965), *The Upstairs*, 1938, 19½ × 12¾ inches, oil on canvas, Cincinnati Art Museum, Fanny Bryce Lehmer Endowment, 1938.10557.

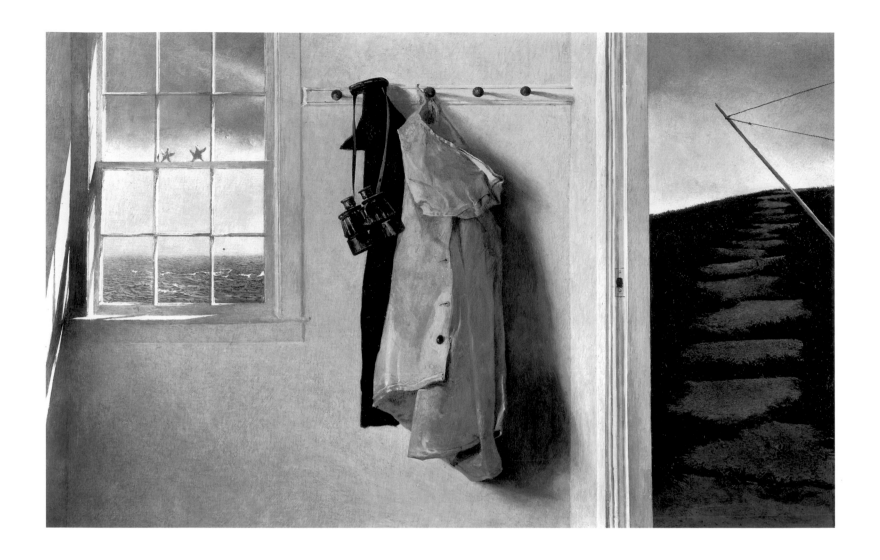

Fig. 65. Andrew Wyeth, *Squall*, 1986, tempera on panel, 17¾ × 28½ inches, private collection.

particular—render him unrecognizable. He compares his creative state to being in disguise, "inside, looking out, watching—and it's not me people are reacting to. I'm not there."[144]

When Wyeth juxtaposes figures and thresholds, the people he depicts appear unaware of the artist's presence, as they are lost in contemplation, absorbed in some activity, or sleeping. Wyeth associates the liminal spaces of thresholds with psychological states of thinking, imagining, and dreaming; the paintings become magical chambers where dreams are played out. In *Night Sleeper* (pl. 66), Wyeth depicts a dog sleeping below two windows at night. Outside, the moonlight has transformed the Mill, a building on the Wyeth property in Chadds Ford, into something surreal, or dreamlike. *Overflow* (fig. 66) and *Day Dream* (pl. 68), which depict the nude Helga lying on a bed in front of a window, explore the intersection of desire, sleep, and dreams. The window, which suggests boundaries that cannot always be crossed with impunity, intensifies the illicit potential of these paintings of sleeping nudes.

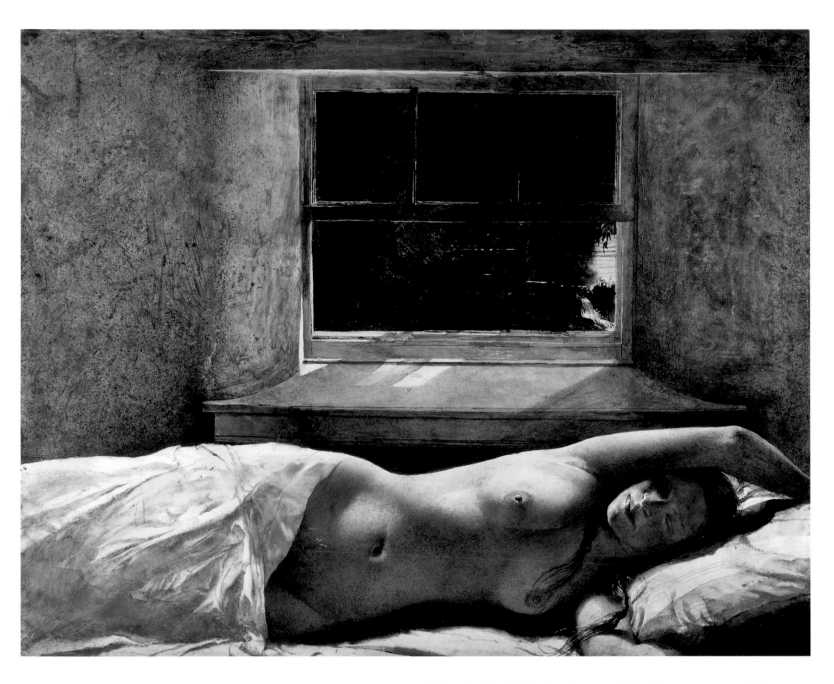

Fig. 66. Andrew Wyeth, *Overflow*, 1978, drybrush on paper, 23 × 29 inches, private collection.

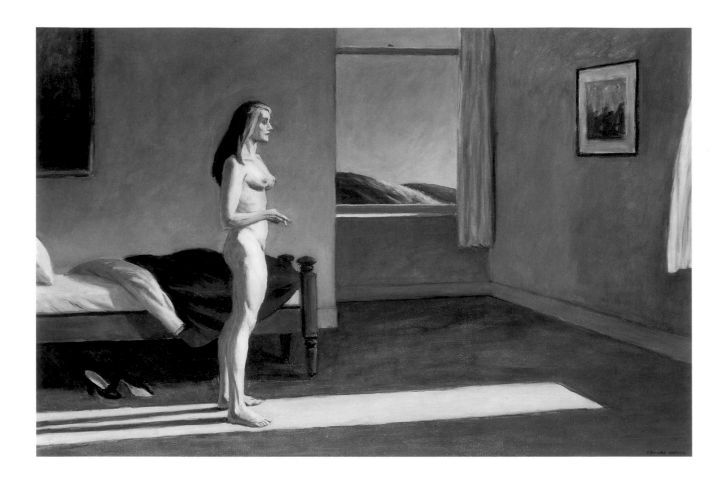

Fig. 67. Edward Hopper (American, 1882–1967), *Woman in the Sun,* 1961, oil on canvas, 40⅛ × 61¼ inches, Whitney Museum of American Art, New York, 50th Anniversary Gift of Mr. and Mrs. Albert Hackett in honor of Edith and Lloyd Goodrich, 84.31.

Wyeth's imagery may have been inspired by Edward Hopper's voyeuristic views of lone figures lost in thought and seen through or beside windows (fig. 67). Hopper is one of the few artists whose influence Wyeth acknowledges. Both gravitated to old houses and empty interiors, and both created frozen, haunting settings with a sense of suspended drama and nostalgia.[145] But as we have seen, Wyeth's windows give glimpses into the lives of his figures, while Hopper's are often dark or boarded up, pushing the viewer away. Moreover, the faces of Hopper's figures are often obscured, making them psychologically distant, while Wyeth's close-up views are persistent reminders of the artist's proximity.

In the late work *Marriage* (pl. 77), Wyeth returns to the theme of the prone figure in bed. The painting was conceived early one morning, when Wyeth walked through his neighbors' house and found them asleep. He focuses on the aged couple's pale heads pressed into white pillows. Beside the bed, an open window offers the only possibility of escape. It is almost dawn, but it is not clear that the figures are going to wake up. The detailed smocking and delicate design on the pink coverlet contrast sharply with the pallor of the figures, making the bed, like the one in *Garret Room* (pl. 39), seem more alive than the figures. To Wyeth, beds also can recall sickness and death. *Chambered Nautilus* (pl. 31), for instance, pictures Betsy Wyeth's dying mother, Elizabeth James, in bed and looking out of a window. The bed, sheets, sewing basket, and particularly the nautilus shell assume a solidity lacking in the figure of Bess, whose life force, Wyeth explained, was slipping out the window.[146] Are the life forces of the aged figures in *Marriage* also in danger of slipping out the open window? Does the window represent the transition from this world to the next, from life to death?

*Ship's Door* (fig. 68) is another late autobiographical work that may reflect Wyeth's frustration with the physical infirmities of old age. For Wyeth, the sailboat was an emblem of psychic potency, but here it is immobilized behind glass. This is not a functioning window for Wyeth's voyeuristic eye: this window permanently encloses Wyeth's symbol of freedom. The binoculars on the wall no longer facilitate his roving eye. The caged birds and the stairway leading to a closed trap-door are further emblems of confinement, and the flat light suggests a

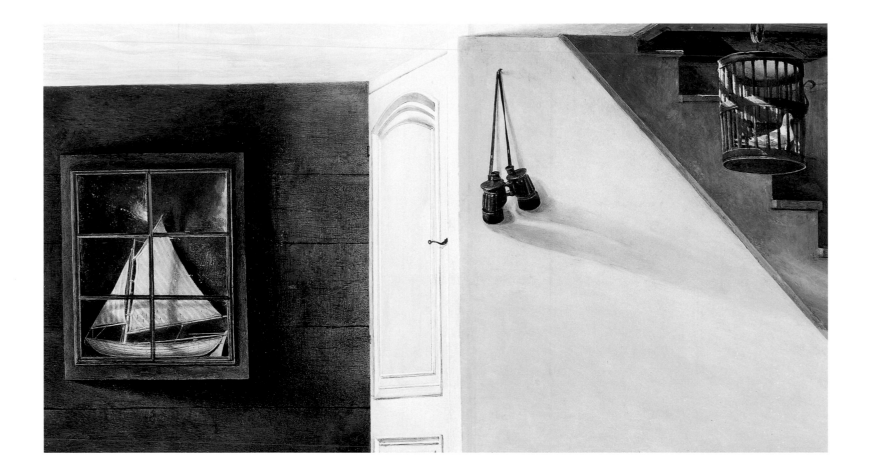

suffocating atmosphere. In *Ship's Door,* Wyeth employs his favorite motifs to express the feelings of stagnation and confinement that accompany old age.

*Renfield* (pl. 82) addresses the same concerns, showing a bare interior with worn wood floors and three tightly shut windows. Dead flies scattered on the floor and windowsills suggest a disquieting sense of isolation from the vast twilight sky and traffic beyond the windows. Wyeth spoke of dead flies evoking the stifling heat of the Olsons' attic where *Wind from the Sea* was conceived. A comparison of the paintings illuminates the changing symbolism of the window in Wyeth's work. *Wind from the Sea,* painted when Wyeth's career was rapidly ascending, uses light, wind, and fabric entering an open window to resurrect a room that had been "dead" for decades. Over the years, the threshold became the transition point where many of these rebirths occurred, but in Wyeth's later works, windows are often slammed shut, with no breeze to breathe life into the scene. *Renfield,* painted fifty years after *Wind from the Sea,* in the twilight of Wyeth's life, contemplates the inevitability of death. Like the dead insects, the octogenarian artist can no longer fly away. The claustrophobic room becomes a metaphor for his deteriorating body, which traps him in immobility. The room itself is the cupola of the house formerly owned by Howard Pyle, where N. C. Wyeth had

Fig. 68. Andrew Wyeth, *Ship's Door,* 1992, tempera on paper, 25⅝ × 45⅞ inches, Collection of Andrew and Betsy Wyeth.

spent many hours. Wyeth produced numerous temperas and watercolors depicting this particular room, with its 360-degree view that suggests the all-seeing, disembodied eye that Wyeth tries to become when painting. While the view in *Wind from the Sea* is onto a vast field with the promise of the ocean beyond, the view in *Renfield* is onto a line of traffic on Route 1 in Chadds Ford. That rush of modernity—one of the first times Wyeth admits contemporary life into his timeless world—makes a startling contrast with the abandoned interior, unchanged since it was built over a hundred years earlier, when N. C. was honing his craft under Pyle's tutelage. Is this worn-down, dried-up room from another era a metaphor for Wyeth himself, watching the powerful forces of modern life surge by?

As *Renfield* suggests, Wyeth imaginatively inhabits his painted interiors. The close perspective goes beyond implying the artist's presence to produce the sense that he has actually become the room, that the windows are the eyes through which he sees the world. Many of Wyeth's interiors feature a pair of windows that suggest eyes, as in

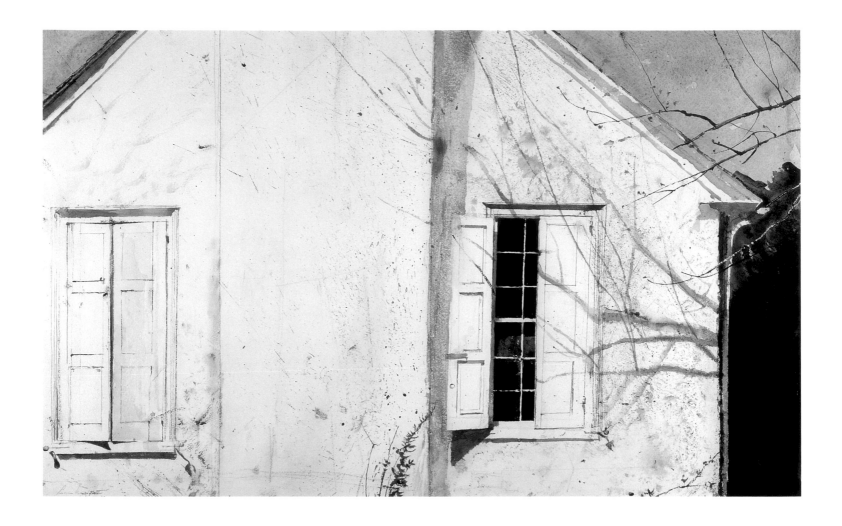

Fig. 69. Andrew Wyeth, *Open Shutter, Study for My Studio*, 1974, watercolor on paper, 19 × 30 inches, Collection of Andrew and Betsy Wyeth.

*Her Room* (pl. 40).[147] *Open Shutter* (fig. 69) shows the side of Wyeth's studio with one window shuttered and one not, suggesting a winking self-portrait. In the campy *Dr. Syn* (pl. 70), based on a full-body x-ray of the artist, Wyeth even drops clues to reading his interiors as self-portraits. A skeleton dressed in an antique naval jacket sits on a stool in the bell tower of a lighthouse.[148] The room is filled with reflections, as if it is underwater. Is Wyeth imagining a watery grave? The skeleton is aligned with the windows in such a way that each eye corresponds to a window, making the room a metaphor for the body.[149] The sense of animation in these empty interiors comes from the ghostly presence of the artist himself.

Thresholds allow Wyeth to control the degree to which the outside world enters his interior realms. These openings metaphorically evoke the way the intensely private Wyeths regulate who and what is permitted into their protected world. In 2002, Wyeth produced *Otherworld* (pl. 85), a painting that contains a startlingly contemporary element along with thresholds, vessels, and landscape elements—a compendium of the major motifs and tensions in the artist's oeuvre. Originally titled *Betsy's World* by Andrew, but changed to *Otherworld*

by Betsy, it portrays the inside of the corporate jet (a vessel, an airship) that used to ferry the Wyeths to and from Maine and Pennsylvania. Betsy Wyeth peers through a window overlooking their home in Chadds Ford; another window overlooks their home on Benner Island. She sits in a comfortable leather seat before a highly polished table, in a spare, monochromatic interior that reflects her carefully arranged world.

To paint this picture, with its cropped composition and elevated perspective, Wyeth would have had to assume an impossible vantage point, pinned to the rounded ceiling. He has imaginatively become one with the plane, transforming himself into a magnificent bird like the one he pictured in his first aerial image, *Soaring* (pl. 11).[150] Here, as an omniscient bird of prey, he surveys his domain and contains his wife, who has both nourished and curtailed his creative freedom for almost seventy years. Yet even as Wyeth soars, he is confined: the interior of the plane, a miniature of Betsy Wyeth's orderly world, remains compressed and claustrophobic, its windows as impenetrable as the plates of glass in *Ship's Door*. In *Renfield*, Wyeth watched as modernity passed him by. In *Otherworld*, he gives up and gives in, becoming one with a powerful vessel of modern technology. The title suggests that the work bears another meaning—that in *Otherworld* the Wyeths are not flying between Pennsylvania and Maine but are en route to another destination altogether. The views from the windows are hazy, as if their earthbound homes are becoming distant memories as the magical plane propels them into the future—a world the artist has often contemplated, but could never fully envision.

## Notes

I would like to thank Wanda Corn, Kelly Morris, Lori Cavagnaro, Kathy Foster, and Sylvia Yount for their thoughtful comments on earlier drafts of this essay. I am especially grateful to Linda Merrill whose editorial suggestions strengthened my arguments and never failed to speed them along.

1. "Finally, if a painting is good, it will be mostly memory." Andrew Wyeth, in Andrew Snell, director, *The World of Andrew Wyeth*, videocassette (London: Home Vision, 1980).

   Much of the literature on Andrew Wyeth is dominated by interviews with the artist. A close examination of this body of work reveals that Wyeth sometimes contradicts himself. In order to avoid these conflicting comments, I have tried to include only those quotations that the artist has repeated over the course of his career. Also, when discussing a picture, I have tried to use quotations given within ten years of the making of the work.

2. Wanda M. Corn, "Andrew Wyeth: The Man, His Art, and His Audience" (Ph.D. diss., New York University, 1974), pp. 136–138.

3. Many nineteenth- and twentieth-century artists took liberties with the conventions and definitions of still life, and Wyeth is no exception. Like Georgia O'Keeffe, Wyeth weds certain still-life conventions to landscape painting.

4. Modern-day mourning practices often include placing photographs on the grave to preserve an image of the deceased. Elizabeth Hallam and Jenny Hockey, *Death, Memory, and Material Culture* (Oxford: Berg, 2001), pp. 72, 75, and 147–159.

5. Quoted in Richard Meryman, "Andrew Wyeth: An Interview," in Wanda M. Corn, *The Art of Andrew Wyeth* (Greenwich, Conn.: Published for the Fine Arts Museums of San Francisco by the New York Graphic Society, 1973), pp. 45 and 47.

6. Corn, "Andrew Wyeth," pp. 123, 125–126, and 131; Richard Meryman, *Andrew Wyeth* (New York: Abrams, 1991), pp. 50 and 52.

7. Quoted in Meryman, *Andrew Wyeth*, p. 25.

8. Susan Stewart, *On Longing: Narratives of the Miniature, the Gigantic, the Souvenir, the Collection* (Durham, N.C.: Duke University Press, 1993), p. 140.

9. Corn, "Andrew Wyeth," pp. 134–135.

10. Corn was the first to note the ubiquity of these formal characteristics in Wyeth's work, arguing that Wyeth does not depict "a physical universe" but rather "a psychic one." Ibid., pp. 139–141 and 168–170.

11. I take the term "magic realism" from *American Realists and Magic Realists*, an exhibition Wyeth participated in at the Museum of Modern Art in 1943. Critics used the term to describe works by many of the realist artists who participated in the show. Wyeth often uses the word "magic" when describing his art making. See ibid., p. 128.

12. Quoted in Corn, "Andrew Wyeth," p. 65; Richard Meryman, *Andrew Wyeth: A Secret Life* (New York: HarperCollins, 1996), pp. 7, 9, and 20.

13. Andrew Wyeth, *Andrew Wyeth: Autobiography*, ed. Thomas Hoving (Boston: Little, Brown; Kansas City, Mo.: Nelson-Atkins Museum of Art, 1995), p. 126.

14. Wyeth also compared Henry Teel's gray coloring and weathered face to the "barnacle-covered granite ledges" of Teels Island. Meryman, *Secret Life*, p. 128. I saw *Teels Island* in May 2004 at the offices of Guggenheim Asher and Associates, New York, the firm that represents the owner. I noticed a pentimento beside the boat suggesting that a seated figure had originally been there but had been erased. I asked Mary Landa, manager of Andrew Wyeth's collection in the Wyeth Office at the Brandywine River Museum, about this, who in turn asked Wyeth himself. Together they viewed a color transparency of the painting. Wyeth could see how the pentimento looked like the ghost of a figure but does not remember painting one in and then out again. Mary Landa, telephone conversation with author, May 5, 2004. Meryman also writes that *Spindrift* (1950)—a tempera of an empty dory—is essentially a full-length portrait of its owner, Henry Teel. Ibid., pp. 128–129.

15. Quoted in Meryman, *Secret Life*, p. 56.

16. Quoted in ibid., p. 55.

17. Quoted in Meryman, *Andrew Wyeth*, p. 59.

18. Quoted in Meryman, *Secret Life*, p. 59.

19. Ibid., pp. 54 and 62–65.

20. Corn, "Andrew Wyeth," pp. 62–63.

21. Meryman, *Secret Life*, p. 48. For other discussions of N. C. Wyeth and the transcendentalists, see Corn, "Andrew Wyeth," pp. 66–68; and N. C. Wyeth, *The Wyeths: The Letters of N. C. Wyeth, 1901–1945*, ed. Betsy James Wyeth (Boston: Gambit, 1971). N.C. wrote that Thoreau "is my springhead for almost every move I can make, except in the intimate matters that transpire between a man and a woman. Here he is utterly deficient, as is Christ, on account of his lack of experience." David Michaelis, *N. C. Wyeth: A Biography* (New York: Knopf, 1998), p. 226.

22. Andrew Wyeth was born on the hundredth anniversary of Thoreau's birth, and in the 1930s he produced illustrations for a selection from Thoreau's *Journals*. Michaelis, *N. C. Wyeth*, p. 390; Meryman, *Secret Life*, p. 108.

23. Corn, "Andrew Wyeth," p. 72.

24. N. C. Wyeth, *Wyeths*, p. 205.

25. Quoted in Corn, "Andrew Wyeth," p. 72.

26. Quoted in Thomas Hoving, *Two Worlds of Andrew Wyeth: A Conversation with Andrew Wyeth* (New York: Metropolitan Museum of Art, 1976), p. 23.

27. Meryman, *Secret Life*, p. 23. One example of N.C.'s control over his son's career occurred when Andrew was offered his first solo show in New York in 1937. N. C. Wyeth, acting as his business manager (as Betsy Wyeth would later do) took on all the logistical details of the show, while Andrew happily painted in Maine. N.C. supervised the mounting, matting, and framing of the works; he drew up the guest list, wrote the foreword to the catalogue, and even (as Betsy Wyeth also would do) titled Wyeth's works. Andrew kept his own schedule, completely immersed in the life of painting. He had no calendar, checkbook, or address book, content to let others take care of these matters for him. Michaelis, *N. C. Wyeth*, p. 335.

28. Meryman, *Secret Life*, p. 23.

29. A couple of weeks before Andrew and Betsy Wyeth wed, Wyeth wrote to Betsy's parents that if Betsy were to return to Colby College in the fall, she would be made student-body president, a high honor. But Betsy wanted nothing of that, he said: her aim in life "was to build my work as high as possible and to give me the rich life I need to build." Quoted in Meryman, *Secret Life*, p. 157. Indeed, in eight years' time, Wyeth would be well on his way to becoming an American icon.

30. Ibid., pp. 321–322. In the early 1940s, Betsy Wyeth urged Andy to get rid of "all this corny color." "I brought white into his life, the snow," she said. Ibid., p. 162.

31. Ibid., pp. 160–166.

32. Betsy Wyeth's titles suggest a specific interpretive gloss to many of her husband's works. Sometimes the titles aid in interpreting otherwise inscrutable paintings; at other times her titles (particularly from 1990 on) limit the range of possible meanings.

33. Meryman, *Secret Life*, pp. 160–161 and 328–330.

34. Corn was the first to note these similarities: see Corn, "Andrew Wyeth," pp. 42–49.

35. Ibid., pp. 42–45.

36. Roger B. Stein, "After the War: Constructing a Rural Past," pp. 18 and 22–23; and William H. Truettner, "Small Town America," pp. 112, 115, and 120–121, in William H. Truettner and Roger B. Stein, eds., *Picturing Old New England: Image and Memory* (Washington, D.C.: National Museum of American Art, Smithsonian Institution; New Haven: Yale University Press, 1989).

37. Wyeth said, "I loved the works of Winslow Homer, his watercolors, which I studied intently so I could assimilate his various watercolor techniques." Quoted in Hoving, *Two Worlds*, p. 15.

38. Corn, "Andrew Wyeth," p. 76.

39. Bruce Robertson, "Perils of the Sea," in Truettner and Stein, *Picturing Old New England*, p. 143.

40. Even though Wyeth's *Maine Fisherman* precedes his father's *Deep Cove Lobster Man*, there are many examples of N.C.'s paintings preceding similar ones by his son. Compare, for example, N. C. Wyeth's *Island Funeral* (1939) and Andrew Wyeth's *Little Caldwell's Island* (1940, pl. 6).

41. Quoted in Hoving, *Two Worlds*, p. 33.

42. Brian O'Doherty, "A Visit to Wyeth Country," in Corn, *Art of Andrew Wyeth*, p. 40.

43. Wyeth, *Autobiography*, p. 124.

44. This same argument can be made about many of Wyeth's drybrush watercolors because they are remarkably similar in style and feeling to his temperas. To achieve his drybrush technique, Wyeth squeezes excess watercolor from his brush and applies it as a virtually dry pigment, creating the magically real, finely layered permanence of his temperas. Some of his watercolors contain drybrush passages.

45. Wanda Corn, "The Art of Andrew Wyeth" in Corn, *Art of Andrew Wyeth*, p. 104. Midcentury American artists who used tempera and may have influenced Wyeth include Thomas Hart Benton, Reginald Marsh, Ben Shahn, and Charles Sheeler. Tempera is a popular, durable, quick-drying medium for mural studies: see Richard J. Boyle, Hilton Brown, and Richard Newman, *Milk and Eggs: The American Revival of Tempera Painting* (Chadds Ford, Pa.: Brandywine River Museum; Seattle: University of Washington Press, 2002), pp. 15–84, for a complete discussion of the people, institutions, ideas, and events that fostered this revival.

46. Quoted in Hoving, *Two Worlds*, p. 34. Betsy Wyeth explained to Meryman that "tempera is the medium for suppression, like a New England church compared to a European cathedral: He's said that the Pilgrims were just as violent in their appreciation of God as the people who worship in a cathedral, but the passions were contained within the structure of a very simple building." Meryman, *Secret Life*, p. 119.

47. Hallam and Hockey, *Death, Memory*, pp. 30, 118, and 166.

48. Wyeth's shift to more monochromatic colors in the late 1940s derives in part from his wife's influence as well as from a broader chromophobia that has lurked in western culture since antiquity. See David Batchelor, *Chromophobia* (London: Reaktion Books, 2000).

49. John Wilmerding, *Andrew Wyeth: The Helga Pictures* (New York: Abrams, 1987), p. 13.

50. Quoted in Meryman, "Interview," in Corn, *Art of Andrew Wyeth*, p. 72.

51. Quoted in ibid.

52. Corn, "Andrew Wyeth," p. 176.

53. Betsy Wyeth gave her husband the French cavalier boots he wears in *Trodden Weed*. They had originally belonged to Howard Pyle. N. C. Wyeth had also used them as props in his paintings.

54. Hoving, *Two Worlds*, p. 33.

55. When Wyeth was thirteen, N. C. Wyeth gave him a facsimile publication of Dürer's watercolors, drybrush paintings, and prints. Wyeth described how over the course of his life he has turned the leaves of the book so many times that they are now worn down. Hoving, *Two Worlds*, p. 17. Even today, he pores over the book. Mary Landa, telephone conversation with the author, December 2003.

56. The boots assume the color and texture of the brown grass, symbolizing Wyeth's intent to become one with nature as he roams the fields in search of subject matter. Indeed, *Trodden Weed* was painted once Wyeth had recovered enough to wander in

nature, one of his favorite things to do: he has likened it to being an animal stalking nature, Corn, "Andrew Wyeth," pp. 65–66. This invisibility, being one with nature, is transcendentalist in origin, evocative of Ralph Waldo Emerson: "Standing on the bare ground, my head bathed by the blithe air, and uplifted into infinite space, all mean egotism vanishes. I become a transparent eye-ball. I am nothing. I see all. The currents of the Universal Being circulate through me." Emerson, *The Complete Works of Ralph Waldo Emerson: Essays, Second Series* (Boston: Houghton Mifflin, 1903), vol. 1, p. 10, quoted in Priscilla Paton, *Abandoned New England: Landscape in the Works of Homer, Frost, Hopper, Wyeth, and Bishop* (Hanover, N.H.: University Press of New England, 2003), p. 145. N. C. Wyeth was influenced by Emerson and probably passed this philosophy on to his son.

57. This painting was inspired by a cold winter in 1994, when the Brandywine River froze and spring brought broken-up ice floes. While looking out at the ice floes from his mill house window, on whose ledge sit the bronze casts of his hands, Wyeth combined the indoor and outdoor views into one. Martha Severens, *Andrew Wyeth: America's Painter* (New York: Hudson Hills for the Greenville County Museum of Art, S.C., 1996), p. 39.

58. Sources for these disembodied hands include the hands emerging from the water in Howard Pyle's illustration *The Boat and I Went By Him in a Rush* from *Sinbad* (1902). See also the armless hand in Pyle's 1938 pen-and-ink illustrations for *The Red Keep.* Joyce Hill Stoner, *A Closer Look: Howard Pyle, N. C. Wyeth, Andrew Wyeth, and Jamie Wyeth* (Wilmington: Delaware Art Museum, 1998), p. 22.

59. Mary Landa and Betsy Wyeth have pointed out that the spruce standing over the pool in the background of *The Carry* is reminiscent of *Witches Broom* (fig. 48), and that the flattened half-moon shapes directly underneath the tree are evocative of the floating eyes in that same painting. By embodying the annually regenerative forms of the landscape, Wyeth magically assures his own immortality. Betsy James Wyeth and Mary Landa, interview with the author, Chadds Ford, Pennsylvania, January 2, 2004.

60. As told by Wyeth to John Wilmerding, who told the author in a phone conversation on February 4, 2004.

61. Henriette Wyeth described her brother's painted objects as "things that the sun, the weather shine on and hurt and tear to pieces and sliver, and they endure and death comes to them. The Wyeths are so concerned with death. But of course we're concerned with death because that's the whole drama of being alive for a while. Death is with us." Quoted in Meryman, *Secret Life*, p. 291.

62. Hallam and Hockey, *Death, Memory*, pp. 47–76.

63. Alexander Nemerov, *The Body of Raphaelle Peale: Still Life and Selfhood, 1812–1824* (Berkeley: University of California Press, 2001), p. 2.

64. A. Wyeth, *Autobiography*, p. 22.

65. N. C. Wyeth schooled his children to develop, hone, and inflame their imaginations, using nature as the starting point and focusing on the power of observation. He frequently organized family excursions and hikes. Wyeth's sister described an early spring hike to find the first spring beauties as "the search for the Holy Grail. . . . The small stars were like the Virgin Mary as far as we were concerned." Meryman, *Secret Life*, p. 49. Wyeth frequently painted spring beauties over the course of his career. Indeed, there is a strong spiritual feeling in Wyeth's painted reveries on nature.

66. Nemerov's *Body of Raphaelle Peale* introduced me to the concept of hovering as an element of embodiment and animation in a still life: see chapter 2, "*Blackberries* and Embodiment," pp. 27–40.

67. See also *Moon Madness* (1982, fig. 10) and *Man and the Moon* (1990).

68. Another still life in the landscape that features the life and death duality is *Sunflowers* (1982). In the watercolor, five sunflowers are seen at close range in front of the open window of a white clapboard building. The round seed head of the largest flower, in the middle, resembles a face unabashedly staring at the viewer. The other flowers twist and turn as if tired and impatient with the whole idea of a family portrait. Their torn and

tattered quality suggests that they are in various stages of decay—that they have reached their peak and are sliding into oblivion.

69. Wyeth's paintings often echo earlier works, and the elongated patch of snow in the middle ground of *Long Limb* recalls the mound of snow that half buries Karl Kuerner in *Spring* (pl. 65). It is possible, therefore, that, for Wyeth, Kuerner haunts *Long Limb.*

70. Other images of birds and windows include *Untitled (#2748)* (1984), *Christmas Wreath* (1958), *Canada* (1974), *Blowing Leaves* (1980, fig. 36), *Swifts* (1991), and *Belfry* (1978). In a 2003 article in *American Arts* that underscores Wyeth's preoccupation with dead birds, the interviewer describes how she encountered the cadaver of a laughing gull that had been placed on the hip-height silver-gray stump of a tree, as if the bird were an offering and the stump an altar. Susanne Klingenstein, "On the Edge: A Visit with Andrew Wyeth," *American Arts* 20 (Spring 2003): 10–18.

71. See for example *747* (1980) and *Otherworld* (2002, pl. 85).

72. Mary Landa, telephone conversation with author, January 28, 2004.

73. Michaelis, *N. C. Wyeth*, p. 428; also quoted in Corn, "Andrew Wyeth," p. 95. See Richard Meryman, "Andrew Wyeth: An Interview," *Life* 58 (May 14, 1965): 110, for a similar statement.

74. Meryman, *Andrew Wyeth*, p. 89. Other works that covertly refer to Wyeth's father include an image of Helga sleeping, *Night Shadow* (1978), that reminded Andrew of seeing his dead father in the casket thirty-four years earlier. See Stoner, *Closer Look*, p. 92.

75. Quoted in Corn, *Art of Andrew Wyeth*, p. 58.

76. Corn, "Andrew Wyeth," p. 96; and Michaelis, *N. C. Wyeth*, p. 428.

77. In American art, the image of the child has often become a symbol of freedom from small-town existence. Milton Brown, *American Painting: From the Armory Show to the Depression* (Princeton, N.J.: Princeton University Press, 1970), p. 176.

78. Wilmerding also compares this running figure to those in Howard Pyle's and N. C. Wyeth's work. Wilmerding, *Helga Pictures*, p. 22.

79. Corn, "Andrew Wyeth," p. 98.

80. Meryman, *Secret Life*, p. 144.

81. Ibid., pp. 11–12; quoted in Hoving, *Two Worlds*, p. 150.

82. Christopher Crosman, "Christina's World" (lecture manuscript, 2004).

83. Meryman, *Secret Life*, p. 18. In the same interview Wyeth described how he is usually alone with his temperas for hours on end, and how he seems to live within his pictures. Wyeth recently mentioned an intense interest in witchcraft and Christina's shoes as he was painting *Christina's World*; according to Mary Landa in a telephone conversation with the author, February 17, 2004. Christina's shoes were inspired by a German shoe that Betsy found in the chimney of an abandoned colonial house. Ibid., p. 20.

84. Crosman, "Christina's World."

85. Quoted in Meryman, *Secret Life*, p. 15.

86. A. Wyeth, *Autobiography*, p. 116.

87. Some of Wyeth's images of women in the landscape suggest an engagement with an older tradition that associates the sensual side of women with lush uncultivated nature.

88. In *Snow Hill*, Wyeth's favored models—most of whom were dead when this was painted—dance around a winter maypole with ribbons attached to it. A little pine tree sits at the top of the pole, as if the models are worshipping it. Does this tree, this giver of life, symbolically bring these people back to life?

89. Laura Rival, ed., *The Social Life of Trees: Anthropological Perspectives on Tree Symbolism* (Oxford: Berg, 1998), pp. 3 and 23–25; and David Fontana, *The Secret Life of Symbols: A Visual Key To Symbols and Their Meanings* (London: Duncan Baird, 1993), p. 100.

90. Meryman, *Secret Life*, p. 329.

91. Wilmerding, *Helga Pictures*, pp. 13–15.

92. Meryman, *Secret Life*, pp. 363–364.

93. In recent years, trees have resurfaced as a major preoccupation: see *Walking Stick* (pl. 84) for another example of a sentient tree.

94. Robertson, "Perils of the Sea," p. 143.

95. Quoted in Meryman, "Interview," in Corn, *Art of Andrew Wyeth*, p. 60.

96. Corn, "Andrew Wyeth," p. 134.

97. Wyeth's tendency to free associate and connect things and people, past and present, is legendary. Of *Rock Island* (1975), for example, an image of a rock in a calm pool of water, Wyeth said, "When the tide is out and that rock is out of the water it looks like a huge animal's head. See the strange eye there? This rock appears only at low water; when the tide is in it is completely submerged. When the barnacles and the blue mussels dry out it looks like one of those Russian fur crowns with the fur and the gold and the diamonds—the ones you see in the Kremlin Museum." A. Wyeth, *Autobiography*, p. 106.

98. Quoted in Hoving, *Two Worlds*, p. 23.

99. Severens, *America's Painter*, p. 33.

100. Anthropologists have long noted the use of containers as metaphors for storing memories of the dead and suggesting continuity. Hallam and Hockey, *Death, Memory*, pp. 26–27.

101. Corn, "Andrew Wyeth," pp. 37–45.

102. Paul Strand, *Time in New England*, text edited and selected by Nancy Newhall (New York: Oxford University Press, 1950), p. vii.

103. Stein, "After the War," pp. 18 and 22–23; and Truettner, "Small Town America," pp. 112, 115, and 120–121. All of the Strand images referred to in this essay come from his book *Time in New England*.

104. Quoted in Meryman, *Secret Life*, p. 144.

105. Truettner, "Small Town America," p. 120.

106. Hoving, *Two Worlds*, p. 46.

107. Corn, "Andrew Wyeth," p. 118.

108. Quoted in Hoving, *Two Worlds*, p. 152.

109. A. Wyeth, *Autobiography*, p. 67.

110. Meryman, *Secret Life*, p. 12.

111. Quoted in Hoving, *Two Worlds*, p. 155.

112. Quoted in ibid., p. 157.

113. Wyeth, *Autobiography*, p. 78.

114. Betsy James Wyeth, *Christina's World: Paintings and Pre-Studies of Andrew Wyeth* (Boston: Houghton Mifflin, 1982), p. 260.

115. Paul Strand's *A Side Porch* (1947) from *Time in New England* is uncannily similar to Wyeth's painting as well.

116. A. Wyeth, *Autobiography*, p. 72. The artist's sister Carolyn Wyeth said of *Spring Fed*: "It's absolute finality. That's it. That trough is like a casket. Those shadows are warm, and yet they're cold, a cold cement look. It's unrelenting. He just lets you look a little at the beautiful landscape. Don't be too contented. That damn pail up there is like a helmet, the way it shines. That's the Germanic—you know, Karl Kuerner making everything utilitarian—and that's the way a casket is to me, utilitarian." Meryman, *Andrew Wyeth*, p. 55.

117. Meryman, *Secret Life*, pp. 59–61.

118. A. Wyeth, *Autobiography*, p. 72.

119. Is this Wyeth's personal interpretation of the Christian ritual of transubstantiation? The title, *Spring Fed*, suggests a fatted calf or lamb, recalling Christian symbolism. Wyeth is not religious in the conventional sense—he does not attend church. (Mary Landa,

telephone conversation with the author, August 9, 2004.) Yet his painted preoccupations with mortality and immortality and his pantheistic worship of nature suggest that through his paintings he has developed his own kind of religion or spirituality. Sometimes his titles and subjects—like the vessels and his many paintings of nuns—suggest a vague interest in the rituals of Christianity.

120. When asked about *The German*, Wyeth said that Kuerner reminded him of his father: "Those are my father's lips—cruel." Meryman, *Secret Life*, p. 87.

121. The snow-smudged brown in the right background is similar to the snow-smudged hill in *Wolf Moon* (1975, pl. 58) depicting the Kuerner farm of the same year—probably a private self-reference.

122. A. Wyeth, *Autobiography*, p. 110.

123. Wyeth's enduring fascination with World War I battles and all things German fueled the intensity of his portrayals of Karl Kuerner. N. C. Wyeth was also fascinated with WWI and brought many WWI images—stacks of illustrated newspapers and stereopticon slides—into the house, all of which Andrew devoured. Also, N.C. had a display of WWI helmets, a canteen, and a gas mask. One of Andrew's favorite war movies is *The Big Parade* (1925), a WWI epic. Andrew was introduced to it as a child and watched it over and over again as an adult. As a boy, he drew many pencil and watercolor portraits of German and American soldiers in WWI battle dress; he played with hundreds of toy soldiers; and made up war games with his neighbors. Meryman, *Andrew Wyeth*, pp. 29 and 28; and Meryman, *Secret Life*, pp. 86–87.

124. A. Wyeth, *Autobiography*, p. 38.

125. Meryman, *Andrew Wyeth*, p. 63. After N. C. Wyeth's death, Wyeth went alone to the Quaker Meeting House to view his father in an open casket. Meryman, *Secret Life*, pp. 343 and 348. That experience left an indelible image in his mind, one he recreates in *Night Shadow* (1979) and one he could be recreating in *Adrift*.

126. Meryman, *Andrew Wyeth*, p. 63.

127. *Christmas Morning* (pl. 15) was one of the first times Wyeth explored the prone figure. This surreal image, which Corn argues was inspired by the Museum of Modern Art's *Magic Realism* show (1943) represents the artist's first attempt to paint death. Hannah Sanderson, mother of Christian, one of Andrew's close friends, died on Christmas morning, and "the artist portrayed her as he had seen her in death, swaddled and lying in winding sheet on her bed in the family dwelling." Corn, "Andrew Wyeth," pp. 89–90. See also Michael R. Taylor's essay in this book.

128. This is akin to Wyeth making his physical self disappear (in his creative reveries) in order to produce paintings. Another painting that exhibits this contrast between figure and object is the drybrush watercolor *Garret Room* (pl. 39). The painting depicts Tom Clark, a Chadds Ford neighbor, lying on a bed covered with a vibrantly patterned quilt. It is wonderfully ambiguous: is the man dead, sleeping, or simply weary from old age? As life seeps out of the inert figure, the multicolored quilt seems to quicken. For an example of a self disappearing and an object coming to life in Romantic painting and poetry, see Nemerov, *Body of Raphaelle Peale*, pp. 61–62.

129. See *The Patriot* (1964), *Nicholas* (1955), *The Kuerners* (1971, pl. 52), *Faraway* (1952, pl. 25), *Maga's Daughter* (1966, pl. 46), *Roasted Chestnuts* (1956), *Ice Storm* (1971), *Outpost* (1968), and *My Young Friend* (1970).

130. Also see *Braddock's Coat* (1969).

131. Wyeth gives detail to the intricately wrought, vermilion Revolutionary War uniform owned by an aid to Napoleon in *Curtain Call* (pl. 67). Hung on a bare wall next to a window, the coat mimics the posture of a standing, probably moving person. The sleeves flare out as if the arms are moving, and the unbuttoned jacket seems to bell at the bottom as if to accommodate the movement of a person's legs. The white embroidery and white covered buttons are rendered in exacting detail.

132. Meryman, *Andrew Wyeth*, pp. 35–36; Corn, "Andrew Wyeth," pp. 124–125.

133. Mary Landa, telephone conversation with author, April 27, 2004.

134. This jacket is an antique recreation made for the artist on the occasion of his induction into l'École des Beaux Arts in 1977. Karen Baumgartner, permissions and database manager in the Wyeth Office at the Brandywine River Museum, telephone conversation with the author, March 21, 2005.

135. A. Wyeth, *Autobiography,* p. 122.

136. Hallam and Hockey, *Death, Memory,* pp. 26–27.

137. Over the years, Wyeth has executed many paintings of arranged objects on or near windowsills that suggest the influence of Vermeer and still-life painters from the seventeenth century to the present. *Groundhog Day* (pl. 35) is one of many works that recall this Northern tradition. Others include *Cranberries* (1966, pl. 45), *Willard's Lunch* (1968), *Tea Time* (1962), and *Five and a Half* (1981).

138. Hoving, *Two Worlds,* pp. 145 and 146.

139. Meryman, *Andrew Wyeth,* p. 57.

140. Meryman, *Secret Life,* pp. 108–110.

141. There are similarities between Wyeth's magic realism and film. Both have voyeuristic qualities that combine a hyperrealism with an element of fantasy, and Wyeth himself enjoys watching movies.

142. Meryman, *Andrew Wyeth,* p. 82. For another Peeping Tom story, see Meryman, *Secret Life,* p. 325.

143. For another artist's preoccupation with binoculars, see Michael Fried, *Menzel's Realism: Art and Embodiment in Nineteenth-Century Berlin* (New Haven: Yale University Press, 2002), pp. 46–47 and 98–99.

144. Quoted in Meryman, *Secret Life,* p. 114.

145. See Paton, *Abandoned New England,* p. 148, for a discussion of suspended drama in Hopper's work.

146. Meryman, *Secret Life,* pp. 293–295.

147. In *Before Six* (1988), Wyeth depicts the interior of his childhood home. Two windows flank a large hearth. One window looks out on the trunk of a large tree. The other window is whited-out and his father's bust of Beethoven sits on the sill. The windows suggest two sides of Wyeth—his abiding interest in natural things and his passion for history and music. His father is, of course, carefully woven into this mix. The windows are eyes, so to speak, that let us glimpse the recesses of Wyeth's mind.

148. Dr. Syn's tunic, an original 1812 naval uniform, had formerly belonged to Howard Pyle. Mary Landa, telephone conversation with author, April 27, 2004.

Dr. Syn was a medical doctor who became a pirate in the 1937 film *Doctor Syn,* a favorite of Wyeth's in his youth. Betsy Wyeth created the setting in the bell tower of the Southern Island light station to evoke Lord Nelson's quarters on the HMS *Victory.* According to Wyeth, the painting is a humorous yet sincere homage to Pyle and to his father. Exhibition label, *Pirates: From the Golden Age of American Illustration,* Farnsworth Museum, June 15–September 21, 2003.

149. Elaine Scarry, in *The Body in Pain: The Making and Unmaking of the World,* describes a room as an "enlargement of the body: it keeps warm and safe the individual it houses in the same way the body encloses and protects the individual within; like the body, its walls put boundaries around the self preventing undifferentiated contact with the world." She compares the windows and doors of a room to "crude versions of the senses." Elaine Scarry, *The Body in Pain: The Making and Unmaking of the World* (New York: Oxford University Press, 1985), pp. 38–39.

150. Wyeth says, "I like to be nothing. I wish I could float over all this. And that's, of course, the effect I'm after in my painting." Meryman, *Andrew Wyeth,* p. 48.

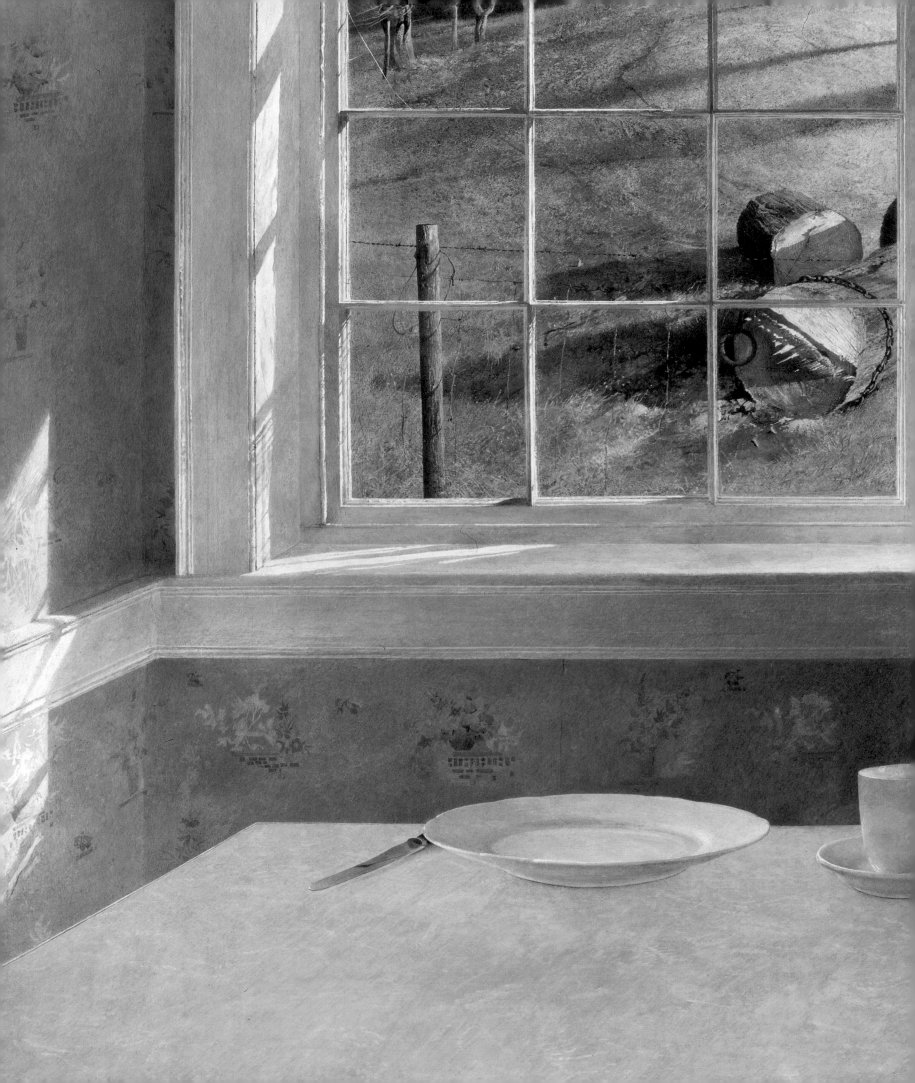

# Meaning and Medium in Wyeth's Art: Revisiting Groundhog Day

Kathleen A. Foster

GROUNDHOG DAY. A WINTER AFTERNOON in an empty country kitchen. The scene is homely, familiar, and yet oddly surreal, suggesting a very particular day—February 2, 1959—and the timeless distillation of days past and future, of lives played out in this place. Alive in the mind of Andrew Wyeth, the absent occupants of this kitchen can be read in the details of the interior and the landscape beyond. Their world as imagined by the artist is real and fantastic, serene and tense, illusionistically recorded and artfully rearranged. Suffused with a sense of silence, loneliness, mystery, and expectation, *Groundhog Day* quietly beckons us to explore Wyeth's distinctive vision and the complex weave of subject, technique, and process that underlies the artist's most memorable images.

The curious began to inquire into the secrets of *Groundhog Day* (pl. 35) not long after it was made in 1959, when the Philadelphia Museum of Art acquired the painting for a high price and with much fanfare. Glad that a painting "with a strong Pennsylvania feeling in it" had entered the collection of a museum in his home state, Wyeth told a Philadelphia journalist that the picture had been painted in his neighbor's kitchen in Chadds Ford. "That February day the sun's rays caught the corner of the table that was set for dinner, awaiting the return of Mr. Kuerner from a farm sale in Lancaster. That is how it started," he said.[1] But there seemed to be more. The newspaper noted that among contemporary artists Wyeth was "alone in his preoccupation with discovering inner meanings in simple objects."[2] The search for inner meanings began. Perhaps responding to the altar-like table, immaculate whiteness, or reverential hush in the picture, a New York journalist asked Wyeth if there were "symbolical references" in the picture, in particular to the Christian feast of Candlemas on February 2, Groundhog Day. No, "not specifically," said Wyeth, reluctant to deny anyone the power of free association that he himself so enjoys.[3] Wyeth does not attend church, but he loves symbols and holidays and good stories, and his account of the genesis of the painting was an obliging fiction: in fact, his wife Betsy

named the painting for the day that it was completed, not the day it was begun.[4]

A different version of "how it started" began to emerge in 1963, in an exhibition including two preliminary studies (see figs. 80 and 81) that showed an element that had disappeared from the painting: a sleeping German shepherd.[5] Two years later, in an interview in *Life*, Wyeth did more than explain the omission:

*Ground Hog Day*—the winter light, the dishes ready for Karl Kuerner's lunch—that is peace, yes, but to me behind it is violence suppressed. At first I had a dog sleeping in it who always barks and snarls at you. But finally the reddish end of the log became his mouth and the jagged wood his bared fangs.[6]

Elaborated by the artist and others over the years, this story of Kuerner's kitchen—evoking "death and madness beneath a thin skin of domesticity"—has become a classic example of Wyeth's imaginative picture-building, with its pattern of erasure and metaphor, its more-than-meets-the-eye realism, and its unsettling emotional potency.[7] Wyeth likes to be surprising and provocative, and (as his early stories attest) he is the primary author of his own legend. Testing his own account against the evidence, we can revisit the "suppressed" drama of the kitchen and the farm that revolves around it. A remarkable sequence of sixty surviving studies and related works reveals the metamorphosis of this image and suggests the layered content of the painting as well as the habits of Wyeth's imagination, the patterns of his training, and the unfolding of his creative process.

"Emotion" is a key word throughout the commentary on Wyeth's work by friends, critics, scholars, and the artist himself. "I start every painting with an emotion—something I've just got to get out," he said as part of his revelation in 1965, when he moved immediately from *Groundhog Day*'s superficial subject, Karl Kuerner's lunch, to the emotional tension at the core: "peace" and "violence suppressed." Emotion, the deep content at the center of his art, impels his choice of subject

matter and its manipulation; never simple, often contradictory or masked, this emotion communicates instantly to viewers, making the image arresting and unforgettable.[8] For the artist, the other important word is "excitement," found in the thrill of discovery and the challenge of making. Expressed openly in scribbled drawings and splashy watercolors, excitement vibrates subliminally in his finished works, even in such measured temperas as *Groundhog Day*.

Subject matter generates both emotion and excitement for Wyeth, although he says that there is too much subject matter in his work, noting that anecdotal or documentary detail has distracted both his admirers and his critics.[9] He would like to be appreciated for the abstract qualities of his work, but the landscape, people, and common objects he has known since childhood are the wellspring of

his imagination, calling forth memory and emotion. If subject didn't matter to him, he could paint anything, travel anywhere; but he only paints what he knows.

If all Wyeth's paintings are about himself and his life, then the farm of Karl and Anna Kuerner occupies a special corner in this personal landscape. "This place is, well, like home to Andy," said Karl, who had given him the run of the place since boyhood, and who ultimately stepped into the place of the artist's father, after N.C. was killed at a railroad crossing within sight of the house.[10] Saturated with such memories, the farm was also charged by the brutal character of Kuerner himself, a veteran of the German army in World War I. Karl became a surrogate for the father that Wyeth regretted he never painted (pl. 21) and a figure from childhood battlefield fantasies come to life (pl. 57), the center of a galaxy of reveries about Karl as machine-gunner, deer slayer, hog butcher, master of death.[11] Fascinated by Karl and his culture of manly, violent authority, Wyeth made hundreds of drawings and paintings that represent the Kuerner farm as a manifestation of Karl's personality. In *Groundhog Day*, Karl's place setting expresses his absent body as well as his plain, efficient, orderly self.

Fig. 70. Andrew Wyeth, *Brown Swiss* (detail), 1957, tempera on panel, 30 × 60⅛ inches, private collection. See plate 32.

Fig. 71. Andrew Wyeth, *Study for Cooling Shed*, ca. 1952–1953, graphite on thick white wove paper, 13⅞ × 10⅞ inches, Philadelphia Museum of Art, gift of Frank A. Elliott, Josiah Marvel, and Jonathan H. Marvel in memory of Gwladys Hopkins Elliott, 1998.

Fig. 72. Andrew Wyeth, *Study for Cooling Shed*, ca. 1952–1953, opaque and transparent watercolor over graphite with scraping on thick white wove paper, 18 × 11¹⁵⁄₁₆ inches, Philadelphia Museum of Art, gift of Frank A. Elliott, Josiah Marvel, and Jonathan H. Marvel in memory of Gwladys Hopkins Elliott, 1998.

Fig. 73. Andrew Wyeth, *Cooling Shed* (detail), 1953, tempera on panel, 24¾ × 12⅜ inches, Philadelphia Museum of Art, gift of Frank A. Elliot, Josiah Marvel, and Jonathan Marvel in memory of Gwladys Hopkins Elliot, 1998. See plate 26.

Another protagonist of the farm that appears repeatedly in Wyeth's work is the early nineteenth-century stone farmhouse at its center, a whitewashed, neoclassical block enlarged around 1850 to cubic proportions, memorably depicted in *Brown Swiss* (fig. 70, pl. 32). With its austere geometry, the house stands in the landscape like a fortress of civilization, rational and artificial, puritanical and foreign. "Andy looked at the house as a great block of ice, cut out of Europe, out of Germany," noted Helga Testorf, "a world of its own."[12] The exterior of this house, like the interior of the kitchen, speaks of a spare, hardworking operation, vigilantly poised against the surrounding dirt and wildness. This tension between human will and nature underlies many images of the farm—overtly in *Wolf Moon* (pl. 58), where the landscape rises in threatening, expressionistic darkness above the house, and latently in *Groundhog Day,* with its contrast of indoor and outdoor worlds. Structurally opposed to nature, the house also contains and is saturated by the exotic volatility of both Karl and his eccentric wife, Anna, who generate the "strange atmosphere" that Wyeth finds "fantastic" and alluring.[13]

Exploring the fields and outbuildings, wandering through the house, Wyeth came and went at will, generously ignored by the Kuerners.

"Andy spends a lot of time over here, painting. We don't pay him any mind. We let him alone. That's what he needs. To be let alone. To know that we don't care how long he stays, or when he comes, or when he leaves. He could just as well be a rabbit coming and going," says Karl, who understood that Wyeth would "like to be invisible."[14] Invisible, he could carry on his own work uninterrupted, without disrupting the flow of life around him; inhabit the life of the Kuerners and feel what it was like to be them; and prowl for subject matter. "When I am out walking, searching, observing, I am almost like a sharpshooter," he says, stalking a subject with both pictorial and emotional potential that will, as he says, make his hair stand on end with excitement.[15] Such hunting can be protracted and agonizing, when nothing comes.[16] And then a familiar sight will suddenly look different: buying firewood as usual at the neighboring Wylie farm, he was electrified by the view in the cooling shed, a building he had visited countless times before (figs. 71–73).[17] "Always looking over the same places, always finding something else," Wyeth had no doubt been in the Kuerner kitchen dozens of times before the winter of 1958–1959, shared meals at the table, looked out the window.[18] Then one day, something clicked.

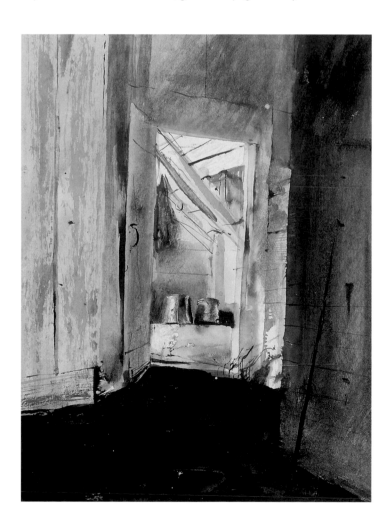

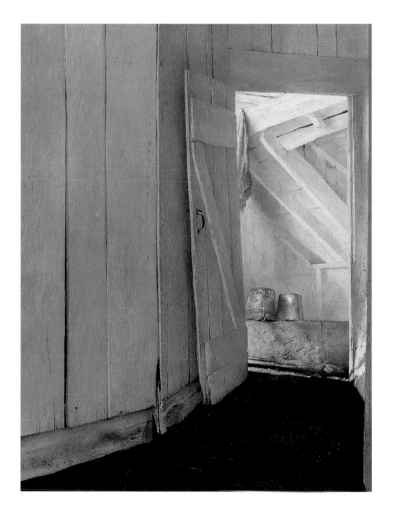

Wyeth was trained to see in this fashion by his father, N. C. Wyeth, the famed illustrator and painter. N. C. taught all his children to find beauty in the world, to remark the fall of light through the trees, to spot the first wildflowers. He banked into their memories riches from books, toys, costumes, family theatricals, and outings. His passion for the richness of daily experience and his cultivation of his children's imaginative lives forever shaped his son's way of looking. To Wyeth, wildflowers are always exciting, tin buckets suggest the helmets of knights, and almost everything connects to memories of his childhood and his father. Frail, sensitive, and highly strung as a child, comfortable being alone for hours, Wyeth was born to be an artist and raised to develop his talent. Encouraged as a child to react explosively to visual stimulation and harbored as an adult to focus his energy on painting, he continues to find excitement in discovery and delight in the free association of memory and vision.[19]

For Wyeth, the first phase of a painting involves walking, looking, mulling over possibilities. The second phase, when a spark of excitement lodges in his mind, involves the process of representation and the application of technique, which is exciting in another way. Wyeth says that too much is made of his technique, and that technical analysis, like the anecdotal aspects of his subject matter or his realism, will often forestall deeper understanding of his work.[20] A display of technique is not his point, just as realism alone is not his goal, but Wyeth's technique is the vehicle of his expression, making visible the emotion and excitement that drives his art, so that an understanding of his use of materials and techniques enlarges awareness of his meanings.

As with his habits of seeing, Wyeth's technique was cultivated by his father, his first and only teacher. "He believed in sound drawing," said Wyeth, who emerged from hours of boyhood practice with an extraordinary skill.[21] His first efforts as a child were in pen and pencil, under the sway of illustrated books, and his first exercises as a student in his father's studio were likewise linear. Drawing has remained his bedrock, the foundation of planning and learning, and the support of his mastery in all media. This method derives from the European academic tradition in its emphasis on life-study and disciplined building from line and value to color. Observation is only one component of this skill, for drawing also signals a conceptual as well as a visual phase of creativity. The linear, colorless codes of pencil drawing are inherently abstract and non-illusionistic, governed by the flat surface of the paper, and completed by the idea held in the mind. Wyeth's drawings, generally undertaken when he is considering a new subject, are about excitement, imagination, and investigation. They can be divided into three overlapping categories that indicate thinking and planning, exploring and testing, and knowing.

All three types of drawing came into play in the development of *Groundhog Day,* unfolding first in a sequence of thirty pages

from a sketchbook, now dismantled, that Wyeth kept in the winter of 1958–1959. Wyeth carries drawing materials and a watercolor kit with him everywhere and he draws all the time, sometimes randomly, just to keep his hand and eye in trim, waiting for something to ignite. Occasionally, he encounters an electrifying subject and moves immediately to watercolor or tempera. Sometimes, excited by the power of an image, he progressively brings it into focus in a chain of drawings and watercolors that are first fact-finding and then simplifying, making the image bolder and more abstract (as in figs. 71–73). More often, he circles a subject, testing its potential and turning over its possibilities in his mind. The road to *Groundhog Day,* traced in its many studies, was unusually convoluted.[22] Interviewed at length by Thomas Hoving in 1976, Wyeth remembered that it "happened this way" in the fall of 1958:

> I had just had lunch one day with the Kuerners (I do that all the time) and I left and wandered around the farm. Then I went up onto the hill where the pines are. I sat for a couple of hours and kept thinking about that kitchen down there with Anna Kuerner in it. And from the hill I saw Karl leaving to go to a farm sale in New Holland. Then, very quickly and penetratingly, because the presence of the kitchen got to me, I started to make some drawing notations from memory showing Anna in the corner with the dog curled up on the cushion next to her.[23]

Pulling out his sketchbook, Wyeth began by imagining the scene: the dog in the lower left corner, Anna silhouetted against the bright east window, and the corner cupboard and the south-facing window suggested at the right (figs. 74 and 75).[24] These excited "thinking" drawings, made from memory, are fast and scribbled, with points of emotional emphasis heavily punched: the dog's belly, eyes, or ear; Anna's torso or the line of her kerchief; the shadowy edges of the windowwell. A table is barely hinted at by the disappearance of Anna's body below a few horizontal lines.

Inspired, Wyeth "went back down to the house and got Anna to pose, but she didn't pose very well." Anna had been wounded by the traumas of emigration, poverty, and too many children; decades earlier, she had retreated into a private world of compulsive cleaning and chores. Tormented by headaches, Anna wore a kerchief tightly bound around her head in the belief that it relieved the pain.[25] She spoke only a few words of English and, though always kind to Wyeth, rarely responded to him. A half-dozen rapid drawings of her from Wyeth's sketchbook (fig. 76) seem jittery in the face of an unhappy sitter. Her body seems heavy, passive, despondent; her expression, lightly sketched, feels remote.[26] Wyeth, sensing her reluctance, darts quickly in these drawings to skewer the principal points. "It's so much like fencing," he says about drawing; his pencil jabs at the paper,

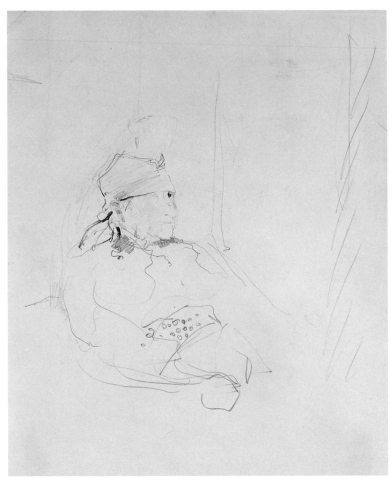

Fig. 74. Andrew Wyeth, *Groundhog Day Study,* 1958–1959, graphite on paper, 11 × 12¾ inches, Collection of Andrew and Betsy Wyeth.

Fig. 75. Andrew Wyeth, *Groundhog Day Study,* 1958–1959, graphite on paper, 13⅜ × 10⅞ inches, Collection of Andrew and Betsy Wyeth.

Fig. 76. Andrew Wyeth, *Groundhog Day Study,* 1958–1959, graphite on paper, 13⅜ × 10⅞ inches, Collection of Andrew and Betsy Wyeth.

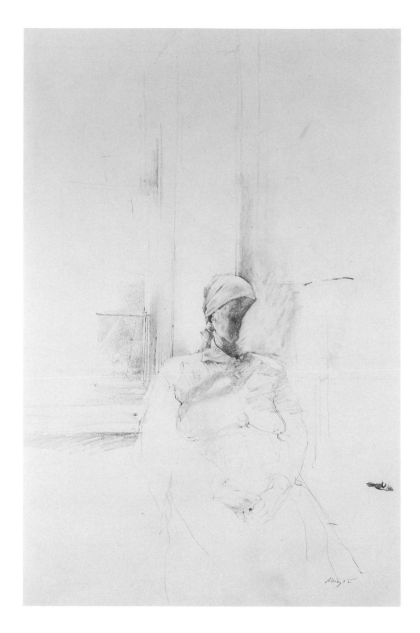

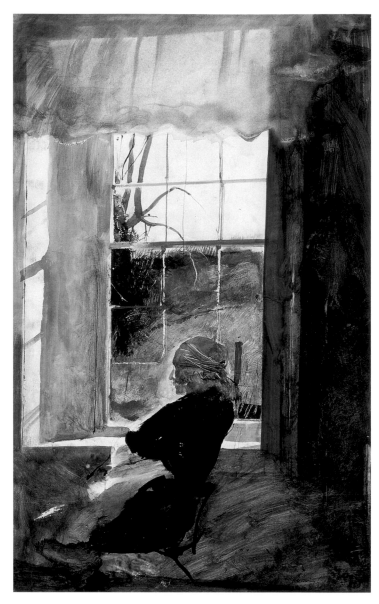

Fig. 77. Andrew Wyeth, *Groundhog Day Study,* 1958–1959, graphite on paper, 21¾ × 13⅞ inches, Collection of Andrew and Betsy Wyeth.

Fig. 78. Andrew Wyeth, *Groundhog Day Study,* 1958–1959, watercolor on paper, 21⅞ × 13⅞ inches, Collection of Andrew and Betsy Wyeth.

poking at eyes, ears, nostrils, and the brow line of her kerchief.[27] Testing the impact of her silhouette from several angles, he tries—with small success—to get inside his sitter's head. Bearing down on the three-quarter pose, Wyeth developed it with more detail and patience in a subsequent study, building out from the figure to the window but casting her features in shadow (fig. 77). Dissatisfied, he attacked the contour of her face with his eraser, and gave up. A different tack, setting Anna in silhouette against the window, turned her dark interiority into the main story and inspired a more developed watercolor (fig. 78). In this solution, Wyeth may have been thinking of her as a rhyme to

Christina Olson, painted in the same way, backlit and confined in her kitchen in Maine, as in *Geraniums* (pl. 36).[28]

This watercolor marked the end of Anna's posing for many years. Too restless, too inaccessible, she departs the painting in a sequence of sketchbook drawings that gradually shift emphasis to the dog (fig. 79): "The dog got more and more important to me, and I did her in many studies. Karl calls her Nellie, as he calls all his German Shepherds, because a sheepherder always calls his dogs the same name."[29] Nellie is Karl's dog, an accessory of his world, a violent tool. Barking and snarling, Nellie guarded the farm, usually while chained to a doghouse

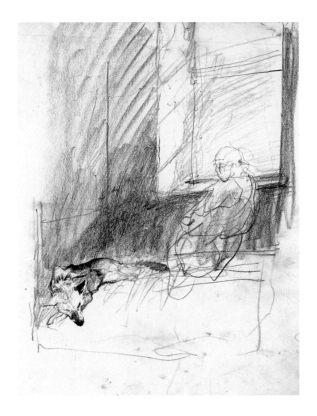

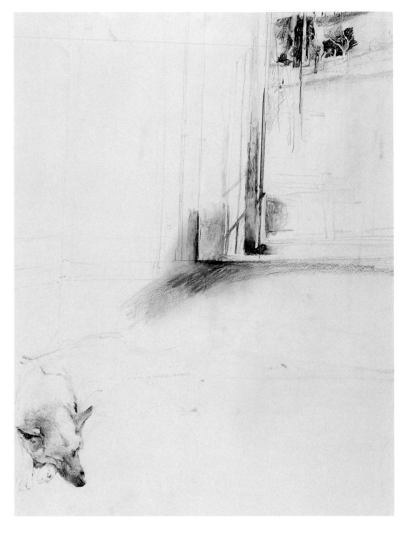

behind the woodshed. Sleeping inside by the stove during the coldest weather, she made a calm model, although she contained, like Anna, barely domesticated wildness. The ostensibly cozy portrait of a woman and a sleeping dog masks the type of explosive potential that Wyeth deeply enjoys. As Anna's companion, Nellie also stands in for Karl, the violent foil to Anna's dogged domesticity; at the same time, Karl is subliminally present in Wyeth's scenario as the master of both dog and wife. "Thinking about it," Wyeth drew closer to the subject, cropping the cupboard and pulling the window to the right, drawing the dog and Anna together until the dog's tail touches Anna's dress. In each of these drawings (as in fig. 74) he emphasizes the sharp black ear of the dog, and its dark muzzle and tail. These points of excitement recur in a series of quicker sketches of the dog that test its pose, profile, and relationship to the chimney corner.[30] The skein of lines representing Anna becomes more and more a placeholder for a model who seems to have left the room, while Nellie and the barred sunlight on the window-well come into stronger focus.

Wyeth's campaign to understand Nellie demonstrates the most intense kind of drawing in Wyeth's process, which seeks deeper knowledge of his subject (fig. 80). These drawings are detailed, fact-finding missions undertaken as pure research, enacting his father's advice to immerse himself in his subject, identify with it, and commit it to memory. "It is like being in communion with the object, with the place," he says.[31] Such drawings are always done from life; in the tradition of

Fig. 79. Andrew Wyeth, *Groundhog Day Study,* 1958–1959, graphite on paper, 13⅜ × 10¾ inches, Collection of Andrew and Betsy Wyeth.

Fig. 80. Andrew Wyeth, *Groundhog Day Study,* 1958–1959, graphite on paper, 22¾ × 16¼ inches, Collection of Andrew and Betsy Wyeth.

mid-nineteenth-century realism, as expounded by John Ruskin, these are exercises in disciplined looking. Although Wyeth is deeply engaged by his subject at this point, these drawings are meticulous and self-effacing, appropriate to a phase of collecting information.

"I kept working on the dog," said Wyeth, "and then I started doing the window." In figure 80, shadows link from Nellie to the window to make a thought bubble above the dreaming dog, with nightmarishly gnarled and dark trees seen through the upper panel. Thinking about inside and outside, the interior life of the dog, the exterior life of the farm, Wyeth begins to explore a structure he developed two decades later in *Night Sleeper* (pl. 66). Windows frequently serve as thresholds

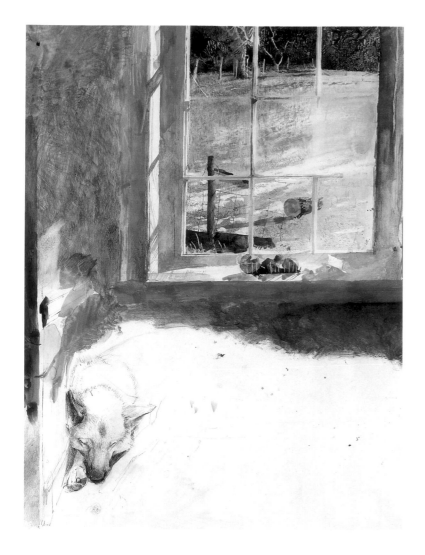

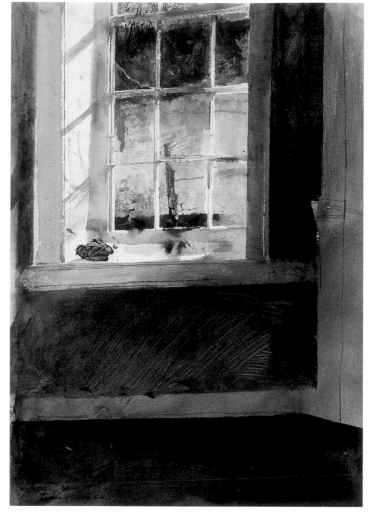

Fig. 81. Andrew Wyeth, *Groundhog Day Study,* 1958–1959, graphite and watercolor on paper, 22½ × 16¾ inches, Collection of Andrew and Betsy Wyeth.

Fig. 82. Andrew Wyeth, *Groundhog Day Study,* 1958–1959, watercolor on paper, 20 × 14 inches, Collection of Andrew and Betsy Wyeth.

between worlds; in *Groundhog Day,* the story is one of uneasy confinement rather than escape.[32] As suggested in figure 80 and taken a step further in the related watercolor (fig. 81), where the dog floats implausibly close to the vivid window, the world outside—of dream, of nature—is bright, cold, wild, unfriendly. Inside, it is calm and snug, less dangerous, but less free.

"Then the dog disappeared," said Wyeth. The window stands alone, much as it appeared in Anna's profile portrait, but now without Anna and only the ghost of Nellie, submerged at the lower left (fig. 82). The fence post lurking outside shifts to the center pane and peers in

at a huddled gathering of forms (onions), bluntly depicted with a few quick strokes on the windowsill. Wyeth subdues the strong ochre and burnt sienna of the walls with a somber glaze, scrubbed with a dry brush to add texture and movement. The forest, with its orange glints likewise veiled by dark washes, moves lower to block the distance. Important ideas are consolidated here: the skewed grid of the composition, the fall of sunlight on the wall, the sense of expectancy.

The intensity of all three window views (figs. 78, 81, and 82) and their importance to Wyeth are indicated by the move to watercolor, which signals a higher level of excitement. The appearance of watercolor in the process ups the ante and transforms the product, for it is at once more realistic and also more emotional than pencil drawing. As Beth Venn has noted, Wyeth's temperas have earned most of his reputation, but watercolor is really his central medium and his most versatile technique, ranging from sketches and studies to finished exhibition works, from broad splashes to detailed drybrush effects.[33] The different level of excitement and the wider range of emotion in this

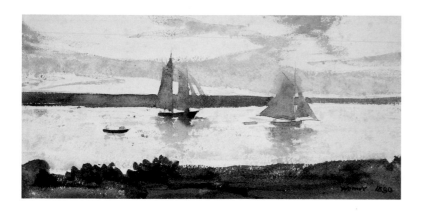

Fig. 83. Winslow Homer (American, 1836–1910), *Two Sailboats,* 1880, transparent and opaque watercolor and graphite with scraping on heavy wove paper, 8¼ × 16⅞ inches, Philadelphia Museum of Art, gift of Dr. and Mrs. George Woodward, 1939.

medium arises from its coloristic and gestural potential as well as its place in Wyeth's life. Just as drawing connects to his training and to the realm of imagination and learning, watercolor relates to his first successes as an artist and to the expression of self. It was his boyhood painting medium, practiced for its own pleasure before his apprenticeship to his father. Wyeth's early taste for watercolor may have come from its traditional availability to children, or from the fact that it was *not* his father's principal medium, but Wyeth has never grown out of it, and his watercolors retain to this day the qualities of youthfulness and freedom. More emotional, spontaneous, and adventuresome for him than either drawing or tempera, "watercolor perfectly expresses the free side of my nature," says Wyeth.[34]

In this spirit, Wyeth earned his first fame in the late 1930s with watercolors consciously made in the heroic American tradition of Winslow Homer. Boldly designed, broadly painted, and strongly colored, his work pursued the impressionistic realism of the turn of the century into expressionistic bravura. Not based on thinking or judging, like his drawings, Wyeth's watercolors are first about sensation. "Watercolor is such a wonderful medium," he says. "You come on something in nature, you're excited, and you can let it out before you begin to think."[35] His unpremeditated response to the motif drives the work, along with the excitement of capturing his vision in a way that is itself visually, abstractly compelling. Wyeth's confidence rises out of his own facility and passion, but his feeling of ownership of the medium and its appropriateness to his goals rests on the triumphs of Homer and

John Singer Sargent, who—with a generation of late nineteenth-century painters—first claimed watercolor as an "American medium." Propelled by Homer and others, the "American Watercolor Movement" established the legitimacy of the medium in the United States after 1870, and by the 1930s the medium was favored by most of the country's progressive painters (John Marin, Charles Demuth, Georgia O'Keeffe, Oscar Bluemner, Reginald Marsh, Adolf Dehn, Charles Burchfield, and Wyeth's contemporary hero, Edward Hopper).[36] Determined to be modern, realist, American, and personally expressive, Wyeth naturally chose watercolor.

Wyeth learned much from Homer's work, beginning with the merits of speed and simplicity. Apart from a shared feeling for horizontal landscape and marine subjects, he took up Homer's bold compositions, broad washes, big brushes, limited palette of saturated colors, and repertory of scintillating technical devices such as scraping, blotting up, and working wet into wet (fig. 83).[37] Building on this set of skills, Wyeth grew fearless, inviting happy accidents and improvising with whatever tools came to hand, notably his fingers and shirtsleeves. The wit and dash of his watercolor effects can be seen in the study of Nellie (fig. 84), in which he transferred wet pigment from one spot to another with his finger, printing texture over an underlying wash to suggest fur.

Behind this enthusiasm for watercolor also stood the illustrator's heritage that made both drawing and watercolor hardworking professional media for Homer as well as N. C. Wyeth. From the circle of his father's master, Howard Pyle, came a legacy of illustrated books known

Fig. 84. Andrew Wyeth, *Groundhog Day Study* (detail), 1958–1959, watercolor on paper, 11⅛ × 11 inches, Collection of Andrew and Betsy Wyeth.

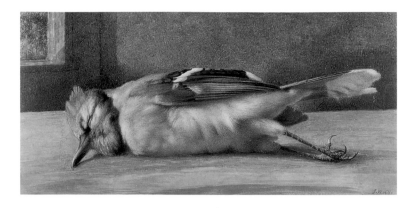

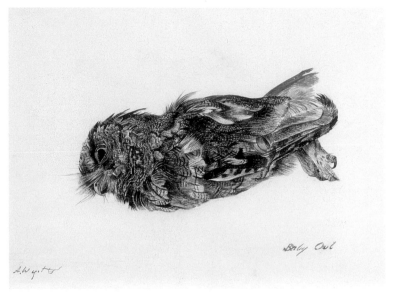

Fig. 85. John William Hill (English, 1812–1879), *Dead Blue Jay*, ca. 1865, watercolor on paper, 5¾ × 12 inches, The New-York Historical Society, 1957.94.

Fig. 86. Andrew Wyeth, *Baby Owl*, 1944, drybrush and ink on paper, 8¼ × 11½ inches, private collection.

in childhood, and the journalistic tradition of watercolor as a field medium. Both ancestries, from Homer and the American watercolor movement, and through Pyle and the illustrator's tradition, connect Wyeth back to Pre-Raphaelite painters in England and the United States, where Ruskinian teaching made watercolor a favored medium. Artists such as John William Hill, pursuing watercolor with fervor in the 1860s and 1870s, shared with Wyeth the same fierce love of nature, the same compositional strategies, and the same technical delicacy (see figs. 40 and 85). Silhouetting a branch of blackberries against the sky (pls. 9 and 10), or bearing down on small objects scattered on the ground, Wyeth keeps alive the sensibilities of the Victorian era in tender moments such as *Baby Owl* (fig. 86).[38]

The Pre-Raphaelite taste inherited from N. C. Wyeth included a reverence for the work of Albrecht Dürer. Studying a book on Dürer given to him by his father, Wyeth absorbed the master's emotional and technical intensity and began to imitate his method of drybrush hatching. In work such as *Crows* (pl. 17), Wyeth took up the legacy of Dürer's famous watercolor of a young hare, "weaving" (as he put it) the fine texture of feathers with a small brush squeezed dry into multiple points. Set boldly on plain paper like the calligraphic flourish of an East Asian master, the image reads powerfully from a distance and delicately from close range. In the 1940s, Wyeth began to develop this technique into a special hybrid, midway between watercolor and tempera. "I want to keep the quality of a watercolor done in twenty minutes," he said about his drybrush technique, "but have all the solidity and texture of a painting."[39]

The precision of this kind of watercolor technique emerged in the next phase of *Groundhog Day* studies, after the dog disappeared, when Wyeth "got interested in the table I saw there. I kept building on the idea, thinking about it, thinking about it, making dozens of studies of the plate, the cup, and the knife. Then I focused in on the wallpaper and I kept working on the wallpaper."[40] More research and planning followed, evident in drawings of windowpanes and chair rail and in both drawings and watercolors of the objects on the table. Some studies of the china focus on a single plate; others (fig. 87) suggest a more casual, everyday grouping that throws into relief the deliberate and selective vision in the final painting. The two windows in the room bathe the table in liquid brightness, with the luminous paper expertly left bare to represent reflections on the enameled kitchen table and the shiny surfaces of the silverware and china. Surprising buried color—washes of blue on the table, chips of red fingerprinted on the loaf of bread—illustrate Wyeth's interjection of brighter tints into a palette typically dominated by yellow ochre and raw umber. Anna's presence and the feminine culture of the kitchen is represented by the inviting loaf of freshly baked German bread and by the dainty flowers on the teacup and the fruit-and-flower motif on the wallpaper.[41] Color studies

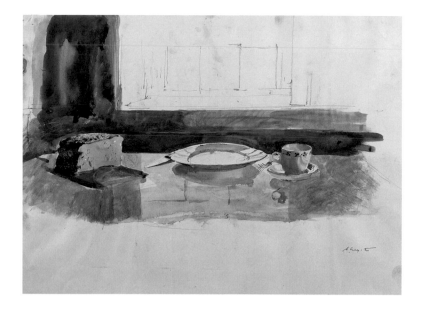

of this wallpaper (fig. 88) include a drawing, to scale, of one of the repeating designs of vases and bricks and a map of the rhythm of the repeat. As an expression of Anna, the pattern reflects Pennsylvania German peasant taste in a modern mode, determinedly gay and yet somehow forlorn in its promise of springtime and domestic tranquility.

Across the wallpaper falls the path of the sun, remembered throughout Wyeth's first "thinking" drawings and lovingly studied again many times in pencil and watercolor, recording the shadow bars across the moldings of the chair rail, the wrinkled edge of the paper pulling loose from the wall, the blurred light from old window glass.[42] Wyeth has often painted this motif, perhaps because each new fall of light summons memories of the others. "To me the sunlight could just as well be moonlight as I've seen it in that room," he remembered in 1965. "Maybe it was Halloween—or a night of terrible tension or I had a strange mood in that room. There's a lot of me in that sunlight an average person wouldn't see. But it's all there to be felt."[43] The sunlight conveys warmth and contributes to the peace that is part of Wyeth's emotional package, but inaccessible, personal responses leave few things simple in his work. Although comforting, the sunshine is also closely associated with the dog that once slept in its path.

> Then the dog came back. After that I kept looking at the logs of a gum tree that had recently been cut. As the log was being hauled near the place, the dog went by quickly and I did a watercolor of that strange juxtaposition. . . . And then all of a sudden, the dog disappeared. Again, the ragged, chopped, sharp sliver part of the log became, in another series of drawings, the dog that wasn't there: they became the fangs of the dog. That dog is nasty, you have to watch her.[44]

Fig. 87. Andrew Wyeth, *Groundhog Day Study*, 1958–1959, watercolor on paper, 12¼ × 16¾ inches, Collection of Andrew and Betsy Wyeth.

Fig. 88. Andrew Wyeth, *Groundhog Day Study*, 1958–1959, watercolor on paper, 13⅞ × 16¾ inches, Collection of Andrew and Betsy Wyeth.

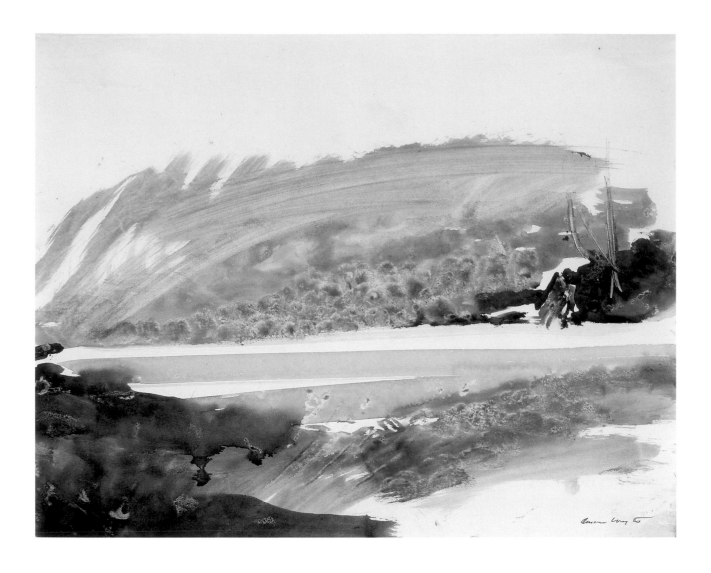

Fig. 89. Andrew Wyeth, *Groundhog Day Study,* 1958–1959, watercolor on paper, 10⅞ × 13⅜ inches, Collection of Andrew and Betsy Wyeth.

The return of the dog, the move outdoors, and the merger of dog and gum tree can be tracked in the sequence of outdoor studies that bracket the artist's work in the house. Earlier, he had recorded in pencil and watercolor the journey of a gum tree that was felled by the stock pond and dragged up the hill until the tractor got stuck, leaving the log outside the kitchen window, not far from the woodshed.[45] Wyeth had recorded the pond, stump, and fallen tree in a series of increasingly bold watercolors in his "Groundhog Day" sketchbook (fig. 89) that recollect both J. M. W. Turner's "color beginnings" and contemporary Abstract Expressionist painting. For Wyeth, watercolor comes into its own outdoors, where he uses it in the impressionist tradition. As in his early watercolors in the 1930s, there is an element of headlong, athletic passion in such work; like a racecar driver at the edge of control, Wyeth enjoys taking the corners on two wheels. His outdoor watercolors from the fall and winter of 1958–1959 demonstrate an equal measure of skill and exhilaration; fast, wet, and spontaneous, made with two or three colors and fat brushes and fingerprints,

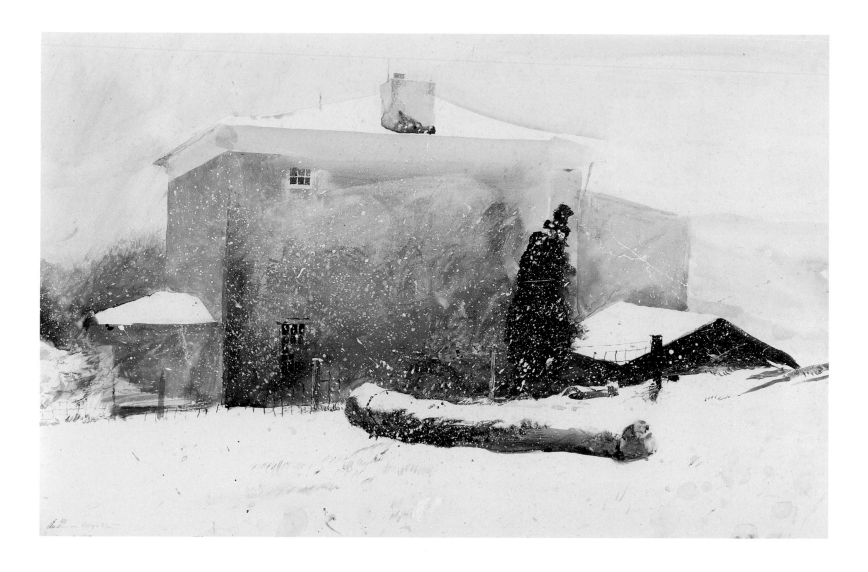

Fig. 90. Andrew Wyeth, *First Snow, Study for Groundhog Day*, 1959, drybrush watercolor on paper, 13¾ × 21¼ inches, Delaware Art Museum, Wilmington, gift of Mr. and Mrs. William E. Phelps, 1964.

they show his ability to improvise technique and exploit accident and surprise.

By midwinter, Wyeth found himself outside the kitchen window he had been studying from within, looking down the length of the log that rests, with its collar of chain, like a half-tamed beast, watching the window at the hearth of the house (fig. 90). The window, studied two years earlier framing Anna's figure inside, opens into the warm place of fresh bread and domesticity.[46] The log evokes Karl, who is master of the gum tree, and the image summons a host of oppositional metaphoric structures based on nature and culture, male and female. The log lifts its "head" slightly to address the window, suggesting a dragon, a cannon, a White Whale, a great battering ram trained on the house, the window, the kitchen, Anna's place. The power of this image prompted Wyeth to paint it twice, even as a snowstorm gathered, and to move from his informal sketchbook to larger sheets of watercolor paper.[47] Dots of white gouache, spattered across the image, and skillful zones of "left" paper, express his lively interest in the view: "I love the

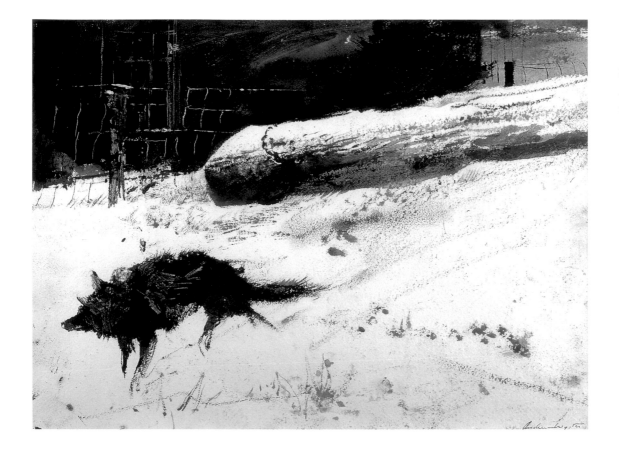

Fig. 91. *Wild Dog, Study for Groundhog Day*, 1959, watercolor on paper, 13½ × 19 inches, Jamie Wyeth.

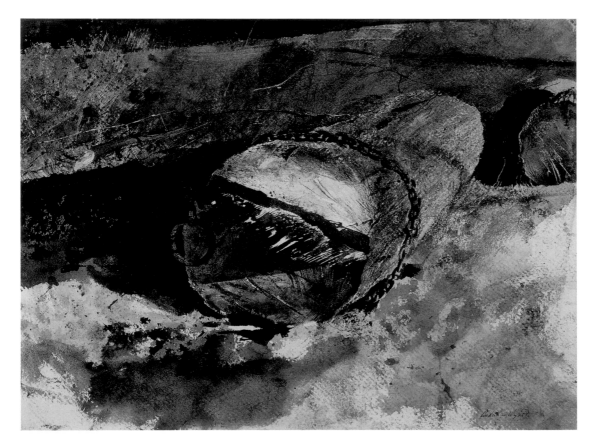

Fig. 92. *Log Chain, Study for Groundhog Day*, 1959, watercolor on paper, 14 × 20 inches, private collection.

bleakness of winter and snow and get a thrill out of the chill," he says. An oncoming storm is especially intriguing: "There's danger in it. You never know how it's going to turn out."[48]

In these studies, the dog, "dangerous and usually chained . . . appeared unexpectedly," slinking cold and wolflike, in front of the log (fig. 91).[49] Deft from long study of Nellie, Wyeth quickly captured what must have crossed his line of sight for only an instant, but the "strange juxtaposition" thrilled his imagination. As in Winslow Homer's famous *Fox Hunt,* and with a similarly Asian sense of composition and calligraphy, he gives us an image of a predator oppressed. The dog, its wet and matted fur suggested by lines scratched into the washes, seems sinister and threatening, the house protected only by the fragile rabbit fencing.

This sequence of log and dog watercolors set the stage for Wyeth's tempera, transforming his view from within the kitchen.[50] The log had already appeared outside the window (see figure 81), but small, benign, and far away. Working from within the house, thinking about the window and the dog, Wyeth saw Karl return with the tractor. Kuerner recalled, "When the ground froze up I was coming back to drag it away again, and Andy was here. He looked out the window and saw that log and said, 'Leave it lay there for a while.' He went to painting then right here, and we left him alone."[51]

Galvanized by his newly animated sense of the log as well as by Karl's need to split it for firewood, Wyeth began a series of drawings and watercolors that study the splintered end of the tree. From indoors, he began to think about the conversation between the fence post and the log and their placement within the mullions of the window.[52] Outdoors, he began a series of portraits of the jagged log that demonstrate the intersection of provocative subject matter and expressive technique typical of Wyeth's watercolors (fig. 92). Focused on the light glinting off the log's "bared fangs" and the collar of chain, these watercolors explode into splashy wet washes and excited scraped and fingerprinted textures.[53]

All this time, Wyeth is thinking about the final painting. He says that at such a moment he likes to gather all his studies, tack them on the wall or spread them out on the floor, and begin the process of synthesis and distillation.[54] In a sense, he has over-prepared, and knows too much about his subject; on the other hand, he now owns the subject completely in his mind, "more vividly perhaps than if it were present."[55] Now comes the most self-consciously "artistic" phase in his process, when all his choices are made at a remove, from studies or from memory. The resolution of a large constellation of ideas into a coherent image was difficult in *Groundhog Day;* Wyeth still remembers his "relief" as the window and table idea emerged, and the dog "disappeared" into the log.[56] Pulling out his sketchbook, he jotted down his concept (fig. 93). Although he would crop this image more tightly

Fig. 93. Andrew Wyeth, *Groundhog Day Study,* 1958–1959, graphite on paper, 10¾ × 13⅜ inches, Collection of Andrew and Betsy Wyeth.

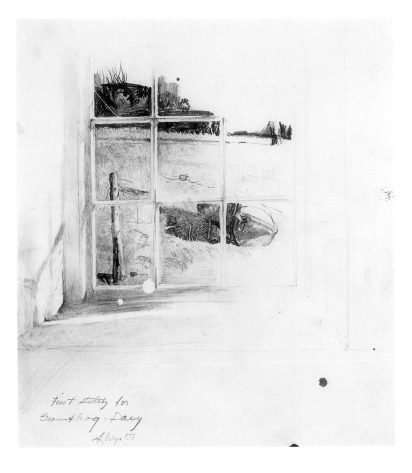

Fig. 94. Andrew Wyeth, *Groundhog Day Study*, 1959, graphite on paper,
13⅜ × 10⅞ inches, private collection.

and replace the tumbler with a cup and saucer in the final picture, the
basic composition of the tempera is expressed here, along with its sub-
liminal excitement: the simple table-setting, the patch of sunlight on
the wall, and the threat from the window, underscored by emphatic
lines that descend like a fang along the path of the log toward the place
of the missing Karl. This sketch lays out the grid of the composition
and narrows the focus, eliminating the earlier difficulties of integrating
the space between the dog and the window by stepping forward and
cropping the view of the floor. New studies of the windowpanes, with
chunks of log immediately outside to the right and the sentinel fence
post positioned at the left (fig. 94), refined the placement of the players
outdoors.[57] Wyeth was ready to begin his tempera.

Egg tempera, the basis of Wyeth's most enduring and celebrated
works, is the slowest of his techniques and, because so much time is
invested in each image, the most intense. He paints only two or three
temperas a year, which means that only a few of the subjects explored
in pencil or watercolor make the grade; not all topics are suited to the
deliberate pace of the medium. He has been known to seize a panel

and begin work immediately on a subject recognized as perfect for
tempera, but most of his paintings develop through the process of
study and testing that was unusually protracted in *Groundhog Day*.[58]
Because the painstaking buildup of paint takes weeks, even months,
the subject must have staying power. "The most difficult thing," he says,
"is to keep up the white heat of excitement after you've started."[59]

Tempera is the technique Wyeth mastered last, and it expresses
maturity, restraint, and contemplation in the way his watercolors rep-
resent youth, spontaneity, and sensation. After some early efforts in
oil under the tutelage of his father, Wyeth learned to paint with tem-
pera in the late 1930s from his future brother-in-law Peter Hurd, one
of many artists enthusiastic about the medium at that time. The two
pages of typed instructions Wyeth received from Hurd survive, now
copied many times for those who inquire about his fastidious, old-
masterish preparation of egg yolk, water, and pigment. Applied with
a small brush, in hatched lines layered and crossed into a dense, matte
surface, tempera demands patience but holds its color and luminosity
over time. As Betsy Wyeth describes it, tempera expresses "suppres-
sion"; for the artist, it also embodies permanence.[60]

The first decision in a tempera involves the panel's size and shape.
Sometimes Wyeth orders his wood panels to a custom size and some-
times he cuts them down from a standard prepared panel, but he rarely
uses the same size twice.[61] In some cases, an available panel can subtly
affect a developing image; in others, the format can be determined in
advance through a series of studies. The last two watercolors completed
before the tempera *Cooling Shed* (including fig. 72) show a shadowed
wall at the right, ultimately cropped when Wyeth moved to the panel
(fig. 73), dramatically pulling the entire composition to the right.
*Groundhog Day*, like a handful of his other paintings, is almost perfectly
square. A square is inherently stable, and it draws attention to the two-
dimensional design of the picture.[62] In *Groundhog Day*, the internal
armature of the composition emphatically echoes the panel in a geo-
metric game of balance and asymmetry. Like Mondrian, Wyeth sets
up a rhythm with the window and its panes, the fence post, chair rail,
tabletop, and corner of the chimneybreast, crossed by emphatic diago-
nals linking the two most animated objects (the patch of sunlight
and the log) and set against a counterpoint of ovals and circles (of
porcelain, wire, iron, wood, and shadow) floating within the grid. The
geometric sensibility of this design illustrates Wyeth's penchant for
abstraction and the cool, classical mentality that controls his work in
tempera.[63] At the same time, forces of restlessness and movement—
the diagonals, the ovals—keep the square format from settling into
stasis. Just as he yanked the doorway to the right in *Cooling Shed* to
give a deliberately "off-balance" surprise to the picture, Wyeth keeps
*Groundhog Day* in motion. The artist's viewpoint, traditionally the
center of a painting, pulls slightly to the right, along with the window,

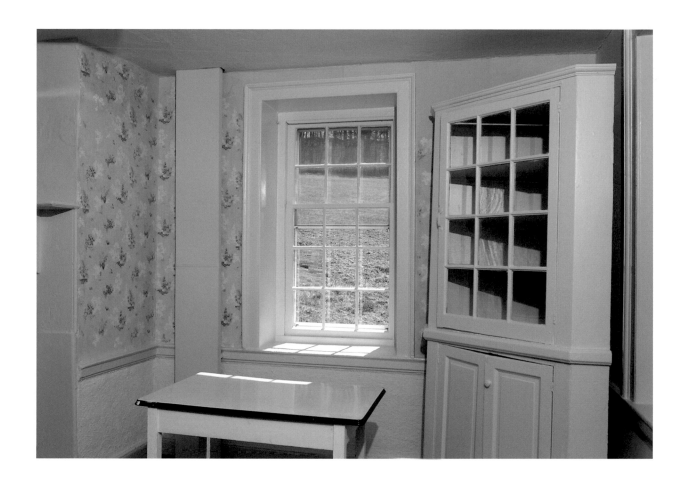

Fig. 95. The interior of the Kuerner kitchen, 2004, courtesy of the Brandywine River Museum, Chadds Ford, Pennsylvania.

the log, and the table. The left side of the painting, by contrast, is empty yet full of diagonal movement, as the patch of sunlight shimmers and slides along the wall.

Hand in hand with the development of Wyeth's surface grid comes the eerie telescoping of space. He eliminates the corner cupboard at the right, crops and foreshortens the wall at the left, brings the log closer, makes the windowsill shallower, the space between the table and wall narrower—all effects that drain space, confuse illusion, emphasize the two-dimensional pattern of the surface, and increase the tension in the room.[64] Comparing his studies from life or a photograph of the kitchen (fig. 95) to the painting, we can track this compression and spot other intentional, subversive inconsistencies that remind us of the unphotographic, invented character of the image. Wyeth does not like rules and he obeys none of the conventions of linear perspective: the receding diagonals of this interior never resolve into a single vanishing point. Instead, they suggest multiple viewpoints: the table as seen from a seated vantage and the window from several standing positions, while the dishes float like objects from other worlds, the plate lit from the left, the cup from the right, neither responding to the light from the window beyond. Long shadows on the grass locate the sun low in the sky, while the bars on the wall seem to have been cast earlier in the day.

Such inconsistencies show the restlessness of the painter, his composite method, and his willfulness; they also make the image subliminally unsettled and leave the spectator slightly disoriented, as if viewing multiple exposures. In the spirit of disregarding rules and inserting motion, Wyeth subtly swells the third windowpane to accommodate the cut edge of the log; moves the fence post; and erases the wire fencing where it becomes inconvenient, all to distribute forms across the surface of the design, to organize and focus the composition.

For Wyeth, the painting of a tempera launches an engrossing phase of work sustained for weeks or months. While much has been explored already in drawings and watercolors, much remains to be ventured and perfected. Because no models were required for *Groundhog Day,* Wyeth could work entirely in his studio, from his sketches, stop to work out problems in new drawings, or paint on the panel with some borrowed objects before him.[65] Or he could simply paint from memory. "If a painting is good," he says, "it will be mostly memory."[66] In his figure paintings, Wyeth begins with the figure; here, the landscape and the logs were evidently painted first, either because the Kuerners needed firewood or because the forms had taken on a portrait-like identity for Wyeth that occupied the core of his reverie.[67] The snarling log now occupies the lower right pane, much as Anna's head, diagonally cut by

her kerchief and a jagged fringe of hair, had been placed in his earlier study (see fig. 75). The sentinel fence post, animated in his imagination into another fang-like presence, comes to rest at the left, and the hillside rises to block the distance, save for a wedge of tormented trees and darkness.[68] Across this landscape, as if dropping a literal window frame, Wyeth painted the grid of mullions and the glint of a broken pane, intervening between the world inside and out. "Tempera is, in a sense, like building," he says.[69]

Backing away and moving indoors, Wyeth turned to the wallpaper and tablecloth. If watercolor is the arena of emotion, these tempera passages are the place of Zen meditation. He loves working on the background "after I get in the mood of a thing"; it is not boring, but transporting, done in a state of reverie.[70] Repeated tiny strokes record the passage of time, like a snowfall; applied with a small brush squeezed dry into multiple points, his hatchings are layered into a dry, matte, shimmering surface, denser than the landscape. "White is always exciting to me," he says, and this is a painting about gold and white, thousands of tones of white, especially in the table, a thrilling field of white to build and inhabit imaginatively, to be absorbed into, ant-like, god-like, invisible.[71] In this universe of his own construction, he can place the flower pattern on the wall as it suits him, set the table as it needs to be. Perhaps completed last, the patch of sunlight on the wall is emphatically the most opaque and highly keyed motif. Acting against the threat of the logs and the cool porcelain, the sunlight is the warm and moving presence that survives from the earliest sketches.

The distillation of Wyeth's concept in *Groundhog Day* demonstrates how the slow buildup of the tempera accompanies the process of stripping down the image. "It's not what you put in but what you leave out that counts," he says.[72] Elimination, not only of figures but of extraneous detail, is a device, like the manipulation of space, that allows the artist to back away from realism and press forward the emotional and artistic message of the painting. Although the cleanliness of the room evokes the obsessive hand of Anna and the spareness tells of the Protestant aesthetic of the farm, Wyeth's sketches have shown a kitchen that is not really this empty. Simplification creates a sense of significance in the remaining objects and lifts the ordinary into the realm of the timeless and special. And so the onions are scraped off the windowsill, the flowered ornament is wiped off the cup, the fork and the loaf of bread are removed. The table becomes austere, almost monastic. Wyeth painted it bare at first: the edge of the table glimmers through the cup, which was painted and then (as scraped areas suggest) slightly moved and enlarged. This careful placement was done for the sake of design and mystery, and to sharpen the identity of the missing person, Karl, who in medieval fashion "eats with a knife," the most ancient and savage piece of tableware.[73] Says Wyeth, "I wanted to get down to the very essence of the man who wasn't there."[74]

So this is Karl's table-setting, although there is no chair for him, and no space for a chair either, if he should arrive. Seated, he would have the log's teeth at his back, hungrily looking over his shoulder, on the axis of his knife. Standing in this kitchen, we are confronted by the log, crisply present at the center of our field of vision, distant and yet sharply, unnaturally focused to seem very close. Although chained, it can easily be imagined hurtling through the frail fencing outside the window, crashing through the glass, pushed to the surface of the painting by a brilliant, irrational dot of orange at its distant edge.[75] Behind this dot an inexplicable form (another log?)—the darkest point in the painting—emerges like a dorsal fin, only to be cropped by the window frame before it can be understood. Bright dot and dark wedge identify the nucleus of the menacing energy banked into this painting. Behind them, puzzling shadows—never seen in Wyeth's studies—loom across the grass. Still, peace and orderliness prevail inside. We are safe behind the table and the moat of space beyond, where Karl, with his knife, invisibly tames the wild things and rules the house.

"It is very quiet when you are in this house alone," said Karl. "Andy painted the quiet right in this picture."[76] Alone in this silent house, Wyeth enjoys inhabiting the roles of resident, voyeur, intruder, imagining Goldilocks exploring, Anna imprisoned, Karl returning. And it is February, the season that Wyeth calls "my time of year."[77] "Winter is a time that really appeals to me," he says. "It gets down to the bones." The coldness excites him, and he likes the fact that "there are not too many people around," so he gets "left alone." Groundhog Day, February 2, is a day of judgment, but the verdict, like much of the evidence in this picture, is contradictory or ambiguous: long shadows on the grass, strong sunlight on the wall, no shadows cast on the table. Strong shadows and bright reflections accompanied the china in the drawings, but (like Anna and Nellie) they have been erased. We are reminded, yet again, that this is a world made to Wyeth's order. The subject is the cold day and the warm kitchen and the missing Karl, but the picture is about Wyeth as he likes to be, alone and invisible, suspending time, conjuring dread. "Everyone's away," said Wyeth, contentedly reconsidering *Groundhog Day* in 1995: "I think you feel that winter is going to last a while."[78]

# Notes

My thanks to Andrew Wyeth collection manager Mary Landa and permissions and database manager Karen Baumgartner; Jim Duff, director of the Brandywine River Museum; Suzanne Penn, conservator of modern paintings at the Philadelphia Museum of Art; and Andrew and Betsy Wyeth.

All drawings are from the Wyeth collection unless otherwise noted.

1. "Phila. Museum Pays $35,000 for Canvas by Penna. Artist Wyeth," *Philadelphia Inquirer,* September 30, 1959, p. 16, Philadelphia Museum of Art curatorial files. At the time, this was a record price for the artist's work and "believed to be the highest ever paid in cash by an American museum for a picture by an American painter during his lifetime." "Phila. Art Museum Buys Wyeth Painting for $35,000," *Philadelphia Evening Bulletin,* September 29, 1959, p. 3. In this first, most innocent and "realistic" presentation of the subject of his painting, Wyeth uses the more old-fashioned term "dinner" for the farmer's midday meal; later he would call it "lunch."

2. "Phila. Art Museum Buys Wyeth Painting," p. 3.

3. "Wyeth Painting Sold for $35,000," *New York Times,* September 29, 1959, Philadelphia Museum of Art curatorial files.

4. My thanks to Mary Landa, who queried the Wyeths on my behalf in July 2004. According to American folklore, if the proverbial groundhog (or woodchuck) sees his shadow on February 2, there will be six more weeks of winter.

5. *Andrew Wyeth: Dry Brush and Pencil Drawings* (Cambridge, Mass.: Fogg Art Museum, distributed by New York Graphic Society, 1963), catalogue numbers 45 and 46.

6. Richard Meryman, "Andrew Wyeth: An Interview," *Life* 58 (May 14, 1965): 100. This interview remains the most useful summary of Wyeth's own account of his work close to the period of *Groundhog Day;* it is reprinted in Wanda M. Corn, *The Art of Andrew Wyeth* (Greenwich, Conn.: Published for the Fine Arts Museums of San Francisco by the New York Graphic Society, 1973), pp. 44–78.

7. Richard Meryman, *Andrew Wyeth: A Secret Life* (New York: HarperCollins, 1996), p. 286. Meryman hears in this painting "Karl's rifle shot offstage, Anna's disembodied voice murmuring in German through the house, the sound of her broken mind."

8. Meryman, "Andrew Wyeth," p. 108. In a questionnaire to visitors to an exhibition of Wyeth's work in 1973, Wanda Corn found that 257 of 701 respondents voted the "single characteristic" of his paintings they liked best to be "the feelings I have when looking at them." Circling words that best described what his art was about, respondents most frequently chose the term *loneliness* (66 percent). Other terms circled by 32 to 47 percent of respondents included *country living, human concern, love,* and *death.* See Wanda M. Corn, "Andrew Wyeth: The Man, His Art, and His Audience" (Ph.D. diss., New York University, 1974), appendix I, pp. 185–186. Corn's analysis of Wyeth's appeal and his place in twentieth-century American art laid the foundation for present-day interpretations of his work.

9. George Plimpton and Donald Stewart, "Andrew Wyeth," *Horizon* 4 (September 1961): 100.

10. Quoted in Gene Logsdon, *Wyeth People: A Portrait of Andrew Wyeth as He Is Seen by His Friends and Neighbors* (Garden City, N.Y.: Doubleday, 1971), p. 30.

11. Many, including the artist, his sister, and his principal biographer, Richard Meryman, have commented that Wyeth's portrait of Karl Kuerner is really a displaced portrait of N. C. Wyeth; see, for example, Wyeth, in Meryman, "Andrew Wyeth," p. 110.

12. Testorf, in Bo Bartlett and Betsy James Wyeth, directors, *Andrew Wyeth: Self-Portrait—Snow Hill,* videocassette recording (Derry, N.H.: Chip Taylor Communications, 1995).

I am indebted to John Milner, who shared with me the description of the house prepared by Wise Preservation Services for the National Historic Landmark Nomination of the Kuerner Farm. Built around 1814, the house may have replaced an earlier dwelling; the third story and hipped roof were added around 1850. Wyeth occasionally

painted in one of the third-floor storerooms, where Karl and Anna posed (as in pls. 21, 52), but there are relatively few paintings or drawings of the interior, and most of them are of the kitchen and stair halls.

13. Bartlett and B. Wyeth, *Andrew Wyeth: Self-Portrait.* "Contrast is the thing that probably has interested me most. It's like the Kuerner house. The smell of gingerbread is there, but there's another side—Karl machine gunning American troops coming toward him through the woods." Meryman, *Secret Life,* p. 325. The legendary personality of the farm and Wyeth's study of it over decades were studied in the exhibition catalogue by Thomas Hoving, *Two Worlds of Andrew Wyeth: Kuerners and Olsons* (New York: Metropolitan Museum of Art, 1976), especially pages 39–62, and the concurrently published book edited by Betsy James Wyeth, *Wyeth at Kuerners* (Boston: Houghton Mifflin, 1976), which publishes 370 images, including about fifty of the studies for *Groundhog Day.* For a more distanced view of the Kuerner subjects, see Corn, "Andrew Wyeth," pp. 120–123.

14. Logsdon, *Wyeth People,* pp. 32 and 37.

15. Hoving, *Two Worlds,* p. 31.

16. Plimpton and Stewart, "Andrew Wyeth," p. 97. Wyeth has often tried to describe the thrill he gets from discovery; see Hoving, *Two Worlds,* p. 31; Bartlett and B. Wyeth, *Andrew Wyeth: Self-Portrait.*

17. "Andy had been in and out of here no telling how many times, and then one day he up and decided to paint it," remembered John Wylie in Logsdon, *Wyeth People,* p. 49.

18. Karl Kuerner, quoted in ibid., p. 37.

19. On Wyeth's legendary childhood and the impact of his father, see Corn, *Art of Andrew Wyeth,* pp. 118–130; Corn, "Andrew Wyeth," pp. 50–76; and Meryman, *Secret Life,* pp. 23–108. As Knutson notes in her essay, and Crosman describes in his profile of Betsy Wyeth in this volume, first his father and then his wife managed Wyeth's career and protected his time.

20. Meryman, "Andrew Wyeth," p. 93. For the "Magic Realists" show at the Museum of Modern Art in 1943, Wyeth wrote that his intent was "not to exhibit craft but rather to submerge it; and make it rightfully the handmaiden of beauty, power, and emotional content." Quoted in Selden Rodman, "Andrew Wyeth," in *Conversations with Artists* (New York: Devin-Adair, 1957), p. 215.

21. Plimpton and Stewart, "Andrew Wyeth," p. 99. For an astute assessment of Wyeth's drawing techniques, see Henry Adams, "Seven Secrets of Andrew Wyeth's Technique," *American Artist Drawing* (Spring 2004), pp. 38–47. Adams notes that technique and feeling are inseparable in Wyeth's work, and he comments on the "reckless emotional intensity" of his drawings as well as his "canny grasp of technique."

22. Wyeth treats his sketches roughly, as tears, splashes, and smudges attest, and he will throw away or burn his work, but at the end of a season in Maine or Pennsylvania his wife Betsy will gather and catalogue his surviving studies, thousands of which remain in the artist's collection housed at the Brandywine River Museum in Chadds Ford and the Farnsworth Art Museum in Maine. Perhaps fewer than twenty of Wyeth's tempera paintings (less than ten percent of his lifetime total) have more than forty preparatory works extant. Only *Brown Swiss,* the great portrait of the exterior of the Kuerner farm (pl. 32), has more surviving studies than *Groundhog Day.*

23. Hoving, *Two Worlds,* p. 76. Unless otherwise noted, the succeeding quotations from Wyeth come in sequence from this text. Similar texts, evidently from the same interviews with Hoving, also appear in Andrew Wyeth, *Andrew Wyeth: Autobiography,* ed. Thomas Hoving (Boston: Little, Brown; Kansas City, Mo., Nelson-Atkins Museum of Art, 1995), p. 51. In conversation with me on November 17, 2004, Wyeth agreed that the first sketches were made in the fall of 1958.

24. Among the sketches from this moment may be those reproduced in B. Wyeth, *Wyeth at Kuerners,* pp. 118 (two drawings at top) and 119 (drawing at right) as well as one that remains in the Wyeth Collection and has never been published. The hallmark of sketches

from this imaginative moment seems to be framing lines around the composition, suggesting distance from the subject, as seen in the mind's eye. Life studies do not seem to be bracketed in this fashion. The sequence of studies I propose here is based on Wyeth's testimony (principally published in Hoving, *Two Worlds*) and the internal evidence of the drawings. It is not the order published in *Wyeth at Kuerners*. In systematically cataloguing the work and later organizing the Kuerner book, Betsy Wyeth interviewed the artist about the sequence of the drawings, but he was not always precise, so the book was ultimately organized by topics.

25. B. Wyeth, *Wyeth at Kuerners,* p. 115. Meryman described Anna as the "heart of the drama of the farm," a figure broken by homesickness and exhaustion, and periodically hospitalized for mental illness. Because she usually declined to pose, Wyeth painted her presence indirectly in onions, blankets, the smoke curling from the chimney, or a lit window. Meryman, *Secret Life,* pp. 286–291.

26. For others in this series, see B. Wyeth, *Wyeth at Kuerners,* pp. 115–117.

27. In Hoving, *Two Worlds,* p. 104. "To me, pencil drawing is very emotional, very quick, very abrupt medium. . . . I will perhaps put in a terrific black and press down on the pencil so strongly that perhaps the lead will break, in order to emphasize my emotional impact with the object. . . . Pencil is sort of like fencing or shooting," ibid., p. 31.

28. See 1231v, in B. Wyeth, *Wyeth at Kuerners,* p. 115. Wyeth studied both women from outside their kitchen windows, as in *Geraniums* (pl. 36); see ibid., pp. 111–113. Wyeth's voyeuristic streak in *Geraniums* places him outside the window, exactly in the place of the fence post that seems to peer into *Groundhog Day.*

29. The others in this sequence are B. Wyeth, *Wyeth at Kuerners,* pp. 119 (drawing at right) and 120 (drawing at left).

30. See three drawings in B. Wyeth, *Wyeth at Kuerners,* p. 121.

31. Hoving, *Two Worlds,* p. 104. Corn notes the example of N. C. Wyeth and Howard Pyle in this kind of immersion in the subject; see "Andrew Wyeth," pp. 70–72.

32. See, for comparison, Knutson's discussion of *Wind from the Sea* (pl. 20), which proposes a landscape of escape and longing.

33. Beth Venn, "Process of Invention: The Watercolors of Andrew Wyeth," in Beth Venn and Adam D. Weinberg, *Unknown Terrain: The Landscapes of Andrew Wyeth* (New York: Whitney Museum of American Art; distributed by Abrams, 1998), pp. 36–48. This was the first major exhibition to explore the importance of watercolor in Wyeth's work.

34. Hoving, *Two Worlds,* p. 33. "Watercolor was Wyeth's first medium, embarked on at the age of eleven some five years before his father took him in hand." "Andrew Wyeth's Magic Reality," *Artnews* 42 (November 1943): 14.

35. Meryman, "Andrew Wyeth," p. 98.

36. See Kathleen A. Foster, "Makers of the American Watercolor Movement, 1860–1890" (Ph.D. diss., Yale University, 1982); and Carol Troyen, "A War Waged on Paper: Watercolor and Modern Art in America," in Sue Reed Walsh and Carol Troyen, *Awash in Color: Homer, Sargent, and the Great American Watercolor* (Boston: Museum of Fine Arts in association with Bulfinch Press, 1993), pp. xxxv–lxxiv.

37. "I loved the works of Winslow Homer, his watercolors, which I studied intently so I could assimilate his various watercolor techniques," Wyeth noted in Hoving, *Two Worlds,* p. 17. Many reviewers in the 1930s hailed him as Homer come again; see Michael R. Taylor's essay in this volume. Wyeth surely knew the collection of Homer's watercolors frequently exhibited at the Philadelphia Museum of Art, including figure 83.

38. See Kathleen A. Foster, "The Pre-Raphaelite Medium: Ruskin, Turner, and American Watercolor," in Linda S. Ferber and William H. Gerdts, *The New Path: Ruskin and the American Pre-Raphaelites* (Brooklyn: Brooklyn Museum and Schocken Books, 1985), pp. 79–108.

39. See E. P. Richardson, "Andrew Wyeth's Painting Technique," *Atlantic Monthly* 208 (June 1964): 62–71; reprinted in Corn, *Art of Andrew Wyeth,* p. 85. "A drybrush happens. It isn't something you plan to do," says Wyeth. He prefers to categorize such works apart,

although the materials are identical, and his distinction seems mostly to be in attitude and method rather than materials. On the development of his drybrush technique, which he credits to Dürer, see Hoving, *Two Worlds,* pp. 15, 17, and 33–35; and Venn, "Process of Invention," p. 41.

40. Hoving, *Two Worlds,* pp. 79 and 82.

41. A patch of the original wallpaper behind the cupboard can still be seen in the room, which has been restored and opened to visitors by the Brandywine River Museum. Betsy Wyeth remarks that Anna Kuerner's "touch is seen in very few places on the farm. One of them is the flowered wallpaper in the kitchen" in B. Wyeth, *Wyeth at Kuerners,* p. 130. Meryman also comments on Anna's "tattered femininity" represented by the wallpaper, *Secret Life,* p. 286. Again, Anna can be paired with Christina Olson, who is often understood to be present in the ragged embroidered curtain in *Wind from the Sea* (pl. 20). Alternate studies show Anna's shoe on the table; see B. Wyeth, *Wyeth at Kuerners,* p. 131.

42. In one Wyeth collection study (not published), Wyeth glued a smaller sheet to a larger one to continue the drawing to include the corner with the patch of sunlight, much as it appears in the painting.

43. Meryman "Andrew Wyeth," p. 114. Meryman notes, perhaps from conversations with Wyeth, that *Groundhog Day* "reverberated" with the memories of Wyeth making mud pies with his sister, and setting them out to dry in a shaft of sunlight.

44. Hoving, *Two Worlds,* p. 82.

45. See "The Gum Tree Log" sequence in B. Wyeth, *Wyeth at Kuerners,* pp. 86–91 and 133–148.

46. B. Wyeth, *Wyeth at Kuerners,* p. 111. Betsy Wyeth notes that "this corner window in the kitchen appears over and over again. The artist will eliminate window after window, but seldom this one." Ibid., p. 110.

47. Meryman compared the log to "the great battering rams that once broke down medieval castles," *Secret Life,* p. 287. See the same construct, of a log pointed at a doorway of a sawmill, in *The Peavey,* a watercolor of 1965. For the initial idea, in pencil in the sketchbook and the other watercolor, see B. Wyeth, *Wyeth at Kuerners,* pp. 141–142. Some of the *Groundhog Day* drawings are on Strathmore paper; most have no watermark. The regular sizes of his watercolors, such as the 14 by 20-inch size also preferred by Winslow Homer (e.g., *Wild Dog,* fig. 91, or *Groundhog Day Study* [Kitchen window], fig. 82), and the traces of adhesive along the edges indicate the use of watercolor "blocks," sketchbooks sealed on all four sides to keep the sheets flat while they are being worked wet. Finished sheets are cut from the block to expose the next page. Other pages show signs of being taped to a drawing board.

48. A. Wyeth, *Autobiography,* p. 101. In 1965, perhaps remembering such images, he confessed that "my wild side that's really me comes out in my watercolors—especially of snow, which is absolutely intoxicating to me. I'm electrified by it." Meryman, "Andrew Wyeth," p. 108.

49. Notes from the Coe-Kerr Gallery, Wyeth Archives. This image in the snow also calls to mind Howard Pyle's frightening illustration of "The Salem Wolf" (1909); see Delaware Art Museum and William A. Farnsworth Library and Art Museum, *Wondrous Strange: The Wyeth Tradition; Howard Pyle, N. C. Wyeth, Andrew Wyeth, James Wyeth* (Boston: Little, Brown, 1998), p. 10.

50. In the unpublished draft of the Andrew Wyeth catalogue raisonné, *First Snow* is annotated, "When this painting had been completed, *Groundhog Day* was begun," probably in November or December of 1958.

51. Logsdon, *Wyeth People,* p. 30.

52. See B. Wyeth, *Wyeth at Kuerners,* p. 146 (drawing at left). This drawing is an interesting combination of observation and compositional planning, with the mullions drawn (or erased) in several configurations, none of which were used in the painting, although the configuration of trees along the distant fence appears in the tempera.

53. See ibid., pp. 144, 146, and 147.

54. Meryman, *Secret Life*, p. 245. Like many of Wyeth's sketches, drawing 1240 from the sketchbook shows a heel mark.

55. Wyeth, in Hoving, *Two Worlds*, p. 50.

56. Andrew Wyeth, conversation with the author, November 17, 2004.

57. Although surely made close to the end of his sequence of studies, fig. 94 is annotated "First Study for Groundhog Day," evidently part of Wyeth's endorsement of the drawing when he later gave it to an admirer.

58. A valuable study of Wyeth at work on tempera, with photographs of his panel at different stages of completion, is Elaine de Kooning, "Andrew Wyeth Paints a Picture," *Artnews* 49 (March 1950): 38–41, 54–56. More recently, Hilton Brown studied Wyeth's materials and technique in tempera in "On the Technical Side," in Richard J. Boyle, Hilton Brown, and Richard Newman, *Milk and Eggs: The American Revival of Tempera Painting, 1930–1950* (Chadds Ford, Pa.: Brandywine River Museum; Seattle: Washington University Press, 2002), pp. 125–130.

59. Plimpton and Stewart, "Andrew Wyeth," p. 99.

60. Hurd's instructions are held in the Wyeth Archives. On the tempera revival of the 1930s and 1940s, see Boyle, Brown, and Newman, *Milk and Eggs*. Meryman cites Betsy Wyeth in his characterization of Wyeth's work in tempera, *Secret Life*, pp. 118–119. On the role of tempera, see Knutson's essay in this volume. Notwithstanding his professed gratitude to Hurd and the old masters of tempera painting, Wyeth has personalized the technique in non-traditional ways. As the paintings conservator Suzanne Penn has pointed out to me in our many conversations about *Groundhog Day*, the variety of Wyeth's handling, from unconventional, broad underwashes to thick impasto, scumbling, and delicate hatching and fingerprinting, is not seen in Renaissance tempera technique. She notes that traditional egg tempera also uses more binder to produce a hard, glossy paint surface, while Wyeth's pigment-rich mixtures build a characteristically powdery, matte surface. Dry, and applied in many complex layers, the paint surface of *Groundhog Day* is inherently fragile.

61. Most of Wyeth's temperas are on prefabricated panels made by artists' suppliers, such as the F. Weber "Renaissance" panel used for *Groundhog Day*, which (according to the label on the back) was originally 48-inches square. Custom-made for Wyeth several years earlier (per inscription on the back noting "date prepared 10.5.55"), the panel was trimmed on the right and lower edges. Wyeth did such work himself, because he cannot bear to be watched, although in conversation he could not recall cutting this particular panel. Andrew Wyeth, conversation with author, November 17, 2004. Philadelphia Museum of Art conservation reports have speculated about the presence of darker forms under the paint surface at the lower right, but Wyeth does not think there was an earlier composition on the panel. Only rarely, as in *Braids* (pl. 64), has Wyeth cut a panel down after painting it; see Meryman, *Secret Life*, p. 354. Paint overlaps on all four edges indicate that *Groundhog Day* was painted after the panel was trimmed to its present size.

62. See John Wilmerding's comments on Wyeth's use of square formats (usually for portraits) in his introduction to this volume.

63. Adam D. Weinberg describes "classical realism" as one of Wyeth's modes, "Terra Incognita: Redefining Wyeth's World," in Venn and Weinberg, *Unknown Terrain*, p. 30. Wyeth will begin his composition on the panel in charcoal, which does not read through the paint surface like graphite, making it impossible to track his work at this stage except as shown in photographs like those published in de Kooning, "Wyeth Paints a Picture." Wyeth continued to refine this grid well into the painting of the tempera, as changes in the placement of the window mullions (visible in raking light) attest.

64. Wanda Corn has astutely identified many of Wyeth's devices of "disembodied" or multiple viewpoints, compressed or expanded pictorial space, and two-dimensional design; she was also the first to develop the links between Wyeth and the photographers of his youth such as Walker Evans and Charles Sheeler, who used close cropping, odd vantage points, and sharp, overall focus in their work. See Corn, *Art of Andrew Wyeth*, pp. 104–112; and Corn, "Andrew Wyeth," pp. 43 and 46.

65. Wyeth borrowed some of the Kuerners' "ironware" to paint from in his studio. When the table unexpectedly collapsed and the china was broken, he searched local markets for identical replacements, which he returned to them without comment. Andrew Wyeth, conversation with the author, November 17, 2004.

66. Video interview, London Weekend Television, 1980, quoted in Martha R. Severens, *Andrew Wyeth: America's Painter* (New York: Hudson Hills Press, 1996), p. 19.

67. See de Kooning, "Wyeth Paints a Picture," pp. 38–40, for an example of a figure painting.

68. "When I was painting it, I felt that the fence post replaced the fangs of the dog." Betsy Wyeth, quoting Andrew Wyeth to me in conversation, November 16, 2004. Wyeth reiterated this himself the following day.

69. Hoving, *Two Worlds*, p. 34.

70. Meryman, "Andrew Wyeth," p. 106. "Truth is, I use tempera partly because it's such a dull medium—those minute strokes put a brake on my real nature—messiness." Ibid., p. 108.

71. Bartlett and B. Wyeth, *Andrew Wyeth: Self-Portrait*.

72. De Kooning, "Wyeth Paints a Picture," p. 40.

73. Hoving, *Two Worlds*, p. 82. "The table set with a knife—that's Karl because he ate with a knife most of the time, no fork"; A. Wyeth, *Autobiography*, p. 51. In raking light, the silhouette of the scraped-out tumbler is visible, overlapping the lower right of the cup and saucer. The surface of the panel has also been scraped to the left of the plate and in the area of the windowsill; Wyeth admitted in conversation that he removed something painted there (November 17, 2004).

74. Hoving, *Two Worlds*, p. 82. In 1961, Wyeth noted that by elimination, he expresses "more the essence of the object than the object itself," Plimpton and Stewart, "Andrew Wyeth," p. 101.

75. Hilton Brown notes Wyeth's use of dots of red on the ear and eyelid of the dog in *Raccoon* (1958), which he describes as a device to enliven "dead" areas. Boyle, Brown, and Newman, *Milk and Eggs*, p. 130. However, as with the log, these dots on *Raccoon* circle the visual and emotional center of the image, not the "dead" peripheries.

76. Logsdon, *Wyeth People*, p. 30. "I was after the silence of the afternoon." Andrew Wyeth, conversation with the author, November 17, 2004.

77. Wyeth in a letter of January 1957, quoted in Agnes Mongan, "Introduction," *Dry Brush and Pencil Drawings*, [p. 2].

78. Bartlett and B. Wyeth, *Andrew Wyeth: Self-Portrait*. "I prefer winter and fall, when you feel the bone structure in the landscape—the loneliness of it—the dead feeling of winter. Something waits beneath it—the whole story doesn't show. I think anything like that—which is contemplative, silent, shows a person alone—people always feel it is sad. Is it because we've lost the art of being alone?" Meryman, "Andrew Wyeth," p. 110.

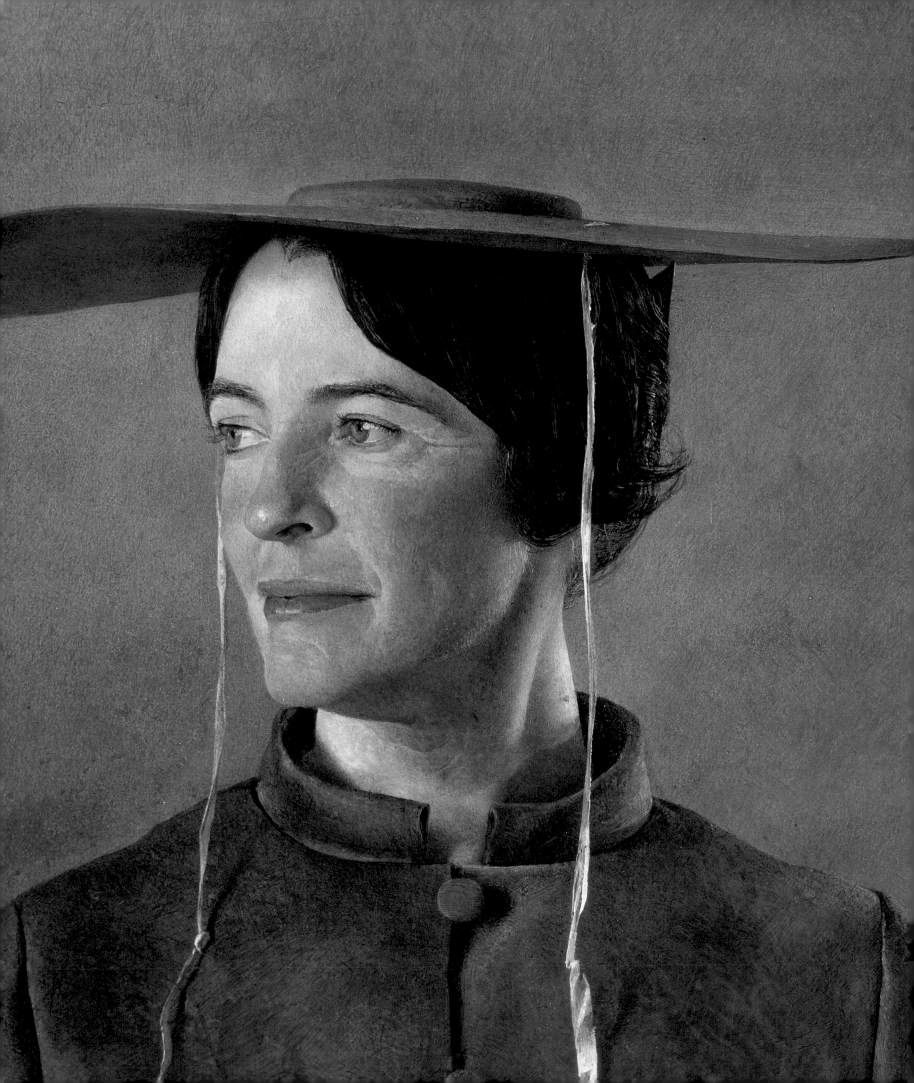

# Betsy's World

## Christopher Crosman

MAGA'S DAUGHTER IS ONE OF Andrew Wyeth's most direct portraits of his wife. Betsy James Wyeth is posed in a three-quarter view (pl. 46). Her posture is erect and proud, she averts her eyes. She wears an antique riding hat with silk drawstrings hanging loosely on either side of her face—a kind of frame within the frame. Her simple high-collared brown dress almost merges with the slightly lighter, dusky brown in the empty and indeterminate background. Her cheeks are slightly flushed; she was reportedly furious with her husband for agreeing to serve on various government art committees that took him away from painting.[1] Yet there is the beginning of a smile and her eyes flash as she looks toward an unseen light source. For Andrew Wyeth, her face *is* the source of light. The picture's deceptively simple composition and muted colors give way to such tonal richness and warmth in Betsy's face that the artist may reveal more about his affection for his wife than he knows.

*Maga's Daughter* is one of dozens of formal and informal portraits of Betsy painted by her husband during their sixty-five-year relationship.[2] Acting as Andrew's model is only one of her many roles: family matriarch and mother of two sons, architectural designer and preservationist, author, critic, publisher, editor, curator, archivist, documentary filmmaker, business and financial manager for family enterprises, gourmet chef, and knitter of her husband's sweaters. The wonder of it is the aura of order, calm, and even serenity that prevails in the Wyeths' homes. As in one of Andrew Wyeth's temperas, there is a lot going on beneath the surface.

Betsy Wyeth's role in her husband's work, as well as the story of her own life and talents, has only begun to be recognized in recent years. Her abilities across a wide spectrum of activities seemingly unrelated to Andrew's art—especially her "colonization" of Benner and Allen Islands—have also received attention.[3] But precisely how and to what degree Betsy has affected her husband's work is difficult to assess because their lives together are so closely entwined. At the same time, they respect each other's independence. Betsy is not a painter herself, but her background and interests may have played a more important role in Andrew's work than many suspect.[4] The pervasiveness of her presence in his art is strongly sensed, yet remains hidden, as even Andrew Wyeth's closest and most perceptive critics and biographers readily acknowledge. This essay can only touch on the indisputable fact of Betsy's influence. A corollary question is how Betsy has affected the way we think about her husband's work, which has immensely complicated the critical response to Andrew's work. Stepping into Betsy's world, as one close family friend has observed, is like entering a John Fowles novel, where the ground is always shifting and our vision is reversed at every step along the extended, mirrored hallway of their lives together.

### Roycroft Child

Betsy Merle James, the youngest of three daughters, was born on September 26, 1921, and raised in East Aurora, New York, a community that was home to the Roycroft workshops, founded in 1896 by Elbert Hubbard. Her parents, Merle Davis James and Elizabeth "Bess" Browning James (also called "Maga" by the family), moved to East Aurora shortly after their first child was born so that Merle could work as an illustrator for various Roycroft publications. The Roycroft workshops were an important manifestation of the American Arts and Crafts movement at the turn of the century. Roycroft design, derived from the theories of William Morris and John Ruskin, was a reaction to the dehumanizing aspects of the Industrial Revolution.

The James family (fig. 96) lived in a Roycroft house, "Harmony Castle," and Elbert Hubbard II was a close family friend. Betsy's early childhood memories include a balcony off her bedroom where she spent many hours in private reverie. As the youngest child, she learned to keep her own company—preferred it, really. One day while skiing across the open fields, she recalls, "I heard laughter coming from a barn. Not just regular laughter but heavy, loud, raucous laughter. I skied over to see what it was about and to my horror witnessed several men watching a pig they had butchered dying as its blood squirted

Fig. 96. The James family at East Aurora, ca. 1927: Merle D. James, Gwendolyn, Betsy, Elizabeth (Maga), and Louise. Courtesy of the Wyeth Family Archives.

from its neck."[5] That first, sudden childhood encounter with terror and brutality—and its cruel beauty—left an indelible impression on Betsy, one that lay dormant until she met Andrew Wyeth and sensed its immanence in his best work.

Her mother, a Connecticut Yankee, came from financial means and could trace her family back eleven generations (William Bradford, an early governor of the Plymouth Colony, was among her ancestors). Bess James was interested in the performing arts, taking the children to theater productions in Buffalo, an important tryout city for new Broadway plays. Although her sisters both majored in art at Syracuse University, Betsy was never interested in painting; theater seemed more magical, alive. She moved easily among Buffalo's social elite, many of whom had estates in East Aurora.[6] But Betsy was always drawn to older people and social outsiders. She recalls dropping in on her older neighbors in East Aurora to talk or help with routine chores, something she also did during her childhood summers in Maine, when she made regular visits to Christina and Alvaro Olson's nearby farm.

Quiet and obedient in her youth, the "good" daughter (in comparison to her outgoing, more worldly older sisters), Betsy was also athletic and sometimes a risk-taker. As a child, she kept her independent spirit hidden from her family, teachers, and friends, showing a willful resolve to organize and control any intimations of chaos and disorder. For instance, Betsy's lifelong interest in architecture and design undoubtedly was stimulated by a childhood game she invented called "Rooms." For much of her childhood and early adolescence, Betsy and her friends

spent countless hours arranging and rearranging pictures of home furnishings that Betsy kept in flat file boxes. The pictures were cut from magazine and newspaper advertisements or illustrations and kept in her archive of images, catalogued by room function—bathroom, living room, dining room, etc. Betsy would select the furnishings and imagine the interior settings and the houses that contained her furnishings.[7] Today the spare elegance of her interior design (including the design of hidden shelving units to hold small kitchen appliances and other clutter) parallels and, indeed, informs the controlled, spare look of many of Andrew's paintings of interiors, notably *Her Room* (pl. 40).[8]

## Photo Editor's Daughter

Her father, Merle James, provided Betsy's most important early art education, an informal apprenticeship that would play an important role in the early years of her life with Andrew Wyeth. James was the rotogravure editor for the *Buffalo Courier-Express*. Betsy regularly accompanied him to his office and to the photography morgue, where she would pore over old news photos, asking why a certain picture was chosen over another for publication. James, an amateur painter, had an artist's eye and considerable knowledge of contemporary, "modern" art, the subject of excruciatingly boring dinner table conversations (in Betsy's view). In his own editorial and journalistic roles, he looked for the telling moment, the photograph that would tell the story or amplify the typeset copy in a meaningful way. He wanted the photograph to connect to the lives of the newspaper's readers, ordinary people in a heavy-industry town that by the 1930s had been hard hit by the Great Depression. The artist in him would have also looked for compositional clarity, the play of light and shadow, the balance of forms, and a coherent pictorial structure. Through him, Betsy learned the fundamentals of connoisseurship and developed a formal visual intelligence that proved uncannily consistent with that of her future husband.

Andrew Wyeth's marriage to a photo editor's daughter may have had a profound impact on his development, affecting choices of subject matter, style, and emotional content. Wanda Corn, in one of the earliest scholarly studies of Wyeth's art, argues that during his formative years, Wyeth and other "metaphoric realists" developed a kind of "camera vision." In these critical years, "the camera was central to the age, James Agee claimed, as it could 'do what nothing else in the world could do: perceive, record, and communicate, in full unaltered power, the peculiar kinds of poetic vitality which blaze in every real thing.'"[9] Several characteristics of "camera vision" were borrowed by painters during the 1930s, "creating interesting compositions by careful cropping and framing, working from unusual view points, and finding abstract arrangements of lights and darks . . . [and] the use of revealing gesture."[10] Wyeth's mature work suggests an understanding of "camera

vision," possibly filtered through the work of such artists as Edward Hopper and Charles Sheeler, as well as the photographers Walker Evans, Dorothea Lange, and Wright Morris.[11] However, according to Betsy Wyeth, Hollywood adventure films of the 1930s and 1940s such as *Dr. Syn, Captain Blood,* and *The Sea Hawk* were probably a more important influence than still photography in terms of drama, gesture, and the suggestion of narrative possibilities "off-camera."[12]

## Bride and Daughter-in-Law

Andrew Wyeth met Betsy James in July 1939. A few days later, he escorted her to a dance in nearby Rockland, Maine, where he asked her to marry him. She said yes. They had known each other for one week (figs. 97–98). Betsy had already enrolled at Colby Junior College, and it was decided that the marriage would have to wait until she completed her first year of college. N. C. Wyeth, though pleased that Andrew had chosen someone from a "good" family, was distraught. Marriage would be more than a minor distraction from his son's promising career; moreover, it would remove Andrew from N. C.'s closed orbit of influence.[13] N. C. was reluctant to let go of Andrew and his condescending attitude toward Betsy deeply offended her. It would be many years before Betsy would reconcile with her father-in-law through a decision to edit and publish N. C. Wyeth's letters after his death. Through this project, she began to appreciate not only N. C.'s profound importance to Andrew and his work but also realized that the father's artistic

sensibility was more subtle and complex than she had thought. She came to see what made him a mythic figure in the family imagination, and also the private sources of his artistic nature. In her foreword, Betsy Wyeth acknowledges that her publication of N. C.'s letters was "to pay back a debt long overdue."[14] What had begun as a kind of apology ended ten years later in a publication that had become a labor of love. "I knew him for six years," she wrote, "but I never understood him until now. Forgive my foolish heart."[15] Through the act of revealing the father to the son, she helped free her husband—and herself.

From the outset of their relationship, Betsy encouraged Andrew toward a new direction in his art. Betsy provided the firm resolve that made it possible for Andrew to pursue his innermost vision at a critical moment when pressure from his father and others—dealers, patrons, and critics—could easily have convinced him to settle for the comfortable success of his early work. The day after they met, Wyeth took Betsy and her sister to his studio. Betsy recounts the moment: "I never said a word but was fascinated by a portrait [in tempera] leaning against the wall. Suddenly A. W. said, 'You haven't said anything, Betsy. What do you like?' 'That.' It was, of course, *Young Swede* [fig. 99], which we still own. A. W. later—much later—told me, 'That was it.'"[16]

Betsy immediately recognized that tempera was Andrew's strength, despite the fact that most of his early experiments with the medium were characterized by the loose, flashy, colorful effects of his watercolors. She encouraged him to abandon his "Frenchy" color and brushwork,

Fig. 97. Andrew and Betsy Wyeth at their wedding, 1940. Courtesy of the Wyeth Family Archives.

Fig. 98. Betsy, Andrew, and N. C. Wyeth at wedding reception, 1940. Courtesy of the Wyeth Family Archives.

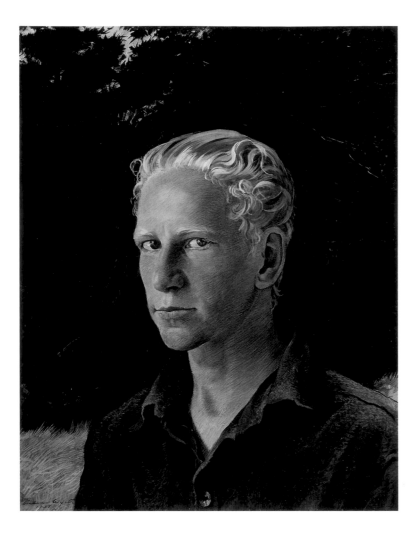

Fig. 99. Andrew Wyeth, *Young Swede,* 1938, tempera on panel, 20¼ × 16½ inches, Collection of Andrew and Betsy Wyeth.

with the dry, crackling leaves of salt grass, is utterly simple. Indeed, N. C. Wyeth thought the painting needed a gun and a dog to give it narrative interest.[17] By this time, though, Andrew had stopped heeding his father's advice, and he (and presumably Betsy) understood that the point of the painting was its emptiness.[18] Viewers would be seduced by what the artist left out and by the implied invitation to bring their own memories and associations to the painting. The story would primarily be the viewer's own. In its unusual cropping, precise drawing, limited color, light and dark contrasts, and concentration on the ordinary, unremarkable act of walking through an open field, Wyeth brings his "camera vision" to bear on his work, coinciding precisely with Betsy's editorial instinct to eliminate all visual information extraneous to Wyeth's essential point—the poetic possibility inherent in the ordinary and commonplace.

Betsy Wyeth edits her husband's work in another significant way. She has managed the family's accounts since 1942, when Josephine Hopper advised her to document Andrew's work.[19] She exerts influence on which works will be released for sale, although she is not directly involved in the sale of Andrew's work.[20] She leaves direct sales to family members and trusted friends, but Betsy found financial independence of her own. By establishing and building a worldwide market for reproductions of Andrew's art, she was not only able to free Andrew from the business side of his career but even to help him see his own work differently.

In the relatively new field of art reproduction, Betsy Wyeth was among the first to recognize a significant business opportunity. She was aware of N. C. Wyeth's pioneering role in popularizing color reproductions, primarily through his long association with Scribner's Illustrated Classics. Even so, the shortcomings of the existing color-reproduction processes had forced N.C. to adapt his palette and technique to meet the technical limitations of commercial printing. Betsy sought to control the quality of reproductions of her husband's work and to provide wider access to her husband's images.[21] Her recognition of a vast popular market for Wyeth reproductions— 55,000 copies of *Master Bedroom* (fig. 101) have been sold—and her insistence on the highest quality of production challenged existing printing technology as well as preconceptions of the art market, blurring the distinction between fine art and limited edition prints.[22] As in other endeavors, she proceeds with a blithe disregard for what anyone other than her husband thinks . . . and Andrew only cares about what Betsy thinks.

which she considered too "fancy," too close to showing off. Intuitively, Betsy sensed the distinctive qualities of tempera: rich earth tones, the gradual building of form through layers of thinly applied pigment that allows a kind of illumination from within, the tight drawing that would concentrate on essential motifs. Her editorial eye, as well as her Roycroft background, told her that craft should manifest itself in the telling detail; that monochromatic shifts from light to dark create pictorial mood and complexity; and that emotional resonance is a product of the ambiguity and mystery found in plain, commonplace subjects. All of these aesthetic possibilities are revealed in one of Andrew's first mature temperas, *Turkey Pond* (fig. 100).

*Turkey Pond* contains the basic compositional elements that would characterize *Christina's World* (fig. 44) four years later: a lone figure in a grassy field, seen from slightly below and behind; a high, uncluttered horizon line; and the elimination of superfluous anecdotal detail. Wyeth's depiction of his close friend Walt Anderson striding across an empty field on a fall day when the bright crispness in the air rhymes

Fig. 100. Andrew Wyeth, *Turkey Pond,* 1944, tempera on panel, 32¼ × 40¼ inches, Farnsworth Art Museum, Rockland, Maine, gift of Mr. and Mrs. Andrew Wyeth in memory of Walter Anderson, 1995.

## Curator and Business Manager

Betsy Wyeth's business activities serve a variety of purposes, including historical and environmental preservation, art-historical research and scholarship, and, most importantly, generating the means to buy back key paintings that she considers essential to preserving Andrew Wyeth's legacy—indeed, the legacy of the entire family.[23] Betsy was the first to recognize that N. C. Wyeth's illustrations for *Treasure Island* were among his best works; she bought nearly all of them back before anyone else noticed their importance. She often buys these works (including her husband's paintings) without Andrew's knowledge, and sometimes withholds a work until his birthday or some other family occasion. Andrew professes not to care where his art goes after a work is finished, yet he is always thrilled to see some of his best works return home like long-absent children. As Andrew's curator, Betsy has meticulously documented his entire oeuvre. Her catalogue raisonné of Andrew's work includes dozens of thick loose-leaf binders of entries on works ranging from childhood drawings to recent watercolors.

In the mid-1980s, when museums were beginning to computerize their collection catalogues, Betsy persuaded Thomas Watson of IBM to develop image-based cataloguing software and hardware. Technology is only now beginning to catch up with the visionary idea that digital images of artworks could open a universe of possibilities for research and education. Andrew Wyeth reviews hard copies of the digital images of his works with Betsy, who records dates, technical information, and anecdotes he resurrects from his prodigious memory. Occasionally the images of early paintings will trigger new works, inspiring Wyeth to revisit subjects, themes, or details that he had long since set aside. The full extent of Betsy's archival activities may never be fully understood. As for many other artists, revisiting earlier themes is central to Wyeth's creative process, especially since so much of his best work is introspective. Andrew's longstanding practice of collapsing past and present, Maine and Chadds Ford, fact and fiction, into new works of art owes much to his wife's cataloguing program and the access it has given the artist to his own work.

Fig. 101. Andrew Wyeth, *Master Bedroom*, 1965, watercolor on paper,
21⅛ × 29½ inches, private collection.

## Set Designer and Producer

Visiting the Wyeths' homes in Maine and Pennsylvania sometimes feels like walking into an Andrew Wyeth painting. It may also be that looking at a Wyeth painting is like walking into Betsy Wyeth's homes. In truth it's both. Since Andrew only paints what he intimately knows, he is in some measure recording and interpreting what Betsy gives him to look at and think about. Betsy's interiors and buildings echo Andrew's paintings and his paintings re-invent her environment and their lives together. Betsy once described herself as the director of the play in which Andrew stars. If so, she is also the set designer and producer.

The Oar House on Benner Island, Maine (fig. 102), named for the large pulling oar over the interior mantle that belonged to Henry Teel, is similar in elevation and proportion (though reversed) to Teel's home on Teels Island, as seen in *Island House* (fig. 103).[24] Whether or not Betsy Wyeth consciously built Oar House with Henry Teel or the Teel house in mind, recent paintings such as *Airborne* (pl. 80) seem to reprise earlier work, but with new emotion and radically different handling. Molting seagull feathers drift from above, a natural scrim lowered on memory that is still fresh and sharply drawn. There is a suggestion of violence, too; the feathers may represent a kind of messy assault on Betsy's too-perfect lawn. Her artificial pond is endangered by the running sea, here protected by a procession of stones forming a loose, irregular wall. If such free associations are far removed from Wyeth's own thoughts, they are precisely what Betsy would want

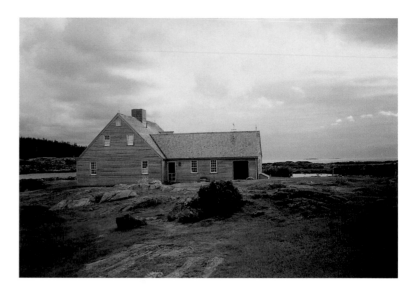

Fig. 102. Oar House, Benner Island, 2001.

Fig. 103. Andrew Wyeth, *Island House*, 1954, watercolor on paper, 13 × 28 inches, private collection.

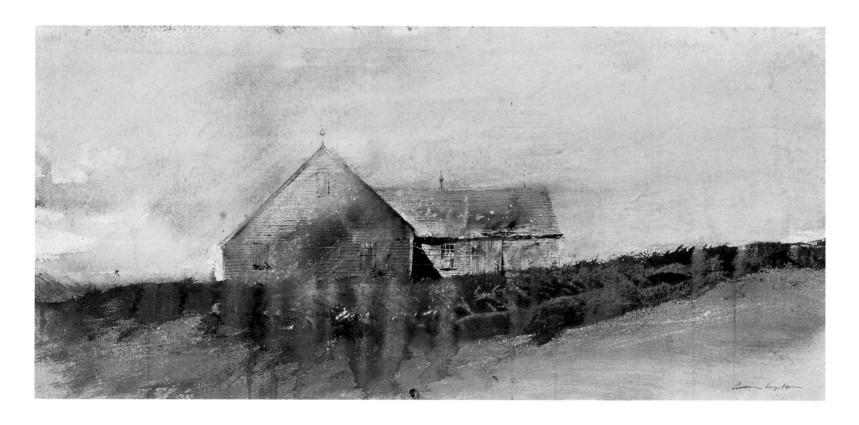

her husband to conjure with, and, in part, why she creates these environments.

*Two If By Sea* (pl. 79) portrays Betsy's adaptation of a winch house, which hauled sailing ships ashore for repairs and maintenance. Her "roundhouse," as it is referred to on Benner Island, is capped by the glass-globed lightning rod from Henry Teel's house. The shape of the building also echoes the octagonal footprint of Mother Archie's Church, the center of an African American community in Chadds Ford that Wyeth knew from childhood. Wyeth has painted Mother Archie's Church and members of the community were his friends and models. (Today, nothing remains of this community except the church's octagonal foundation.) The roundhouse initially contained Betsy's large collection of antique nautical charts of mid-coast Maine, including examples from the *Atlantic Neptune,* one of the earliest and most accurate charts of the New England coast.[25] The charts, published in England in 1774, greatly aided the British navy during the early years of the American Revolution, which may explain the title's reference to Paul Revere's famous ride. Inside the roundhouse are plaster busts of Thomas Jefferson and John Paul Jones; a replica of a tile from Mt. Vernon's greenhouse veranda is at the center of the room, quarried from the same English quarry from which George Washington had ordered the originals.

Betsy's glass-enclosed octagon, her light-filled study by day, becomes in *Two If By Sea* something far more mysterious, almost ominous. Smoke from the candles pulls slightly to the left toward an unseen open door or window; in the painting there is no door, and the windows are closed. By the mid-1990s there were many ghosts in Wyeth's life—his father and mother, his brother Nathaniel and sister Carolyn, Christina and Alvaro Olson, Karl Kuerner, Walt Anderson, and most of his long-time models and closest friends.

*Two If By Sea* recalls an earlier tempera, *The Witching Hour* (pl. 63) set in the eighteenth-century schoolhouse that Betsy salvaged from its former owner in Cushing. As in *Two If By Sea,* smoke from the candles in the chandelier drifts toward an unseen door or window. In the actual schoolhouse, the wainscoting contains old schoolboy graffiti but also evenly spaced, beautifully carved floral forms (possibly apotropaic symbols). A bench holds several antiques, including a black-faced rag doll named Little Evil that appears in Wyeth's painting of the same title.[26]

The entire Wyeth family shares an interest in the supernatural, death, and madness—subjects they often have fun with but also take very seriously. In fact, humor and seriousness are often reflected in the same work of art, yielding a third quality they refer to with the Shakespearean phrase "wondrous strange."[27] The history and manifestations of the Wyeths' fascination with witches, the macabre, and the supernatural are too complex and multifaceted to describe here; for both

Andrew and Betsy, the supernatural is real, and reality is saturated with what Betsy calls "the whisper of history."[28]

Since Betsy opened up Allen Island by cutting a road from one end to the other, Andrew has painted several works there, notably the large tempera *On the Edge* (fig. 104). The painting depicts a lone figure at the southern tip of Allen Island with her head turned, looking out to sea. With blond hair, long spindly legs, and an oversized navy peacoat, she stands on a large granite outcropping, like a human seagull, waiting and watching. The painting is a kind of meditation on whiteness, which Wyeth associates with Maine and with death, presented here in a stunning array of tones, values, and color chords, almost Whistlerian in its subtlety and range. At the beginning of their life together, before Andrew's palette was fully formed, Betsy had suggested that her husband explore the aesthetic and emotional qualities of white. Betsy's buildings and landscapes are transformed by her husband into paintings that are also homages to and portraits of his wife's creativity.

## Model

Betsy Wyeth has posed for her husband many times, appearing in watercolors as early as 1939. She and Andrew, often accompanied by Walt Anderson, used to picnic along the St. George River and nearby islands, where Andrew painted and Betsy flirted with both men. These are the colorful, exuberant, sun-shot watercolors of Andrew's youth, such as *On Bar Island* (fig. 105), exhibiting the qualities that Betsy was even then trying to discourage in her new husband's work. It is hardly surprising that a young man dazzled by the beauty of his new wife would have wanted to express his exuberance and barely contained desire. The watercolors drip with passion, yet are old fashioned in their light touch and respectful distance from Betsy. *Gone Ashore* (fig. 106), a watercolor depicting Betsy asleep in her bed on Benner Island, has the same respectful view, warm light, and caressing brush strokes, but the rumpled bed linens and her bare shoulders imply that the artist's passion remains undiminished nearly sixty-five years later.

During the summer of 1948, Betsy lent her slender figure to the painting that eventually became *Christina's World*—although the figure's gnarled, misshapen hands and arms are modeled on Christina Olson's limbs, ravaged by an undiagnosed malady (possibly polio or an inherited, extremely aggressive form of arthritis). Betsy recalls crawling repeatedly across their living room floor in Cushing so that Andrew could get the motion right; Wyeth was less interested in physical likeness than in emotional and psychological truth.

Even as an anonymous stand-in, Betsy Wyeth is integral to the equivocal mood of *Christina's World*, which each viewer experiences differently. In a way most of us sense only subconsciously, Wyeth folds his wife's youthful vigor and arrested movement into Christina's distressed limbs and implied immobility.[29] The multiple, even conflicting,

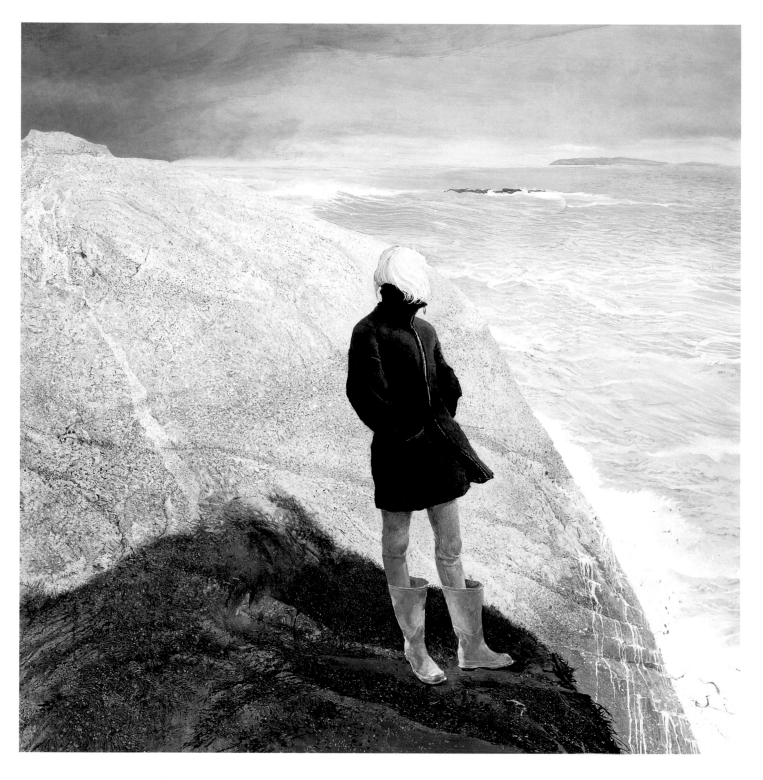

Fig. 104. Andrew Wyeth, *On the Edge*, 2001, tempera on panel,
48¾ × 49⅛ inches, private collection.

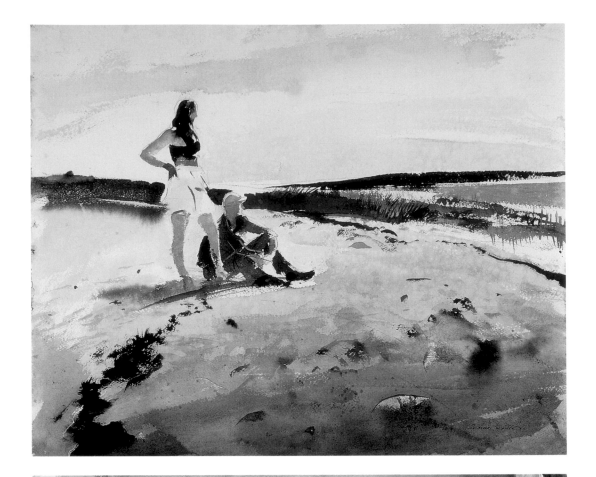

Fig. 105. Andrew Wyeth, *On Bar Island* (first version), 1944, watercolor on paper, 18 × 22 inches, Collection of Andrew and Betsy Wyeth.

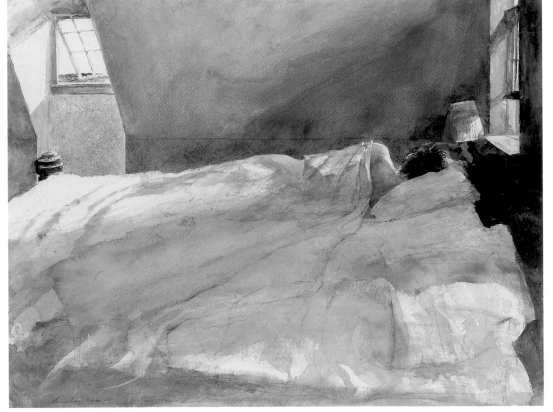

Fig. 106. Andrew Wyeth, *Gone Ashore*, 2003, watercolor on paper, 18 × 23½ inches, Collection of Andrew and Betsy Wyeth.

responses that Wyeth's work evokes—hope and despair, endurance and fragility, closeness and distance, intimacy and anonymity, age and youth—are functions of the artist's ability to transform his young wife into the very being of Christina Olson. The painting is pure fiction in other ways: the placement of the figure on the hill (as countless photographs of would-be Christinas in the field attest), and the absence of farming implements, trees, and bushes. Yet the painting remains true to Wyeth's feelings for his models and their kindred spirits.

*Her Room* (pl. 40), a portrait of Betsy Wyeth, reveals how objects and places are often surrogates for individuals in Wyeth's art: an oar becomes Henry Teel; a pair of battered doors in the Olson house stand for Christina and Alvaro (pl. 49); a massive boulder near the Wyeth's Cushing farm in *Far from Needham* (pl. 44) refers to N. C. Wyeth. In *Her Room*, originally titled *Eclipse*, the strange light is that of a solar eclipse. On the day it was conceived, the Wyeths' sons, Nicholas and Jamie, were out on the water in a boat, and Betsy and Andrew were growing concerned by the rising wind and a dangerous chop on the river. Wyeth records the eclipse-shadowed, agitated motion of the water that seems to rise ominously and threaten the calm, ordered safety of the house. Betsy is present in other ways, as well. She had gathered the neatly graduated seashells on the windowsill near Winslow Homer's studio in Prout's Neck. (Her sons would sometimes move one shell to

Fig. 107. Andrew Wyeth, *The Erratic, Study for On the Edge*, 2001, watercolor on paper, 21 × 39¼ inches, private collection.

see if she would notice; she always did.) The antique chest and conch shell seem disproportionately large for the room, recalling Betsy's childhood love of dollhouses. Light scatters through the antique glass panes that Betsy painstakingly collected for the newly constructed house. Andrew appears in a miniature self-portrait barely discernible on the brass doorknob, a nod to art history—perhaps recalling Jan van Eyck's miniature self-portrait in his *Portrait of Giovanni Arnolfini and His Wife.*

## Giver of Titles

Betsy is responsible for giving titles to most of her husband's paintings, although Andrew plays a part. Some titles change from exhibition to exhibition and publication to publication, but titles do matter in paintings that have narrative or metaphoric content. The titles of Wyeth's works give a generalized sense of what is important but don't specify precise meanings, and they always come after the fact, when the painting is finished. Often Betsy's titles create new ways of thinking about a picture that may be different from Andrew's own, but are ultimately

Fig. 108. Andrew Wyeth, *Omen*, 1997,
tempera on panel, 48 × 40 inches,
Collection of Andrew and Betsy Wyeth.

consistent with the subject. Titles range from the prosaic and matter of
fact (*Wood Stove, Alvaro's Hayrack, Dil Huey Farm, Kuerner's Hill*) to
the poetic and allusive (*End of Olsons, Brown Swiss, Far from Needham*)
to the private and enigmatic (*The Erratic, Oliver's Cap, No Trespassing*).
Betsy's titles are often meant to reveal and conceal simultaneously.

Descriptive titles often mask or at least obscure personal associa-
tions that only the Wyeths understand. Who can guess what *The Erratic*
(fig. 107), a portrait of one of Wyeth's longtime models, means: the
personality of the model, the weather in Maine that summer, the resis-
tance of the watercolor medium? In fact, "erratic" is a geological term
to describe a large stone left by retreating glaciers, as depicted in the
painting. Allusive titles such as *Omen* (fig. 108), a startling painting
of a nude African American woman sprinting across an open field in

pursuit of a meteor hurtling across the sky, could as easily refer to
kitsch horror films as to dark dreams of impending catastrophe. Titles
do offer glimpses into how the Wyeths think about the work. Whether
Betsy amplifies, obscures, or changes the meaning of a work, only
Andrew can say, although it is safe to assume that any distortions of his
original thoughts about a work of art are fully endorsed by the artist in
the cause of strangeness, dissonance, and obfuscation. The more open-
ended a title, the more likely it conveys the artist's full range of inten-
tions and complex feelings about a given subject.

Like *Omen, Otherworld* (pl. 85) is another of Andrew Wyeth's unex-
pected recent temperas, one that refutes criticism that the artist is only
interested in the past, in worn-out themes and sentimental reverie on
ways of life that have long since disappeared. An earlier title, *Betsy's*

*World* (suggested by Andrew and subsequently changed by Betsy), indicates that the figure with her back to the viewer is Betsy. The views from the flanking portholes are of the Wyeth homes in Maine and Pennsylvania—Betsy's worlds collapsed in time and space. The implication is that both Wyeths live in the fast-moving present but that they can look back with pride and affection on their legacy and achievement. If the painting is something of a poignant exchange on their lives together, it also recalls something Andrew once said to Richard Meryman: "I could see myself doing airplanes in airports, the planes taking off, landing—the oil dripping from motors; feel the storms and clouds the plane has passed through—like the days of ships coming in. It's the ability to see beyond."[30] And, Betsy adds, "A marriage that lasts as long as ours is an old beat-up ship."[31] This recent painting is something of a reprise of the birds-eye view perspective of Andrew's early temperas such as *Soaring* (pl. 11). An important influence on Andrew's early work was "seeing the 'small world' we knew from Stephen Etnier's sea plane."[32] The height from which we view the Wyeths' homes in *Otherworld* is that of a relatively low-flying seaplane and not from the high-altitude Gulfstream jet depicted in the painting.

The title of Andrew's recent tempera *The Carry* (pl. 86) refers to a place where canoes and other portable craft must be taken out of a stream and carried above or below the rapids. Carries are common throughout the lakes and rivers of interior Maine and are well marked in wilderness guides. The term "carry" also suggests, in a more generalized sense, a transition from one stage to the next, a place between different terrains. Betsy believes that the painting is a self-portrait, although she does not elaborate.[33] The technique is different from that in Andrew's earlier work. The trees and water in the background are painted with the precision and tightness of his earlier temperas, but the foreground, especially the surging rapids and nearby rocks, is loosely painted in a manner that strongly suggests his early watercolors. In contrast to Andrew's typical tempera technique, using brushes with pin-sharp points made of hairs less than half an inch long, the foreground of this painting looks as though it were attacked with a five-inch-wide house-painter's brush. In the context of the picture, splatters and random drips of white paint read convincingly as churning foam in the rushing stream and along the nearby banks; viewed in isolation, the white splatters on the dark ground appear abstract, as gestural as a painting by Jackson Pollock or Willem de Kooning. In the foreground the streams collide violently, dispersing into thin spray and mist that gradually give way to a calm pool of water in the distance. In the left foreground, the falls appear to surge out of the picture plane into the viewer's space. The painting is a tour de force incorporating a lifetime of technical, metaphoric, and formal approaches. In this, the painting is a kind of self-portrait. I would argue that it is also a dual portrait of Betsy and Andrew,

Fig. 109. Andrew and Betsy Wyeth, 1982.

especially at its turbulent, irrational center, where the reversing falls defy the laws of nature. But the painting is also Andrew and Betsy in its gentler, interior reaches, where calmness and light anchor the churning foreground. If *The Carry* is about transition, it is also about continuity; its marriage of contrasting forces is what gives this painting and the Wyeths' marriage such resonance, strength, and vitality.

In one way or another Betsy Wyeth has always been able to jolt her husband, give him a reason to paint. The act of providing physical references and reminders—her buildings and landscape design, her preservation and provision of studio props, her work to keep N. C. Wyeth's legacy alive, her presence in portraits, her indefatigable efforts to record her husband's work, her business ventures—her calm determination, imagination, and dedication have always served her husband's art.

## Notes

1. Betsy James Wyeth, note to the author, October 2004.

2. Including many "indirect" portraits where Betsy's presence is implied through objects and places that the artist associates with his wife. Asked why he has never painted a nude portrait of Betsy, he replied, "she belongs to me, not anyone else." Betsy James Wyeth, note to the author, October 2004.

3. Richard Meryman's biography of Andrew Wyeth, *Andrew Wyeth: A Secret Life* (New York: HarperCollins, 1996), is indispensable in this regard and is as much a biography of Betsy as of the artist. Meryman's book is the primary source for most of the biographical information contained in this essay as well as for the much of the evidence of Betsy's role in her husband's art, especially during the early years of their marriage. My own interviews and informal conversations with Andrew and Betsy Wyeth during the past decade confirm Meryman's sensitive observations, which I have largely paraphrased. See also, David Michaelis, *N. C. Wyeth: A Biography* (New York: Knopf, 1998); and Paul Theroux, "Betsy's World—Part I: Betsy Wyeth's Life on Benner Island, Off the Coast of Maine," *Architectural Digest* 60 (June 2003): 172–183, 254; and "Betsy's World—Part II: Betsy Wyeth Creates a Serene Haven on Maine's Allen Island," *Architectural Digest* 60 (July 2003): 134–143.

4. Several artists' wives—Josephine "Jo" Hopper (Mrs. Edward Hopper), Sally Michel (Mrs. Milton Avery), and Lee Krasner (Mrs. Jackson Pollock), for example—who were artists in their own right functioned as their husbands' business agents, cultivated art world connections, managed sales and, most importantly, placed their own artistic ambitions on hold or abandoned them altogether in order to devote their energy and social skills to enhancing their husbands' careers. See, for example, Gail Levin, *Edward Hopper: An Intimate Biography* (New York: Knopf, 1995) and especially Barbara Novak, "The Posthumous Revenge of Josephine Hopper," review of *Edward Hopper: An Intimate Biography,* in *Art in America* 84 (June 1996): 27–31.

5. Betsy James Wyeth, note to the author, October 2004.

6. In 1962 the Albright-Knox Art Gallery in Buffalo mounted a major retrospective exhibition, *Andrew Wyeth: Temperas, Water Colors and Drawings,* that was also a triumphant homecoming for Betsy. The exhibition was held between November 2 and December 9.

7. Betsy Wyeth, conversation with author, December 2004.

8. Wyeth's biographer Richard Meryman notes that "Betsy was drawn to the chaos of the Olsons but frightened by a wild streak within her. 'That's why I'm so organized,' Betsy says, 'I've liked to come home to orderliness because I'm so chaotic underneath, so really wild that I really have to keep things in order. I've always done that.'" Meryman, *Secret Life,* p. 143.

9. Wanda M. Corn, "Andrew Wyeth: The Man, His Art, and His Audience" (New York University, Ph.D. diss., 1974), p. 46.

10. Ibid., p. 48 f.

11. Ibid., p. 40 ff.

12. Betsy James Wyeth, note to the author, October 2004.

13. See Michaelis, *N. C. Wyeth* for an in-depth discussion of N.C.'s complex persona and the central importance of family in his life.

14. N. C. Wyeth, *The Wyeths: The Letters of N. C. Wyeth, 1901–1945,* ed. Betsy James Wyeth (Boston: Gambit, 1971), p. 4.

15. Ibid., p. 5.

16. Betsy Wyeth, note to author, October 2004.

17. Richard Meryman, *Andrew Wyeth* (New York: Abrams, 1991), p. 78.

18. Asked about her reaction to N.C.'s comments, Betsy confirmed that she insisted that Andrew should leave out any suggestion of anecdote or narrative. Betsy James Wyeth, conversation with the author, December 2004.

19. Meryman, *Secret Life,* p. 179.

20. Wyeth is no longer represented by a commercial gallery (by his choice). In recent years most sales are handled though their son Nicholas or a longtime friend and private collector of Wyeth family works.

21. In 1976 Betsy Wyeth founded Chadds Ford Publications, limited run reproductions of a select number of paintings, both watercolors and temperas. Along with the open-edition (unlimited) reproductions of Wyeth's work issued under license through the New York Graphic Society, the limited edition reproductions are closely controlled and supervised by Betsy and the artist. For example, the first proof for an early limited edition reproduction, *Her Room* (pl. 40), has seventeen detailed color corrections and other notations, all in the artist's hand. Wyeth's direct involvement in the printing process rivals that of many traditional printmakers who also depend on technicians to execute the final print from a separate image provided by the artist. With the advent of high-quality photomechanical and now computer-generated printing processes, the number of prints that are identical in quality is more or less infinite. Today the line between fine art prints and reproductions has grown considerably less clear and the definition for an "original" print primarily hinges on the degree of the artist's personal involvement in the process. For instance, "Giclee" prints, computer-controlled, laser-printer reproductions scanned from an existing image, are increasingly accepted as "originals" by artists, dealers, and print-world purists alike. Betsy's phenomenal success with reproductions of Andrew's work greatly increased public awareness of Wyeth's work but also caused a degree of consternation among museum officials who view the limited editions as "collectibles" rather than authentic, "original" prints. As noted above, Wyeth's involvement in the process undercuts this argument as have evolving print technologies.

22. Closely linked to her reproduction ventures, Betsy Wyeth has been an advocate for stronger artists' copyright laws and artists' rights to receive fair market value tax deductions for donations of their own work to non-profit organizations (legislation still pending).

23. Another successful business enterprise is her partnership with a skilled jewelry artisan, Don Plywell, who adapts, with Betsy's critical eye, details such as millstones, lobster buoys, cornstalks, and shells from Wyeth's paintings to create pendants, necklaces, and earrings. Betsy once remarked that she doesn't mind wearing millstones around her neck "as long as it's gold." Her casual joke is heavily ironic since jewelry and outward manifestations of wealth have never been motivations for her business ventures. Having the means to pursue other interests and especially her interest in Andrew's work is what matters most. Betsy Wyeth also produced (with noted painter, Bo Bartlett) a widely acclaimed documentary film on Andrew Wyeth that has sold steadily since its release in 1995. Bo Bartlett and Betsy James Wyeth, directors, *Andrew Wyeth: Self-Portrait–Snow Hill,* videocassette recording (Derry, N.H.: Chip Taylor Communications, 1995).

24. Although Oar House resembles Teel's house, it was based on the Hoffses' house in Friendship, Maine, which Betsy had measured many years ago before it was torn down. Betsy James Wyeth, conversation with the author, December 2004.

Many of Maine's eighteenth-century homes have similar elevations and proportions with modest "cape" facades and attached ells; and these homes are often attached to substantial barns. These rambling structures are indigenous to northern New England and partly an accommodation to severe winter weather.

25. Considered the first great maritime atlas, the *Atlantic Neptune* was published in 1774, compiled by the Swiss-born English surveyor Joseph F. W. Des Barres. For nearly fifty years after their publication the *Neptune* charts were the standard nautical charts of the East Coast.

26. The name "Little Evil" was given by a friend who accompanied Betsy on the day she acquired the doll that subsequently included several minor catastrophes. Everyone concluded that their misfortunes must have been caused by the doll, whose smiling face seemed to mock their distress.

The actual schoolhouse bench also supports a battered shoe, a seventeenth- or early eighteenth-century artifact that Betsy found behind the walls surrounding the chimney in the abandoned Hoffses' house in Friendship. She has no idea why she even looked there, but somehow felt the presence of something. At the time, she was unaware that hiding a shoe in the main chimney-well of a home during construction is a European custom, perhaps dating to the Middle Ages or earlier, to ward off evil in general and, in particular, to keep the house safe from witches. Both Betsy and Andrew relish such accidental encounters with history, fantasy, and horror. Betsy James Wyeth, conversation with the author, June 2004.

27. Betsy Wyeth conceived and curated *Wondrous Strange: The Wyeth Tradition; Howard Pyle, N. C., Andrew, and James Wyeth,* the inaugural exhibition for the Wyeth Center at the Farnsworth Art Museum in 1998.

28. Betsy James Wyeth, conversation with the author, June 2004.

29. Wyeth occasionally uses two or more models for a final version, combining the physical and psychological characteristics of each: *Surf* (1978), is based on studies of both Siri Erickson and Helga Testorf; *Maidenhair* (1974) is both Helga and a young woman from Maine, Elaine Benner.

30. Meryman, *Secret Life,* p. 132.

31. Meryman, *Secret Life,* p. 429.

32. Stephen Etnier was a respected artist who lived in Maine (Rockwell Kent's only student) and a close friend of the Wyeths. According to Betsy Wyeth, their frequent plane rides with Etnier were extremely influential in many of Wyeth's works after 1940, where the "small world" perspective appears in several paintings. Betsy James Wyeth, note to the author, October 2004.

33. The title is also quite literal. While working on this painting Andrew Wyeth lost his footing on the bank and slipped into the water, a potentially life-threatening accident for the eighty-seven-year-old artist who has had hip replacement surgery and was alone at the time. Betsy James Wyeth, conversation with the author, summer 2004.

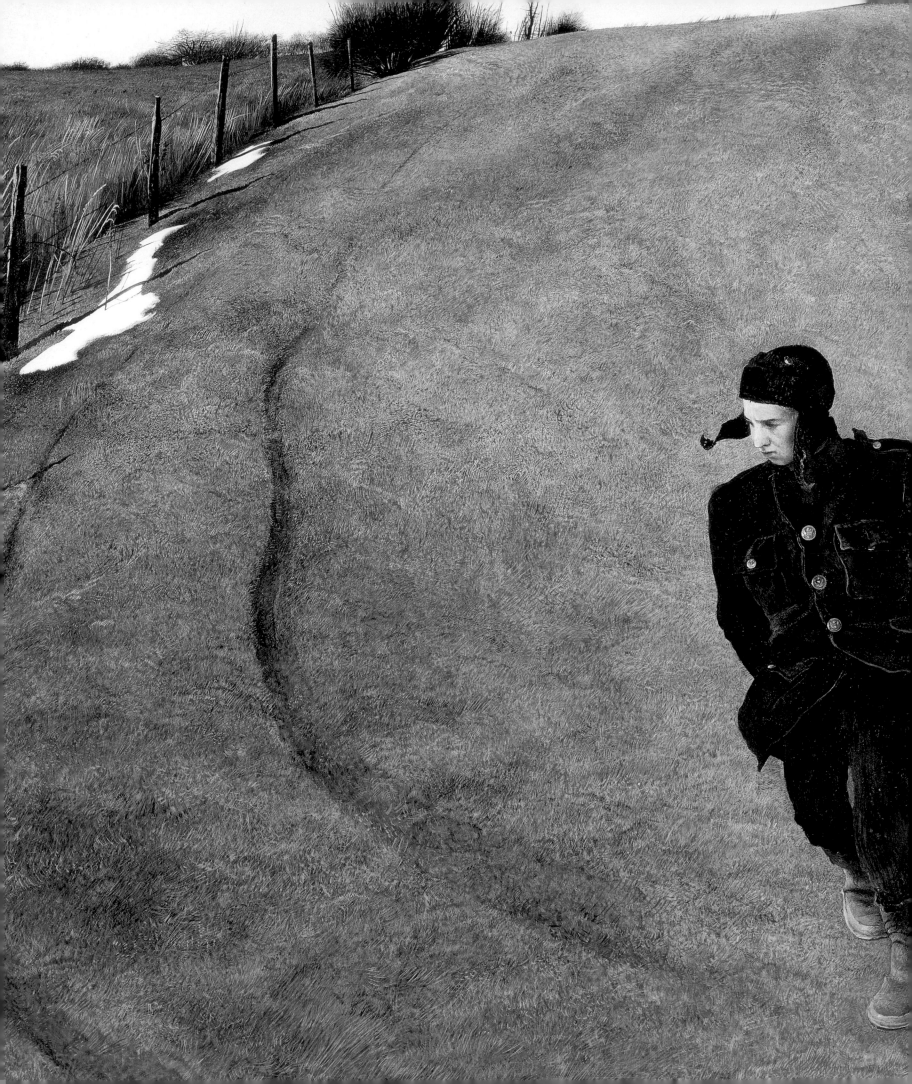

Plates

PLATE 1  *Life Mask of Abraham Lincoln*  1934    Oil on canvas, 25 × 27½ inches

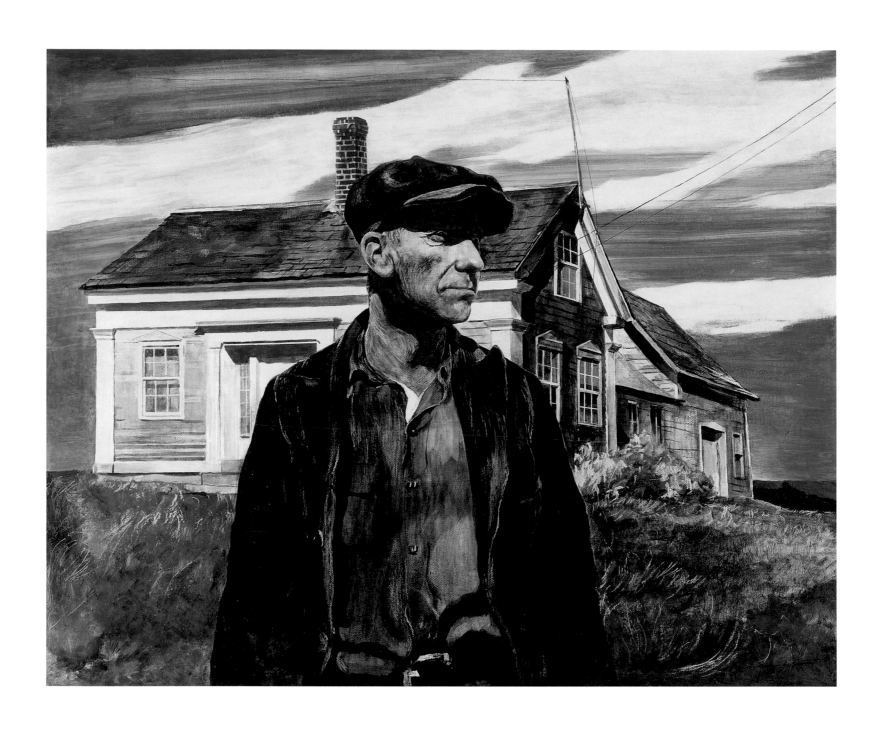

PLATE 2 *Charlie Ervine* 1937 Tempera on panel, 31¾ × 39¾ inches

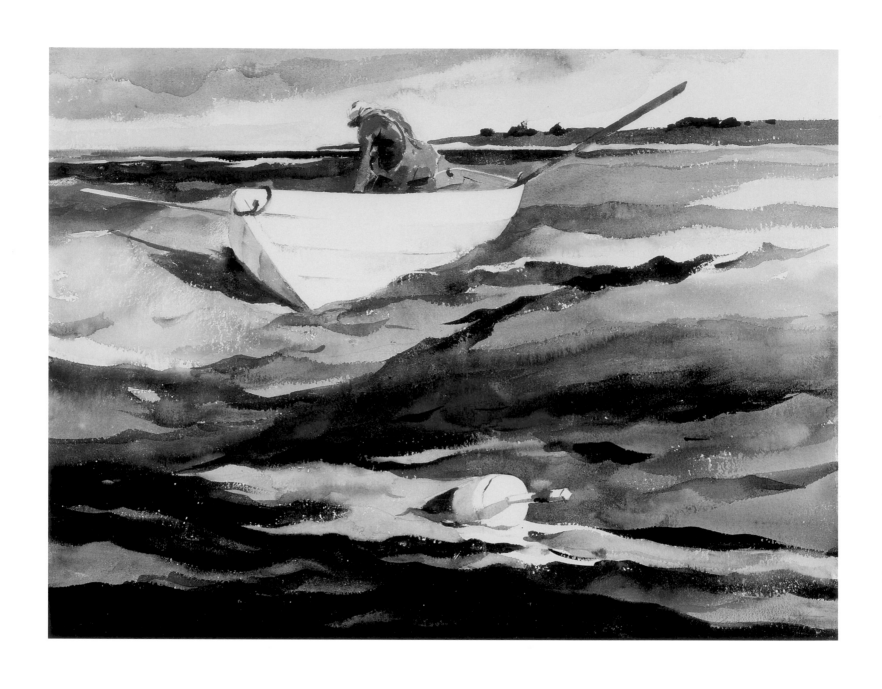

PLATE 3 *The Lobsterman* 1937 Watercolor on paper, 22½ × 29 inches

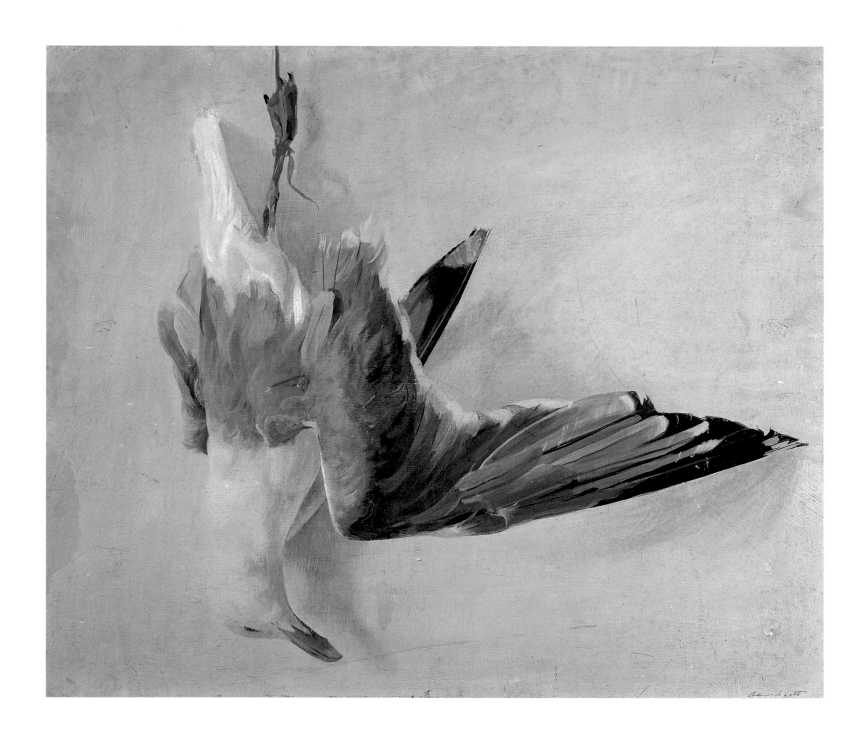

PLATE 4  *Dead Gull*  1938    Tempera on panel, 25 × 30 inches

PLATE 5  *Mussels, Study for Little Caldwell's Island*  1940    Ink and watercolor on paper, 13 × 17 inches

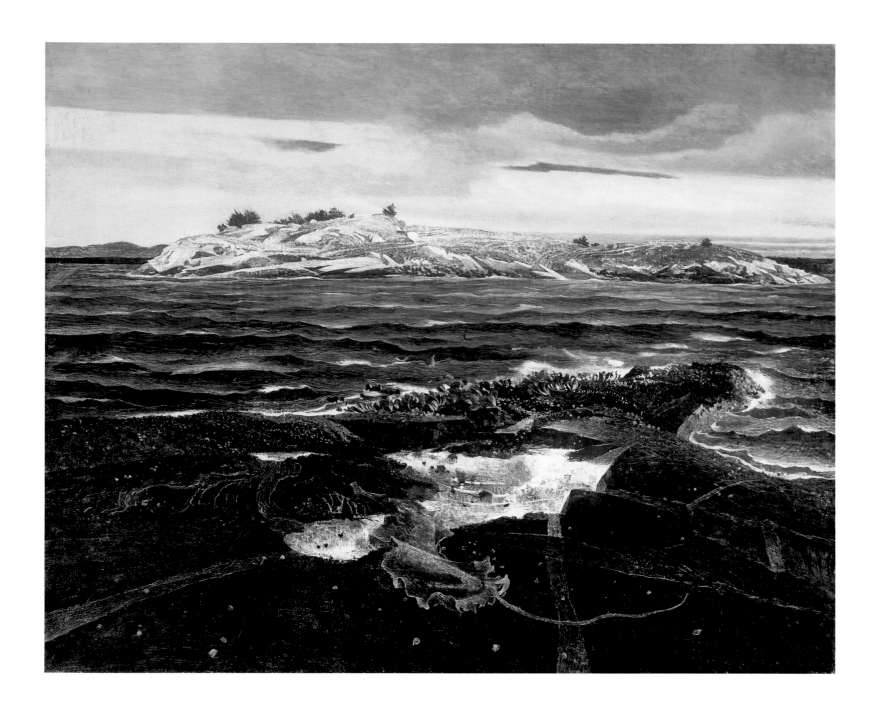

PLATE 6  *Little Caldwell's Island*  1940  Tempera on panel, 32 × 40 inches

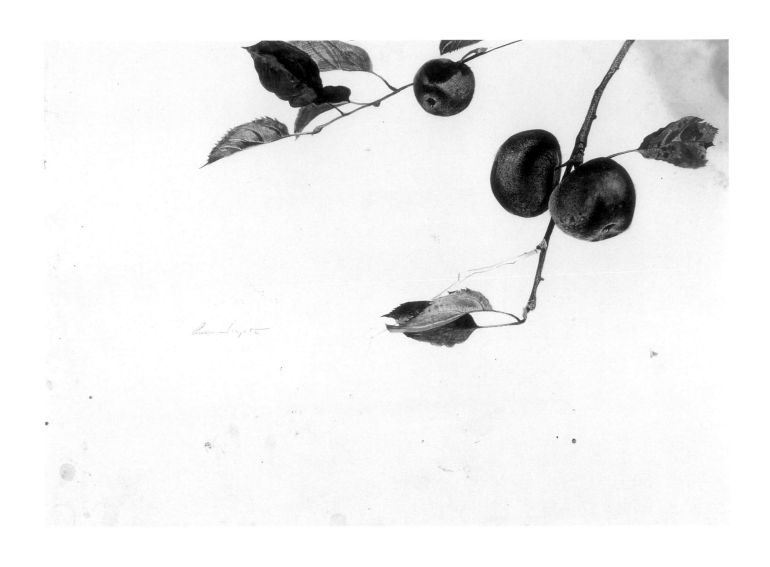

PLATE 7 *Apples on a Bough, Study for Before Picking* 1942 Drybrush on paper, 14¼ × 20½ inches

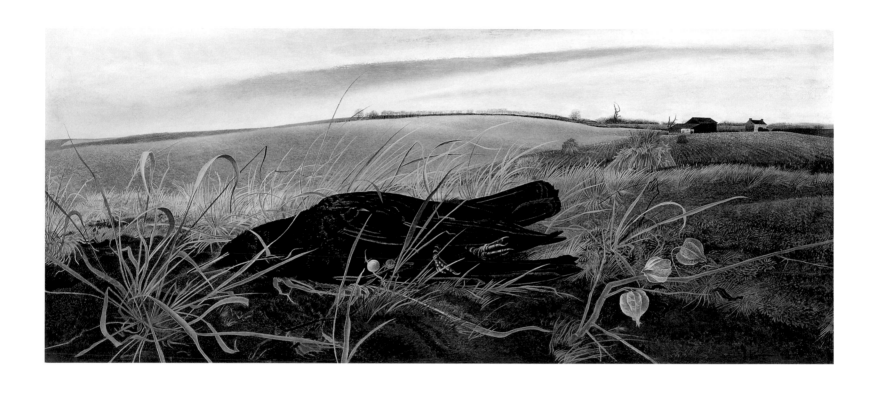

PLATE 8  *Winter Fields*  1942  Tempera on panel, 17¼ × 41 inches

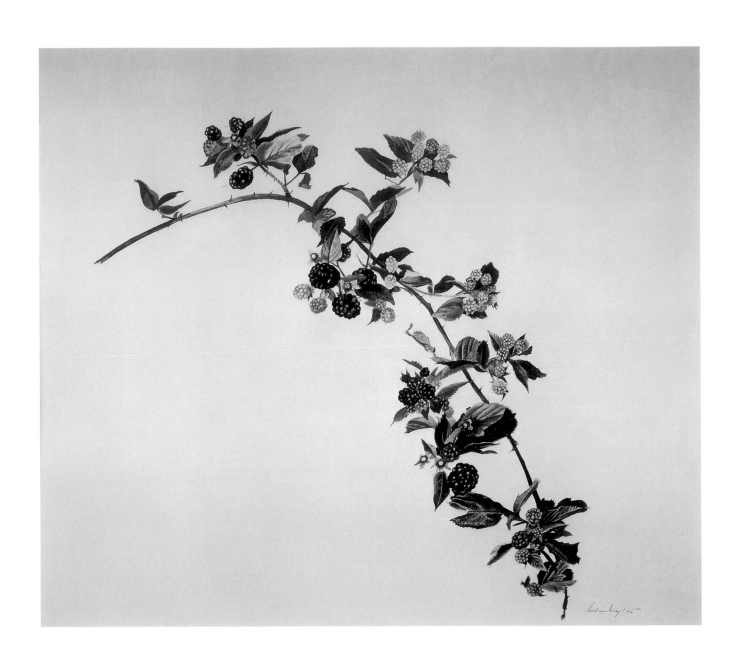

PLATE 9 *Blackberry Branch, Study for Blackberry Picker* 1943 Drybrush on paper, 22 × 26⅞ inches

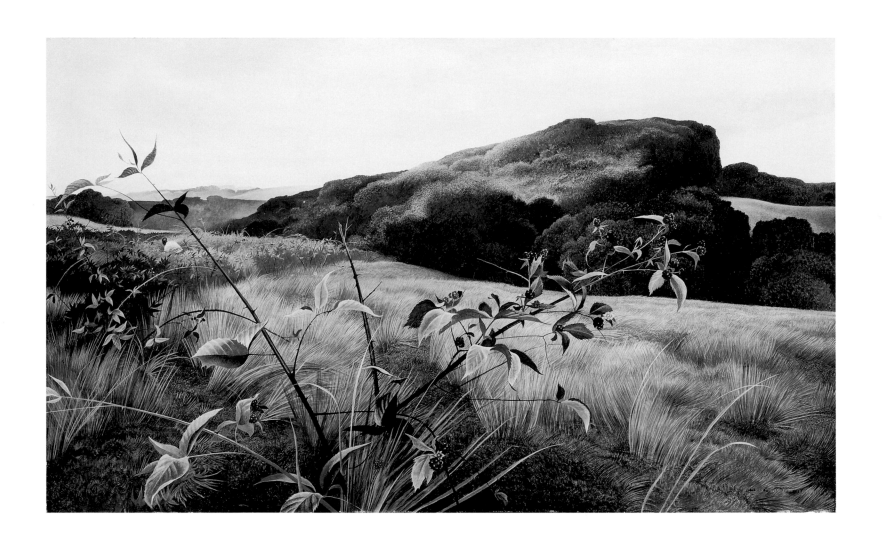

PLATE 10 *Blackberry Picker* 1943 Tempera on panel, 28¾ × 48¼ inches

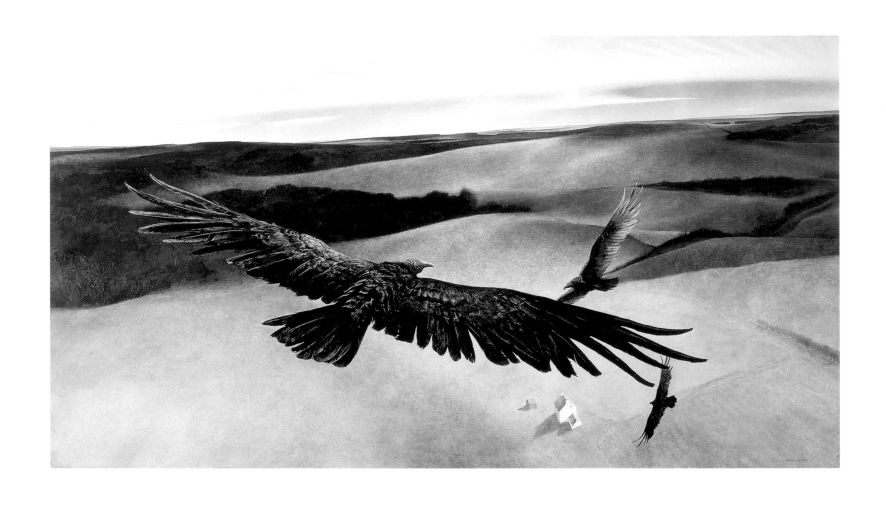

PLATE 11  *Soaring*  1942–1950  Tempera on panel, 48 × 87 inches

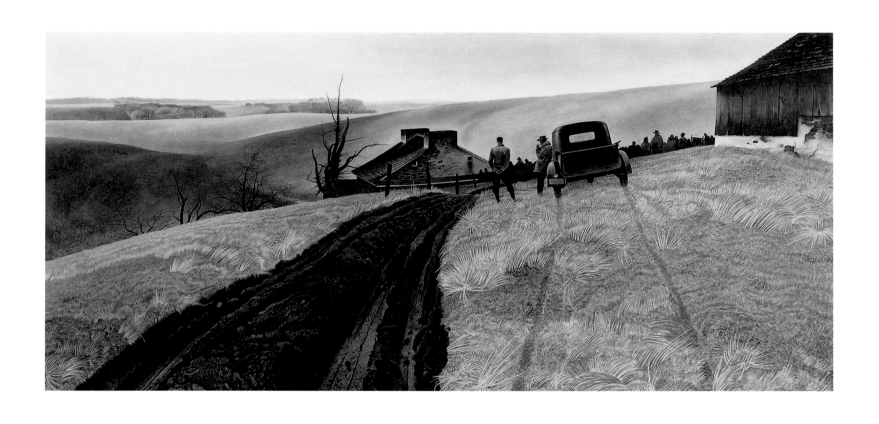

PLATE 12 *Public Sale* 1943 Tempera on panel, 24 × 48 inches

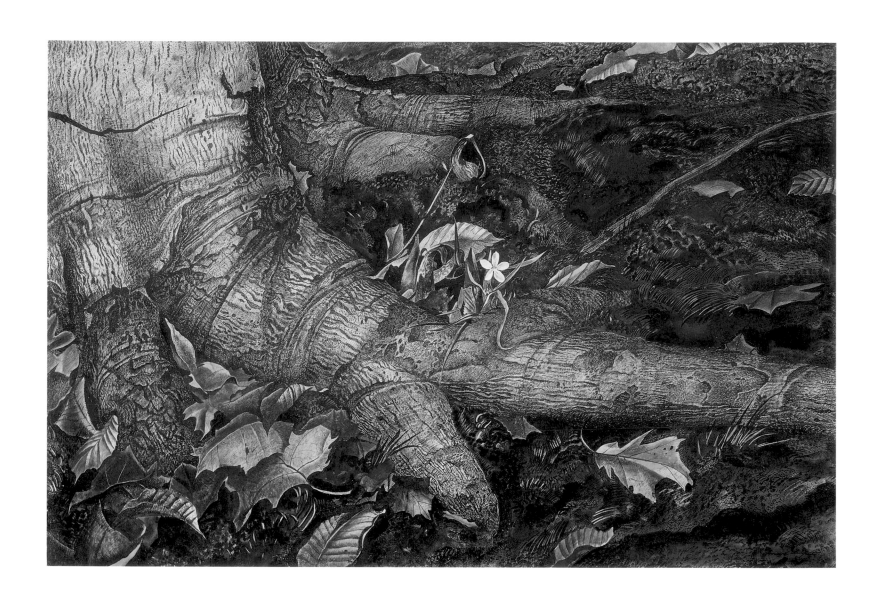

PLATE 13 *Spring Beauty* 1943 Drybrush on paper, 20 × 30 inches

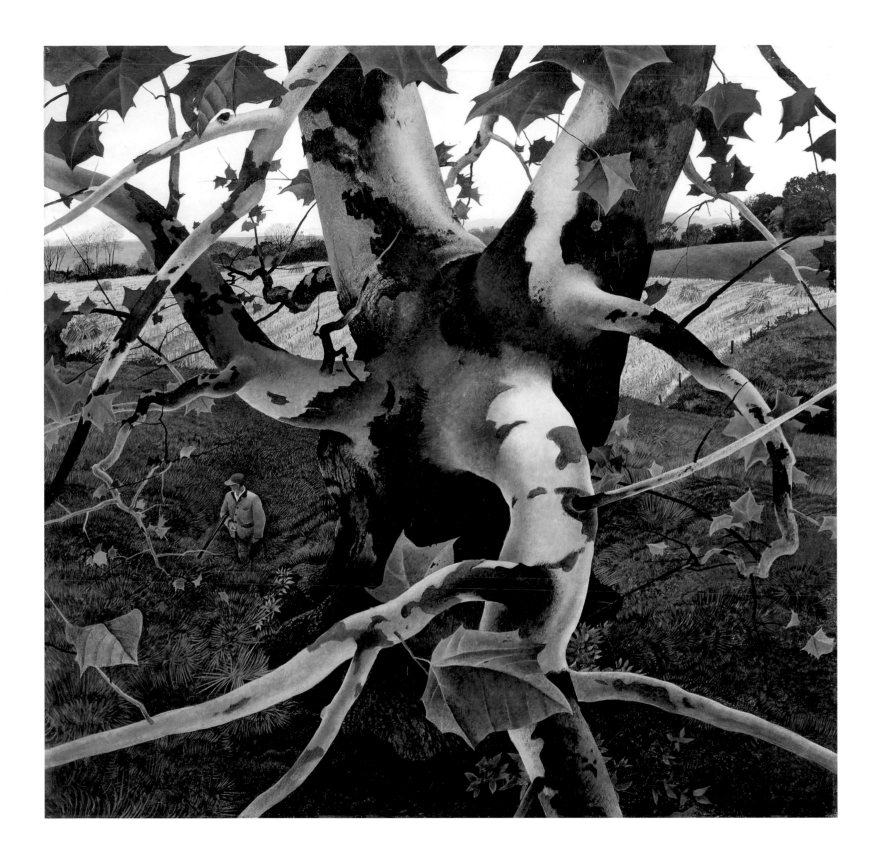

PLATE 14  *The Hunter*  1943    Tempera on panel, 33 × 34 inches

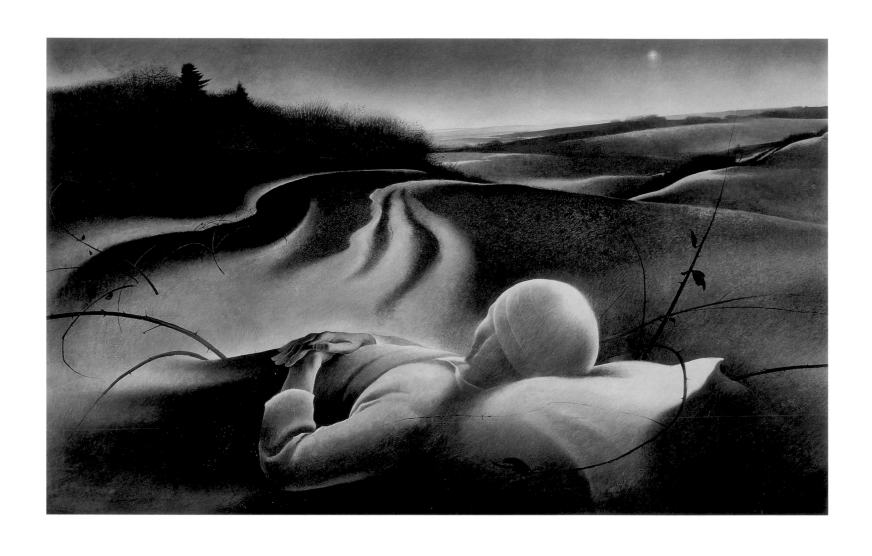

PLATE 15 *Christmas Morning* 1944 Tempera on panel, 23¾ × 38¾ inches

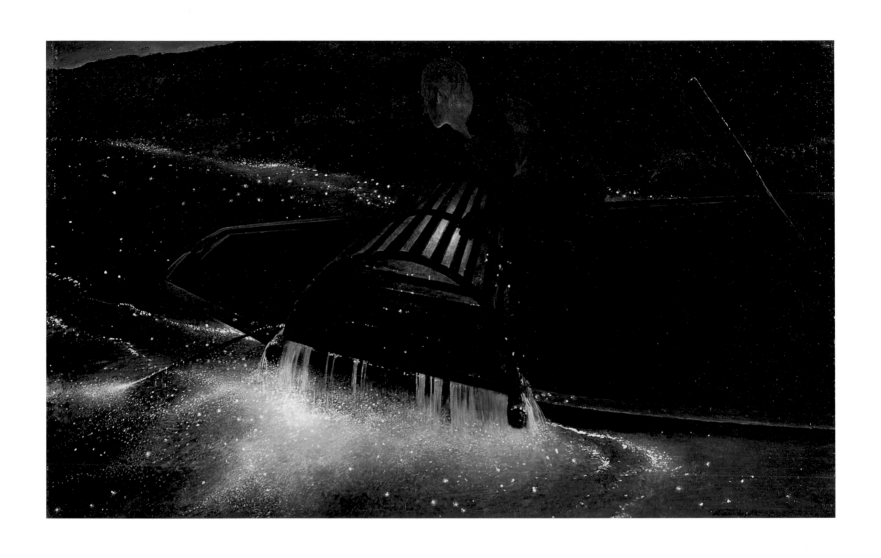

PLATE 16 *Night Hauling* 1944   Oil on Masonite, 23 × 37⅛ inches                                        139

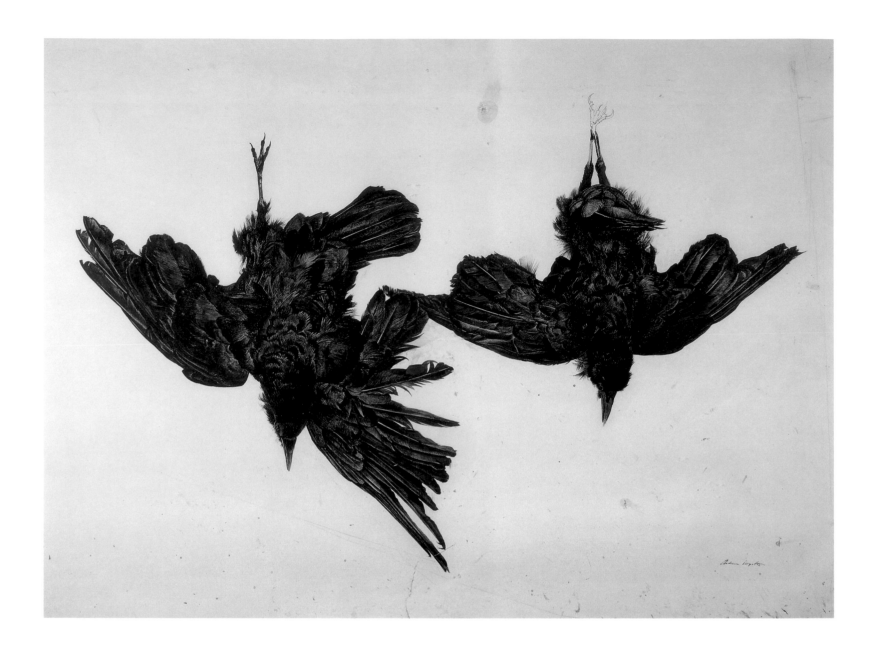

PLATE 17 *Crows, Study for Woodshed* 1944 Drybrush on paper, 33 × 47 inches

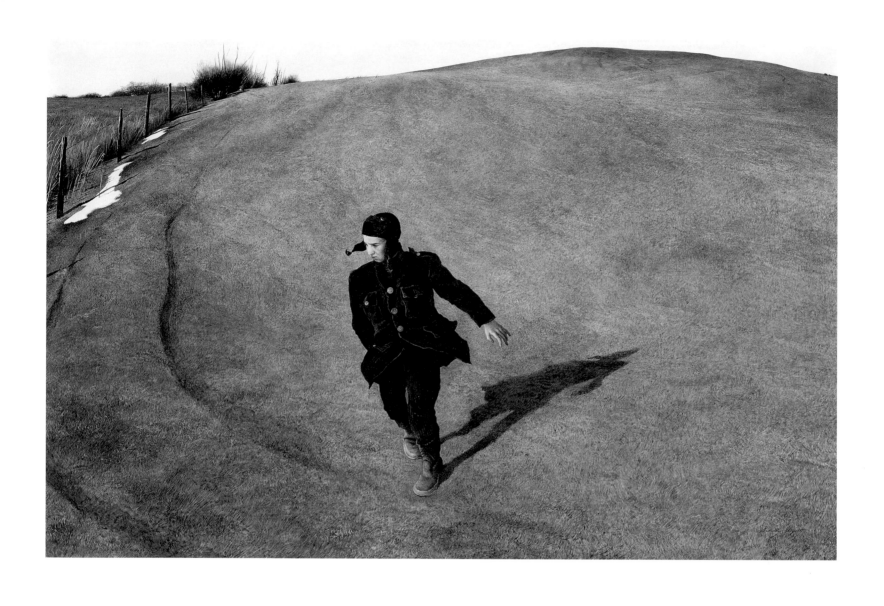

PLATE 18  *Winter, 1946*  1946    Tempera on panel, 31⅜ × 48 inches

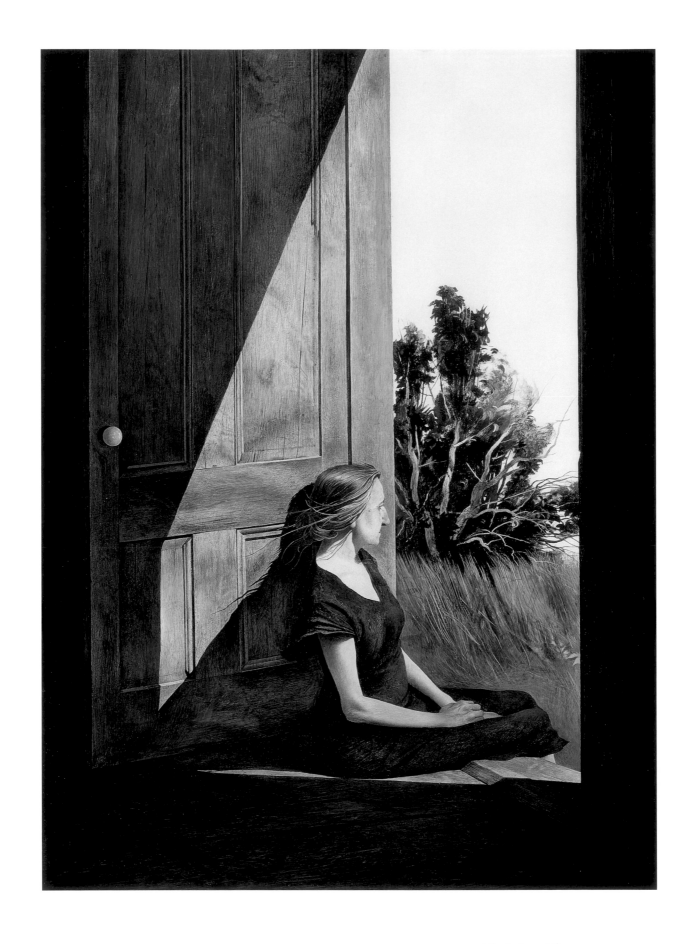

PLATE 19  *Christina Olson*  1947  Tempera on panel, 33 × 25 inches

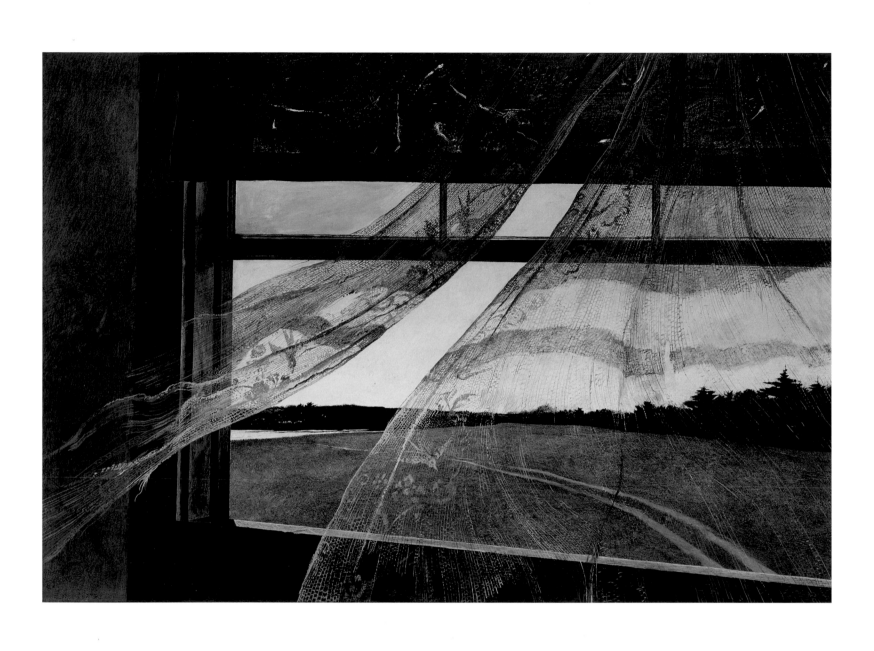

PLATE 20  *Wind from the Sea*  1947    Tempera on Masonite, 18½ × 27½ inches

PLATE 21 *Karl* 1948 Tempera on panel, 30½ × 23½ inches

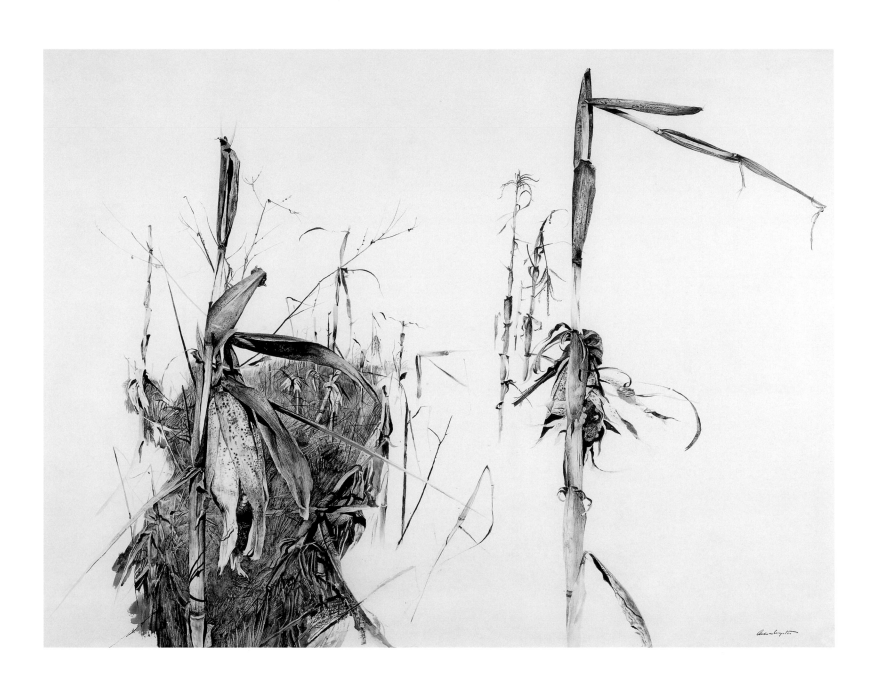

PLATE 22 *Winter Corn* 1948 Drybrush on paper, 29 × 38¾ inches 145

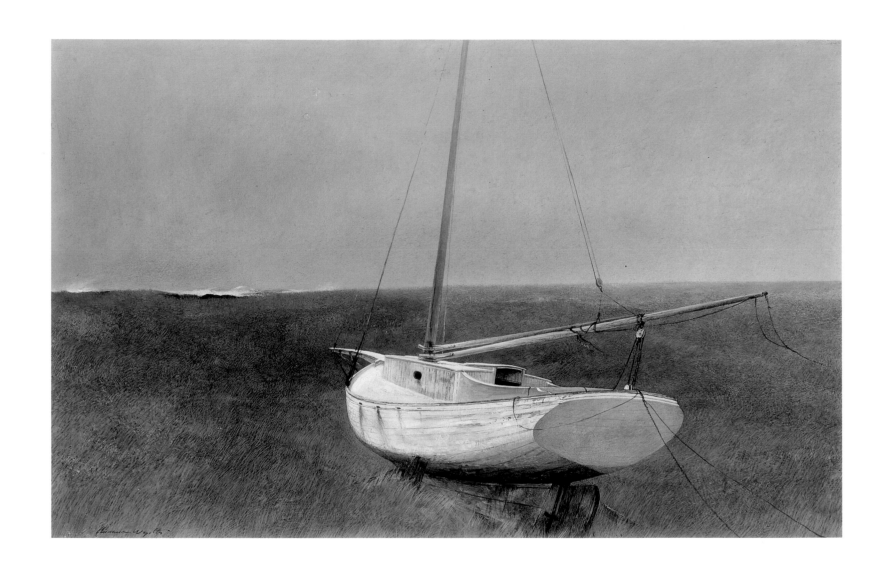

PLATE 23 *Below Dover* 1950 Tempera on panel, 10 × 16 inches

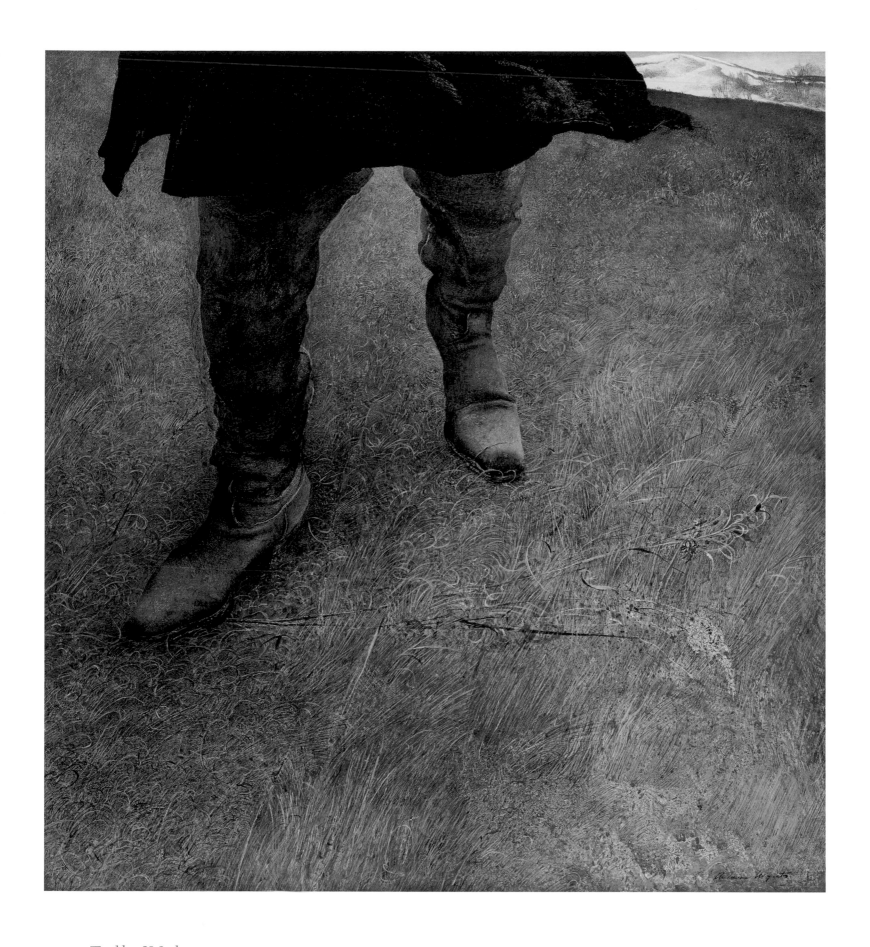

PLATE 24  *Trodden Weed*  1951    Tempera on panel, 20 × 18¼ inches

147

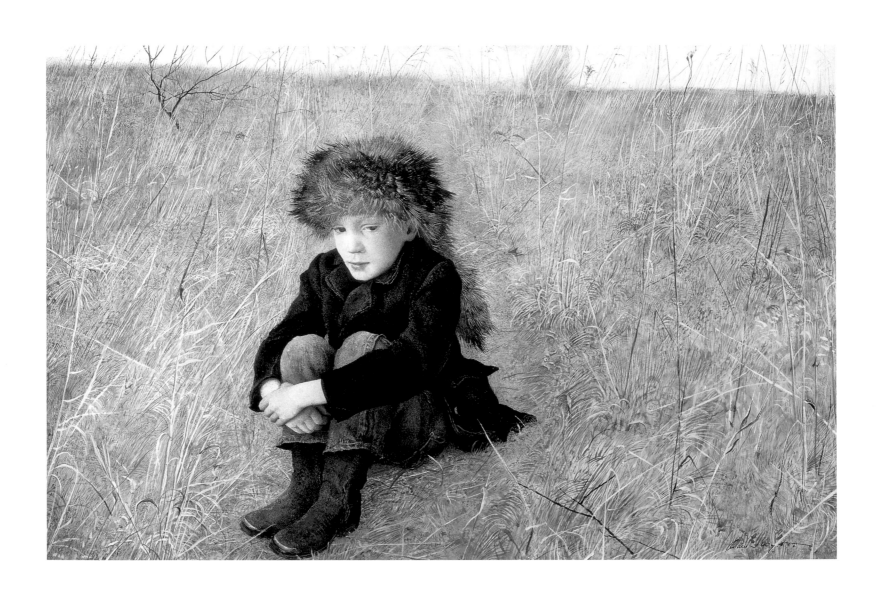

PLATE 25 *Faraway* 1952   Drybrush on paper, 13¾ × 21½ inches

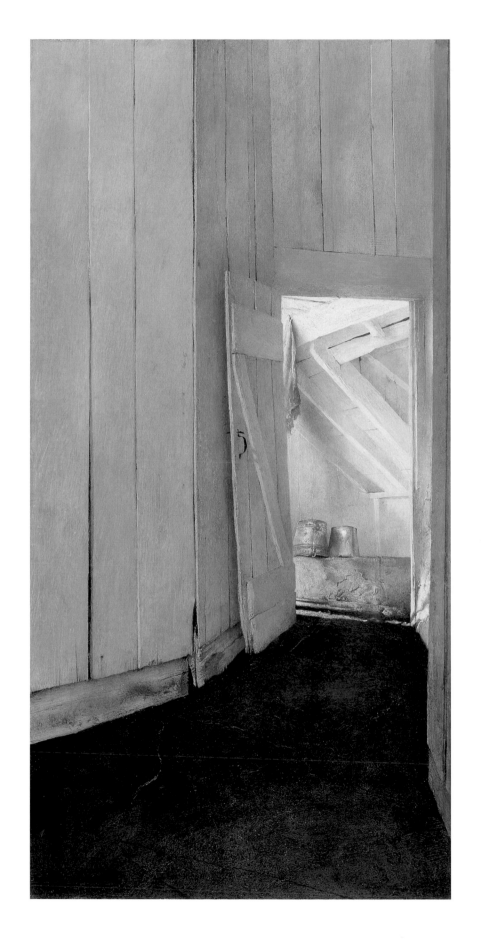

PLATE 26  *Cooling Shed*  1953    Tempera on panel, 24¾ × 12⅜ inches

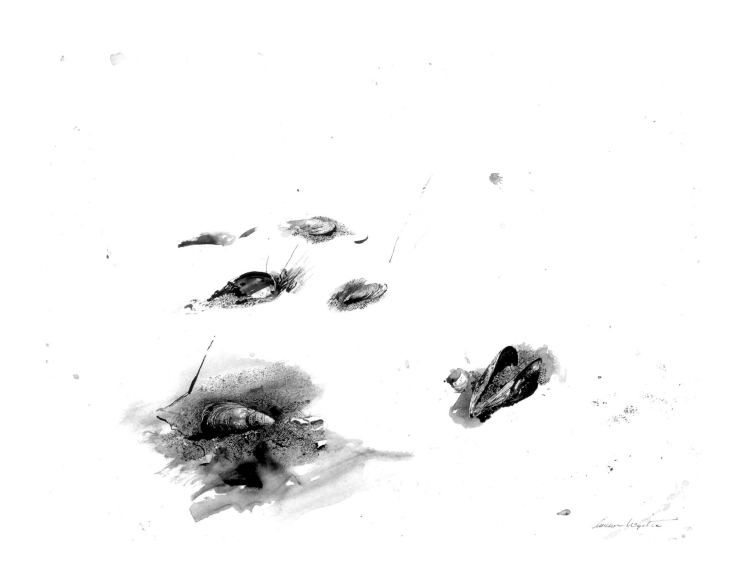

PLATE 27  *Seashells, Study for Sandspit*  1953    Drybrush on paper, 11⅜ × 15⅜ inches

PLATE 28  *Corner of the Woods*  1954  Tempera on panel, 38¾ × 31⅛ inches

PLATE 29  *Monday Morning*  1955   Tempera on panel, 12 × 16⅜ inches

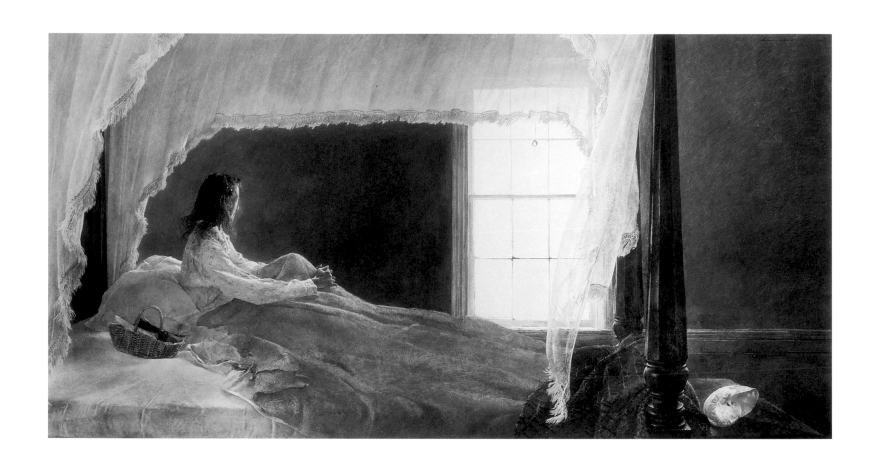

PLATE 31 *Chambered Nautilus* 1956 Tempera on panel, 24¾ × 47¼ inches

PLATE 32  *Brown Swiss*  1957    Tempera on panel, 30 × 60⅛ inches

PLATE 33 *Hay Ledge* 1957 Tempera on panel, 21½ × 45¼ inches

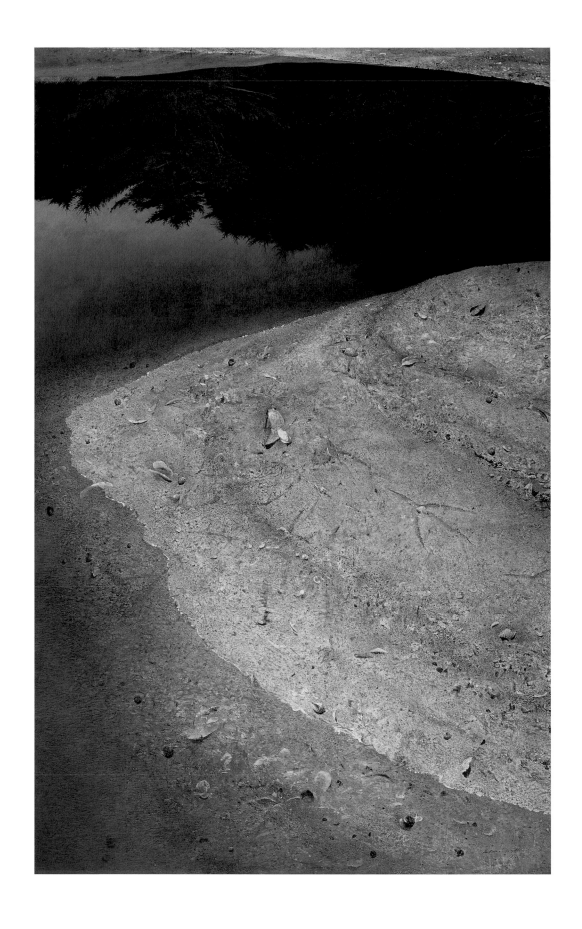

PLATE 34  *River Cove*  1958  Tempera on Masonite, 48 × 30⅛ inches

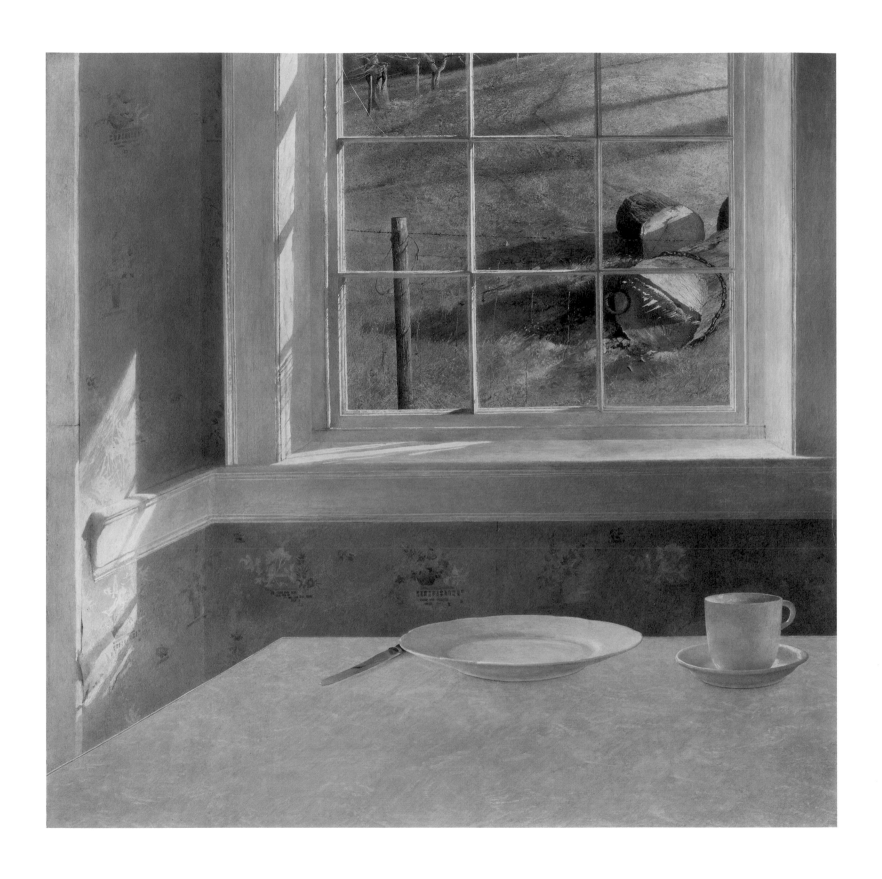

PLATE 35 *Groundhog Day* 1959 Tempera on panel, 31⅜ × 32⅛ inches

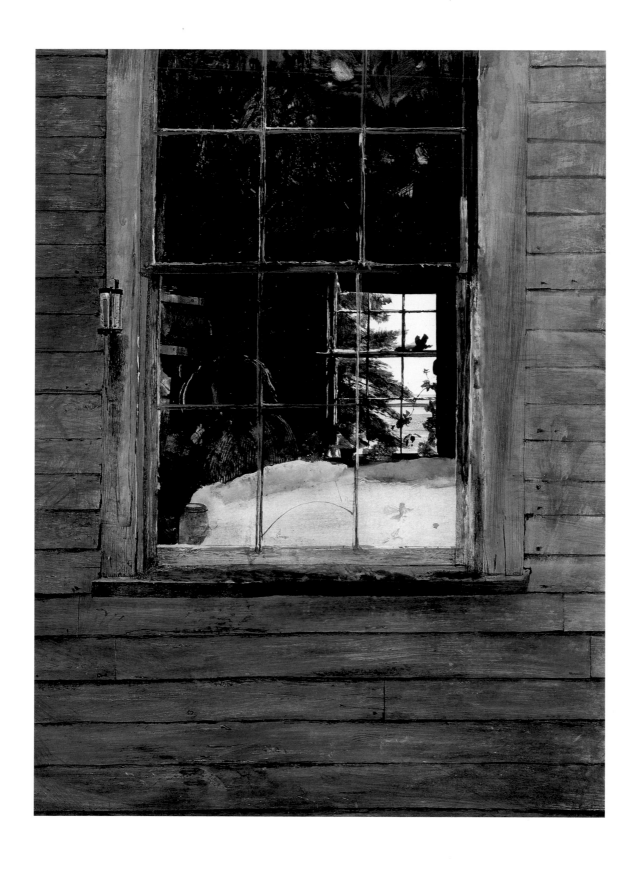

PLATE 36 *Geraniums* 1960     Drybrush watercolor on paper, 20¾ × 15½ inches

PLATE 37  *Distant Thunder*  1961  Tempera on panel, 48 × 30½ inches

PLATE 38 *Light Wash* 1961    Watercolor on paper, 30½ × 24½ inches

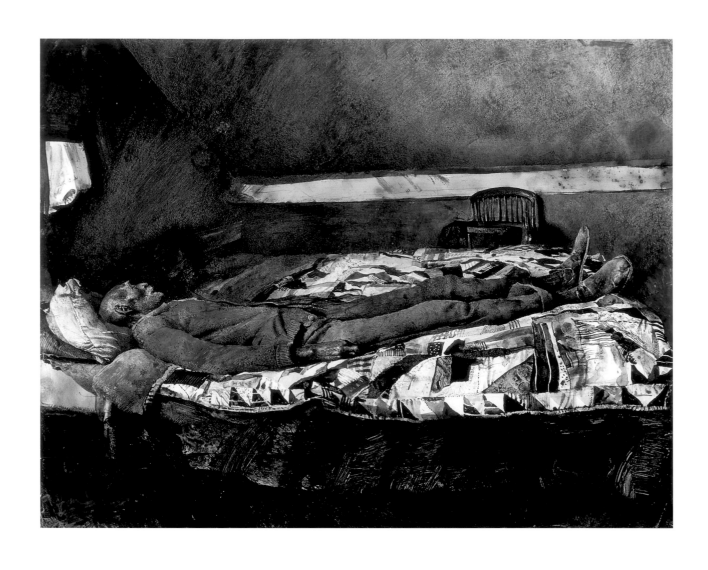

PLATE 39  *Garret Room*  1962    Drybrush on paper, 17½ × 22½ inches

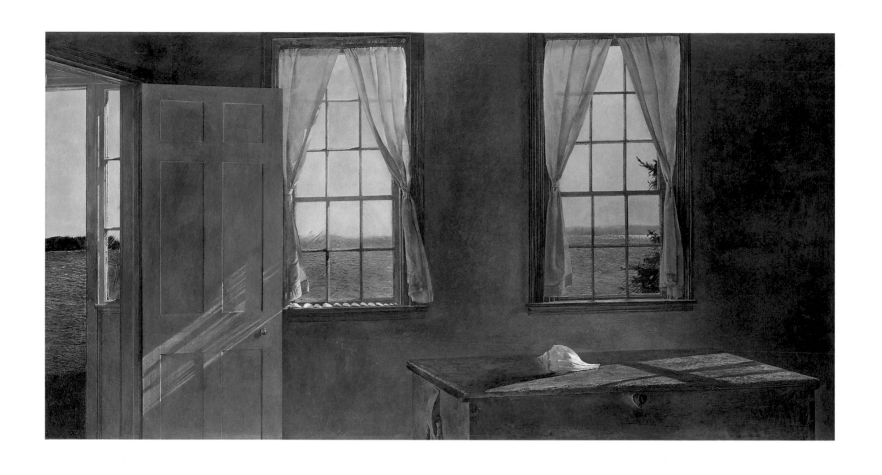

PLATE 40 *Her Room* 1963 Tempera on panel, 24⅜ × 48 inches 163

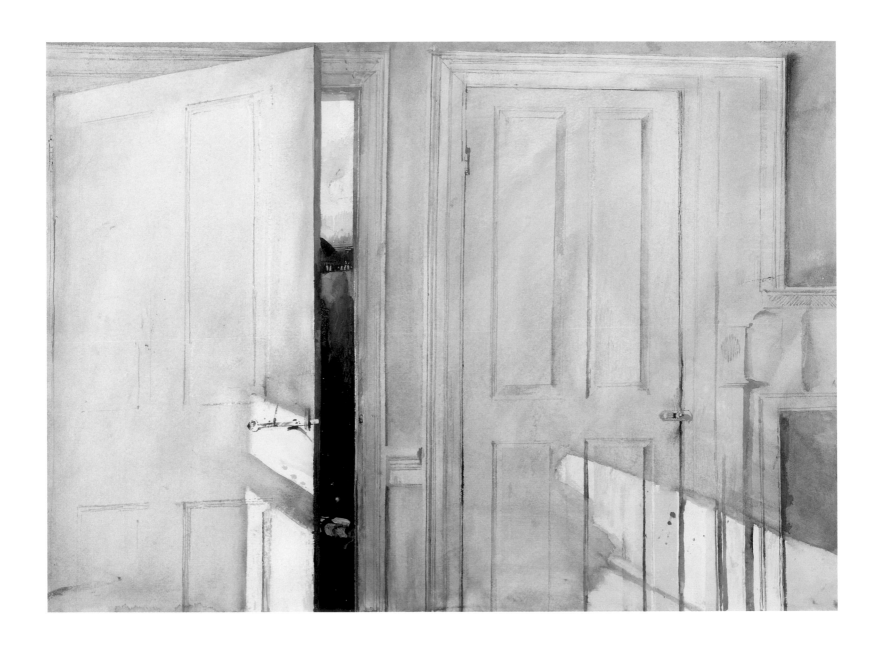

PLATE 41  *Open and Closed*  1964  Watercolor on paper, 21 × 30 inches

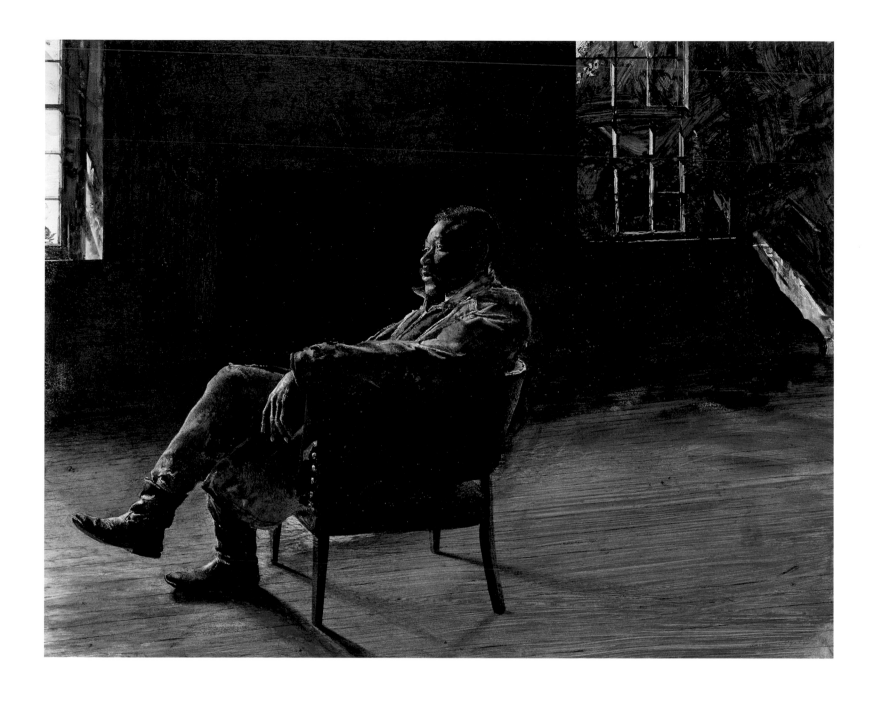

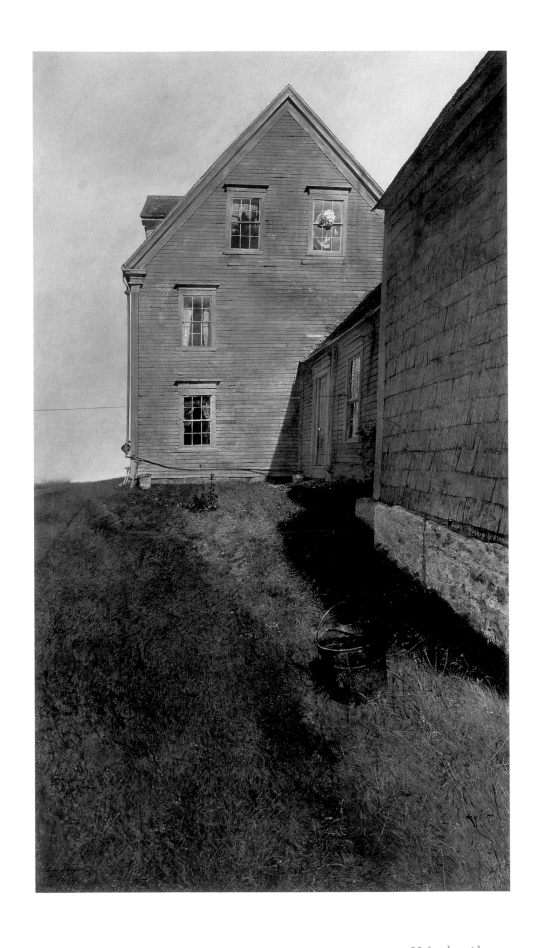

PLATE 43  *Weatherside*  1965   Tempera on panel, 48⅛ × 27⅞ inches

PLATE 44  *Far from Needham*  1966  Tempera on panel, 44 × 41¼ inches

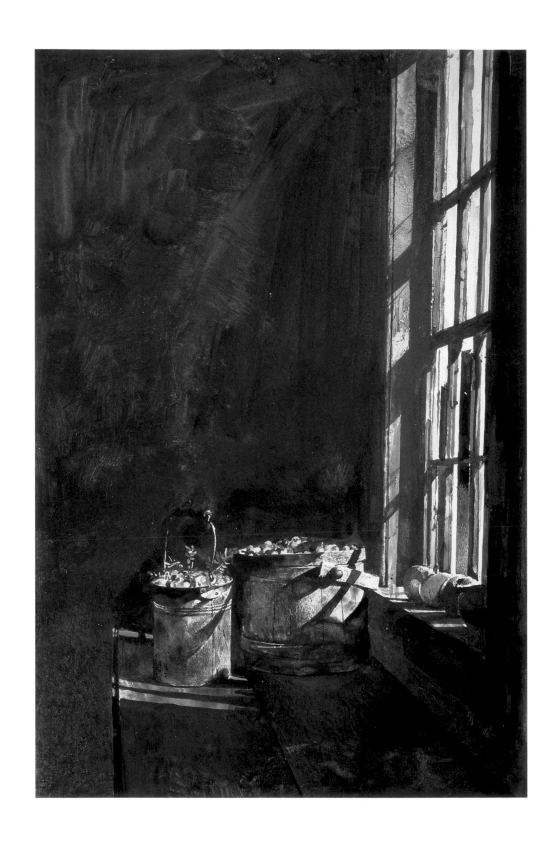

PLATE 45 *Cranberries* 1966  Watercolor on paper, 18 × 12 inches

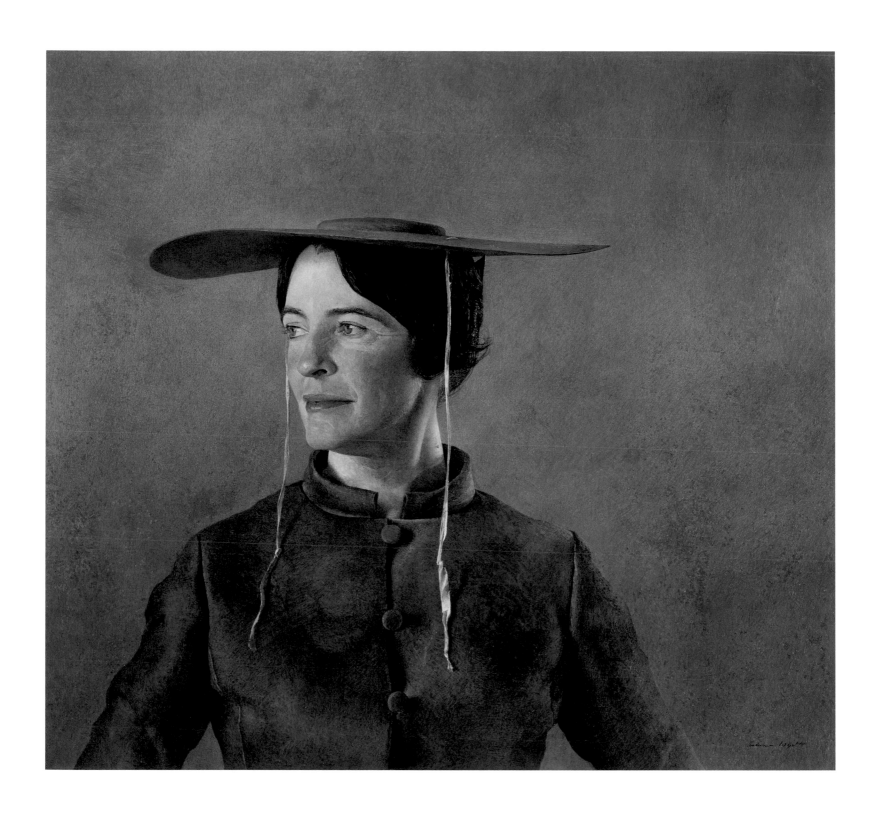

PLATE 46  *Maga's Daughter*  1966  Tempera on panel, 26½ × 30¼ inches

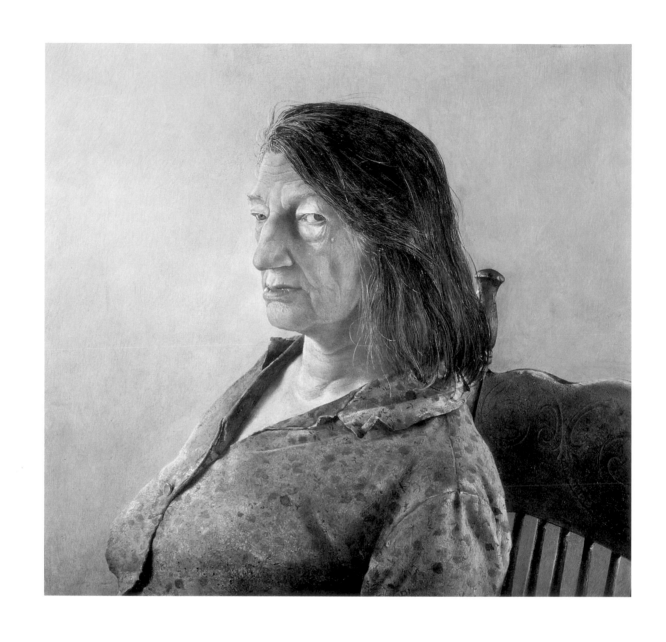

PLATE 47 *Anna Christina* 1967 Tempera on panel, 21½ × 23½ inches

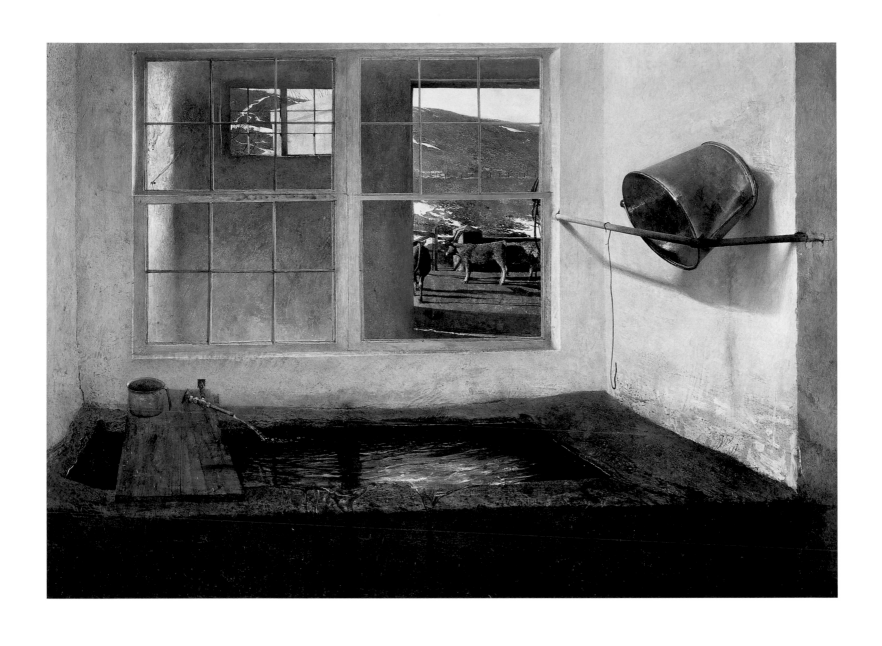

PLATE 48  *Spring Fed*  1967  Tempera on panel, 27½ × 39½ inches

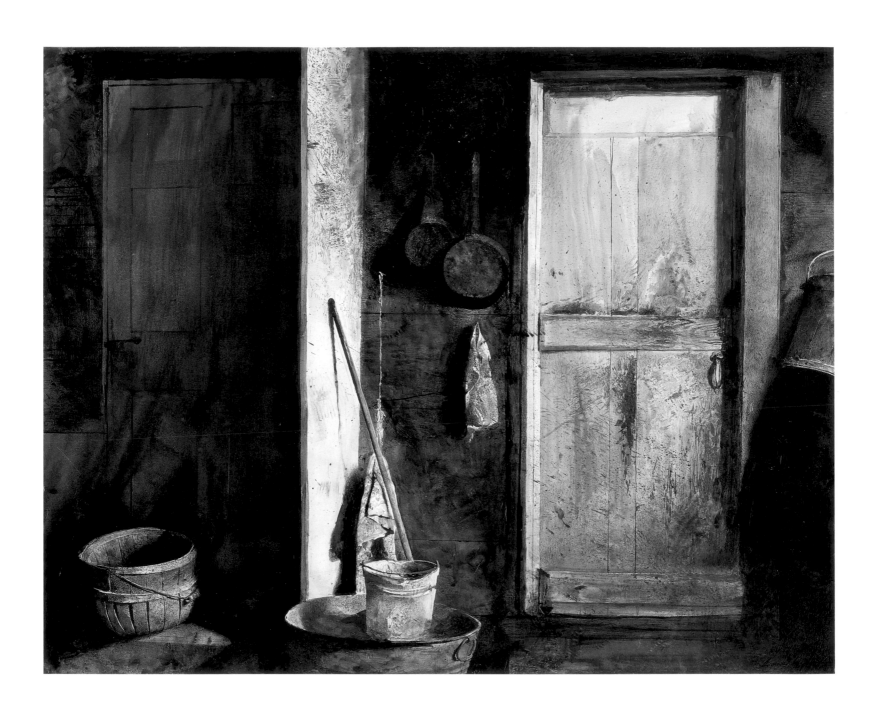

PLATE 49  *Alvaro and Christina*  1968  Watercolor on paper, 22½ × 28¾ inches

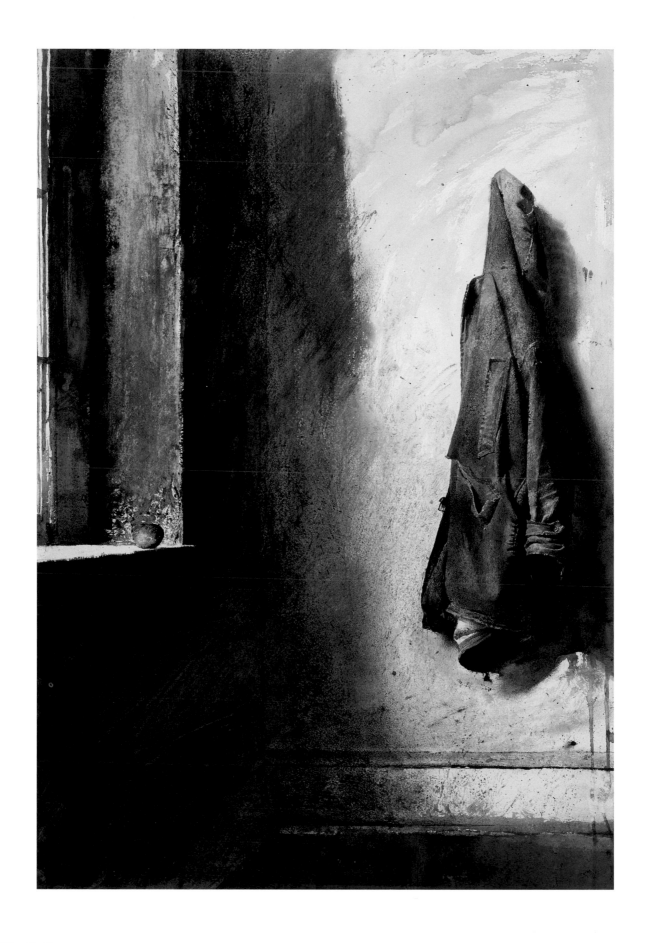

PLATE 50 *Willard's Coat* 1968 Watercolor on paper, 29½ × 21 inches 173

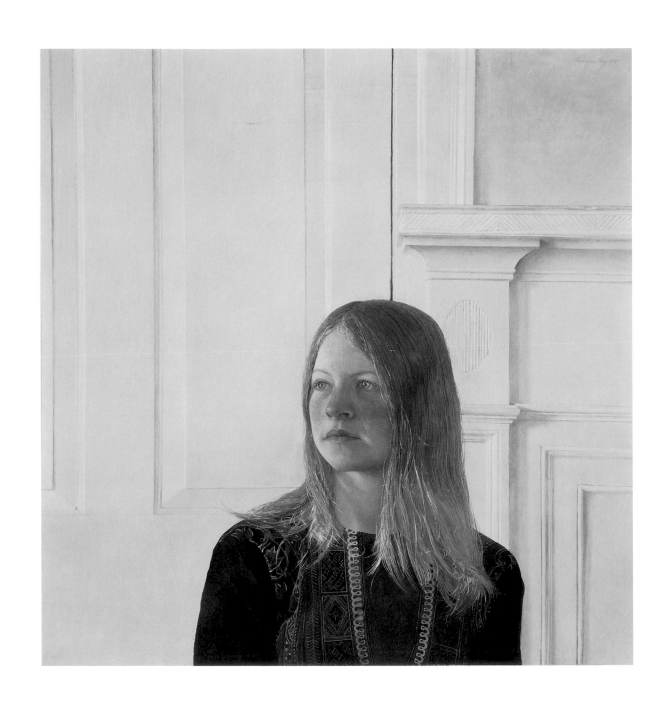

PLATE 51 *Siri* 1970 Tempera on panel, 30½ × 30 inches

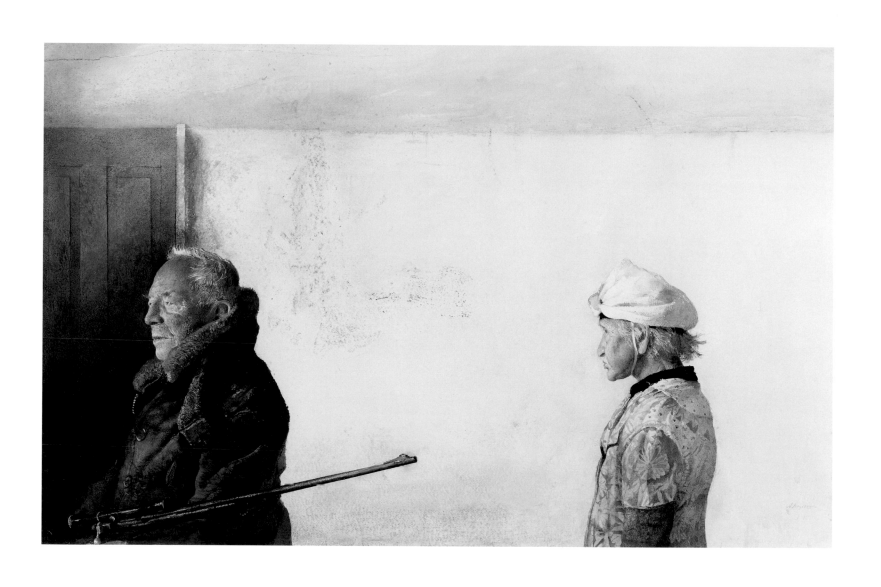

PLATE 52  *The Kuerners*  1971     Drybrush on paper, 25 × 45 inches

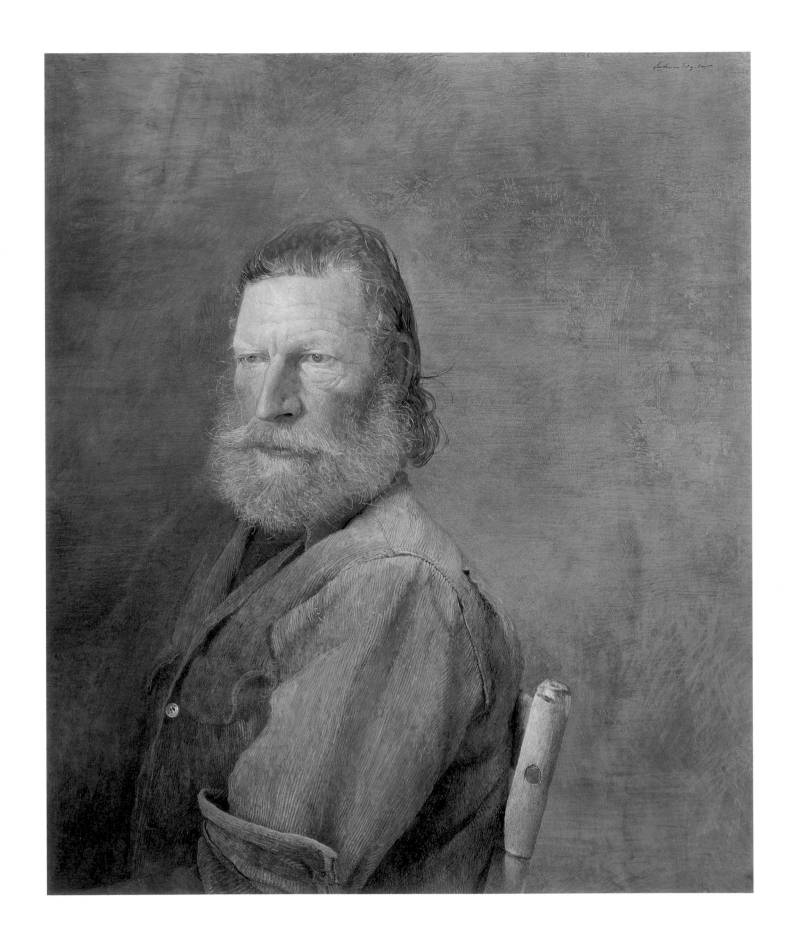

PLATE 53 *Sea Dog* 1971 Tempera on composition board, 28 × 24 inches

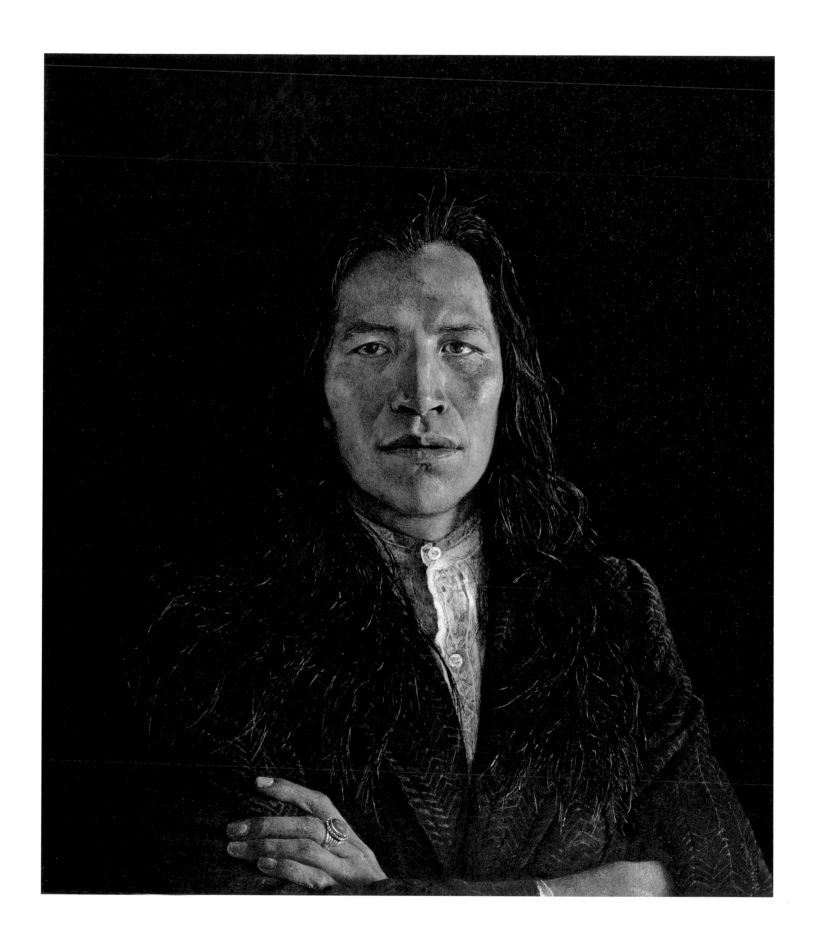

PLATE 54 *Nogeeshik* 1972 Tempera on panel, 24⅝ × 21⅜ inches

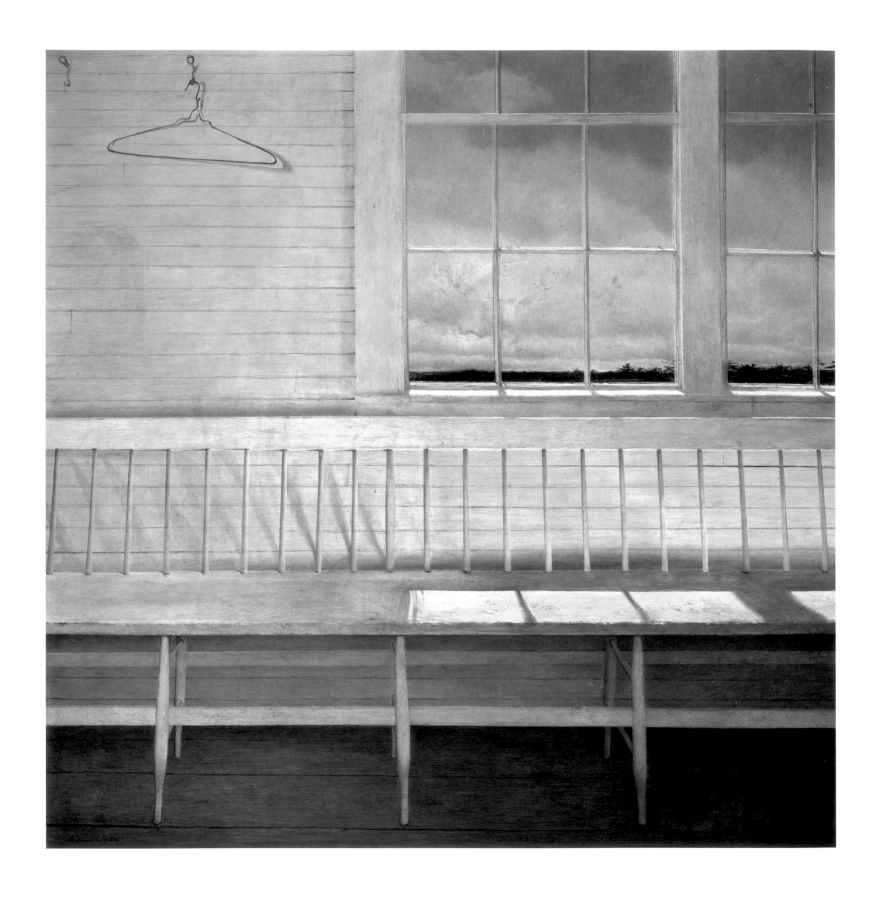

PLATE 55 *Off at Sea* 1972  Tempera on panel, 33¾ × 33½ inches

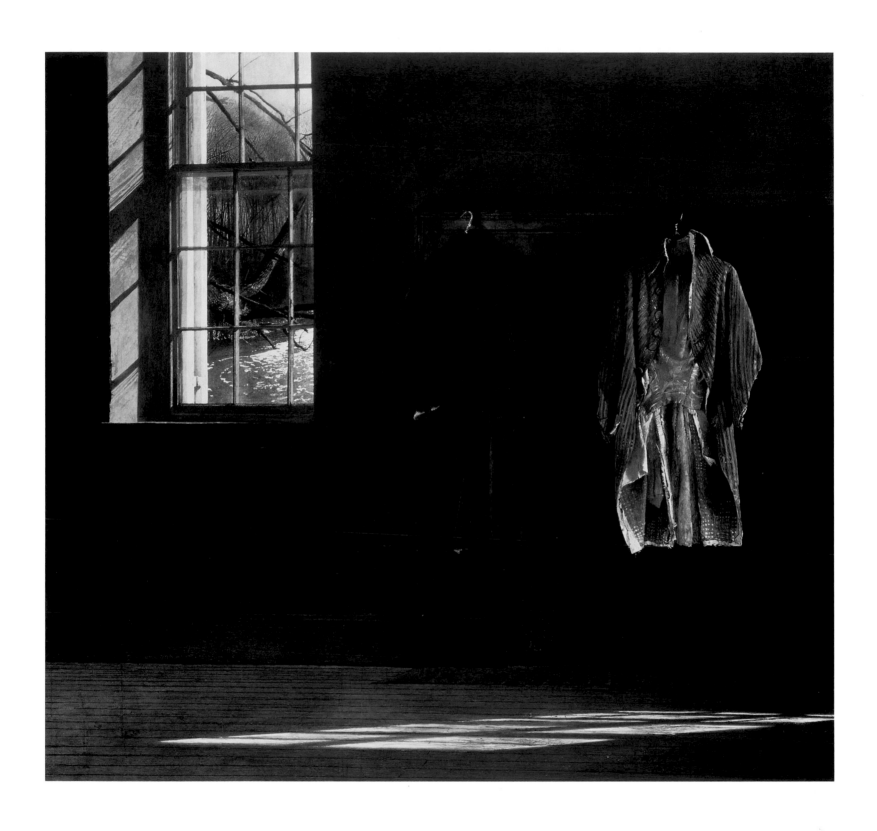

PLATE 56 *The Quaker* 1975   Tempera on panel, 36½ × 40 inches                                    179

PLATE 57 *The German* 1975 Watercolor on paper, 21 × 29 inches

PLATE 58 *Wolf Moon* 1975 Watercolor on paper, 40⅛ × 29 inches 181

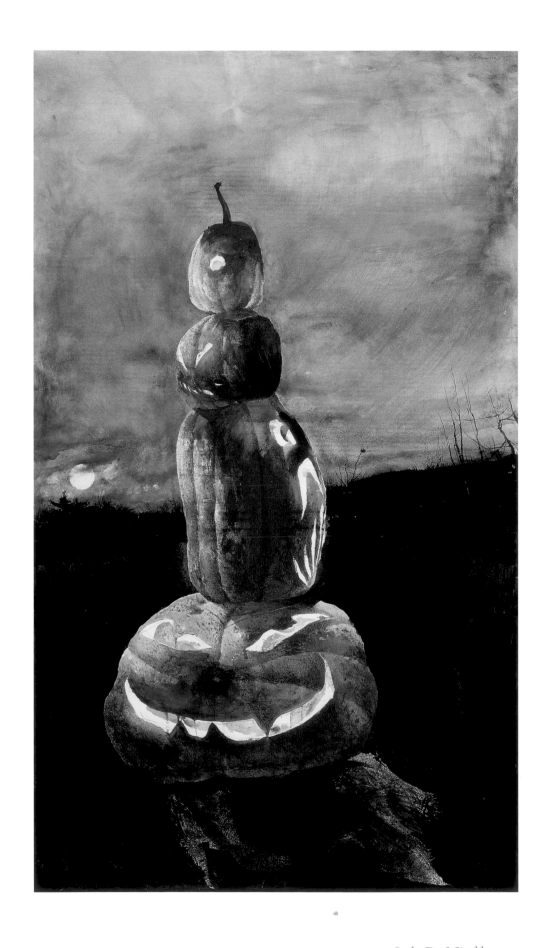

PLATE 59 *Jack-Be-Nimble* 1976 Watercolor on paper, 53 × 31½ inches

PLATE 60 *Pine Baron* 1976 Tempera on panel, 31⅜ × 33¼ inches

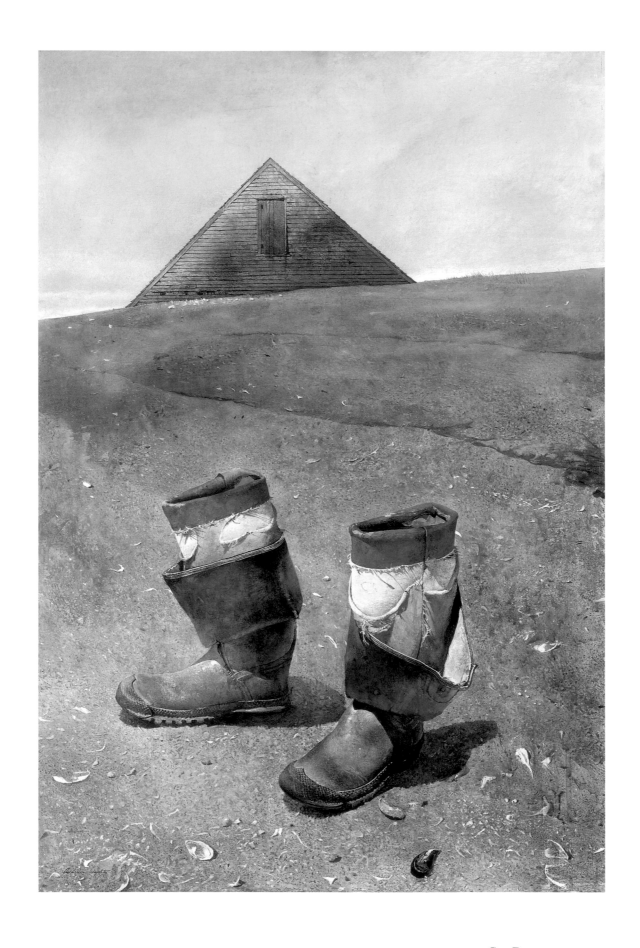

PLATE 61 *Sea Boots* 1976 Tempera on panel, 29 × 19¾ inches

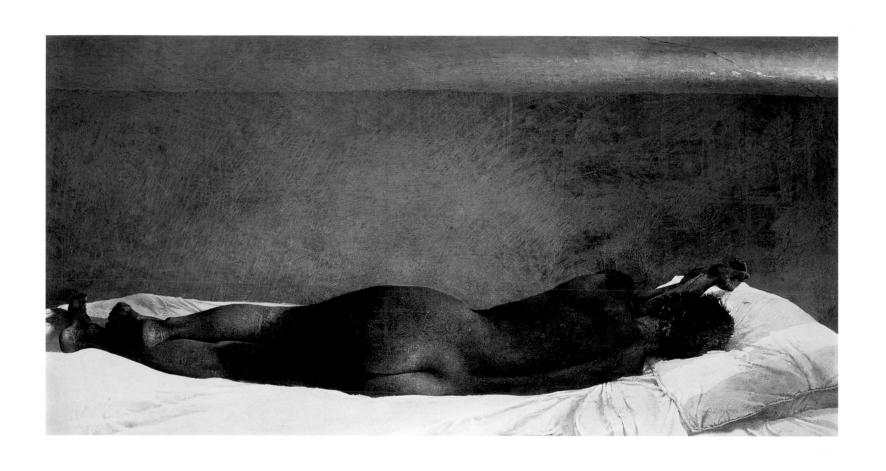

PLATE 62  *Barracoon*  1976    Tempera on panel, 17¼ × 33¾ inches

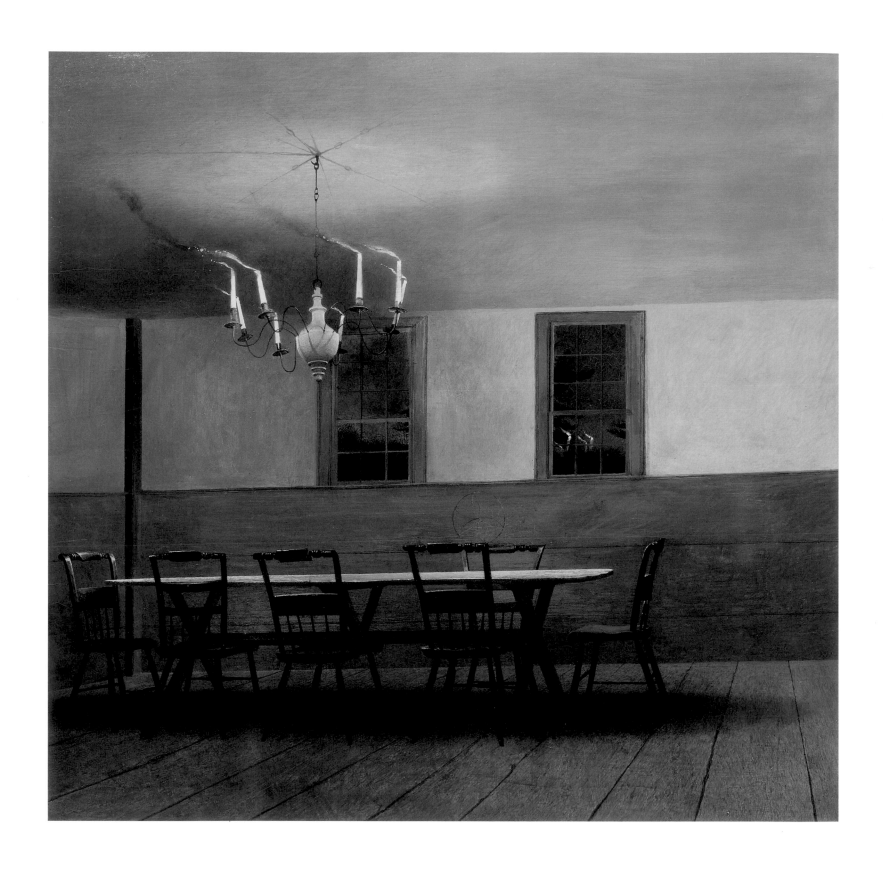

PLATE 63 *The Witching Hour* 1977 Tempera on panel, 30⅝ × 31¾ inches

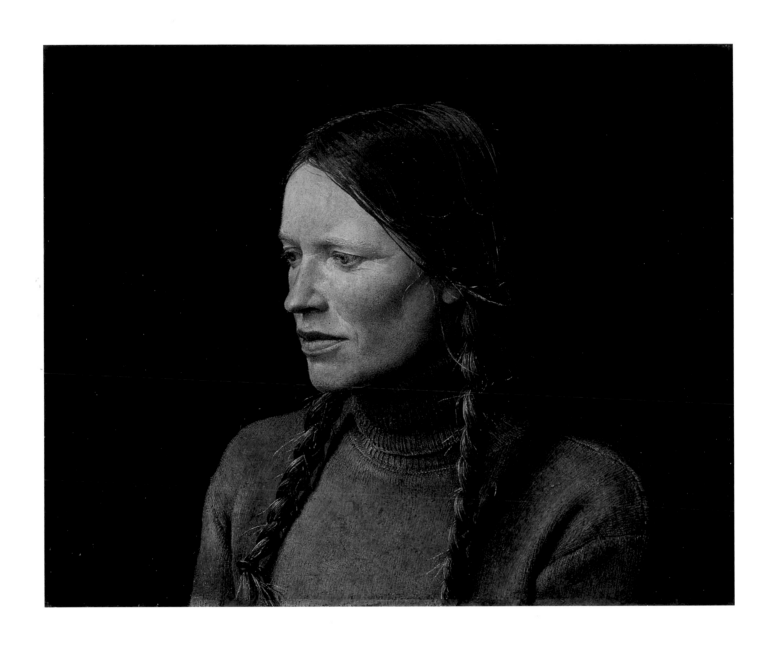

PLATE 64 *Braids* 1977 Tempera on panel, 16½ × 20½ inches

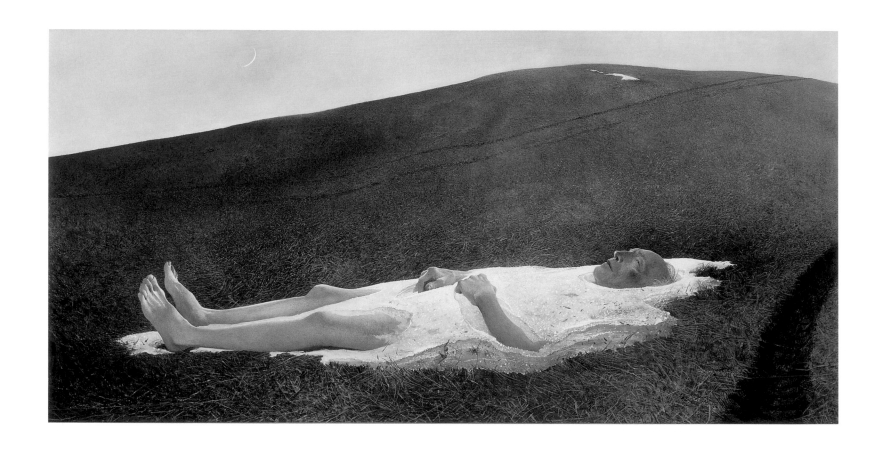

PLATE 65 *Spring* 1978 Tempera on panel, 24 × 48 inches

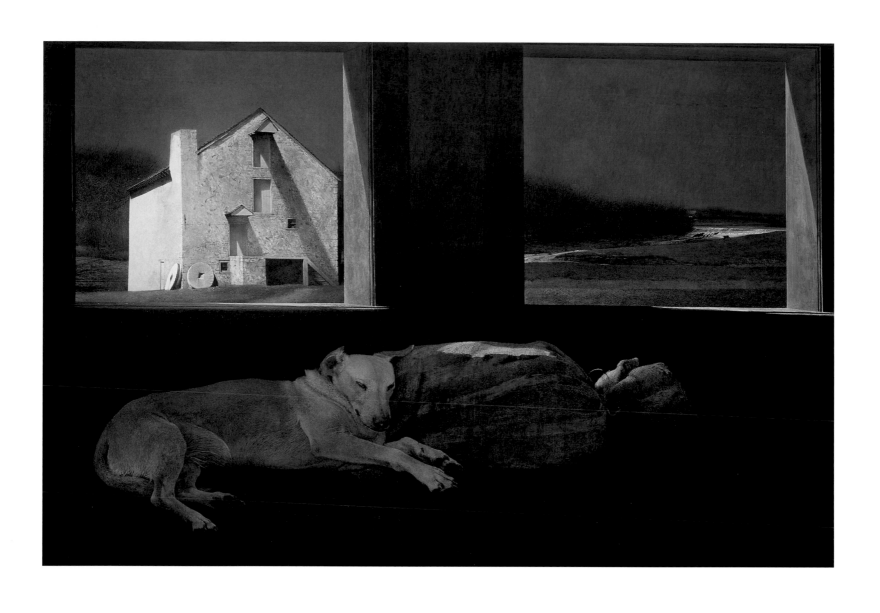

PLATE 66 *Night Sleeper* 1979 Tempera on panel, 48 × 72 inches

189

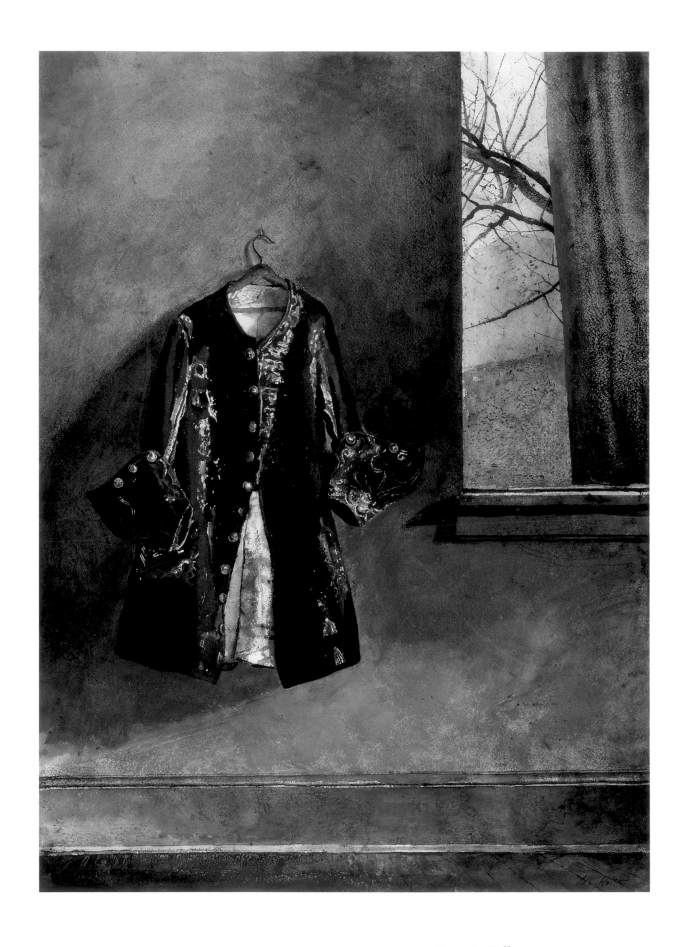

PLATE 67 *Curtain Call* 1979 Drybrush watercolor on paper, 30¾ × 22½ inches

PLATE 68  *Day Dream*  1980  Tempera on panel, 19 × 27⅜ inches

PLATE 69 *Big Top* 1981 Drybrush on paper, 28¾ × 51 inches

PLATE 70 *Dr. Syn* 1981 Tempera on panel, 21½ × 18¾ inches

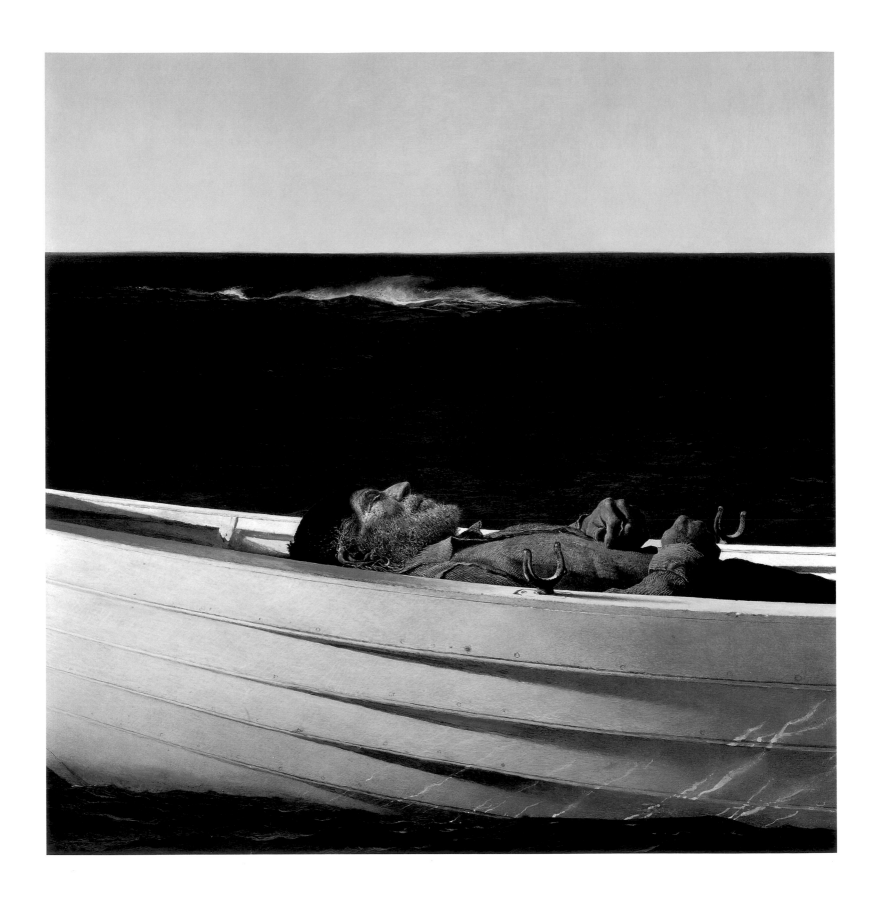

PLATE 71 *Adrift* 1982 Tempera on panel, 27⅝ × 27⅝ inches

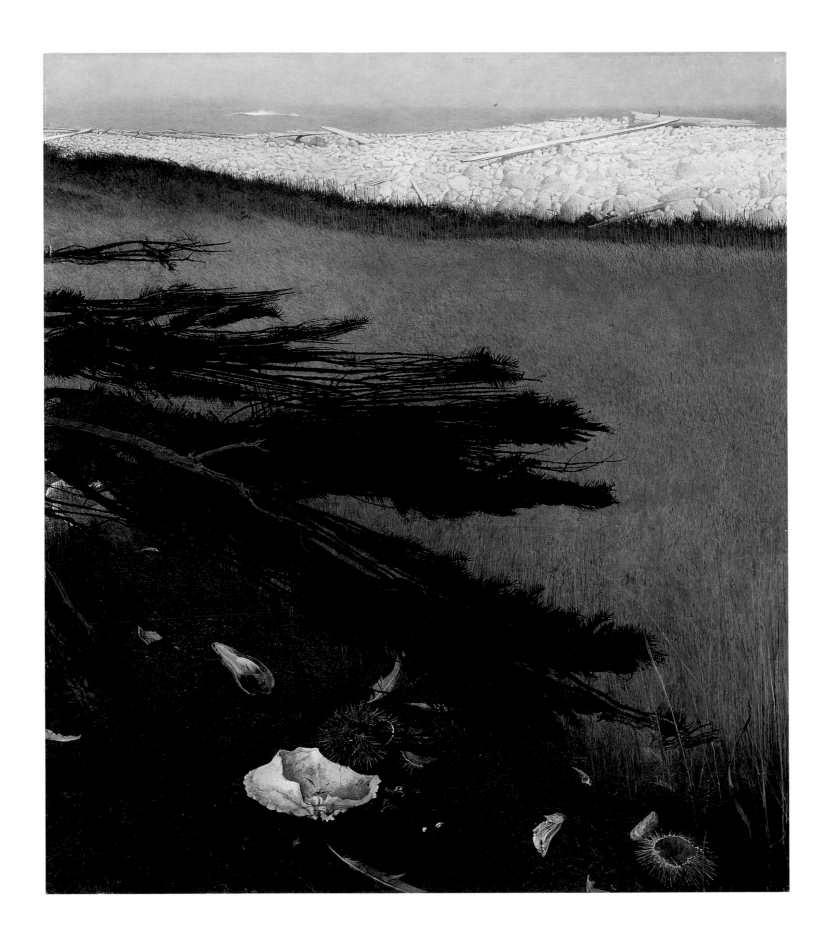

PLATE 72  *Raven's Grove*  1985   Tempera on panel, 30 × 26½ inches

195

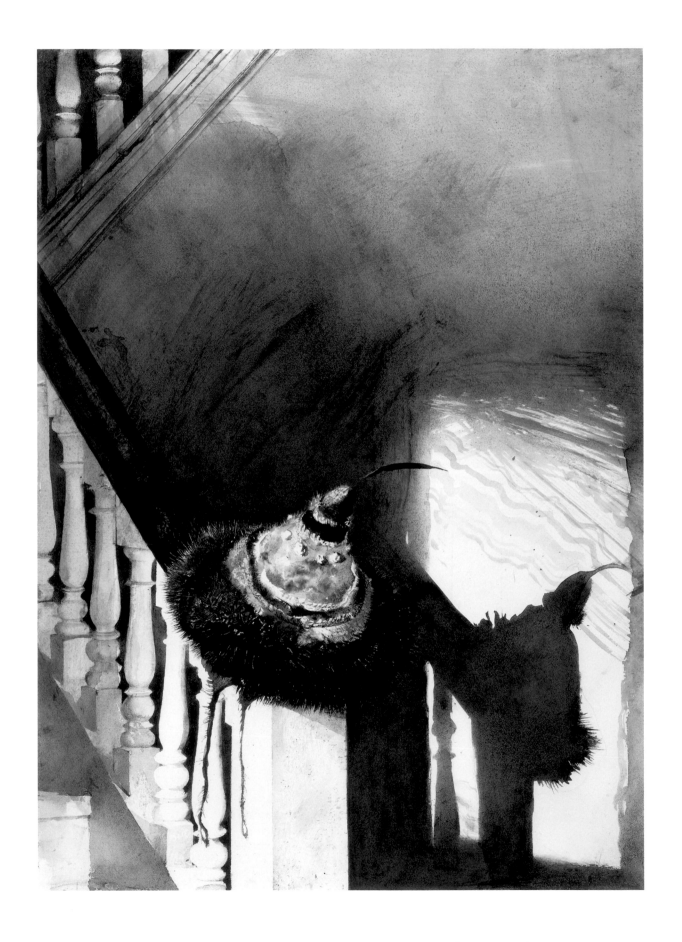

PLATE 73  *A Feather in Her Cap*  1987   Watercolor on paper, 30¼ × 22⅜ inches

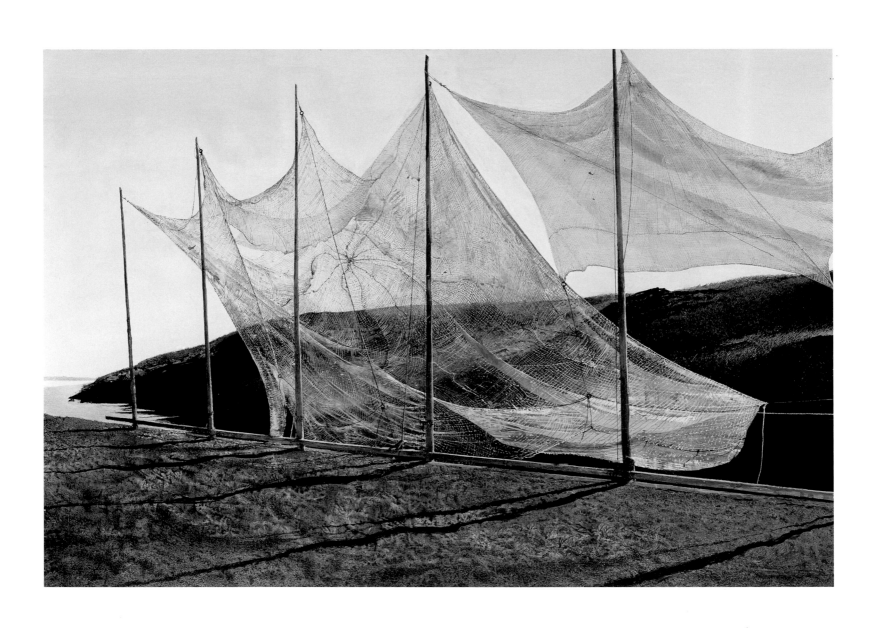

PLATE 74  *Pentecost*  1989    Tempera on panel, 20¾ × 30⅝ inches                                    197

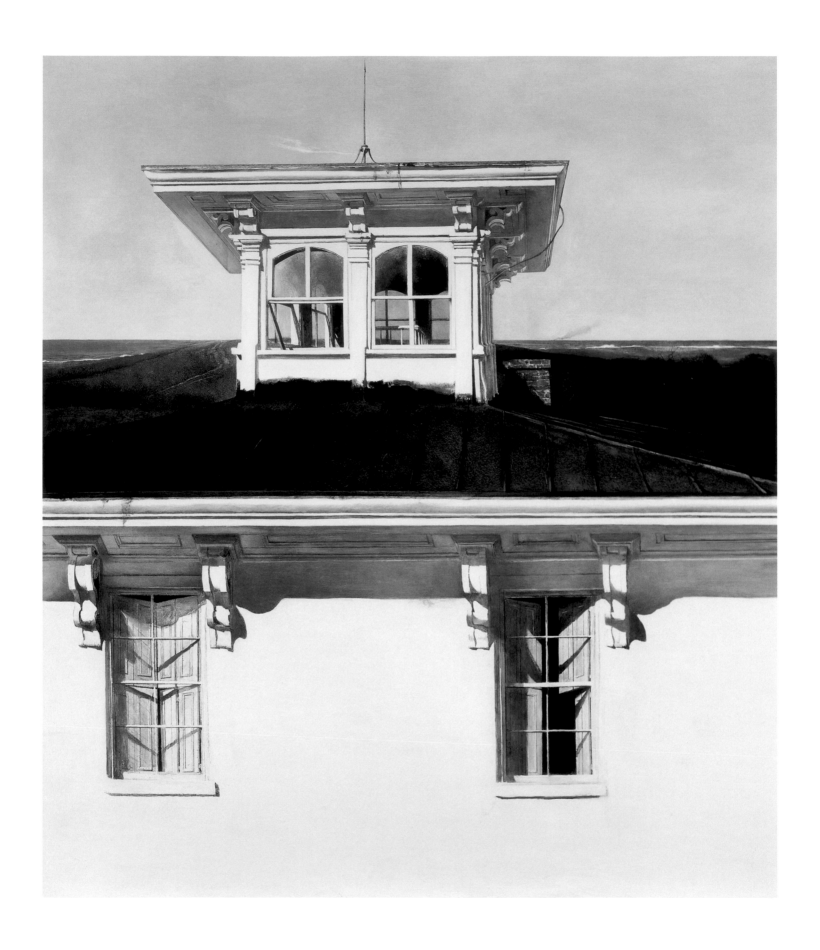

PLATE 75  *Widow's Walk*  1990  Tempera on panel, 48¼ × 43⅜ inches

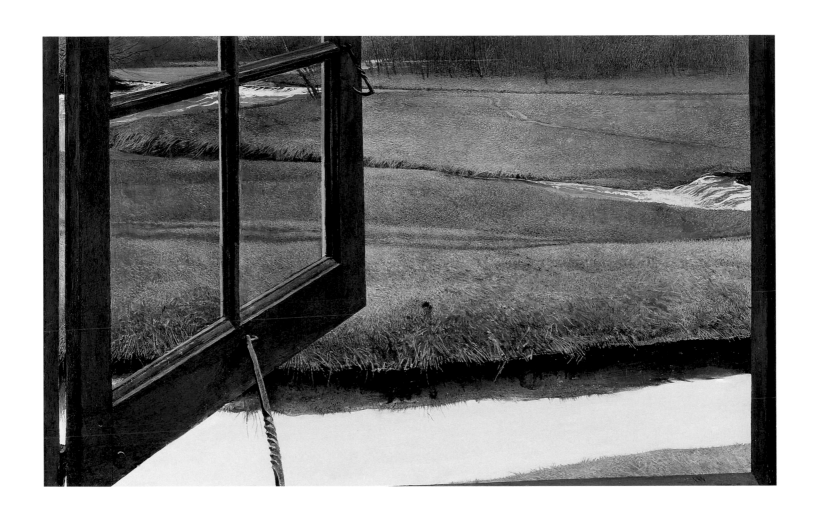

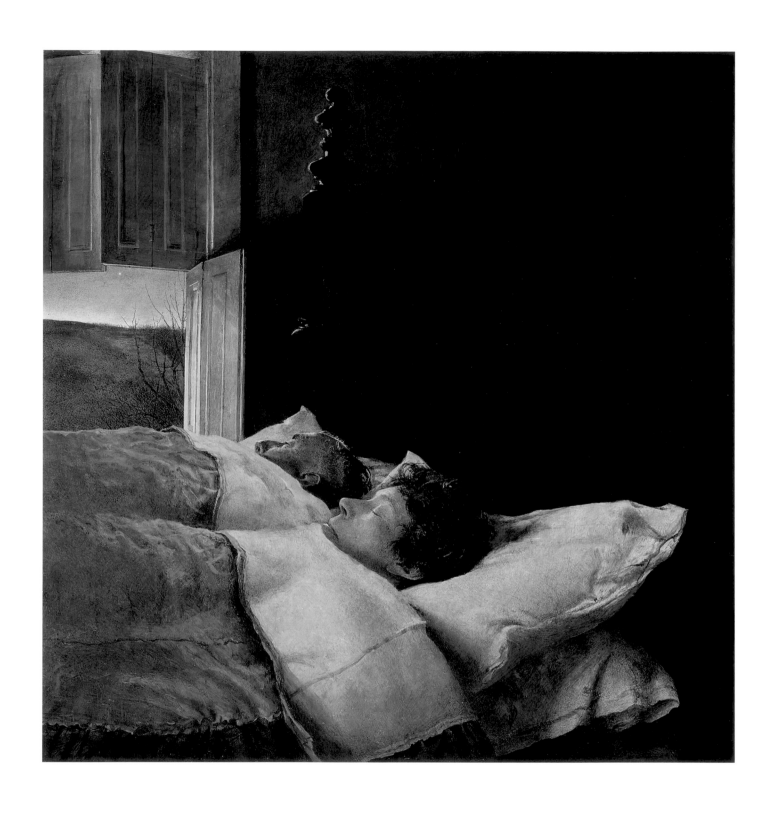

PLATE 77 *Marriage* 1993 Tempera on panel, 24 × 24 inches

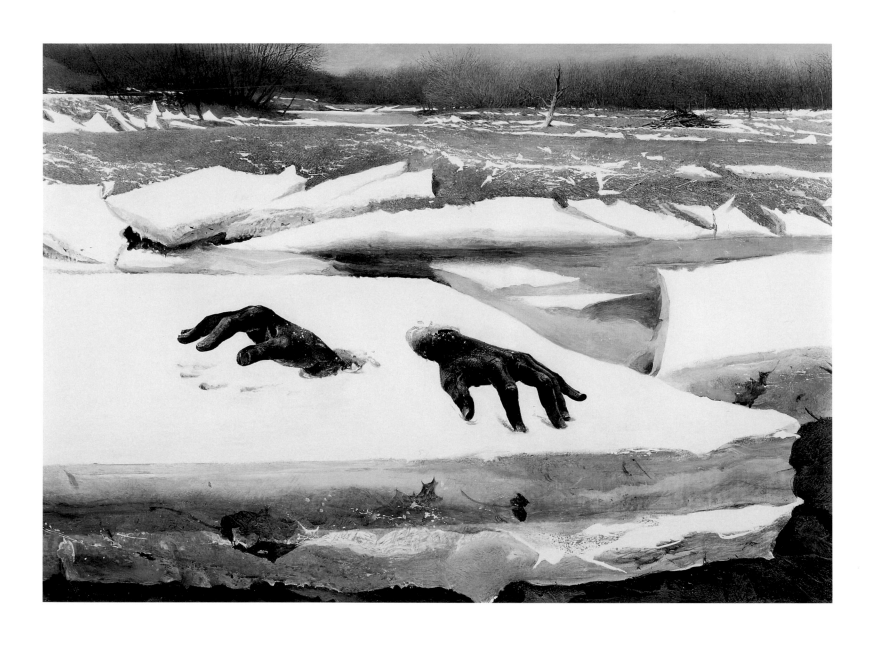

PLATE 78 *Breakup* 1994    Tempera on panel, 19¾ × 28 inches

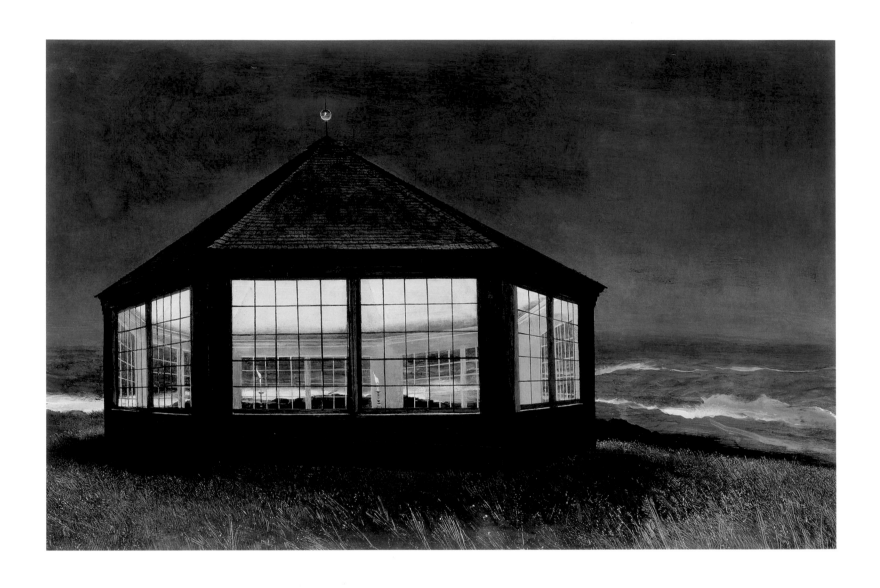

PLATE 79 *Two If By Sea* 1995   Tempera on panel, 31 × 48 inches

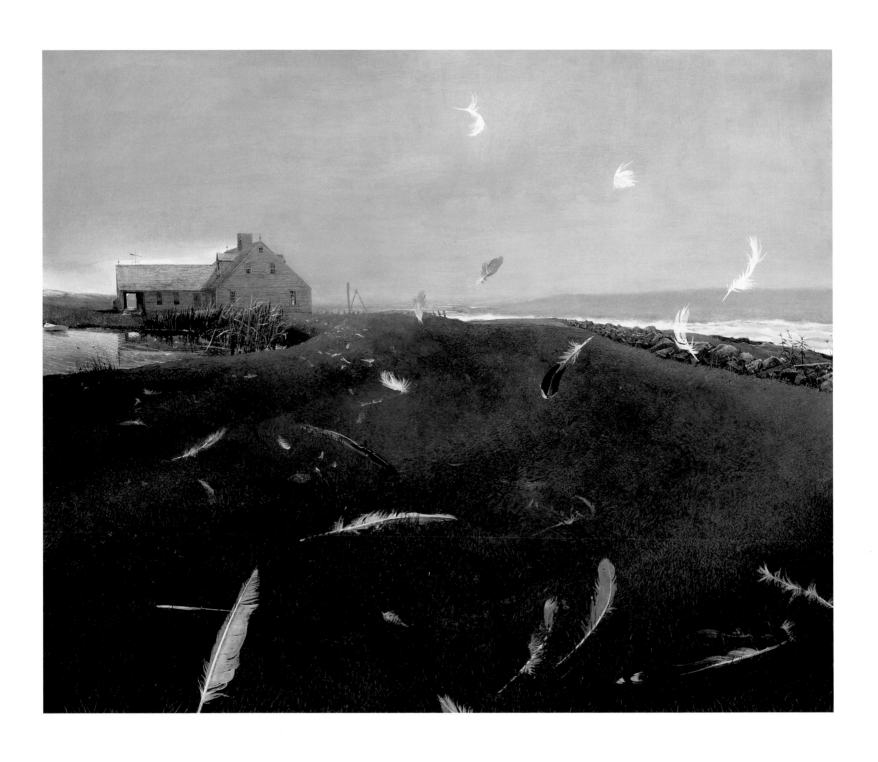

PLATE 80 *Airborne* 1996    Tempera on panel, 40 × 48 inches    203

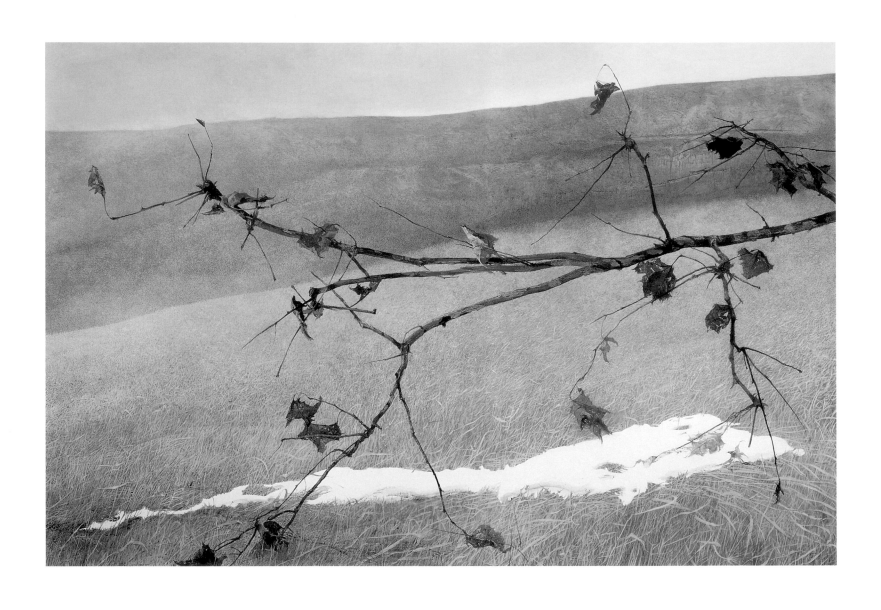

PLATE 81  *Long Limb*  1998    Tempera on panel, 48 × 72 inches

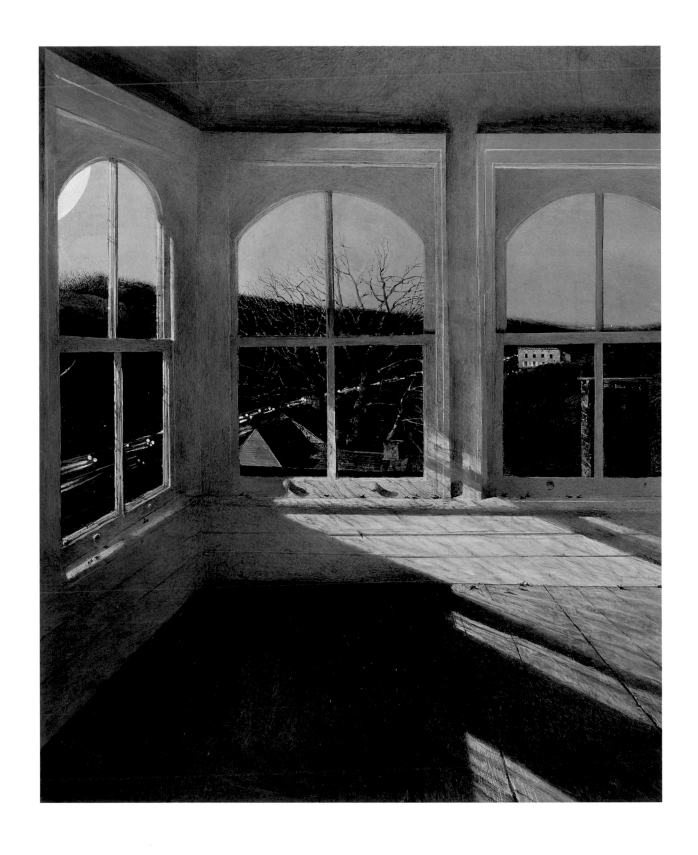

PLATE 82 *Renfield* 1999 Tempera on panel, 34¼ × 28¾ inches 205

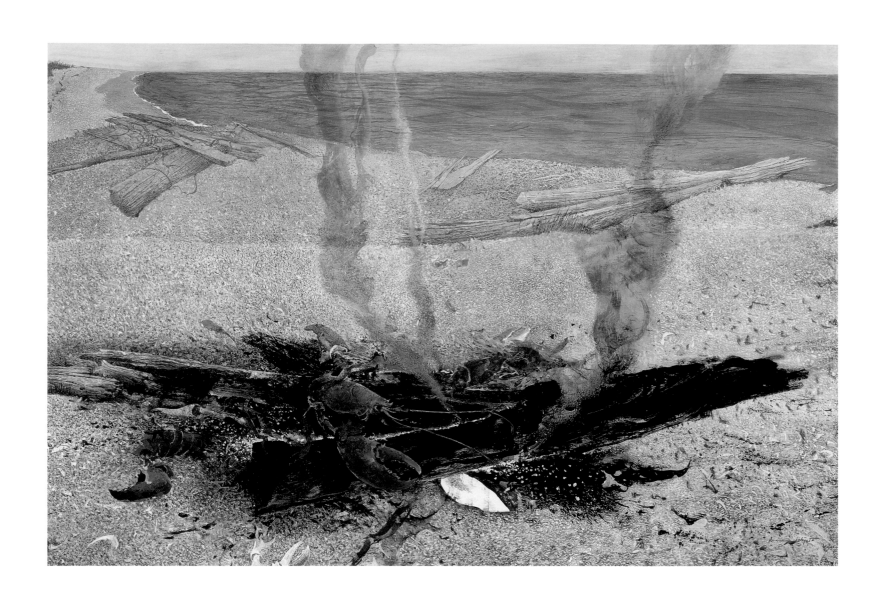

PLATE 83 *Embers* 2000 Tempera on panel, 24 × 36 inches

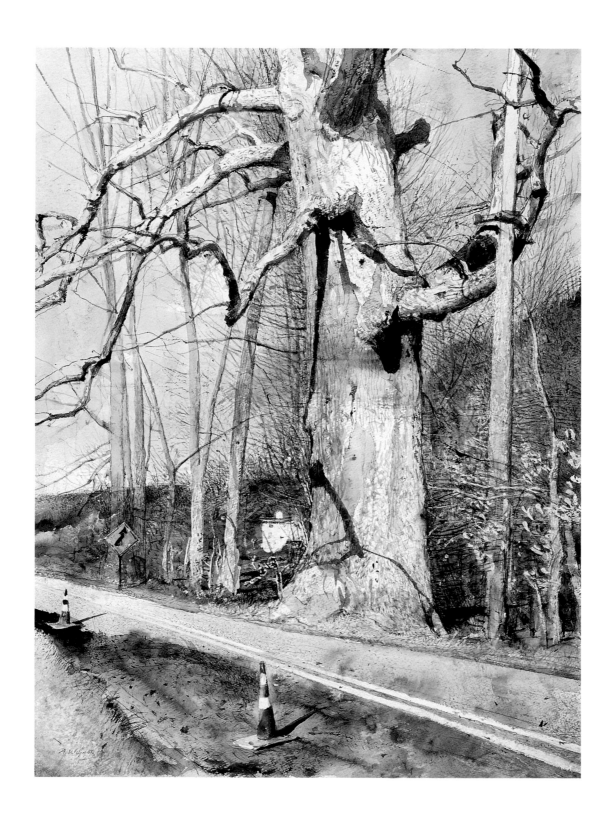

PLATE 84 *Walking Stick* 2002 Watercolor on paper, 23⅞ × 18 inches 207

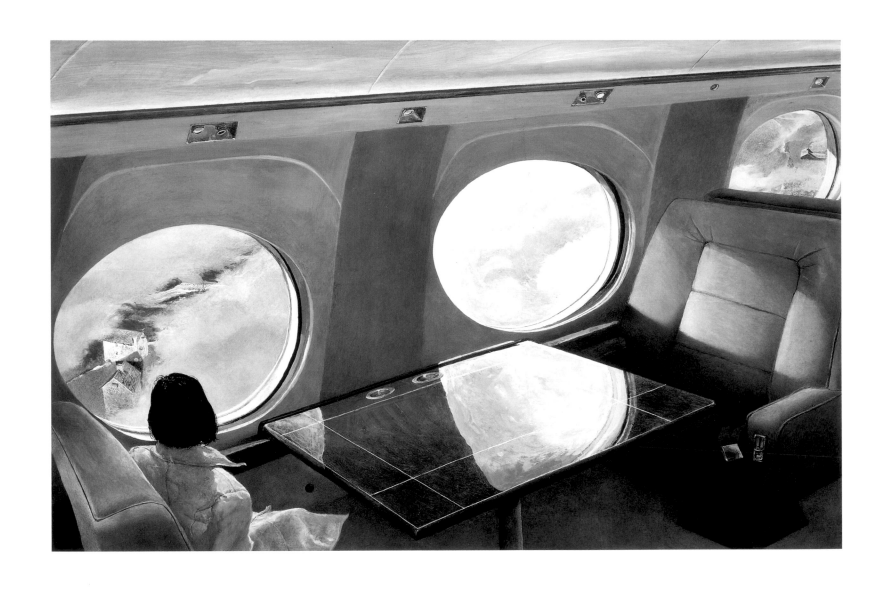

PLATE 85 *Otherworld* 2002 Tempera on panel, 30½ × 47¾ inches

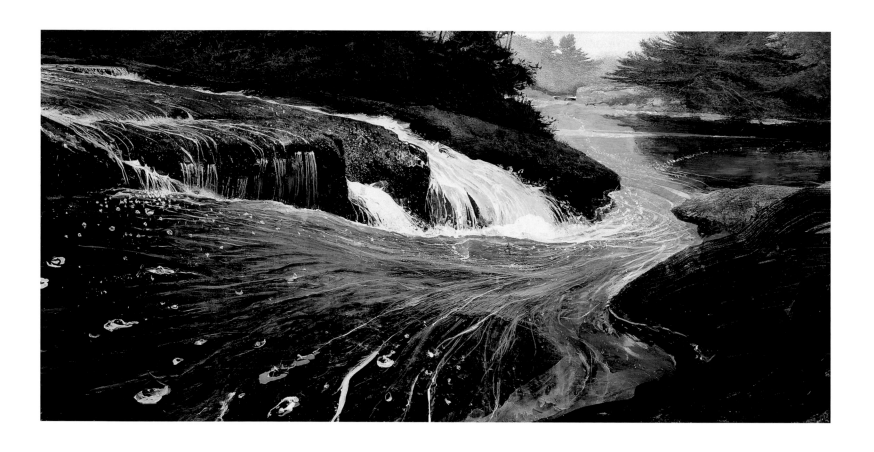

PLATE 86  *The Carry*  2003    Tempera on panel, 24 × 48 inches

# Checklist of the Exhibition

All works copyright of Andrew Wyeth

1    *Life Mask of Abraham Lincoln*, 1934
Oil on canvas
25 × 27½ inches
Collection of Andrew and Betsy Wyeth
Plate 1

2    *Charlie Ervine*, 1937
Tempera on panel
31¾ × 39¾ inches
Collection of Andrew and Betsy Wyeth
Plate 2

3    *The Lobsterman*, 1937
Watercolor on paper
22½ × 29 inches
Hunter Museum of American Art,
Chattanooga, Tennessee
Gift of the Benwood Foundation
Plate 3

4    *Dead Gull*, 1938
Tempera on panel
25 × 30 inches
Collection of Andrew and Betsy Wyeth
Plate 4

5    *Mussels, Study for Little Caldwell's Island*, 1940
Ink and watercolor on paper
13 × 17 inches
Delaware Art Museum, Wilmington
Special Purchase Fund, 1964
Philadelphia only
Plate 5

6    *Little Caldwell's Island*, 1940
Tempera on panel
32 × 40 inches
The Cawley Family
Plate 6

7    *Apples on a Bough, Study for Before Picking*,
1942
Drybrush on paper
14¼ × 20½ inches
Collection of Andrew and Betsy Wyeth
Plate 7

8    *Winter Fields*, 1942
Tempera on panel
17¼ × 41 inches
Whitney Museum of American Art, New York
Gift of Mr. and Mrs. Benno C. Schmidt in
memory of Mr. Josiah Marvel, first owner of
this picture, 77.91
Plate 8

9    *Blackberry Branch, Study for Blackberry Picker*,
1943
Drybrush on paper
22 × 26⅞ inches
Collection of Andrew and Betsy Wyeth
Plate 9

10    *Blackberry Picker*, 1943
Tempera on panel
28¾ × 48¼ inches
Private Collection
Plate 10

11 *Soaring,* 1942–1950
Tempera on panel
48 × 87 inches
From the collection of the Shelburne Museum,
Shelburne, Vermont
Plate 11

12 *Public Sale,* 1943
Tempera on panel
24 × 48 inches
Philadelphia Museum of Art
Bequest of Margaret McKee Breyer, 2000
Plate 12

13 *Spring Beauty,* 1943
Drybrush on paper
20 × 30 inches
Sheldon Memorial Art Gallery, University of
Nebraska-Lincoln, UNL-F. M. Hall Collection
Plate 13

14 *The Hunter,* 1943
Tempera on panel
33 × 34 inches
Toledo Museum of Art, Ohio
Plate 14

15 *Christmas Morning,* 1944
Tempera on panel
23¾ × 38¾ inches
Curtis Galleries, Minneapolis, Minnesota
Plate 15

16 *Night Hauling,* 1944
Oil on Masonite
23 × 37⅛ inches
Bowdoin College Museum of Art,
Brunswick, Maine
Gift of Mrs. Ernestine K. Smith, in memory
of her husband, Burwell B. Smith
Plate 16

17 *Crows, Study for Woodshed,* 1944
Drybrush on paper
33 × 47 inches
Lyman Allyn Art Museum, New London,
Connecticut
Plate 17

18 *Winter, 1946,* 1946
Tempera on panel
31⅜ × 48 inches
North Carolina Museum of Art, Raleigh
Plate 18

19 *Christina Olson,* 1947
Tempera on panel
33 × 25 inches
Curtis Galleries, Minneapolis, Minnesota
Plate 19

20 *Wind from the Sea,* 1947
Tempera on Masonite
18½ × 27½ inches
Mead Art Museum, Amherst College,
Amherst, Massachusetts
Extended loan from the Estate of
Charles H. Morgan
Plate 20

21 *Karl,* 1948
Tempera on panel
30½ × 23½ inches
Private Collection
Plate 21

22 *Winter Corn,* 1948
Drybrush on paper
29 × 38¾ inches
Private Collection
Plate 22

23 *Below Dover,* 1950
Tempera on panel
10 × 16 inches
Private Collection
Plate 23

24 *Trodden Weed,* 1951
Tempera on panel
20 × 18¼ inches
Collection of Andrew and Betsy Wyeth
Plate 24

25 *Faraway,* 1952
Drybrush on paper
13¾ × 21½ inches
Jamie Wyeth
Plate 25

26 *Study for Cooling Shed,* ca. 1952–1953
Graphite on thick white wove paper
13⅞ × 10⅞ inches
Philadelphia Museum of Art
Gift of Frank A. Elliott, Josiah Marvel, and
Jonathan H. Marvel in memory of Gwladys
Hopkins Elliott, 1998
Philadelphia only
Figure 71

27 *Study for Cooling Shed,* ca. 1952–1953
Opaque and transparent watercolor with
scraping on thick white wove paper
18 × 11¹⁵⁄₁₆ inches
Philadelphia Museum of Art
Gift of Frank A. Elliott, Josiah Marvel, and
Jonathan H. Marvel in memory of Gwladys
Hopkins Elliott, 1998
Philadelphia only
Figure 72

28 *Study for Cooling Shed,* ca. 1952–1953
Opaque and transparent watercolor on
thick white wove paper
15⅞ × 11⅞ inches
Philadelphia Museum of Art
Gift of Frank A. Elliott, Josiah Marvel, and
Jonathan H. Marvel in memory of Gwladys
Hopkins Elliott, 1998
Philadelphia only
Not illustrated

29 *Cooling Shed,* 1953
Tempera on panel
24¾ × 12⅜ inches
Philadelphia Museum of Art
Gift of Frank A. Elliott, Josiah Marvel, and
Jonathan H. Marvel in memory of Gwladys
Hopkins Elliott, 1998
Plate 26

30 *Seashells, Study for Sandspit,* 1953
Drybrush on paper
11⅜ × 15⅜ inches
Collection of Andrew and Betsy Wyeth
Plate 27

52  *Geraniums,* 1960
    Drybrush watercolor on paper
    20¾ × 15½ inches
    Collection of Andrew and Betsy Wyeth
    Plate 36

53  *Distant Thunder,* 1961
    Tempera on panel
    48 × 30½ inches
    Private Collection
    Plate 37

54  *Light Wash,* 1961
    Watercolor on paper
    30½ × 24½ inches
    Cummer Museum of Art and Gardens,
    Jacksonville, Florida
    Plate 38

55  *Garret Room,* 1962
    Drybrush on paper
    17½ × 22½ inches
    Private Collection
    Plate 39

56  *Her Room,* 1963
    Tempera on panel
    24⅜ × 48 inches
    Collection of the Farnsworth Art Museum,
    Rockland, Maine
    Museum purchase, 1964
    Plate 40

57  *Open and Closed,* 1964
    Watercolor on paper
    21 × 30 inches
    Collection of Mr. and Mrs. L. H. Caldwell III
    Plate 41

58  *Monologue,* 1965
    Drybrush and watercolor on paper
    22¼ × 28½ inches
    Collection of the Brandywine River Museum,
    Chadds Ford, Pennsylvania
    Anonymous Gift, 1983
    Plate 42

59  *Weatherside,* 1965
    Tempera on panel
    48⅛ × 27⅞ inches
    Private Collection
    Plate 43

60  *Far from Needham,* 1966
    Tempera on panel
    44 × 41¼ inches
    Private Collection
    Plate 44

61  *Cranberries,* 1966
    Watercolor on paper
    18 × 12 inches
    Greenville County Museum of Art,
    South Carolina
    Gift of Noel and Ellison McKissick
    Plate 45

62  *Maga's Daughter,* 1966
    Tempera on panel
    26½ × 30¼ inches
    Collection of Andrew and Betsy Wyeth
    Plate 46

63  *Anna Christina,* 1967
    Tempera on panel
    21½ × 23½ inches
    Jointly owned by the Brandywine River
    Museum, Chadds Ford, Pennsylvania,
    and Museum of Fine Arts, Boston
    Anonymous Gift
    Plate 47

64  *Spring Fed,* 1967
    Tempera on panel
    27½ × 39½ inches
    Collection of Mr. and Mrs. William D. Weiss
    Plate 48

65  *Alvaro and Christina,* 1968
    Watercolor on paper
    22½ × 28¾ inches
    Collection of the Farnsworth Art Museum,
    Rockland, Maine
    Museum purchase, 1969
    Plate 49

66  *Willard's Coat,* 1968
    Watercolor on paper
    29½ × 21 inches
    Jane Wyeth
    Plate 50

67  *Siri,* 1970
    Tempera on panel
    30½ × 30 inches
    Collection of the Brandywine River Museum,
    Chadds Ford, Pennsylvania
    Purchased by John T. Dorrance, Jr.;
    Mr. and Mrs. Felix du Pont; Mr. and
    Mrs. James P. Mills; Mr. and Mrs. Bayard
    Sharp; two anonymous donors; and the
    Pew Memorial Trust, 1975
    Plate 51

68  *The Kuerners,* 1971
    Drybrush on paper
    25 × 45 inches
    Collection of Andrew and Betsy Wyeth
    Plate 52

69  *Sea Dog,* 1971
    Tempera on composition board
    28 × 24 inches
    North Carolina Museum of Art, Raleigh
    Gift of R. J. Reynolds Industries, Inc.
    Plate 53

70  *Nogeeshik,* 1972
    Tempera on panel
    24⅝ × 21⅜ inches
    Collection of Andrew and Betsy Wyeth
    Plate 54

71  *Off at Sea,* 1972
    Tempera on panel
    33¾ × 33½ inches
    Private Collection
    Plate 55

72  *The Quaker,* 1975
    Tempera on panel
    36½ × 40 inches
    Margaret and Terry Stent
    Plate 56

73 *The German,* 1975
Watercolor on paper
21 × 29 inches
Collection of Andrew and Betsy Wyeth
Plate 57

74 *Wolf Moon,* 1975
Watercolor on paper
40⅛ × 29 inches
Collection of Andrew and Betsy Wyeth
Plate 58

75 *Jack-Be-Nimble,* 1976
Watercolor on paper
53 × 31½ inches
Collection of Andrew and Betsy Wyeth
Plate 59

76 *Pine Baron,* 1976
Tempera on panel
31⅜ × 33¼ inches
Fukushima Prefectural Museum of Art, Japan
Plate 60

77 *Sea Boots Study,* 1976
Watercolor on paper
21½ × 23⅜ inches
Collection of Andrew and Betsy Wyeth
Not illustrated

78 *Sea Boots Study,* 1976
Watercolor on paper
20⅞ × 16⅞ inches
Collection of Andrew and Betsy Wyeth
Not illustrated

79 *Sea Boots Study,* 1976
Watercolor on paper
21⅞ × 29⅞ inches
Collection of Andrew and Betsy Wyeth
Not illustrated

80 *Sea Boots Study,* 1976
Watercolor on paper
28¾ × 22¾ inches
Collection of Andrew and Betsy Wyeth
Not illustrated

81 *Sea Boots Study,* 1976
Drybrush on paper
20¾ × 16½ inches
Collection of Andrew and Betsy Wyeth
Not illustrated

82 *Sea Boots,* 1976
Tempera on panel
29 × 19¾ inches
Detroit Institute of Arts, Michigan
Plate 61

83 *Barracoon,* 1976
Tempera on panel
17¼ × 33¾ inches
Collection of Andrew and Betsy Wyeth
Philadelphia only
Plate 62

84 *The Witching Hour,* 1977
Tempera on panel
30⅝ × 31¾ inches
Collection of Andrew and Betsy Wyeth
Plate 63

85 *Braids,* 1977
Tempera on panel
16½ × 20½ inches
Private Collection
Plate 64

86 *Spring,* 1978
Tempera on panel
24 × 48 inches
Collection of the Brandywine River Museum,
Chadds Ford, Pennsylvania
Anonymous Gift, 1987
Plate 65

87 *Night Sleeper,* 1979
Tempera on panel
48 × 72 inches
Collection of Andrew and Betsy Wyeth
Plate 66

88 *Curtain Call,* 1979
Drybrush watercolor on paper
30¾ × 22½ inches
Courtesy of Frank E. Fowler
Plate 67

89 *Day Dream,* 1980
Tempera on panel
19 × 27⅜ inches
The Armand Hammer Collection
Armand Hammer Museum, Los Angeles,
California
Gift of the Armand Hammer Foundation
Plate 68

90 *Big Top,* 1981
Drybrush on paper
28¾ × 51 inches
Collection of Andrew and Betsy Wyeth
Plate 69

91 *Dr. Syn,* 1981
Tempera on panel
21½ × 18¾ inches
Collection of Andrew and Betsy Wyeth
Plate 70

92 *Baron Philippe,* 1981
Watercolor on paper
13¾ × 21¾ inches
Honorable and Mrs. William B. Schwartz, Jr.
Atlanta only
Figure 30

93 *Adrift,* 1982
Tempera on panel
27⅝ × 27⅝ inches
Collection of Andrew and Betsy Wyeth
Plate 71

94 *Virgin Birch,* 1982
Watercolor on paper
21½ × 29½ inches
Private Collection
Atlanta only
Figure 39

95 *Raven's Grove,* 1985
Tempera on panel
30 × 26½ inches
Portland Museum of Art, Maine
Gift of Elizabeth B. Noyce
Plate 72

96   *A Feather in Her Cap,* 1987
     Watercolor on paper
     30¼ × 22⅜ inches
     Collection of Andrew and Betsy Wyeth
     Plate 73

97   *Pentecost,* 1989
     Tempera on panel
     20¾ × 30⅝ inches
     Collection of Andrew and Betsy Wyeth
     Plate 74

98   *Widow's Walk,* 1990
     Tempera on panel
     48¼ × 43⅜ inches
     Courtesy of Frank E. Fowler
     Plate 75

99   *Love in the Afternoon,* 1992
     Tempera on panel
     17⅝ × 28⅝ inches
     Ambassador and Mrs. William S. Farish
     Plate 76

100  *Marriage,* 1993
     Tempera on panel
     24 × 24 inches
     Private Collection
     Plate 77

101  *Breakup,* 1994
     Tempera on panel
     19¾ × 28 inches
     Private Collection
     Plate 78

102  *Two If By Sea,* 1995
     Tempera on panel
     31 × 48 inches
     Collection of Andrew and Betsy Wyeth
     Plate 79

103  *Airborne,* 1996
     Tempera on panel
     40 × 48 inches
     Collection of Andrew and Betsy Wyeth
     Plate 80

104  *Long Limb,* 1998
     Tempera on panel
     48 × 72 inches
     Collection of Andrew and Betsy Wyeth
     Plate 81

105  *Renfield,* 1999
     Tempera on panel
     34¼ × 28¾ inches
     Collection of Andrew and Betsy Wyeth
     Plate 82

106  *Embers,* 2000
     Tempera on panel
     24 × 36 inches
     Courtesy of Frank E. Fowler
     Plate 83

107  *Walking Stick,* 2002
     Watercolor on paper
     23⅞ × 18 inches
     Private Collection
     Plate 84

108  *Otherworld,* 2002
     Tempera on panel
     30½ × 47¾ inches
     Courtesy of Frank E. Fowler
     Plate 85

109  *The Carry,* 2003
     Tempera on panel
     24 × 48 inches
     Courtesy of Frank E. Fowler
     Plate 86

# Lenders to the Exhibition

Andrew and Betsy Wyeth

## Private Collectors
Anonymous lenders
Mr. and Mrs. L. H. Caldwell III
The Cawley Family
Ambassador and Mrs. William S. Farish
Nobuo Nemoto
Honorable and Mrs. William B. Schwartz, Jr.
Joyce and Henry Schwob
Margaret and Terry Stent
Mr. and Mrs. William D. Weiss
Jamie Wyeth
Jane Wyeth

## Institutions
Armand Hammer Museum, Los Angeles, California
Bowdoin College Museum of Art, Brunswick, Maine
Brandywine River Museum, Chadds Ford, Pennsylvania
Cummer Museum of Art and Gardens, Jacksonville, Florida
Curtis Galleries, Minneapolis, Minnesota
Delaware Art Museum, Wilmington
Detroit Institute of Arts, Michigan
Farnsworth Art Museum, Rockland, Maine
Fukushima Prefectural Museum of Art, Japan
Greenville County Museum of Art, South Carolina
Hunter Museum of American Art, Chattanooga, Tennessee
Lyman Allyn Art Museum, New London, Connecticut
Mead Art Museum, Amherst College, Amherst, Massachusetts
Museum of Fine Arts, Boston
North Carolina Museum of Art, Raleigh
Philadelphia Museum of Art
Portland Museum of Art, Maine
Shelburne Museum, Shelburne, Vermont
Sheldon Memorial Art Gallery, University of Nebraska-Lincoln
Toledo Museum of Art, Ohio
Wadsworth Atheneum Museum of Art, Hartford, Connecticut
Whitney Museum of American Art, New York
Winterthur Museum, Delaware

# Index

Page references to illustrations appear in **bold** type.

# Photo Credits

The publishers wish to thank the museums, galleries, and collectors named in the illustration captions and below for permitting the reproduction of works in their collections and for supplying photographic material. Additional information regarding copyright and credits is provided below.

All Andrew Wyeth images © Andrew Wyeth unless otherwise noted.

## Plates

Pl. 8  Photography: © 1998, Whitney Museum of American Art, New York.

Pl. 11  Photography: Ken Burris.

Pl. 12  Photography: Graydon Wood, 2000.

Pl. 28  Photography: © 2005 Museum of Fine Arts, Boston.

Pl. 49  Photography: Melville D. McLean.

Pl. 51  © Brandywine Conservancy.

Pl. 55  Photography: Courtesy of Grete Meilman Fine Art, Ltd.

Pl. 64  Courtesy of Ann Richards Nitze and Masami Shiraishi. © AM Art, Inc.

Pl. 72  Photography: Melville D. McLean.

Pl. 77  Photographers used frequently by the Andrew Wyeth office include Rick Echelmeyer, Steve Morrison, Joseph Painter, and Peter Ralston.

## Figure Illustrations

Fig. 3  Photography: © 1989 The Metropolitan Museum of Art.

Fig. 6  © Estate of John Marin/Artists Rights Society (ARS), New York. Photography: Roy Elkind, New York.

Fig. 7  Photography: Smithsonian American Art Museum, Washington, D.C./Art Resource, NY.

Fig. 11  Addison Gallery of American Art, Phillips Academy, Andover, Massachusetts. All Rights Reserved.

Fig. 15  Courtesy of Ann Richards Nitze and Masami Shiraishi. © AM Art, Inc.

Fig. 19  Photography: © 2003 The Metropolitan Museum of Art.

Fig. 28  © 2005 Artists Rights Society (ARS), New York/SABAM, Brussels.

Fig. 29  © Brandywine Conservancy.

Fig. 31  Photography: William E. Phelps, 1941.

Fig. 40  Photography: Peter Harholdt, 2004.

Fig. 44  Photography: Digital Image. © The Museum of Modern Art/Licensed by SCALA/Art Resource, NY.

Fig. 47  Courtesy of Ann Richards Nitze and Masami Shiraishi. © AM Art, Inc.

Fig. 56  Photography: © 1950 Aperture Foundation, Inc., Paul Strand Archive.

Fig. 66  Courtesy of Ann Richards Nitze and Masami Shiraishi. © AM Art, Inc.

Fig. 71  Photography: Amelia Walchli, 2005.

Fig. 95  Photography: Jim Graham.

Figs. 97–98  Photography: Stewart Love.

Figs. 99, 104, 106–108  Photographers used frequently by the Andrew Wyeth office include Rick Echelmeyer, Steve Morrison, Joseph Painter, and Peter Ralston.

Fig. 100  Photography: Melville D. McLean.

Fig. 102  Photography: Courtesy of A. Call.

Fig. 109  © Charles Isaacs. All Rights Reserved.